TRANSPARENT
WATERCOLOR

THE ART & DESIGN SERIES

For beginners, students, and working professionals in both fine and commercial arts, these books offer practical how-to introductions to a variety of areas in contemporary art and design.

Each illustrated volume is written by a working artist, a specialist in his or her field, and each concentrates on an individual area—from advertising layout or printmaking to interior design, painting, and cartooning, among others. Each contains information that artists will find useful in the studio, the classroom, and in the marketplace.

BOOKS IN THE SERIES:

The Complete Book of Cartooning
JOHN ADKINS RICHARDSON

Carving Wood and Stone: An Illustrated Manual
ARNOLD PRINCE

Drawing: The Creative Process
SEYMOUR SIMMONS III and MARC S. A. WINER

How to Sell Your Artwork: A Complete Guide for Commercial and Fine Artists
MILTON K. BERLYE

Ideas for Woodturning
ANDERS THORLIN

The Language of Layout
BUD DONAHUE

Nature Drawing: A Tool for Learning
CLARE WALKER LESLIE

Painting and Drawing: Discovering Your Own Visual Language
ANTHONY TONEY

Photographic Lighting: Learning to See
RALPH HATTERSLEY

Photographic Printing
RALPH HATTERSLEY

A Practical Guide for Beginning Painters
THOMAS GRIFFITH

Printmaking: A Beginning Handbook
WILLIAM C. MAXWELL/photos by Howard Unger

Silkscreening
MARIA TERMINI

Silver: An Instructional Guide to the Silversmith's Art
RUEL O. REDINGER

Transparent Watercolor: Painting Methods and Materials
INESSA DERKATSCH

Woodturning for Pleasure
GORDON STOKES/revised by Robert Lento

DE CORDOVA
MUSEUM

Born in Europe, INESSA DERKATSCH studied art and art history in Munich and Paris before receiving her Master of Arts degree from the University of California at Berkeley. She teaches painting and drawing at the Rhode Island School of Design in Providence.

TRANSPARENT

INESSA DERKATSCH

WATERCOLOR
Painting methods and materials

A SPECTRUM BOOK PRENTICE-HALL, INC., Englewood Cliffs, New Jersey 07632

Library of Congress Cataloging in Publication Data

DERKATSCH, INESSA.
 Transparent watercolor.

 (Art and design series) (De Cordova museum series)
 (A Spectrum Book)
 Bibliography: p.
 Includes index.
 1. Water-color painting—Technique. I. Title.
II. Series.
ND2430.D47 751.4′22 79-24280
ISBN 0-13-930321-9
ISBN 0-13-930313-8 pbk.

PLATE 1: Reproduced by permission from Johannes Itten,
The Elements of Color (A Treatise on the Color System
of Itten), Otto Maier Verlag, Ravensburg, Germany, 1970.
PLATE 2: Courtesy of Noldestiftung, Seebüll, Germany.
PLATE 3: Courtesy of the Erbengemeinschaft Dr. W. Macke.

THE ART & DESIGN SERIES.
THE DE CORDOVA MUSEUM SERIES.

Cover illustration:
JONATHAN PRINCE
Great Granberry Pool.

10 9 8 7 6 5 4 3 2

EDITORIAL/PRODUCTION SUPERVISION
BY ERIC NEWMAN
INTERIOR DESIGN BY MARJORIE STREETER
AND DAWN L. STANLEY
PAGE LAYOUT BY MARY GREEY AND GAIL COLLIS
MANUFACTURING BUYER: CATHIE LENARD

PRENTICE-HALL INTERNATIONAL, INC., *London*
PRENTICE-HALL OF AUSTRALIA PTY. LIMITED, *Sydney*
PRENTICE-HALL OF CANADA, LTD., *Toronto*
PRENTICE-HALL OF INDIA PRIVATE LIMITED, *New Delhi*
PRENTICE-HALL OF JAPAN, INC., *Tokyo*
PRENTICE-HALL OF SOUTHEAST ASIA PTE. LTD., *Singapore*
WHITEHALL BOOKS LIMITED, *Wellington, New Zealand*

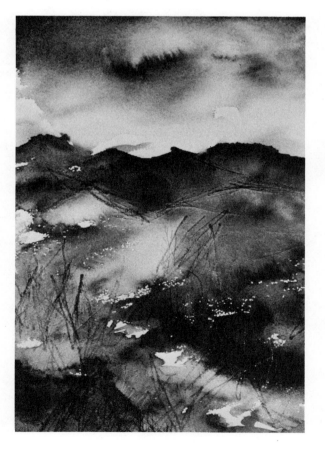

Contents

CHAPTER TWO
Artistic tools and materials 14

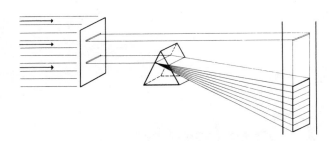

CHAPTER THREE
Color *34*

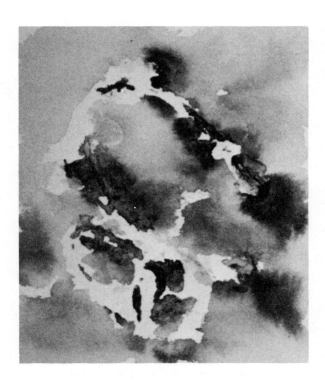

CHAPTER FOUR
Watercolor technique and exercises 54

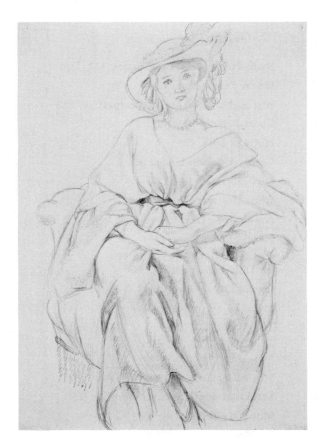

CHAPTER FIVE
Drawing 72

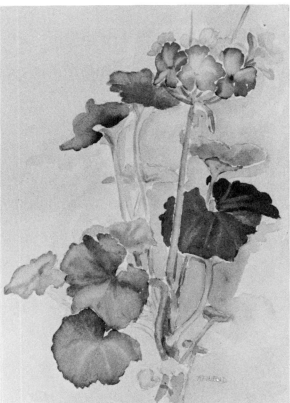

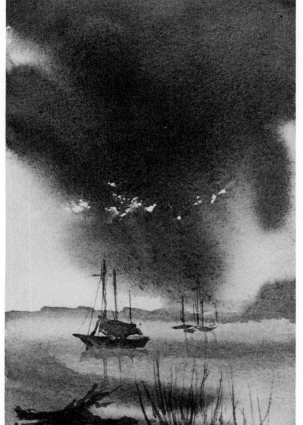

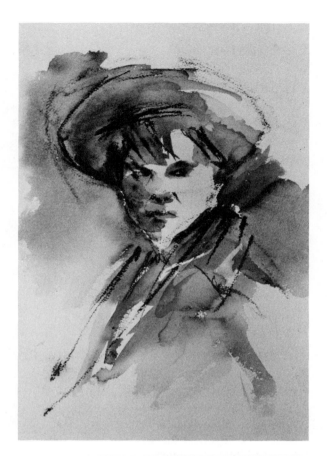

CHAPTER EIGHT

Portraits 168

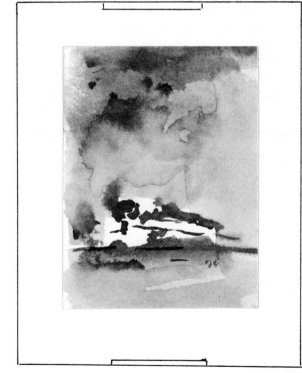

CHAPTER NINE

Framing watercolors 202

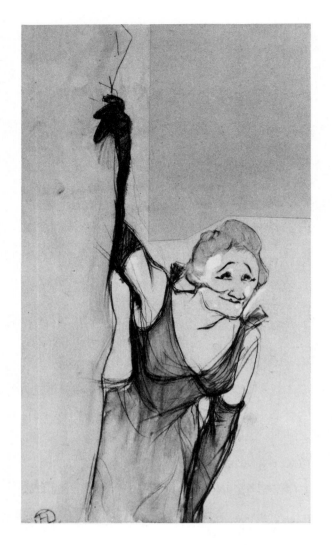

Preface

My interest in watercolor began while working with solid acrylic plastics. These modern, man-made materials have fascinating visual properties. They have mass, yet are transparent and when dyed in various colors allow color fusion and color layering on a three-dimensional level. In watercolor I sensed similar and additional possibilities that I wanted to explore further.

This led to my discovery of watercolor's equally unique visual and artistic potential; the historical context in which it came, so to speak, of age in the nineteenth century; and its diverse uses by artists today. It also lead to my teaching watercolor painting, and with this the challenge and opportunity to see my ideas applied by a variety of different people.

This book focuses on what is unique about watercolor and what distinguishes it

from other water-based media. It capitalizes on watercolor's transparency and shows in a step-by-step manner how to achieve it. I emphasize, foremost, the visual dynamics of the medium, its ability to interact directly on the painting surface to produce new colors, textures, and forms. Although I use the time-honored subjects of still-life, landscape, and portrait, my approach differs markedly from popular watercolor-instruction books that give primarily stylistic guidelines on "how to" paint these subjects, usually in the author's own painting style. My instructions on how to master the technical intricacies of the watercolor medium are not dependent on a particular painting style nor contingent on a specific subject matter.

Still, most beginners like to test their technical competency of the watercolor medium by painting realistically at first. Landscapes are the most popular subject in watercolor and are frequently tried first. However, skill and mastery of watercolor can be achieved just as well by practicing in an abstract painting style, in order to "tune-in" or "get the feeling for" the medium. Ultimately it makes little difference whether you paint apples or Aphrodite as long as you emphasize, in addition to the subject, the "medium's" eloquent message.

With this book, then, I hope to give you the best of both: specific subjects illustrated by a variety of painting styles, as well as emphasis on the impulsive temperament of watercolor that you should learn to harness and control as you would guide a spirited horse.

The layout of the book follows the format I use in teaching watercolor painting. The book is intended as a classroom text, but I hope that it will serve also as a reference source for theoretical and practical questions. The scope is intentionally broad and general

so that a person interested in learning to paint with watercolor may follow the instructions at home.

When selecting watercolor tools and materials, beginners often become confused by the variety available; often they end up with colors that will fade or otherwise disappoint them at an early stage in their watercolor exploration. Since the ability to control and master watercolor painting is closely tied to the quality of its tools and materials, I have given a detailed description of those, one that students can use most successfully.

The watercolor exercises will introduce you to the basic watercolor technique, the brushwork involved in color formation and color interaction. These exercises have served me well in classroom instruction, but they can be altered or amplified to suit your own needs. Artists interested in the abstract or nonobjective qualities of the watercolor medium can use them as a point of departure for their own purposes or to achieve unusual visual effects.

I have included a detailed chapter on color because in transparent watercolor painting, "color" is such a vital element that it can be considered the very base of its existence. I explore the different facets of the phenomenon we call *color*, its chameleon-like nature, and its inexhaustible source of study and pleasure. Furthermore, the role it played in the nineteenth century, providing new artistic objectives and pictorial resources, should be of interest to the watercolorist.

The short chapter on drawing serves, I think, as an introduction to the chapters on still-lifes, landscapes, and portraits. Each begins with a brief historical introduction to the subject, followed by a discussion of the basic visual and technical considerations and, finally, a guide to rendering the subjects in

watercolor. The illustrations of historical, students', and my own work show a variety of individual applications of the unique qualities of the watercolor medium. Studying watercolors by many artists helps students to understand that "abstract" or "realistic" portrayal of subjects is, in fact, quite subjective and encourages them to take liberties with their own work.

The book ends with a chapter on framing. The choice of a frame is the final artistic decision and concludes an artist's visual statement. In addition to being a fancy fixture, the correct framing materials serve the vital function of preserving the watercolor and assuring its longevity. Here I am passing on results of my own experiences with framing watercolors and useful tips from conservation departments of various museums.

The appendix lists sources of watercolor tools, materials, and outlets that furnish items not commonly available on the market. The suggested watercolor palette, as well as the guide to the composition and permanency of watercolors, may serve as a reference for choosing your watercolors. I have listed an extensive bibliography because I believe that familiarity with the literature on watercolor and watercolor instruction is important for the would-be watercolorist.

Acknowledgments

A book like this is the sum total of many long and lonely hours of work, struggle with words, and distillation of ideas often resulting in moments of elation and despair. Many friends and colleagues have contributed to its final shape. Acknowledging their support here seems almost an afterthought because I can hardly do it justice. Still, I want to thank them all, especially Merrie Blocker for introducing me to Prentice-Hall, Inc.; Lynne Lumsden, senior editor of Spectrum Books, and her assistant Frank Moorman, who gave me plenty of encouragement; Eric Newman, who guided this book expertly through its stages of production; and Mary Greey, who patiently and with much skill coordinated all the watercolor illustrations with the text in the layout of the book. Mary Baures and Megan Marshall untangled a number of sentences, weeding out my perennial Germanisms. Paul Birnbaum and Linda Sevey had good advice on how to photograph the watercolor illustrations, a much more difficult task than it seems. Susan Aron, Beth Stewart, and Johanna Bohoy deserve thanks for their line drawings and graphic work, as well. And I am especially indebted to Marjorie Cohn of the Fogg Museum's Center for Conservation and Technical Studies at Harvard University for information about tools, materials, and the archival standards for watercolors. I am also very grateful to the many artists, museums, and private foundations that gave permission to reproduce their watercolors.

Finally, I would like to thank the students at the DeCordova Museum School whom I taught at the beginning of this project, and my students at the Rhode Island School of Design who are rejoicing with me now that it is completed. Their artistic efforts reproduced in this book are, after all, the testing ground for my own ideas on teaching watercolor painting. My deepest thanks, however, go to my parents for their unfailing encouragement and support.

TRANSPARENT WATERCOLOR

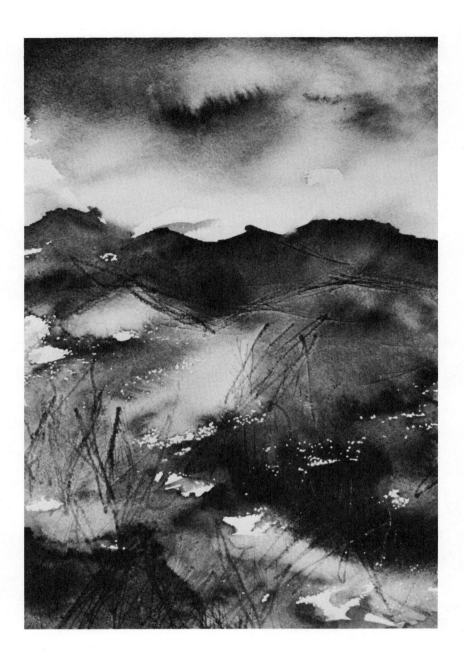

THE PAPER IS THE STAGE; colors, the actors; light, the director. Brushstrokes collide, fracture, and crystallize. Colors fuse into luminous veils, emerge as tangible forms, fade as familiar objects. We, the audience, are captivated by the drama.

The scene is familiar to lovers of watercolor. Its painting style allows intimate participation in the color's happening and the impulse of the brush. It attracts and fascinates, yet is also mysterious and elusive. Like a well-staged play, watercolor withholds the details of its production. We walk away wondering, is it the transparency, the depth, or the luminous glow?

I will attempt to decode these feelings of mystery and sneak behind the curtain to look at watercolor's special visual effects to discover its essential qualities, its historical influences and transformations, and, most of all, its uniqueness. Guided by the notion that fascinations are insatiable and yearn for more

CHAPTER ONE

Watercolor: the medium

information and contact, I will try to show that knowledge deepens understanding and adds to watercolor's magic.

The colors in watercolor painting and their appearance on the white paper surface are suggestive of a special technique. A closer look reveals that they are applied in two distinct manners. In one, the brushstroke is visible, crisp, hard-edged, with definite shape (Figure 4.2); in the other, it is soft and seems to inhale the colors, erasing and fusing its track (Figure 4.1.). These two kinds of color applications give watercolor its unique quality, its effervescent charm, its identity. And even though other water-based media, such as the monochrome inks, share some of the same techniques, they lack that special ingredient, the magician with constant surprises: color.

The technique creating these special qualities is successive color layering. Each color is applied individually onto the dry or

premoistened paper surface, and colors are allowed to fuse and blend, blue and yellow into green, or to shine through various layers, producing multiple color tones and harmonies. The paper surface plays a crucial part, providing the setting, or the environment, for this happening. Color layering in either a crisp or fused manner relies on the paper's ability to absorb the color pigment. As on a cushion, the color sinks in or rests on its support. The process is additive; new colors are built up successively from light to dark. White paper acts as the lightest value, and colors become darker as they float or sink into each other, interacting to form new tonal ranges. Technically, this process demands careful planning and judgment of color interaction, since color clarity depends on color purity. Once paint is mixed on the paper's surface, there is no painting over, no erasing the brushstroke. Success or failure is as plainly visible as in an acrobatic act. And this process of color application, probably watercolor's most difficult technical aspect, is also the most exciting for the viewer, who becomes a participant in the performance.

True watercolor, as distinguished from water-based colors such as tempera and gouache, has color depth because of its transparency. Each delicate color layer builds the picture surface as it creates or transforms new subtle hues. This is first of all due to the pigment itself. Watercolor pigment is a fine powder combined with clear binders and dispersing agents that enable it to sink readily into the paper's fibers. The pigment for acrylic or oil colors, on the other hand, is coarser and combined with a thicker binder that gives it a pastelike consistency. Opaque paints can cover a variety of surfaces easily and, of course, may be thinned to a watery

consistency for a more or less transparent effect. Likewise, watercolors can be used directly out of the tube and applied on a variety of surfaces in an opaque manner. This, however, does not capitalize on watercolor's unique qualities. And since I believe that an artistic medium should be explored for its intrinsic properties, I want to focus primarily on watercolor's see through, *body-less* quality. Within it lies watercolor's greatest asset and artistic potential.

Since the pigments in watercolor paint are really minute color particles, they readily sink into the paper's fibers, anchor themselves there, and reflect from its surface. White paper provides the maximum reflective surface for the color's brilliance. Since light is reflected mostly in pure pigments, the identity and purity of each color on the paper should be retained. If colors are indiscriminately mixed on the palette, or if too many colors, especially complementary colors, such as green and red, are allowed to mix on the paper, they may cancel each other, get murky, and appear dull and nontransparent. Thus, controlling color interaction and retaining the identity of each color in a mixture are skills the watercolorist must perfect.

When using opaque paints such as oil or acrylic, the artist has more leeway because of their covering power and built-in reversibility. Color combinations can be mixed on or off the painting surface, either on the palette or right on the canvas. If a color is too dark or the wrong tonality, it can be repainted as desired. Brushstrokes can be continually erased or redirected, leaving no previous tracks. With opaque paint, therefore, there is room for the artist to change his or her mind. In watercolor painting, on the other hand, each brushstroke is visible, and color mixing is

usually irreversible. Once the color is set on the paper, it cannot be removed, only screened or altered by another color. This, then, most markedly distinguishes watercolor painting from other painting media.

Water-based paint has its origins in prehistoric times. Charred wood or bones were combined with water or water-soluble substances and used to paint on the walls of caves. Ancient forms of watercolor paint had a pastelike consistency because of the surfaces on which they were applied. The rough interiors of caves or even the smooth limestone surfaces of Egyptian tombs lacked absorbency and thus required a thick layer of paint. The distinction between *body color* and *transparent* watercolor did not exist. Color was applied in a variety of styles depending on its purpose, which was either decorative, ritualistic, or commemorative. Papyrus and parchment, perhaps the oldest paperlike materials, were favored for watercolor application, but they did not significantly influence watercolor painting technique. Fresco painting, as seen in the palaces and homes of antiquity, somewhat resembles the washes and glazes of watercolor. But the application of water-based colors on wet plaster requires totally different painting techniques. In the Orient, silk and papers made from various fibers (often referred to as rice papers) called for their own special watercolor technique, which the Chinese and Japanese artists perfected. Most painting surfaces available to Western watercolorists, however, had little effect on the traditional watercolor painting methods. They lacked brightness or the necessary degree of absorbency to allow watercolor to be rendered in its full transparency and brilliance.

The manuscripts and woodcuts of the Middle Ages can be considered the earliest watercolor-like works of art. Transparency in color application is often seen in thinly applied layers of paint, but these appear incidental and are visible only in details of the subject matter. Not until the beginning of the fifteenth century, when papermaking processes reached a higher development in Europe, did the application of watercolor paint significantly change. An absorbent, thick, and slightly rough paper with the right surface and consistency for transparent watercolor painting became available. When the pigment was sufficiently watered down, thin layers of color sank into the fibers and retained, even with successive applications, the visibility of each color. New possibilities opened, and a painting style evolved that capitalized on watercolor's unique potentials: transparency, color depth, and clarity.

Availability of new artistic materials, however, does not necessarily mean exploration of their potential. Innovation usually runs a track parallel with tradition. Today, for instance, sheet acrylic plastic is often used and fabricated like wood or metal. Although not in itself wrong, this practice fails to take full advantage of the unique visual and artistic qualities of this modern material.

Similarly, in the fifteenth century the opaque use of watercolor prevailed, and its transparent application is seen only in isolated examples. The German Renaissance artist Albrecht Dürer is credited with being one of the first painters to capitalize on watercolor's transparent qualities. Among his numerous paintings are delicate landscapes composed of layers of color painted in swift, spontaneous brushstrokes (Figure 1.1). These paintings demonstrate the first adventurous

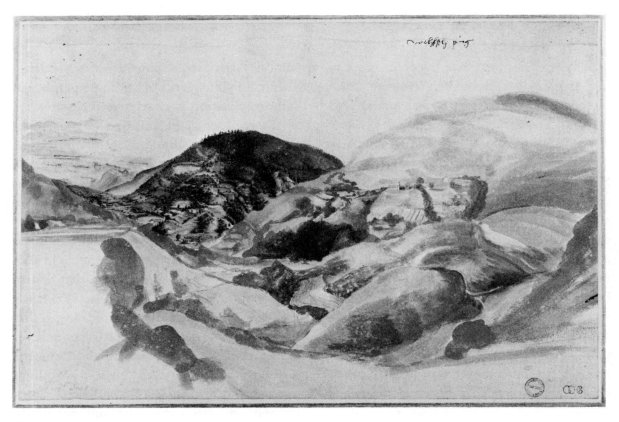

Figure 1.1
ALBRECHT DÜRER (German, 1471–1528)
Wehlsch Pirg [landscape] (watercolor, 210 × 113 mm).
Courtesy of Ashmolean Museum, Oxford, England.

use of transparent watercolors. Their innovative nature is especially apparent when they are compared with contemporary landscapes painted with heavy, opaque *body colors* in a rather linear and descriptive style. Even among Dürer's own work, the transparent landscapes are extraordinary, marking an abrupt departure from his earlier, more traditional use of watercolor. There is no documentation, however, as to whether Dürer was aware of the unique quality of his watercolor application, whether he considered it worthy of exploration, and how much his transparent technique influenced artists in the following century.

Not until the middle of the eighteenth century was watercolor again used in such an experimental and exciting manner. The impulse for exploration came from a variety of sources, one of which was water-based monochrome inks such as bistre and sepia.* Fluid and versatile, they allowed direct, spontaneous painting and were used mostly for the study of the human figure and landscapes. When applied in transparent washes, they behaved like watercolor, but since they were monochrome, they lacked the subtle shades and tones of color. Seventeenth-century painters used them to sketch landscapes and to record with fluid brushstrokes the atmospheric grandeur of nature. Studies of landscapes done by the painters Poussin and Lorrain (Figure 1.2) were especially admired

* Bistre is a combination of gum, glycerine, and the soot of burned wood; used as a wash, it has a yellowish-brown color. Sepia is prepared from the ink sacs of the cuttlefish. It is very dark brown and semi-transparent and is used as watercolor or ink. (Ralph Mayer, *The Artist's Handbook of Materials & Techniques* [revised edition]. New York: The Viking Press, 1965.)

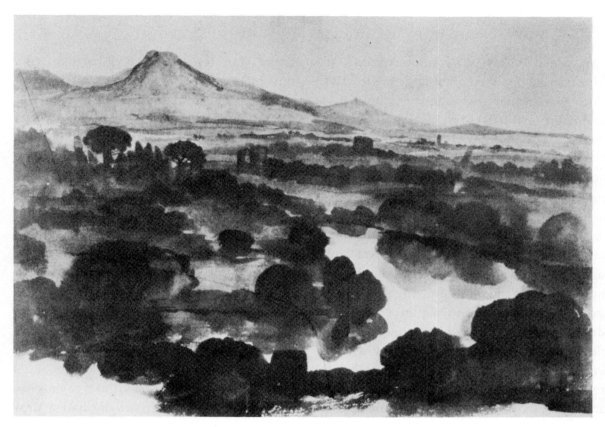

Figure 1.2
CLAUDE LORRAIN (French, 1600–1682)
Le Tibre en Amont de Rome (brush and bistre on white paper,
4¼ × 10⅝ in.).
Reproduced by permission of the Trustees of the British Museum, London.

by the late eighteenth- and early nineteenth-century Romantic artists and became a source of inspiration to the English watercolorists, who explored this landscape-painting technique with watercolors.

In the eighteenth and early nineteenth centuries, watercolor was predominantly used in preparatory studies for oils or frescos.* Like the inks, it was favored for making notations, sketching outdoors, or adding color definition to pen and ink drawings. When rendering the details of plant and animal life, scientists preferred opaque watercolors for their exactness. The landscape painters in the early nineteenth century, however, deserve the credit for having dis-

covered watercolor's unique transparent qualities and for making them popular as a means of recording the everchanging face of nature. Compact and convenient for traveling, watercolor kits accompanied many adventurers on their explorations of various parts of the world. The explorer Sir Walter Raleigh is said to have taken watercolors along on his journey to North America.

Watercolor's rather modest tools and materials and its seemingly uncomplicated techniques appealed to amateurs as well as to artists. By trial and error alone, the amateur could achieve, if nothing else, interesting colors and forms. Thus watercolor had a wide appeal and became a medium especially favored by the rising bourgeosie. It satisfied their yearning for a simple, inexpensive art

* One example is a study of the famous painting *The Raft of the Medusa*, painted by Théodore Géricault in France around 1818.

7

form. Since it was fairly unpretentious, it helped to justify their dabbling in the arts, which was further encouraged by the many watercolor manuals that appeared at this time.

For serious artists, however, watercolors provided an extension of the customary pen and ink drawings used to record travel experiences. Just as today we take along cameras, some of our most famous artists traveled with watercolor kits to Italy and the Orient and painted scenic views of ancient monuments and historical sites. Pen and ink sketching had served this function well, but color gave added dimension. In direct confrontation with nature, quick brushstrokes could leap across the paper, spread and blend into color areas, and fuse into semblances of water, mountains, or trees (Figure 1.3). Landscapes

offered countless possibilities for exploring atmospheric conditions, seasonal changes, the textures of flora and fauna—in short, an immense array of visual stimuli which artists could distill into pictorial equivalents. And like no other medium, watercolor captured with spontaneous gestures of moving colors the immediacy of the artist's response. Artists gradually realized that color alone, without rigid lines, could structure a landscape, and that color's visual properties were better suited to approximate the experience of nature.

Traditionally, artists had relied on solid lines and forms to translate nature's elements into landscape pictures. Color followed as an added and descriptive element. Watercolor's ability to structure with color and to emphasize nuances other than *solidity* had a pro-

Figure 1.3
J. M. W. TURNER (English, 1775–1851)
View of Lake Lucerne (watercolor).
Reproduced by permission of the Trustees of the British Museum, London.

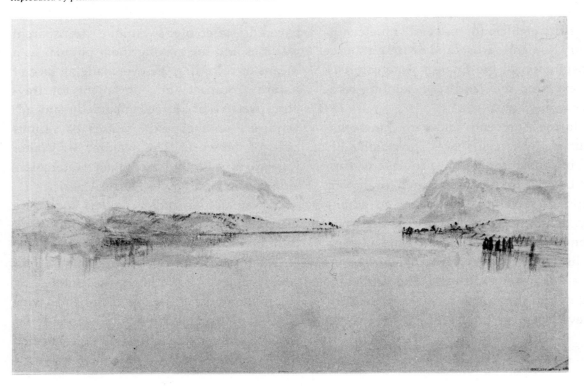

found influence on man's experience of his surroundings and on the traditional "linear" description of landscapes. As an artistic, expressive means, *color* was always considered powerful, but never an equal to *form*. Even in the late nineteenth century, some artists still referred to color as a "feminine" artistic element and to line as a "masculine" one. The partisans of color continued to argue with the draftsmen for its "sensuous" qualities as opposed to the "rational" merits of line. Not unlike women at the time, color was in the process of profound liberation. Its mercurial, unpredictable nature inspired the Romantic artists and became for the Impressionists a subject of serious observation and study.

Romantic watercolorists in the early nineteenth century turned primarily to color when depicting landscapes because it expressed their feelings about nature and conveyed its moods. Often the subjects they chose, such as deep forests or exotic historical sites, encouraged exuberant use of color. Furthermore, dynamic and sensuous elements of nature such as rain and fog encouraged an exploration of light. As an agent that both revealed and concealed, natural light brought out subtle color nuances and changes. Watercolor, best of all other media, could approximate these natural conditions with washes and glazes. Lines in these paintings were reduced and remained visible only as soft pencil marks underpinning color. "When the tones are right, the lines draw themselves," proclaimed the champion of the Romantic spirit, Delacroix. He explored watercolor on a purely visual level, unlinked it from its customary definition in relation to form, and allowed it to carry the picture's structure (Figure 1.4).

The British artists in the early nineteenth century, the circle of watercolorists that gathered around Bonington and Turner, were perhaps the most influential liberators of color. They set off waves of responses, producing "Anglomania" in France as well as enthusiasm elsewhere in Europe and in North America. Their watercolor technique, today considered the classical English style, used colors in subtle tonal nuances, in several layers; each layer became successively more detailed and distinct as the painting reached completion. This time saw the formation of the first watercolor societies, in which artists insisted on the separation between *body colors* and *watercolor*; for transparent watercolor, they claimed, has its own unique visual potential. The watercolors from that era, however, do not look like watercolors today. They are not as transparent and often seem comparatively washed-out. This is due not only to the deterioration of paper and the subsequent fading of colors, but also to the practice of tinting the papers with neutral cream or grey colors. Even though white paper, probably of higher quality than ours today, was available, it became less reflective when tinted first. This was, of course, a technical matter based on the artist's painting style, but visually the practice had significant consequences.

Color brilliance, which depends on light reflection, was muted in these paintings because of undertinting. The discovery of "white" as the context in which colors could display their maximum brilliance was an immense breakthrough. Even though Romantic artists had an intuitive grasp of the importance of *white*, it took the Impressionists to provide the explanation. Aided by scientific discoveries, they analyzed the visual appearance of color as the perception of light on objects. They noted that the appearance of color changed as light changed. Visually,

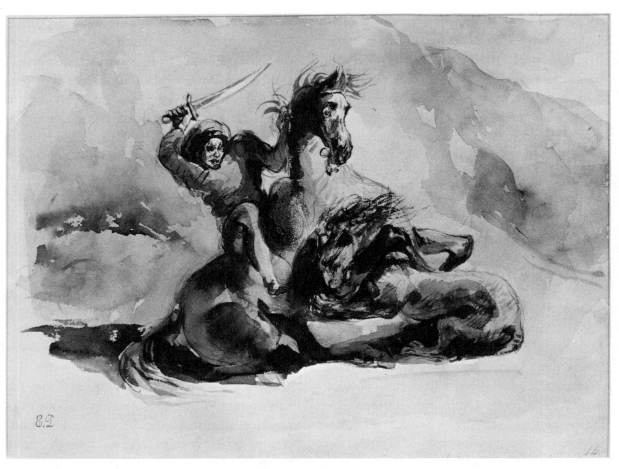

Figure 1.4
EUGENE DELACROIX (French, 1798–1863)
Combat d'un Cavalier et d'un Lion (wash drawing, 9 × 12 in.).
Courtesy Museum of Fine Arts, Boston (17.3145).

light can corrode and dissolve the most solid object. Turner, in the forefront of the nineteenth-century British watercolorists, had prefigured this phenomenon in his misty paintings (Figure 1.5). The French Impressionists capitalized fully on the fleeting play of light in their numerous landscapes, allowing multitudes of colors to define and structure their objects and forms. (See Monet's "Morning on the Seine at Giverny," Figure 3.3.)

One might think that the Impressionists would have been ideal watercolorists, but with the exception of a few landscape studies, their major work was in oil. The scientific interest in light and color to which the Impressionists were inclined could perhaps do very little with the capricious, unpredictable medium of watercolor. Oil paint allowed these artists to apply color slowly and methodically and it gave them the freedom to change colors as light changed. But, because of the mid–nineteenth-century visual observations and studies, color became liberated and gained a place in painting which it has retained since. Watercolor painting continued

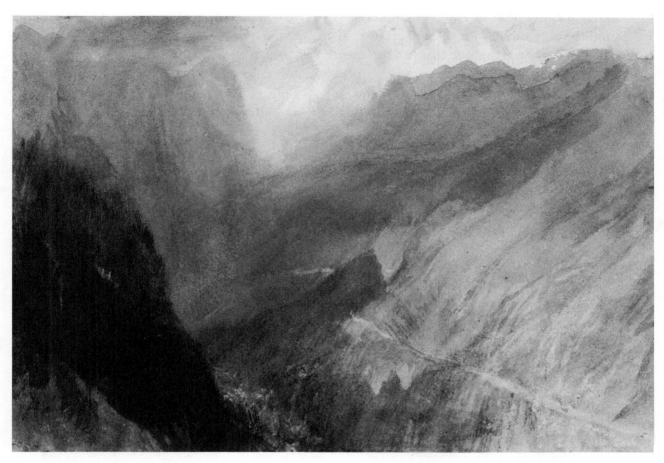

Figure 1.5
J. M. W. TURNER (English, 1775–1851)
Alpine Valley (watercolor, 7¼ × 10½ in.).
Courtesy Museum of Fine Arts, Boston
(Ernest W. Longfellow Fund, 42.305).

to be explored in the art movements that followed. It was used for both its descriptive and expressive potential, and in opaque or transparent application. The wide range of subjects and even wider range of artistic styles are illustrated in the following chapters.

As artists, we inherit the explorations and discoveries of previous generations. Our artistic efforts are the most recent link in the evolutionary chain, and our artistic viewpoints and uses of color and form are inseparable from what has come before us. Today watercolor retains two potential uses: the traditional "opaque," and the more recent "transparent." Artists are using both, often without a clear-cut distinction between the two. Furthermore, the multimedia orientation of contemporary painting gives us license to mix many kinds of paint. And, of course, artistic genius can breathe life and vitality into any combination of artistic media.

I have focused on the transparent qualities of watercolor because their use is especially adventurous and technically demanding. Knowledge of color interaction and thus of the intricacies and possibilities of transpar-

ency are essential in exploring watercolor's unique potential. Watercolor painting is also a craft; it has a technique that can be learned and applied. Comprehending and controlling the medium enables the artist to paint any subject in any style, from a traditional landscape to a color field composition.

The emphasis on experimentation in the 1960s and 1970s has encouraged the combination of traditional painting techniques with new materials. In the stained canvases of the 1960s, we see unprimed cotton take the place of watercolor paper's traditional function. Watered-down acrylic paint is capable of forming transparent layers of washes and glazes which behave on the canvas almost

like watercolors (Figure 1.6). Other modern materials, such as solid acrylic plastics and casting resins, permit color interaction and formation on a large scale and as sculpture. Built-in transparency and the optical ability to transmit as well as reflect light (light piping) encourage unparalleled color exploration (Figure 1.7). Perhaps the use of modern materials today and the discovery of their artistic potential can be stimulated by practice with more traditional materials such as watercolor. I hope that this excursion into the essence and transformation of watercolor painting will inspire further exploration of its unique characteristics as outlined in the following chapters.

Figure 1.6
MORRIS LOUIS (American, 1912–1962)
Winged Hue II (acrylic on canvas).
Courtesy Museum of Fine Arts, Boston (anonymous bequest, 1972.1073).

Figure 1.7
INESSA DERKATSCH
Study in Light Reflection (Light Piping) (acrylic plastic).
Collection Ariston.

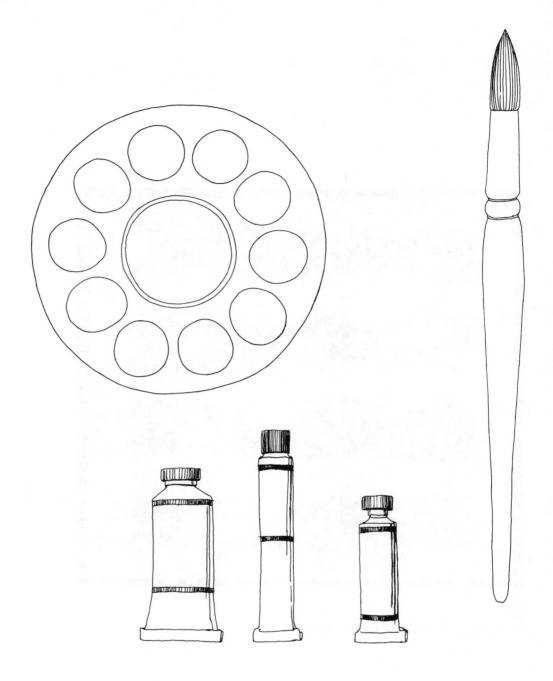

THE TOOLS YOU NEED FOR PAINTING with watercolors are relatively simple: paint, brushes, paper, and water. These are easily obtained, and their use does not require an elaborate setup or preparation. Aspiring watercolorists often start with a dime-store painting kit.

One of the biggest surprises for the beginning watercolorist, however, is discovering how much the quality of the artistic tools and materials influence the painting skill. The right kind of watercolor paper, quality colors, and good brushes make a substantial difference in the painting process. They are intimately linked to the behavior of the watercolors and determine the visual effects and the appearance of colors. Of course, while technical competence is not achieved simply by switching to the right tools and materials, their use does have an immediate as well as a long-range effect (Figure 2.1).

CHAPTER TWO

Artistic tools and materials

COLORS

Watercolor's transparency and brilliance are determined by the composition of the pigments, the choice of paper, and the way the artist uses them. These factors also determine whether the colors will retain their brightness.

Watercolors should not be confused with water-based colors such as gouache, tempera, and acrylic polymer. Although soluble in water, these have a different consistency and produce different visual effects. Even though all artists' paints are derived from the same pigments, they differ markedly in how finely the pigment is ground, its density, and the proportion of binder or vehicle in which it is suspended. In water-based opaque colors, the pigment is rather coarse and combined with a thick binder, giving the colors a certain amount of body. True water-

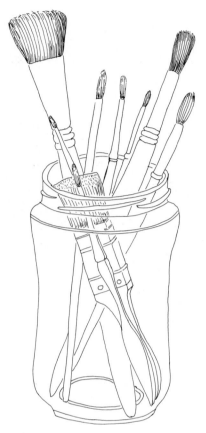

Figure 2.1
Watercolor tools: Brushes.
Illustration by Susan Aron.

another. Dime-store or inexpensive watercolors usually contain coarse pigments, which are "cut" by cheap fillers like chalk or clay. They look very "colorful," but when they are applied to paper, more paint is needed for color brilliance, and usually they become much lighter or lose brightness when they dry. Thus the more concentrated the pigments, the less paint is needed during painting. Quality watercolors will retain their brightness when they dry and are generally permanent.

The first pigments for painting were probably the residues of burnt objects such as charred bones or wood. Throughout history man has searched for new color sources, and those derived from mineral, vegetable, and animal origins now yield a rich palette. Ochres, umbers, siennas—the earth colors—are still derived from clays and ores for use in the best-quality colors. Brilliant and luminous colors were once extracted from the roots and flowers of plants. Some artists still consider the red and rose tonalities of the madder root, originally used to color fabrics and wool, to be unmatched by synthetic counterparts. Juices extracted from animals, such as the reddish purple from the cochineal insect or the sepia brown from the bags of cuttlefish, were used in previous centuries and are still available today. Colors produced from the oxides of heavy metals such as cobalt, cadmium, and lead probably owe their existence to the curiosity of alchemists and the advancement of science. These inorganic compounds yield concentrated color pigments; their density produces quality opaque paints and also watercolors.

The newest additions to the paint family are synthetic colors derived from coal tar dyes. Both aniline and azo dyes are widely used in industry to color such materials as fabrics, wools, and plastics. For artistic pur-

colors, on the other hand, contain only a minimal amount of binder, usually a gum (Gum Arabic) and dextrin (a starch derivative), and the pigment is finely ground and purified so that it will not separate or coagulate. Moistening and dispersing agents (glycerin, sugar, or honey) are also added to the gum to ensure the right consistency and optimal behavior on absorbent watercolor paper.

Quality watercolor is finely ground, concentrated pigment with no other fillers added. This density is visible, giving the colors, when aligned in a tray or squeezed on a palette, a very dark appearance. Because of pigment density, colors like blue, purple, and green are not easily distinguished from one

poses, synthetic dyes are used in colored inks and felt tip pens, and also converted into paint pigments referred to as *lakes*. In the making of watercolor paints, coal tar dyes are combined with inert solid substances such as a semi-transparent calcium phosphate to yield the colored pigments of lakes. Zinc or tin oxides, known for their high density, as well as cadmium sulphate and various manganese, cobalt, and iron compounds, are usually the precipitants of opaque colors.

Color Permanency

Color stability and permanency are affected by any condition which causes a chemical or physical reaction and makes the pigment change or deteriorate.

Because colors are derived from different sources, some colors are not compatible with others. Some mixtures can produce undesirable visual effects or create destructive chemical reactions on your watercolor paper. From a chemical standpoint, lakes should not be mixed with raw earth colors or pigments derived from copper and lead. The chemical reactions may cause them to fade, lose their brilliance, or blacken. Visually, the dyes in lakes have a strong tinctorial quality, which means that they sink readily into the paper and almost stain it. When they are combined with the coarser metal-derived colors, their different behavior on the paper causes them to appear "gritty" and murky. Sometimes colors like cobalt blues and violets produce uneven effects even when they are used on choice watercolor paper. This happens when the pigments are not sufficiently purified from byproducts during manufacturing. Watercolor is also affected by air pollution, temperature change, humidity, or any other condition that produces a chemical reaction.

The most serious offender is direct sunlight.

It seems ironic that light, so necessary for color brilliance, is also color's greatest enemy. The paucity of pigment which makes transparency possible is also the main reason for some watercolors' vulnerability to sunlight. Opaque colors are somewhat protected by pigment density and generous amounts of binder which slow the fading process. Varnish is applied to oil paintings to shield them from dust and air pollution, and also to some extent from ultraviolet light. The glass cover on framed watercolor paintings, however, does little to protect them from those damaging rays.* Our historical watercolors have been preserved by the sophisticated techniques of museum conservation departments. They are stored carefully and usually exhibited in dimmed light, which requires some eye adjustment and concentration on our part, but usually adds to the paintings' intimate charm.

Most manufacturers producing watercolor paint are concerned about the permanency of their pigments and test them for this. They state, however, that permanency and color stability are relative and influenced by a variety of conditions beyond their control. The testing methods used to determine color permanency simulate such destructive conditions as heat and light. But these tests can only account for reactions to controlled laboratory conditions and not the uncertainties of the "real world." Reputable companies publish charts that list the chemicals in each color, their compatibility, and degrees of permanency (see the appendix). These can be obtained from manufacturers or retailers.

My experience has been, however, that many watercolorists are initially uncon-

* There is a framing glass now on the market that has ultraviolet screening properties.

cerned with the quality and permanency of their art materials. Beginners often become annoyed when asked to assimilate information about the nature of paint before they know how to lift a brush and paint with it. Initial artistic experimentation can be done, of course, with inexpensive colors and little information, but not without problems. Watercolors are not all equally stable. Violet, for example, is notoriously fugitive, but several more stable hues of it exist. So artists have choices, the awareness of which can prevent unpleasant surprises. If you select your watercolors carefully, you can have a full palette of permanent pigments. (See the appendix for more specific information on color, its compatibility, and permanency.)

Manufacturers

Practically every firm that makes artists' materials also makes watercolor paints. Their reputations are based on the large variety and selection of materials and tools. Some companies are more specialized and manufacture just a few selected products and paint-related supplies.

A student or artist searching for watercolor paints should look closely at a company's advertisements and brochures. Watercolor paints are often displayed with brilliant color charts, but these are not reliable. Since printing ink cannot reproduce the tonality of a color on watercolor paper, these charts just approximate the color and can be used only as guides. Some companies, however (Winsor & Newton and Horadam-Schminke, for example), have charts that show colors on watercolor paper.

Usually companies make several grades of watercolors, and cost is one indication of higher quality. The most expensive colors are made with pigments derived from costly sources. They are usually called *artists' colors.* Metal-derived pigments (cadmium, cobalt) are the bases for expensive colors, but for most colors there are less expensive synthetic equivalents. Some companies offer information on the pigments' composition and permanency; others do not. Very few companies state their colors' compatibility with other colors or what agents might affect their stability.

Watercolors of various qualities are made by domestic and foreign companies. Grumbacher, one of the largest American firms, offers a complete line of artists' as well as less expensive students' grade colors. Permanent Pigments also produces quality watercolors and, as their name may indicate, they emphasize pigment permanency and furnish information about it. Most artists find that the best watercolors are those made by Winsor & Newton. This is an old, established British firm that prides itself on being the first "Artists' Colourmen" to publish a list of colors with composition and permanency details. Their *Artists' Selected List Watercolors* come in a large variety of hues, many of which are still derived from vegetable or animal sources. Winsor & Newton is the only company that offers rare colors like genuine Lapus Lazuli Ultramarine Blue. They also offer a moderately priced color line called *Cotman,* derived from azo dyes in a more limited color range, and a variety of small, inexpensive color boxes of all sizes (Figure 2.2). Complete permanency information and compatibility ratings of their colors are available to the public (see the appendix).

Nevertheless, confusion often results when selecting watercolors for the first time. The name of a color, for example, is not always a reliable indication of its hue. Hooker's green is not necessarily the same green in

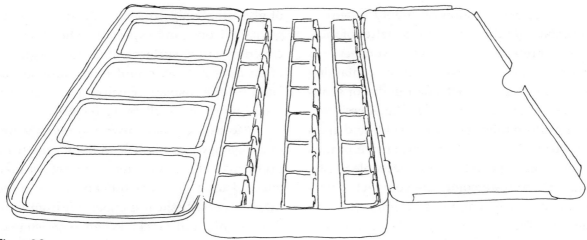

Figure 2.2
Watercolor box with cakes (has built-in mixing area).
Illustration by Susan Aron.

every brand of watercolor. It can range from a fairly deep forest green to a rather yellowish green. One reason for its variability is that green is a combination of blue and yellow. But other factors also enter, such as the density of color pigment, the proportion of pigment to fillers, and whether the pigment is inorganic or derived from a dye. Some names of colors are generic, while others are invented by the company. Even though the pigment's source is often listed on the label, colors may vary. Cadmium yellow, for instance, includes yellows ranging from lemon to orange, but some manufacturers also refer to it as Aurora or Orient yellow. Names also change; a green once called Monastral Fast green is now called Winsor green; traditional names, such as "indigo," which indicate a natural origin of a pigment, may now be a dye.

The artists'-grade watercolors are the best and preferred by serious painters. They have the largest color selection and the most reliable quality. Prices vary depending on the pigments' source. Student-grade watercolors are more limited in color range and usually made from synthetic pigments; each color is the same price. Their moderate price range

makes them an attractive choice for beginners.

Inexpensive watercolors, those which can be bought in the drugstore or dimestore, are not recommended. Their color range is restricted, and although they look attractive, their quality is usually poor. Heavy fillers as well as other chemicals are added to the synthetic pigments, making their permanency questionable. When applied on paper, they lack brilliance and fade quickly. In a class situation where comparison with more expensive colors is possible, the shortcomings of inexpensive watercolors are easily recognized.

Packaging of Colors

Watercolors come in a variety of containers and sizes. The quality of the color does not depend on its physical form. Superior and medium-quality paints come in both tubes (moist) and pans (dry and semimoist). Very inexpensive watercolors, however, come invariably in cakes (dry), usually in a plastic box or tray.

Once the question of quality is settled, the choice of tubes or pans is a matter of individual preference. A large assortment of colors in trays or boxes, usually containing one or two hues of each color in dry or semi-dry cake form, are available. The boxes often have built-in mixing compartments and areas for storing brushes. More expensive brands have colors in porcelain or replaceable plastic pans. These watercolors are compact, portable, and convenient for traveling; they are ideal for the backpacking artist who has to consider the bulk and weight of camping gear. The color box or tray is also popular with beginners who are experimenting with watercolors and do not want to make a heavy initial investment (Figure 2.3).

Since cakes or pans of watercolor are solid or semisolid, they need to be moistened before use. To facilitate this procedure, the semimoist cakes have an additional amount of glycerin. Some artists find it frustrating to get paint from pans, especially when they are covering large surfaces. But the beginner often does not mind and is actually stimulated by the display of colors in a tray and their immediate availability (Figure 2.4).

Moistening cakes with too much water or allowing water to settle in them can create problems. The binder tends to get washed out and used up more quickly, causing the cakes, especially the less expensive brands, to dry, shrink, and crack. When remoistened, small pieces of pigment may attach themselves to the brush and find their way onto the paper's surface; it is difficult to remove them before they create an undesirable visual effect. Therefore, colors should be moistened lightly and only as needed, avoiding water puddles. When you dip the brush into the colors, be careful not to contaminate one color with another. This precaution, of

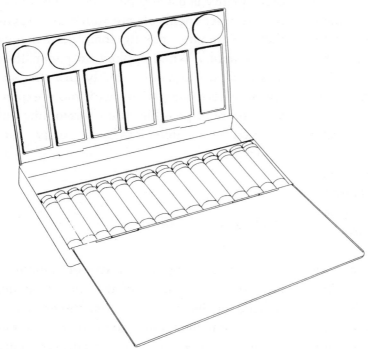

Figure 2.3
Watercolor box with tubes (provides large built-in mixing compartment).
Illustration by Susan Aron.

Figure 2.4
Watercolor tray with cakes. Colors may be solid or
semi-moist.
Illustration by Susan Aron.

course, is basic to *transparent* watercolor painting, which aims at retaining the purity of each hue that goes into a color mixture.

Watercolors in tubes are available in assorted sizes, and, depending on their quality, can be quite expensive (Figure 2.5). In the long run, however, they are more economical, because the color can be measured and

mixed according to the artist's need. Tubes are purchased individually or in a color assortment in a metal box or plastic tray with various size compartments. This is a convenient package, but since often the box does not have enough space for mixing large amounts of color, an additional palette may be necessary.

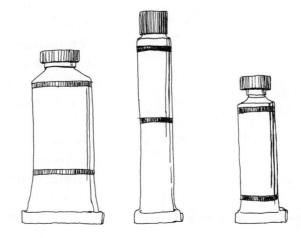

Figure 2.5
Three different sizes of watercolor tubes.
Illustration by Susan Aron.

Any waterproof smooth surface can serve as a palette: a china dinner plate, a piece of glass or Plexiglass, wax paper, or even a muffin tin. It is best, however, if the surface is white like the watercolor paper so that a color's hue can be judged correctly. Watercolor palettes can be purchased in many shapes and sizes, as fold-up boxes, square or round plastic, ceramic, or metal trays (Figure 2.6). Colors squeezed from tubes onto the palette can be stored on it; even after they dry and harden, they can be used again. Artists often assign each color a certain compartment on a tray and replenish it when necessary.

Tubes, however, can present problems. They may be partially dried out when purchased, or dry out when not tightly capped; their shelf life is not unlimited. The chemicals and pigments may also separate, so that squeezing them pushes the binder out before the pigment. If this happens, the whole tube has to be emptied and mixed before the color

becomes usable again. Often tubes on sale have these problems, so the beginner should be cautious of them. Some students have dipped "problem" tubes into fairly hot water and then manipulated them in an attempt to mix the contents. This method is sometimes successful, but its success depends on the kind of pigment. Metal-derived colors, for example, dry out relatively easily and are difficult to reconstitute.

Removing the caps from tubes is one problem commonly encountered in the classroom. This difficulty sometimes arises when tubes are new and tightly sealed. It occurs more often, however, when the tubes are already in use and the color is not wiped off properly before they are recapped. Forcing them open can literally wring their necks. Desperate attempts to open them range from holding a match to their caps to speaking to them. The flame causes the caps to expand and loosen, but it may also make them crack. Once the cap is broken, the tube is bound to dry out. I suggest a less drastic measure like soaking or holding the tubes under hot water. This method takes patience, but it works. A hopelessly closed or dried-out tube can be opened from the bottom; and if the color does not seem to have deteriorated, it can be used in its solid form.

I prefer a combination of tubes and pans. The tray with solid colors is convenient for traveling, and the tubes offer quality, color selection, and economy. I use the Horadam watercolors, the metal box with twenty-four pans, made by Schminke. This is a German firm, not as old and established as Winsor & Newton but certainly as reputable and conscientious. Whenever I am in Europe, I restock supplies and otherwise supplement them with the best Winsor & Newton watercolors, selected with an eye toward permanency.

Figure 2.6
Watercolor palette. This round type is one of the many kinds available.
Illustration by Susan Aron.

WATERCOLOR PAPER

Most crucial in your selection of watercolor materials is choosing the right paper. Paper has an immediate effect on the behavior of watercolor pigments. This in turn affects the artist's technical skill. Most of all, paper has a direct bearing on the permanency of the watercolors. Ideally, watercolor paper should be thick, white, made of 100 percent linen rag, and cold-pressed. This is a lot to ask of paper, as I will point out shortly.

Ordinary paper, the kind used for drawing or writing, has few of the above features. Made from wood pulp that is chemically treated for whiteness, it is hot-pressed into sheets of a certain thickness. The hot-press finish produces a smooth, sleek surface texture, over which pens and pencils glide easily. For watercolor painting, however, such paper is unsuitable. It is too smooth and too thin and resists absorbing the watercolor pigment.

Most watercolor papers are thicker and more absorbent, and contain a higher grade of wood pulp. They are hot-pressed with a surface textured to hold color pigments, to *pool* them, so to speak. The hot-press finish, however, is problematic. Water does not easily penetrate its surface, and when it does, the moisture swells the paper, producing uneven tension between dry and wet areas. The surface buckles and the pigment settles unevenly, resulting in "sunburst" or "curtain" effects. The color does not actually sink into the deeper fibers of the paper but stays on top. (The hot-press finish is often abbreviated as HP.)

Using such hot-press watercolor paper is a very trying experience for beginners. Many give up because technical mastery of watercolor painting seems unattainable. Few realize how much the paper influences the watercolor's behavior and the painter's skill. If pigments do not sink into the fiber of the paper but float on top, they become contaminated by successive color application; thus clarity and brilliance, two of the most important aspects of watercolor paintings, are virtually impossible to achieve. Unless colors are applied in very light layers, they will invariably mix and fuse, and if buckling causes them to settle unevenly, the paper will look as if it is stained. Unfortunately, it is in the purchase of the paper that beginners usually hit or miss. This is often because good watercolor paper is expensive or because the student is not well informed or is ill advised about its properties.

Another problem is that ordinary, mold-made watercolor paper has a detrimental effect on the pigments. The wood pulp in these papers is bleached and refined with sulfite compounds and sized with various other chemicals. The sizing of a paper is the binder which amalgamates the wood fibers. Animal or vegetable glues—rabbit skin or wheat paste—were once used for sizing, but today it is usually a synthetic resin. The chemicals in heavily sized papers eventually affect colors, causing changes in their appearance and stability. The oxidation process which ages and deteriorates paper can be noticed quickly perhaps in newsprint which, when left in the sun, turns brown. Moisture and air pollution—especially exhaust fumes from automobiles—accelerate this process.

Archival Qualities

How artists' materials withstand the wear and tear of time and other destructive influences is more the concern of conservation departments of museums than of the beginning wa-

tercolorist. However, any artist working with paper has to be interested in its aging factor if his or her work is to last. Lately, there has been an increasing awareness of the archival qualities of art materials, and artists have made an effort to get information from manufacturers about the quality of paper.

One important aspect of good archival-quality paper is its acid content. Acidity is indicated by the paper's *pH range*, which is the hydrogen potential of chemical activity, and is expressed on a scale of one to fourteen. On this scale, seven is neutral, above seven is basic, and below, acidic. Ordinary writing paper and most artists' papers are all highly bleached and, depending on their sizing and pulp, quite acidic. Archival quality paper, on the other hand, is made from 100 percent cotton fibers that are not heavily chemically treated and are as near neutral (pH 7) as possible. But the pH of a paper is not stable. The higher the chemical content of a paper, the more likely the pH will change when moisture penetrates its fibers. A variety of chemicals and atmospheric conditions, as well as the proximity of seemingly benign materials, such as wood and plastic, can change it. This may explain the reluctance of manufacturers to commit themselves to a set pH range and publish it. Today it is customary to buffer artists' paper, making it more basic (with a higher pH) to guard against eventual deterioration. But this is not the answer either. Many watercolors are changed by paper that is too basic, a condition just as detrimental as acidity.

Currently every imaginable kind of paper exists on the market. Many are made from synthetic fibers which look suitable and often intriguing. Modern industry, seemingly trying to substitute as much plastic as possible for traditional materials, advertises these papers as having the same properties as quality watercolor paper. In our fabrics, nylon and dacron replace cotton, so why not also replace the rag content of paper with plastic? My students sometimes brought to class papers made from various cellulose acetates. In addition to their susceptibility to unpredictable chemical effects, these papers behave quite differently from quality watercolor paper. They soak up water more rapidly, and the pigments settle into their fibers unevenly, often coagulating in certain areas and leaving definite water stains. Plastic does not have the absorption capacity of cotton and does not expand and contract in the same manner. One paper called Aquarius contains fiberglass that can come loose and cause skin irritation. Synthetic papers might be fun to experiment with, but I do not recommend them for the serious study of watercolor technique.

Quality Watercolor Paper

Quality paper is made from rag fibers that are not heavily bleached or chemically treated. Linen rag was traditionally used, but is now almost a thing of the past. Sometimes linen rag paper can still be found in Europe, but it rarely appears in the United States. Just as cotton has replaced linen canvas, primarily because of cost, most of today's better watercolor paper is 100 percent cotton rag. Sometimes paper contains only a certain percentage of cotton, usually stated by the manufacturer. The surface finish of watercolor paper can be either hot-press or cold-press, depending on its artistic purpose. The

cold-press finish, however, is the choice of most watercolorists, and certainly the one for beginners. It is much easier to work with and makes the paints' behavior more predictable and easier to control. (The cold-press finish is often abbreviated as CP.)

The cold-press finish is created by pressing the cotton fibers into a certain thickness with cold rollers. These leave the paper with a porous surface, or a *tooth* of either a semirough or a rough texture. Since the cotton fibers are compressed but not sealed together, this paper expands evenly when moist and dries flat. The texture of cold-press paper provides little traps in which the pigment anchors itself naturally. The less expensive papers imitate this feature with a mold-made pattern.

Cold-press finish paper is expensive, because it requires long, quality cotton fibers, and its production rate is slow. Unless the manufacturer explicitly states that a paper is cold-press, we can assume that it is not. Not all artists' supply stores carry quality, cold-press watercolor paper. Sales personnel in many stores are often uninformed about paper quality and will recommend and sell to students any paper. In that case, trial and error become inevitable.

I prefer my students to use a watercolor paper that comes from France and is made by Arches. It contains 100 percent cotton rag, is cold-pressed, and comes in rough and smooth finish and a variety of thicknesses. This is an excellent paper of nearly neutral acidity (7.5 pH). Fabriano, an Italian firm, also makes quality papers in both hot- and cold-press finishes; however, I found them slightly less absorbent than the Arches paper. Other good brands of watercolor paper are made by the British Royal Watercolor Society (RWS),

Arnold, Creswick, and Crisbrook. The American Watercolor Society (AWS) also makes a reliable brand. All quality watercolor papers carry a watermark, a trademark of the manufacturer, which indicates which side is the front. Some variation in texture is usual, but both sides can be used equally well for painting.

When purchased by the sheet, quality watercolor paper has two edges that are irregular and fuzzy rather than cut. Such deckle edges are produced by the manufacturing process when the paper is rolled out on the press. Papers which are pressed into individual sheets are sometimes referred to as handmade. This is somewhat misleading, because they are not "made by hand" but on machines that are perhaps less automated, slower, and at least partially controlled by hand. Truly custom-made papers rarely appear on the market. They can be ordered, however, from private manufacturers according to specifications of size and thickness, or other qualities and characteristics that suit a special need.

Interest in handmade paper has stimulated many artists to try this traditional craft in their own kitchens. Apparently paper can be made on a modest scale with fairly simple materials and tools. The *American Artist Magazine* devoted its August 1977 issue to papermaking and listed sources of supplies and private companies who specialize in custom-made papers for artists. Paper mills in Europe provide this service, and American artists have actually gone there and produced their own papers. In Japan, where many papers are still made in the old papermaking tradition, paperhouses and other companies also provide custom-made papers. (Appendix lists sources.)

Oriental Paper

Papers with very loose fibers, often called rice papers, are not actually made from rice fibers but from mulberry bark. Most of them come from Japan, but some from China. Most thin and almost transparent Oriental papers are not suited for watercolor painting. Several though, among them the Hosho and Kozo papers, can be used successfully with watercolor. The quality of these papers varies, however, and it is difficult to obtain information about their composition. All of the Oriental papers I have purchased either here or in Europe are heavily bleached or otherwise chemically treated. Watercolors fade on them very quickly in comparison with other quality papers, and they have bleached my best watercolors as fast as wood pulp paper would. Better and unbleached papers such as Washe No Mise exist (see the appendix). I suspect the paper imported to this country is mainly for pen and ink, a medium which uses black ink and just a minimal amount of color.

Watercolor technique for Oriental paper requires a special touch. Because the fibers are so loose and the surface so porous, the pigments instantly sink in, soaking up the color like blotting paper. Each color application is definite and leaves a mark. The paper cannot be manipulated, and sometimes the friction of the brush alone will make it fall apart, especially if too much water is used. This paper definitely requires knowledge of brush stroke technique and familiarity with color formation. The visual effects that can be achieved, the velvety look of soft blended edges, for example, are exquisite. But such paper is a challenge even for the advanced student, and I do not recommend it for beginners.

Sizes and Formats of Watercolor Papers

Quality watercolor paper is sold by the sheet in various thicknesses. The thickness, measured by weight, ranges from 72 to 400 pounds. The paper's weight is determined by measuring a ream (500 sheets) of the standard 22" × 30" size. A medium watercolor paper is ca. 140 pounds. Very heavy papers are those in the 300 and up weight range. Traditionally, sizes of watercolor paper had names like Imperial (22" × 30"), Royal (12" × 24"), Double Elephant (27" × 40"), and Antiquarian (31" × 53").

The Imperial standard size is still the most popular today. Many papers are made first in rolls of a specific weight and width and then cut into smaller sizes. Some papers (like Arches) can actually be purchased by the roll (20 yards). Arches paper and certain Grumbacher brands are also sold in tablet form. A tablet is like a block, except that the paper is fastened on all sides by a glue-like solution. The sheets can be easily peeled off by inserting a knife into an opening provided for this purpose. The tablets are available in different sizes, weights, and finishes. The tablet format seems to be the modern answer to the tradition of taping watercolor paper on a board. But it does not work. Paper naturally expands when wet, and buckles when gummed on all sides, creating ripples. It seems counterproductive to use this kind of format for quality, cold-press, rag paper. The tablet's main advantage is its convenience for the traveling painter, who can use it for a support when painting outdoors. One pays for this convenience, however, because tablets are more expensive.

In class we have tried some domestic

printmaking papers, such as Rives BFK and Lana. These are quality etching papers made from 100 percent cotton rag, and their acidity is within the nearly neutral range. Their consistency and behavior are, however, quite different from those of cold-press watercolor paper. First of all, they are hot-press. Since etching paper is soaked in water before it goes to press, a cold-press finish is unnecessary. Furthermore, the rag fibers are short and smooth, since they are pressed into the design of the etching plate during printing, thus providing a less textured surface. Nevertheless, with a certain amount of preparation and caution, these papers can work well for watercolor painting.

By soaking a sheet until it is fully saturated with water (about fifteen minutes), you can somewhat remove the hot-press finish, leaving the paper surface rougher and much more absorbent. The color pigment sinks into the fiber readily and evenly, with no buckling. The fiber, however, is loose and cannot easily be manipulated with a brush or sponge. Etching paper is well worth trying, available almost everywhere, and a good substitute when cold-press paper cannot be obtained.

The soaking process is actually the traditional manner for preparing watercolor paper. Soaking prevents a less expensive paper from buckling. The moistened paper is either taped to a board with water-soluble tape (butcher's tape), or stretched over a frame like a canvas. When it dries, it shrinks and becomes very tight and can be painted wet or dry without buckling.

This method, recommended by many traditional watercolorists, is used even with expensive watercolor paper. I do not see much sense in stretching paper, because even if buckling can be prevented, inexpensive paper retains all of its other problems. With quality watercolor paper it seems unnecessary and time consuming. A good paper expands without buckling and dries fairly flat. If it dries unevenly, it can be remoistened on the back and pressed between two sheets, usually overnight, until it is flat.

Finally, I would like to mention some questions that frequently come up in class. Since quality watercolor paper is expensive, students think that using it to learn technique is wasteful. I am constantly asked, "Why can't we buy cheap watercolor paper to practice watercolor technique?" I am sorry to say that paper is so intimately connected with color behavior and brush movement that practicing on cheap paper is almost impossible. Imagine learning to play the guitar by using a poorly working instrument whose sounding board is split and buzzes with every vibration. You go through all the right fingerwork, but you can never go beyond the limitations presented by the instrument. Basically, you do not know what you are doing because you do not hear the right sound. In watercolor painting, the paper is your sounding board.

WATERCOLOR BRUSHES

Along with the paper, the watercolor brush is closely connected with painting technique. It transports the pigments onto the paper and directs their shape and movement. For this purpose, it should be absorbent, thick, and pliable (Figure 2.7). The bristle brushes used with oil or acrylic paints are different; they

Figure 2.7
Semi-flat mop-type watercolor brush.
Illustration by Susan Aron.

are usually stiff and designed to spread the paint and hold a minimum amount of water.

Watercolor brushes vary in shapes and sizes and in the types of animal hair used. The best, made from red sable, are most often recommended but least often purchased. They combine all the desired features of a good watercolor brush: fine textured hair, absorbency, flexibility or "spring" when wet, and, most of all, a tip that tapers to a fine point. But they are also frightfully expensive, and few beginners can afford them. Sable hair comes from the tail of the Russian red tartar marten; the best hair is uniform in length, strength, thickness, and elasticity. Hair selected for the best brushes is naturally tapered and, when tufted in a brush, gives the red sable a belly where it is thickest. The cost depends on the thickness and increases with the length of the hair. A large brush is six times as expensive as a small one. Small sable brushes are found in almost every store and cost a few dollars, whereas the larger sizes, most commonly used for watercolor painting, can cost as much as fifty or seventy-five dollars. These brushes (sizes sixteen and up)

are rarely stocked and have to be specially ordered, placing the buyer in the position of ordering a brush without having seen or inspected it. Both quality and price vary according to brand.

By the way, not all sable is red sable. Black sable, once more popular, has now become quite rare. It originally came from the wood and stone marten, but now is derived from tails of the eastern Canadian civet cat. The hair is rather thick and straight, and is used in flexible oil brushes.

The most common watercolor brush on the market is called Sabeline. This is a misleading play on the word and gives no more than the illusion of the real thing. These brushes are all made of animal hairs that vary greatly in thickness, strength, and pliability. Manufacturers do not state the origins of the hair, or if they do, they sometimes refer to it as "camel" hair. This is a misnomer, since camel hair is not used in these brushes. Rather, the term is a convenient coverall for any type of animal hair that is soft and finely textured (Figure 2.8).

Most of the hair for moderately priced

Figure 2.8
Flat, large ox-hair watercolor brush.
Illustration by Susan Aron.

watercolor brushes comes from rodents such as squirrels. Often fitch hair is used, derived from the tail of the Russian fitch or from the North American skunk, but brushes made from this type of hair are too soft and pliable and become soggy when wet. They also bend into a position and do not bounce back. This last is the most common liability of a relatively inexpensive hair brush which mimics an old, worn-out brush. Very good, average-priced, flat watercolor brushes with short hair are made from ox hair (Figure 2.9). The fine hair that grows inside the ears is quite thick, soft, pliable, and naturally tapered. The better Oriental brushes, those used for Chinese or Japanese brush painting, are made from badger or leopard hair; the less expensive, those commonly on the market, are made from goat hair, taken from the goat's back or from its whiskers. All Oriental brushes are inserted into bamboo handles (Figure 2.10).

Hair of unidentifiable origins, as well as hair from the animals just mentioned, often varies in quality and texture. Their flexibility is either too little or too great. The brush point is not naturally tapered but machine cut to its tapered end. Sometimes such hair is

ground with an abrasive to make it pointed. In a naturally tapered brush, the point is usually visible even when the brush is dry. Mechanically tapered brushes are often dipped into a water-soluble glue that holds the hair together. The brush's appearance is deceptive, because the point achieved with this treatment is not necessarily the point the brush will have when wet. Gluing, however, is a very common protective treatment for shipping and storing and is easily washed out with soap and water. The mechanically cut brushes we used in class became quite useful after friction from the papers' surfaces wore the tips into more pronounced points. They also became more porous and capable of absorbing more water. Unlike delicate red sable brushes, which wear out easily and must be treated gently, this type of brush is rugged and actually gets better with use.

Synthetic watercolor brushes made from plastic fibers such as nylon are advertised as having the resiliency and softness of the finest sable. (Grumbacher makes one called "Erminette.") Although this might sound good to a beginner, it is actually very deceptive: Plastic simply does not have the

Figure 2.9

Figure 2.10

Figure 2.9
Flat, small ox-hair watercolor brush.
Illustration by Susan Aron.

Figure 2.10
Oriental watercolor brush with bamboo handle (may be made of goat, badger, or leopard hair).
Illustration by Susan Aron.

properties and behaviors of natural animal hair. The synthetic brush does not absorb water, but traps it between its fibers, and lacks the pliability and bounce necessary for spreading watercolor over the paper surface. Although students often bring brushes like these to class, I do not consider them suitable for learning the watercolor technique. The amount of water and pigment they absorb is difficult to judge and control. They compare to real sable as nylon compares to silk.

The metal shaft (ferrule) and handle are also distinguishing parts of a good brush. Most manufacturers state what kind of metal is used and whether the ferrule is seamed or seamless. Both affect how securely the hair fits. Obviously the metal has to be rustproof, so most medium-priced brushes are either aluminum- or nickle-plated metal. The more expensive brushes are invariably made with a seamless nickel ferrule. The hair is sorted and shaped into form, either by machine or by hand (*hand cupped*). The hair should be fastened at the belly for maximum flexibility and spring. It is glued into the ferrule with a setting compound and attached to a wooden or plastic handle. Usually a well-cured hardwood prevents warping, and it is sealed and lacquered to make it moistureproof. Sometimes plastic handles are used, and in some brushes the end of the handle is cut at a slant (Figure 2.11). The sharp edge is used to scrape or burnish dry or wet watercolor paper for special effects.

Sizes and Shapes

The choice of a particular brush according to size and shape really depends on the artist's purpose. Even though each shape creates a different brushstroke, the accomplished watercolorist rarely switches brushes for each stroke. Part of learning watercolor technique is discovering how many different brushstrokes can be implemented with one brush. The round brush is the most versatile (Figure 2.12). It holds a large quantity of water and, if pointed well, will make very fine lines, or, depending on pressure and touch, wide, broad strokes. I consider a flat brush, which does not hold much water, a specialty brush for making broad, straightedged strokes (as seen in Plates 3 and 5). The semiround brush has the best characteristics of both the round and the flat brushes, but is not suited for fine points. Fan-shaped brushes are special effect brushes designed to make very fine, multiple lines (Figure 2.13). Mop brushes, or wash brushes, are used usually to lay on heavy wet areas, such as the sky of a landscape or seascape (as in Plate 20). The brush size should be geared, of course, to the paper size.

Many artists' supply companies make watercolor brushes. Grumbacher, Winsor & Newton, and Robert Simmons, for example, feature large selections of quality brushes. But rather than buying a particular brand, you should examine the brush that you intend to buy to see if it has the features you

Figure 2.11
Flat watercolor brush with cut handle (the sharp edge of the handle is used to scrape or burnish watercolor paper).
Illustration by Susan Aron.

Figure 2.12

Figure 2.13

Figure 2.12
Large, round all-purpose–type watercolor brush (similar to the Art Sign No. 20).
Illustration by Susan Aron.

Figure 2.13
Fan-shaped watercolor brush (for special watercolor effects).
Illustration by Susan Aron.

desire. Note also that sizes (indicated by numbers) are not standardized. A size twenty brush from one company may not be the same size as a size twenty from another. The brush we have used successfully in class is made by Art Sign (see Figure 2.12). The number twenty round watercolor brush, made from ox hair, is the best-quality brush for its price on the market. I have used mine for many years and, like very few things in life, it has become better with time.

I do not recommend a large assortment of brushes, and do not believe that only pure red sable will work. In class we have used Sabeline brushes with good results. What I do insist on, however, is a fairly large size brush, number twenty and up. For the beginner, only one brush is really necessary. The mastery of watercolor technique is largely based on the artist's familiarity with the medium, and his or her ability to predict and control the paint with the brush. By beginning with just one brush, you will become familiar with its behavior and eventually learn the right brush movement for the desired result. This process is slowed down by the use of too many brushes. Eventually,

of course, you can add brushes in various sizes and shapes. I have seen students become very attached to one brush and, perhaps because of its familiarity, use it for almost all their watercolor work. But this is an individual matter that you have to decide for yourself.

Care of Brushes

Taking care of your brushes will make them last longer. The brush should always be rinsed in clear, warm (not hot) water, squeezed out, and allowed to dry with the hair standing up. If color accidentally dries on the brush, soaking it for a short period of time will soften and remove it. If the color is hard to remove, you can use a mild soap like Ivory. Always rinse thoroughly. At no time should the hair be pulled apart in an attempt to remove the dry pigment; this is the fastest way to ruin a brush. Brushes should not be soaked in water for a long period of time. Reserve your watercolor brush for water-based paint. Acrylic and oil brushes withstand harsh solvents and quite a bit of manipulation from

the friction of the canvas, whereas a fine sable brush will wear out in no time. Sometimes extensive soaking causes the painted wood handle to peel. Although this is not harmful to the hair of the brush, it is rather unaesthetic and might affect the way the brush is held. Repainting or taping can hide this disfiguration. With care, a brush can have a long life and become the artist's trusted companion during his or her mastery of technical skill.

Figure 2.14
Natural sponge for soaking up water or color; also for special effects.
Illustration by Susan Aron.

Supplementary Equipment

In addition to color, paper, and brushes, you will need *two water containers* (quart size) and, of course, a supply of water. One container is for rinsing your brush after each use, and the other for diluting your paints with clean water. Change your water often and keep the rinsing and diluting procedures separate to ensure the purity and brilliance of your colors.

A small *natural sponge,* sold in drug stores for makeup, is handy for soaking up excess water or color and can also be used to add texture for special effects. Most often it removes excess color and water or lightens an area. A natural sponge is more gentle than its synthetic counterpart, and even with scrubbing does not damage the paper's surface (Figure 2.14). However, paper towels, tissue paper, or rags can be used to scrub or blot. One of my students used a white T-shirt which by the end of the course had become beautifully color stained; it looked as if one of the Impressionists had attacked him with a brush.

Since many paintings require a preliminary pencil sketch, you will need a *soft pencil* and *eraser.* Pencil lines should not compete with the delicate color application. A pencil

that is too soft will smudge when erased, and one that is too hard will press into and incise the paper. I do not recommend charcoal, even though it is used by some traditional watercolorists, who cover it with opaque watercolors. The eraser should be soft and white so as not to leave any colored smudges. The white gum-type or kneaded ones that architects use work well. I recommend vinyl erasers, as they will not leave grit or grease on your paper.

Instead of stretching watercolor paper, I suggest for aesthetic reasons that you tape its edges. *Masking tape* (⅔″–1″), taped around the edges of your watercolor paper, sets margins to your composition and makes an instant clean border that simulates a frame. You can paint over the tape (since color will not penetrate it), and for certain compositions we actually divide the paper into squares with tape. (See Plates 7 and 30.) This also comes in handy for framing purposes; the margins provide space for the mat so that you do not have to cut anything from your composition. (See chapter on framing.) A word of caution: masking tape is not considered archivally suitable for use with watercolors. If left on too long it will deteriorate, leaving a sticky residue (especially if the weather is

hot) and harm the paper; so remove it as soon as the painting is finished.

Watercolors are usually painted on a flat surface. Unless you are using the running color effect or are painting with opaque water-based colors, you do not need an easel. Small easels that hold a standard sheet of paper and can be tilted at various angles are available for watercolor painting. But I do advise against them, and against sketching stools, hairdryers, and lamps, which are props favored by more traditional watercolorists.

Instead, I recommend a fairly good-sized table (for indoor painting) or a drawing board (for outdoor painting) and adequate light. Find a convenient area where you can leave your equipment set up so that you can turn to it often. Be conscious of the environment in which you paint and its influence on your subject matter. Natural light (daylight) and artificial (fluorescent and incandescent) light will affect the appearance of your colors differently. How and why this is so will be discussed in the next chapter.

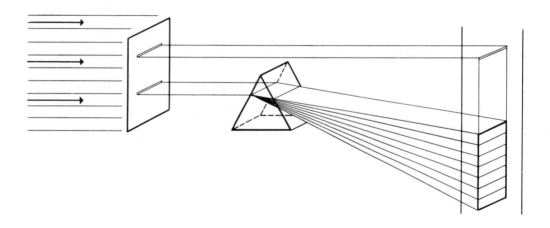

COMPARING A WATERCOLOR with its black and white reproduction, you will discover the importance of *color* in watercolor painting. The reproduction may as well have been painted with India ink. None of the colors' modulations, formations, and subtle tones of transition are visible. Thus, color gives watercolor painting its life, essence, and uniqueness.

But not only watercolor depends on color. If we took color out of our daily existences, our lives would be the poorer for it. Throughout history, color has played an immensely important role as an expressive, communicative, and suggestive agent. From the body paint of primitive man to the psychedelic thrills of the 1960s, color has conveyed its own messages. History could probably be studied just by analyzing the uses and changes of color, and its ritualistic,

CHAPTER THREE

Color

symbolic, and heraldic qualities. And a history of scientific progress could be written by tracing the alchemist's conception of color, rooted in a belief in the mystical and magical powers of chemical compounds, to our sophisticated scientific understanding of color in the spectrum, as a small section of visible radiant energy among numerous electromagnetic waves.

Even though color is part of our daily lives and something we take for granted, an exploration of its nature makes us realize how very little we actually know about it. What is color? How is it formed? Is the "red" of a stop sign part of the octagonal shape, or does the red exist separately from it? When we call a flower "yellow," does everyone automatically understand what color we mean? When we are feeling "blue" or are in the "red," are we actually talking about colors? If

you stop to think about it, you will realize that "color" is one of the most difficult qualities to define. It is truly chameleon-like, because so many variables are involved in its formation and in our perception of it.

Colors are said to be in continuous flux, changing identity in relation to such factors as shape, size, background, and adjacent colors, but most dramatically in relation to the presence of light. We cannot see color without illumination, because color *is* actually light. Thus, color is not the surface of an object, such as the red of a stop sign, but the red light reflected from the sign. The surface of an object is responsible only for preferentially reflecting certain light rays and absorbing others. The stop sign absorbs all the other colors of the spectrum to a much greater degree than it absorbs red. Small amounts of other colors are also reflected, which accounts for the many different "reds" perceived. We see primarily red because it is the only light ray strongly reflected; and when it reaches the human eye the sensation is experienced as color.

Light, therefore, causes color sensation. The red stop sign is the *cause*, but light reflecting from it is the *effect* that the human eye registers as color sensation. That color actually depends on light can be illustrated most vividly by looking at certain objects in different lights. Mercury-vapor streetlamps, for example, distort and alter colors beyond recognition. Faces lit at night by mercury-vapor streetlamps appear green and ghostlike. But even less drastic changes in light alter colors. The different spectral contents of evening light, candle light, and bright daylight all have the power to transform colors. As the great colorist and theoretician Joseph Albers points out, color deceives us contin-

ually. We do not know what we see, because color is never seen as it physically is.

How do we see color, and what are its physical properties? Today our knowledge of its physical properties and physiological effects is quite extensive. We know that color is only one small section of the electromagnetic energy waves that make up the spectrum. Scientists call color "visible radiant energy" because the human eye can see it, whereas other energy waves such as infrared heat waves, ultraviolet light, or X-rays are invisible because of their frequencies of vibration or wave lengths. Experiments have shown that some insects, bees, for example, can see ultraviolet light, just as dogs can hear high-frequency sounds inaudible to us. The human visual system (eye–brain) has adapted to the sun's spectrum, rich in reds and yellows. It is highly specialized and, as some scientists speculate, perhaps still evolving.

Inquiries about the nature of light, color, and vision go back to the ancient Greeks. Their understanding, however, was limited and largely speculative. In the seventeenth century, along with investigations of many other physical phenomena, Isaac Newton started to analyze color and experiment with its formation. He observed that sunlight, even though it appears "colorless," is actually made up of colored rays. When allowed to pass through a glass prism, it breaks up into colored rays—violet, indigo, blue, green, yellow, orange, and red (Figure 3.1). Certain environmental conditions, such as rain, fog, or a fine dispersion of ice crystals or atmospheric dust, can also cause color to break up into its spectral constituents and form a rainbow. The colors we see in our ordinary surroundings, however, are not spectrally pure, because the objects on which light re-

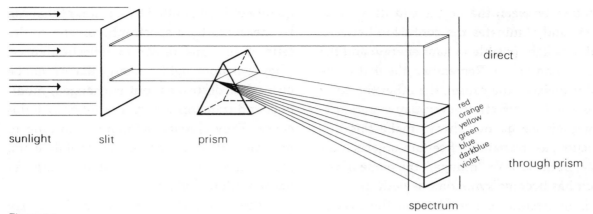

Figure 3.1
Color spectrum.
Reproduced by permission from Johannes Itten, *The Elements of Color* (A Treatise on the Color System of Itten), Otto Maier Verlag, Ravensburg, Germany, 1970.

flects have a variety of surfaces that alter the colors. This is why color is so difficult to define. We can never quite separate the objects themselves from our perception of their colors.

Thus, the absorption and reflection of light is responsible for the appearance of a particular color and color sensation. The surface texture of an object, the material of which it is made, whether it is transparent or opaque, make a dramatic difference in how we see color. Smooth surfaces reflect light at a straight angle. On a highly reflective object, like a red tomato, we see red and also a white highlight. This occurs where light strikes most directly and is totally reflected, yielding white, the color of light itself (Figure 3.2).*

Dull or rough surfaces scatter light at varying and dispersive angles, creating areas light and dark, highlight and shadow. A ceramic sculpture, for instance, might have glazed surfaces showing highlights that reflect light and shadows that scatter or absorb

* The highlight is a reflected image of the light source and appears on the surface at a point where the angle of incident light is equal to the angle of reflection, as in a mirror. The smoother the surface, the sharper the division between the highlight and the surrounding colors.

Figure 3.2
Chromatic reflectors: selective absorption of light by chromatic reflectors, such as artists' pigments and dyes.
Illustration by Susan Aron.

it. Absorption of light by a surface will make it appear dark or even black. The absence of light, however, is the absence of color. At the bottom of the ocean there is no light and consequently no color. This points up the crucial role that light plays in color formation and perception, and thus its role as "friend or foe" during artistic creation.

The objects or surfaces on which we register the sensation of color are called by the scientist *colorants*. This term makes the dis-

tinction between the object and its appearance, and eliminates the confusion between color as light (visible radiant energy) and the color of an object. Remember, the first is the color *stimulus* (the cause), the other the color *sensation* (the effect). In everyday experience, however, we do not always make this distinction, as the names of certain objects indicate. In the case of "orange," the name of the fruit has become synonomous with its color. It is interesting to speculate on the experiences that may have been responsible for this terminology, and on why they have left their mark on our language. Perhaps in his initial encounter with the object "orange," man catagorized it according to its color to distinguish it from a grapefruit of equal size.

There is a controversy, however, over whether we encounter our environment initially in terms of color or form. Some primal physical sensations like hotness can be associated with color. We learn, often painfully, that fire is hot and burns. Thus, color becomes a powerful agent that calls forth associations, via sensations that identify certain objects and allow us to physiologically experience certain phenomena. Some psychologists believe that color's visual impact is much stronger than form's, and that we initially learn by recognizing color and only later in life associate color with its shape, or form. For the visual artist, of course, this is a very important consideration in the creative act, and much of modern artistic color experimentation and exploration is based on this insight.

The study of color can be approached from various angles. Scientists study the physical properties of light, usually under laboratory conditions with precision instruments. They are interested in the kind and

quality of light emitted by a colorant that can be measured by a spectrophotometer to determine its transmission or reflection curve. They look upon light as energy that cannot be created or destroyed, but is changed, modified, and transformed by a number of influences. They classify colorants according to how they reflect, absorb, or transmit light and are not interested in the variables of the visual sensation made on the observer.

Psychologists, on the other hand, are concerned with color sensation or visual reaction as it takes place in the human mind. They study the aspects of color that influence color associations, color symbolism, and mental and psychological color reactions. Experimentation with color sensations has led to a color psychology that can predict and test color reactions, such as color blindness or color preferences.

Visual artists are interested primarily in the aesthetics of color sensations derived from pigment colorants and, to a lesser degree, colored light. Their major aim is to organize color into visually pleasing and expressive compositions. The visual effects, however, depend on the type of colorant they use and how it is applied. Transparent watercolors (as compared with opaque paints and body colors) are light transmitters. When applied in layers to a reflective surface such as white paper, they allow other colors to form by the process called color subtraction. If blue is glazed over yellow, green is formed by absorbing, or subtracting, red. This means that pigment colors, when interacting in mixtures, lose their original brilliance, and that the more often they are mixed, the darker or more muted they become. This is true whether they are applied transparently on the paper's surface or premixed on the

palette. Hence, the basic law of watercolor: *Every color mixture is made at the expense of brilliance and luminosity.*

Familiarity with the basic laws of color mixing is necessary for the artist to predict color formation on watercolor paper. Use of opaque colors or body colors requires familiarity as well, but more leeway is usually possible there, because an undesirable color mixture can be repainted. In watercolor, however, there is a point of no return. The loss of clear and luminous colors because of indiscriminate color mixing is the most common mistake made by the beginner. Instead of premixing colors on the palette, try to use them as they come out of the tubes (in which case they might be already subtracted, as in green, which is a combination of blue and yellow), and form additional hues by washes and glazes directly on the paper. *Ideally, the identity of each color going into a mixture should be retained, so that two colors on your paper produce not just one color but three: the two originals and the mixture.* (Look at the color plates, especially 2, 9, 15, 16, and 20.)

Consequently, color application and color behavior are intimately linked and ultimately responsible for the luminous and transparent appearance of watercolors. The artists' pigments available, however, are not always spectrally pure, but may be already subtracted and thus produce a variety of hues in different color combinations. Alizarin crimson, for instance, is a red that also contains some blue (see the woman's dress in Plate 35), whereas vermillion is a red that contains some yellow (see the red trees in Plate 25). This affects subsequent color mixtures. Other factors, such as the size of the pigment, the vehicle in which it is suspended, and the paper's surface, also influence color

formation. Metal-derived pigments (cadmium, cobalt) are somewhat more gritty and not as easily absorbed by the paper, causing a less transparent effect than the tinctorial quality of lakes, the dye-derived colors. Also, the cleanness of the water influences the purity of the colors. Subtle changes in color tonalities are therefore inevitable, no matter how hard you try for color purity.

Thus, *subtractive* color formation is the basis for any pigment color interaction and responsible for creating additional hues. It must be distinguished from *additive* color mixing, which is color produced by mixing chromatic light. When colored light beams are projected onto a screen, colors are not physically mixed but are superimposed on one another. The same would pertain to light passing through transparent glass disks and creating additional colors. The physical properties of chromatic light differ from those of pigment colorants. A mixture of all the colored light beams creates white. The primary colors of chromatic light are green, red, and blue, and should not be confused with the primary pigment colors, red, blue, and yellow.

Even though in most artistic work pigment colors are used subtractively, an additive color-mixing principle was explored by the Pointillists' broken color technique. Pure pigment colors applied in tiny dots on the canvas are mixed additively by the eye and fused into one color. This process is similar to that of color printing, wherein small color dots, visible only with a magnifying glass, fuse into colors and shapes. The Pointillists, notably Seurat, based their broken color technique on the nineteenth-century scientific theories of Young, Helmholz, and especially Chevreul, who had observed the addi-

tive color-mixing principle in tapestry weaving, where tiny threads form individual colors.

Speculation about color behavior, its formation and interaction, has been the concern of artists, especially colorists, throughout history. Today much of our understanding and artistic use of color stems from the study of color in the nineteenth century. The French painter Delacroix was one of the first artists to observe shadows of complementary colors on objects and the effect of these on surrounding colors. Gleaming in the afternoon sun, the green buttons on an officer's white uniform had red shadows around them, giving a purplish hue to areas of his blue vest. Interest in the visual phenomenon of color and our visual perception started with the Romantic artists in the beginning of the nineteenth century (see Figure 1.5) and reached its pinnacle with the French Impressionists and Pointillist painters.

By the end of the century the interest in color had become increasingly scientific. No longer based just on intuition or direct observation, theories about color behavior (such as the additive color-mixing principle) and optical studies were incorporated and became the basis for artistic statements. Against public outrage, artists worked relentlessly to demonstrate their visual perceptions of color. Today, we look at the Impressionists' landscapes, the poplar trees on river banks illuminated by the morning sun, and wonder what all the furor was about. They are so pleasing that we tend to forget the rational color analysis which was the basis of these visual delights (Figure 3.3). Of course, in the meantime, our color perceptions have been conditioned by numerous subsequent color experiments in the twentieth century.

The Impressionists demonstrated in their paintings that they were not interested in the *local*, or customary, color generally associated with an object, but rather in the *contextual* color caused by the variation of light in the environment. Thus a red flower such as a poppy is not just red but a particular "red," because of influences in the area in which it grows. The flowers next to the poppy, its leaves, the time of day, and most of all the quality of sunlight influence the "red" and make it a particular hue. What is important is not the particular red the artist started with, but rather the ability to demonstrate how red is modified by its context. Thus, in an Impressionist's painting additional colors are introduced by colored shadows from surrounding flowers and grass, shifting sunlight, and reflections from water, and these constantly change the appearance of the red, dissolving it into particles of many colors, while fusing its shape with its surroundings.

This painting style demonstrates visually color's dependency on sunlight, as well as how our perception constantly changes and can be manipulated. It questions what we "see" and what we "know," and how our knowledge can interfere with the perception of an object, and vice versa. Monet, the most thoroughly scientific Impressionist painter, repeatedly questioned the deceptive nature of light and the stimulus and sensation aspects of color and form. With single-mindedness he pursued his observations of colored objects well into the twentieth century, painting them under different light conditions, trusting only his eye (see Figure 3.3.) At one point he expressed the wish that he had been born blind and only later in life regained sight, so that he could "see" and experience external reality (nature) fresh, without the prior knowledge that influences vision. The Impressionists saw colors in nature and

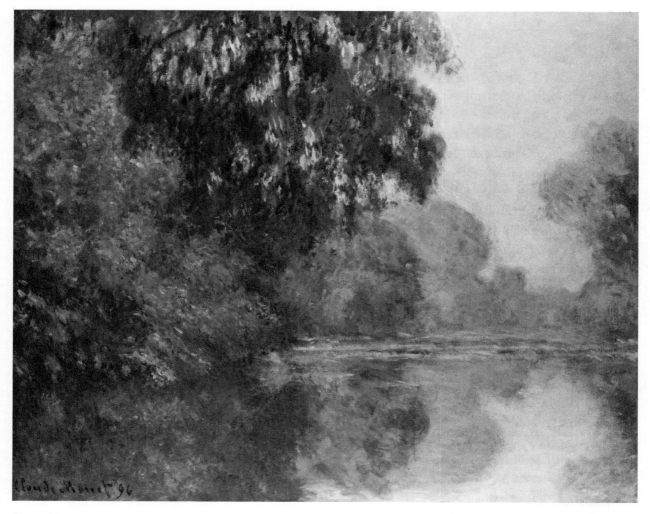

Figure 3.3
CLAUDE MONET (French, 1840–1926)
Morning on the Seine at Giverny (oil on canvas, 29 × 36¼ in.).
Courtesy Museum of Fine Arts, Boston (Julia Cheney Edwards Collection, 39.655).

painted them in landscapes as no artists had before them. Even though public acceptance of their work was slow, they became an immensely important liberating force, opening our eyes to the beauty of color in nature. After Impressionism, as one art historian put it, color lost its innocence. Landscape painting was never the same again.

Art movements following Impressionism either criticized or expanded its view of color. The Pointillist painters shifted from the obsession with the appearance of color to the emphasis on forms and objects. In very rational painting methods, color particles become frozen and solidified shapes. The basis of artistic exploration was no longer the direct observation of color in nature, but rather the theory behind its optical interaction as it made shapes and forms.

Cézanne learned the lesson of the Impressionists, but was determined to go further and use color not as an end in itself but as a means to a *new* end. His major concern became the solid three-dimensionality of objects and those features that conveyed their identity, which he claimed was due to their shapes and forms rather than to the surface variations caused by the constantly changing light. Thus, instead of defining the objects with tiny color specks, he used layers of color, weaving glazes as if forming a dense fabric and allowing them to interlock into

41

composition and forms. This was a significant step beyond the *color* emphasis of the Impressionists, and reintroduced emphasis on *form*. For Cézanne, color had its importance, but its role was structural. In his watercolor paintings, especially, colors shape the appearance of objects (Figure 3.4).

In the early twentieth century, the German Expressionists and to some extent the French Fauvists explored a move away from the visual sensation of the eye to the emotional sensations registered in the deep recesses of the mind. Their interest was primarily in the psychological effect of color and the message it conveys. Applied in strong primary hues, it could produce intense responses in the viewer. Frequently, in their paintings, subject matters of no distinct colors, such as horses and barns, were disfigured with slashing brushstrokes of brilliant

yellows and blues. Or the subtle tonal modulations of a human face might be fractured into complementary reds and greens. This dramatic use of primary colors was meant to shock viewers and force them into disregarding customary associations of color and objects, in order to change their conception of, and feeling for, both.

Expressionists consciously wanted to burst the automatic response triggered by familiar objects, and as the Surrealists practiced displacement by taking a familiar object such as a chair and placing it in an unusual context such as a graveyard, so the Expressionists disfigured an object by applying strong color to elicit a new and stronger emotional response from the viewer. Trees could be painted flaming red and water the color of gold when seen in sunlight (Figure 3.5). Their inspiration came from primitive art and chil-

Figure 3.4
PAUL CÉZANNE (French, 1839–1906)
Chateau Noir and Mont. St. Victoire (watercolor and pencil, 14¼ × 19¼ in.).
Graphische Sammlung Albertina, Vienna, 24.081.

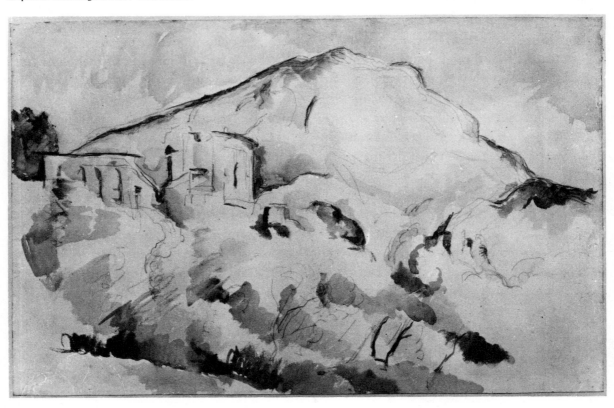

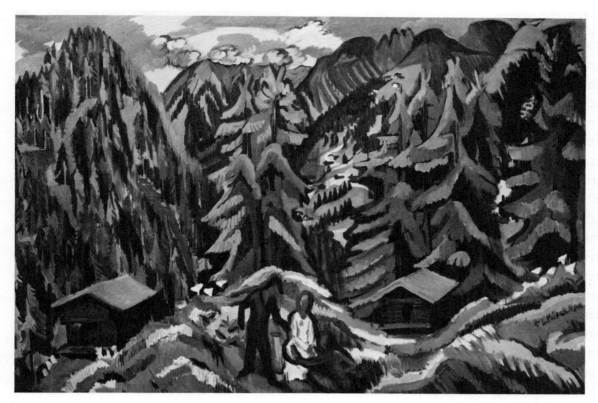

Figure 3.5
ERNEST LUDWIG KIRCHNER (German, 1880–1938)
Mountain Landscape from Clavadel (oil on canvas).
Courtesy of Museum of Fine Arts, Boston (Arthur G. Tompkins Residuary
Fund, 56.13).

dren's paintings, which express feelings based on intuitive responses rather than reason. Expressive use of color and distortion of form are not concerned with "realistic" and descriptive characteristics of an object, such as the fact that a tree has green leaves and grows out of the ground, or with its transient visual character as observed by Impressionists, but rather with color's power as an expressive agent. In such paintings, color has a life of its own and thus can be experienced and enjoyed for its own sake.

At the turn of the century another important visual phenomenon was discovered: color's physiological ability to stimulate the viewer. The Russian painter Wassily Kandinsky claimed that color has as much stimulating power as music, provided that it is used *nonobjectively*. He explained that when "yellow" is seen by itself, as just a color area,

it is experienced as a strong visual element capable of producing an intense response in the viewer. However, when the same yellow color is seen on a mailbox (mailboxes during Kandinsky's time in Germany were yellow!), the viewer responds primarily to the object, and because of that association the color has less impact. He claimed that color, therefore, in its pure and nonobjective use, has the same stimulating power as sound from a musical instrument.

Kandinsky based this observation on the scientific fact that both color and sound belong to the spectrum and are among the electromagnetic waves, such as infrared heat waves and tissue-destroying x-rays, that affect human physiology. Since sound is basically abstract and therefore not easily associated with an object, he kept insisting that color experience is strongest when it is also

abstracted. Although color and sound associations were not new at that time (they date back as far as the sixteenth century, when attempts were made to merge painting with music by linking the musical scale with color harmony), Kandinsky's color–sound comparison is based on personal experience. In his autobiography he reveals that he heard music when he saw color, and vice versa. This synesthetical experience, quite rare among artists, became the basis of his breakthrough into nonobjective painting. He speculated that by dispensing with objects and using pure color in his paintings, he could compose colors like the musician composes sounds, and the viewer could experience them as purely visual sensations.

Theoretically, Kandinsky was ahead of himself. It took many years, and much justification, and numerous essays on painting before he actually could paint, with just pure colors, *nonobjective* paintings. He tells about a significant "aha" experience that showed him that he was on the right track. One day he came home and saw in the twilight of his studio an incredibly beautiful painting. Fascinated by its colors and forms and their intense visual effects, he rushed toward it to see who had left this work. He soon discovered that it was one of his own paintings standing upside down. The inverted position of the painting had abstracted the fairly realistic subject matter so that objects could no longer be recognized. Thus he was allowed to experience them as pure colors and forms. From this point on, he claims, he was convinced that his paintings did not need recognizable features such as objects or subjects, and that in fact these were actually deterrents from the visual and sensual impact of a painting.

In 1910, Kandinsky painted the first nonobjective painting, a watercolor composed with just color and form (Figure 3.6).* It is perhaps no coincidence that he used the watercolor medium for this venture into "pure" abstraction. It can be speculated that watercolor, because of its visual dynamics, congeals easily into shapes and forms without the artist's conscious search for them. The act of composing becomes a happening in which the painter is a spectator as well as a participant. Each spontaneous gesture with the brush yields a color–form element. Kandinsky's insistence that color does not have to define form but already is form holds especially true for watercolor painting.

Historically, this marks the threshold of pure abstraction, or, as Kandinsky preferred to call it, *nonobjective* painting, because abstraction can exist in various degrees. His paintings from that point on were large oil canvases, orchestrated with pure, intense colors arranged like the tones in a musical composition. Even though he was partial to the nonobjective painting style, he claimed that the stimulating qualities of color could be evoked in any style, ranging from the most realistic to the most abstract, provided that the artistic materials were used sensitively and composed in a manner that effected strong reverberation in the viewer.

Kandinsky thus represents a transition from realistic representation to artistic freedom. For the watercolorist, this means the ability to capitalize on the visual dynamics of the medium, allowing them to carry the artistic message. However, all the color inquiries in the last century represent important liberations and opportunities to explore color's full visual potential, whether for descriptive purposes or as an expressive agent.

* Art historians have challenged this date, and some believe that Kandinsky was not the only artist painting "nonobjectively" at that time.

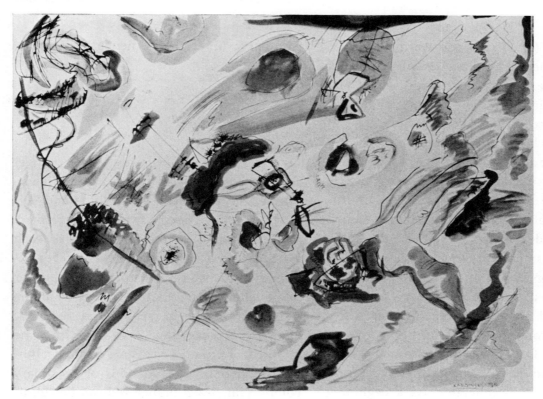

Figure 3.6
WASSILY KANDINSKY (Russian, 1866–1944)
First Abstract Watercolor (1910) (19¼ × 25 inches).
Collection Mme. Nina Kandinsky, Neuilly-sur-Seine, France.

As watercolorists, we profit from the trials and experiments of artists in the past. Their works stand as road signs along our artistic avenues, pointing in many directions. Today you can choose which color aspect you want to emphasize in your painting. For example, using local color like the traditional painters, you can give an apple, for instance, the most delicious red imaginable; or you can paint it on a tree and with contextual color show how the environment and sunlight cast shadows and alter its appearance. Like the Impressionists, you can paint the apple's shape becoming less distinguishable and its color more muted with less sunshine. Or, like the Expressionists, you can emphasize the "redness" of an apple by using a red so bright and aggressive that it appears to have a life of its own. The apple is almost incidental except as the carrier of the color. Red, in this case, could be a patch of color signifying the juice of life itself, or lusciousness, or lust. Your emotional response to "red," based on associations, would be triggered by the color. Other colors, such as a complementary green could reinforce red and denature the apple even more. You might even choose to make the apple hardly recognizable, or even irrelevant, because you are happy just using red and are applying it on the picture's surface in any form that the brush or the mind dictates. In this case, like Kandinsky, you would be using the color red nonobjectively.

The lesson learned from Cézanne's use of the watercolor medium is perhaps the most relevant for the watercolorist. In his still-lifes, he painted objects, such as apples,

45

with color (often cool and warm colors) to bring out their three-dimensional quality, but at the same time he introduced salient features that indicate their identity, signifying that they are not just geometrical bodies but apples. His landscapes, especially those after 1890, strike a beautiful balance between realism and abstraction: he painted recognizably but at the same time capitalizing on the unique qualities of the watercolor medium, allowing departure in either direction. Cézanne's important visual and theoretical contribution has certainly shaped our artistic thinking in this century. However, the lesson we learned about color and its expressive qualities from the Expressionists is equally important. They taught us that watercolor is "color," and that it has its expressiveness, in addition to subject matter. As a beginning watercolorist, you should keep this foremost in your mind. For this reason the fundamentals of color and its terminology are discussed in the following section.

The Color Wheel

Colors can be arranged into complicated and sophisticated systems, but for our purposes we will consider just the color wheel that shows the basic pigment colors and their combinations. Primary colors are placed to form a triangular position, with secondary and analogous colors between them (Plate 1).

Primary Colors

Primary pigment colors (red, blue, and yellow) are the basic colors from which all other colors are mixed. They cannot be produced by mixing other colors; hence their name, *primary*.

Secondary Colors

Secondary colors (purple, green, and orange) are created by mixing two primaries. Thus, purple (red and blue), green (blue and yellow), and orange (red and yellow) are formed, and, depending on the proportion of each primary, can lean in either direction. For example, an orange can be more red orange, or more yellow orange. A true orange would be an equal mixture of yellow and red. Obviously, proportions vary so much that the mixtures of primaries can give an almost infinite number of combinations of secondary colors. Thus, each orange red can be subdivided into six additional segments, which vary in degrees of orange red tonality, beginning with orange red and becoming progressively more red. These intermediate colors are referred to as analogous, or harmonious, colors.

Analogous, or Harmonious, Colors

Analogous colors are between secondary and primary colors. Often they are referred to as intermediary colors, because they share a color tone with those they adjoin. In watercolor painting intermediate colors can be produced by glazing or washes. A red glaze by the same red results in a darker hue of red or an analogous color. Furthermore, other colors can be produced by adding black or white, but this is irrelevant to the transparent use of watercolors.

Complementary Colors

Colors opposite each other on the color wheel are complementary. Each one of the three primary colors is complementary to a mixture of the other two. Red is complementary to green, because green is a combination of yellow and blue. Blue is complementary to orange, because it is a combination of yellow and red, and yellow is complementary to purple because it is a combination of red and blue. Color absorption is at work here. The visible color is the complement of the color that has been absorbed, no matter what the mixture is. Looking at your color wheel, note the colors across from each other. You will see green blue as a complement to red orange, and all the other different combinations.

Complementary colors are important in watercolor painting, because when placed side by side they create the greatest contrast. Thus, red next to green creates the maximum contrast, bringing out the intensity of each color. On the other hand, complementary colors are the most difficult colors to work with. When mixed, they cancel each other and produce muted or neutral hues. It is with these colors that beginners make most of their mistakes. Watercolor paintings that lack color brilliance and look muddy are the result of the indiscriminate mixing of complementary colors. Accomplished watercolor technique requires the successful use and mixture of complementary colors. (See color plates.) Some of our greatest watercolorists, such as Emil Nolde, exhibit an exquisite use of primary and complementary colors. Nolde's watercolors have extraordinary contrast that retains luminosity, clarity, and brightness. When he allows complementary colors to mix, their interaction is carefully controlled, producing just enough muted hues to broaden the color range. (See Plate 2.)

Cool and Warm Colors

Long before the science behind their visual effect was discovered, artists knew intuitively about the advancing and receding qualities of cool and warm colors. Thus, colors of blue, green, and purple tonality seem cool and appear to retreat, whereas those of red, yellow, and orange ranges seem warm and appear to advance. Today we know that this is not just a psychological effect based on associations, such as red with fire and blue with the distant sky. Instead, colors actually have different temperatures, because they have different wave lengths and are therefore refracted differently by the lens of the eye. Red rays are bent or refracted by the eye's lens less than blue rays, and to compensate in focus, the brain registers red as being closer than blue. Often a pulsating color sensation occurs when warm and cool colors are placed next to or on top of each other, such as a green on a red background. The different focus demanded by each color and the eye's consequent adjustment cause this pulsating action, as eye muscles expand and contract to focus on each color alternately. To the viewer, each color has a different *apparent depth.* Although not in watercolor, this effect was best exploited by the twentieth-century painter Vasarely.

For the watercolorist, cool and warm colors can construct space and the dimensionality of objects on a picture plane. (See Figures 4.5 and 4.7.) Color perspective can likewise be created with cool and warm

colors, which is a much more modern means of creating space in painting than the traditional linear perspective of the old masters. When color was explored in the nineteenth century, this was one of its most exciting discoveries. The cool and warm colors can be opposite or next to each other on the color wheel, and therefore, visually, create both harmony and contrast. This largely depends, however, on their intensity, size, and shape.

Tertiary and Neutral Colors

Tertiary colors (browns and greys) are created when all the primaries are mixed. Depending again on the proportion of each, they vary slightly in color tone, leaning toward one or the other primary. Thus, Payne's grey is a bluish grey with a higher proportion of blue than of either yellow or red. Neutral colors are created when two complementary colors are mixed in equal proportions, which basically means the mixture of all primaries. Neutralizing a color means muting its brilliance. The color becomes darker, losing its initial purity. The more colors that are mixed, the more muted they become, until they turn totally grey.

Hue, Value, and Chroma

These are terms used to describe the three qualities of a color. The Munsell System of color notation and terminology (devised by the Boston artist Albert Munsell in 1912) uses these terms to describe the visual sensation of colors.

HUE

This term indicates the different colors on the color wheel. In the Munsell System,

hue implies a certain color attribute in which a color varies according to value, intensity, or brilliance. Light blue and dark blue are both color variations of the same hue. A hue is, then, a somewhat more specific description referring to a quality of a particular color. The term is often used interchangeably with the term *color*.

VALUE

The lightness or darkness of a color is referred to as its *value*. For example, light and dark red are the same hue but differ in value. In watercolor, adding more water to a color makes it lighter and consequently changes its value. In opaque watercolors, white is usually added to lighten a color's value. At the same time, however, white cuts down a color's purity. The value of a color also indicates its *depth*, or degree of luminosity and brightness. Although it is not reproduced in color, Paul Klee's watercolor is a good example of color values (Figure 3.7).

CHROMA, SATURATION, INTENSITY

These terms refer to the color's purity or strength and are often used interchangeably. The purer the color, the more brilliant it is and the more intense its chroma. Primary colors in their pure state (unmixed with any other color) have the greatest chroma. An analogous color such as orange red, on the other hand, has lost its original intensity due to its mixture with a secondary color. *Color subtraction* accounts for this loss, because each pigment absorbs some of the visible light of the spectrum. Thus, the more often colors are mixed the less intense they become, as they move toward eventual greyness. Obviously, black and grey (being noncolors) lack chroma, intensity, and saturation. Adding white or black to a color subtracts from its

Figure 3.7
PAUL KLEE (German–Swiss, 1879–1940)
Mauerpflanze [*wall-flower*] (pen and watercolor, 11¼ × 13 in.).
Courtesy of Museum of Fine Arts, Boston (Seth K. Sweetser Fund, 64.256).

original brilliance. You should not confuse chroma with value, because a color's intensity will stay the same (in watercolor painting) even if it is lightened with water or darkened with the same color by glazing.

Tints and Shades

Neutral colors, or greys, are mixtures of two complementary colors in equal proportions. They cancel each other, thus losing their chroma. They should be distinguished from white or black which, when added to primary or secondary colors, subtract their brilliance but do not neutralize them. They become tints or shades. A *tint* is a color with white added, resulting in a lighter value. A *shade* is a color with black added, resulting in a darker value. Although this is irrelevant for the painter who uses watercolors transparently, you should note that adding white (such as Chinese white) to any color produces a lighter color tint, and thus a lighter color value, and that adding black makes the color darker in value or shade. Black and white, not actually colors, subtract from a color's brilliance and change its value but do not actually change the hue. They do cut a color's transparency, however.

Color Relativity

As you will note in the color plates, the combination of colors rather than individual colors accounts for a painting's visual appearance. The individual colors actually change with colors in their proximity. A yellow or blue on your palette will look different on your painting, though the difference might be subtle. This change occurs because of colored shadows produced by simultaneous and successive color contrasts. If you place a *yellow* adjacent to a *blue*, its complementary *purple* makes it look more *bluish purple*. At the same time, the blue creates its own complementary *orange*, modifying the *yellow* and giving it a more *orange* appearance.

Something similar happens when you stare at a green intensely for a few seconds (the colorant has to be brightly lit and on a white surface); suddenly you will see a shadow of its complementary color, red. Color fatigue is responsible for this phenomenon. The tiny rods and cones of your eye's retina that are responsible for color perception get fatigued and cause a momentary color blindness. The receptors cancel the red, and the yellow and blue that form the complementary *green* are briefly visible. Try this experiment and see if you can experience this color contrast. Often an American flag (made up of the complementary colors green, black, and orange) is used to illustrate this effect. Experiencing color fatigue, you should see the true colors (the red, white, and blue of the flag). Since we all perceive color differently, there is no absolute way of measuring color perception.

Color appearance is due to a variety of contrasts, such as those between light and dark, brilliant and muted, and large and small, that reinforce and subtract from each other. Similar to spices, where one strong taste complements another—salt, for instance, emphasizing sweetness—a dull color next to a bright one emphasizes it by contrast. This is an essential visual dynamic, vital for an engaging and captivating artistic composition.

Color Combinations

The transparent application of watercolor allows countless possibilities of color combinations. This is its greatest asset but also its greatest liability. Painting with an opaque color, the artist can move from light to dark, from one contrast to another, making revisions constantly. Painting with watercolors, on the other hand, the artist finds that colors not only change or become darker with successive reapplication, but also lose their original brilliance and become hopelessly muted and muddy. Watercolor painting is thus similar to combining musical chords: You have to know what colors harmonize and when to leave *what* out. And just as the harmony of musical instruments accounts for the pleasing sound, so the interaction of successful color combinations accounts for a pleasing visual experience.

The color combinations, the size of the individual color areas, their brilliance, and their values all influence a painting's appeal. It is impossible to give specific color formulas, because color choices are personal. Some traditional painters suggest certain rules of thumb, such as painting large areas of muted colors to contrast with small bright areas. This kind of advice, however, is very theoretical, and as academic as suggesting the

addition of a pinch of salt to an apple pie to bring out its sweetness. Obviously it makes sense, but how much color (or spice) to add and in what proportion is crucial and must be a personal decision.

As a watercolorist be especially aware of the *weight* of colors and how their intensity, value, or chromatic differences can balance each other; this awareness is critical to composition. Thus, a very small area of an intense red may have the same weight as a much larger muted or light area. (See Plate 36.) This may have been what the traditional artist had in mind with the suggestion of a combination of muted areas set off by small brilliant ones. It is the *quantity* versus *quality* consideration. Joseph Albers has made many interesting studies balancing color weight.

Color value is intimately connected with the feeling of a color's weight. Some artists maintain that a color's value in a painting is much more important than the color itself. Artists who have made color a study, Joseph Albers or Johannes Itten, for example, constantly point to the harmonizing effect of colors of similar value.* Analogous colors of similar value have the same weight (and therefore, balance) and unify each other in a composition, provided that they are used in the same quantity. (See Plate 37.) In a watercolor painting, a variety of analogous colors can be produced by glazing or simply by allowing the primary and secondary colors to interact with each other in washes. These colors are like the supporting actors in a play: Their role is not vital, since the main characters carry the plot, but they certainly underline, or "color," the action.

* Their important studies on color might be useful for beginners: Joseph Albers, *The Interaction of Color*, Yale University Press, New Haven, 1963; Johannes Itten, *The Elements of Color* (A Treatise on the Color System of Itten), Otto Maier Verlag, Ravensburg, Germany, 1970.

Thus, colors of equal value have the tendency to merge visually and become unified. In your painting, the shape of an object, no matter how many individual colors it contains (a tree can have greens, yellows, reds, and browns), is tied to the values of the colors representing it. The instant that the value of one color dominates, the balance tips, altering the object's form. The *shape* of a tree is therefore more essential than its constituent colors, even though *within* it there might be value differences, such as between the dark branches of limbs and the shadows created by pockets of space between foliage. Color value is therefore relative. When we call a flower red, it is always red in relation to the colors surrounding it. In a painting of a poppy in a green field, the poppy's bright red color should be calibrated according to the other colors you are depicting in its proximity. Thus, observe the color combinations in your painting and adjust them for maximum visual interest.

Subject's Color versus Painting's Color

Plato states that the artist does not *match* external reality but rather *makes*, or creates, a new reality with the work of art. Thus, when painting a landscape, you are creating an illusion of what you see. Colors in nature are quite different from those in artists' pigments. You can only approximate the color of nature in your painting. Watercolorists, like other artists, use their medium as a vehicle to interpret what they see and observe. Even in the most "realistic" school of painting, they rely on numerous artistic conventions (such as three-dimensionality and perspective) to depict their subject matter.

Beginners often forget this important artistic license and become too obsessed with matching colors in the watercolor with those of the subject. Remember, the colors and their relationship to one another in your composition are far more significant than those you see in the still-life or landscape. You want to *approximate* with your own color choices and combinations that which you see, not imitate them. In that respect you are being true to your watercolor medium and following its visual laws and dynamics, which are quite different from those in nature. Cézanne expressed this idea beautifully when he said, "Art is a harmony parallel to nature."

Color Mixtures

Our abilities to see colors, as well as our color preferences, are as different as our thumbprints. We all have an intuitive color sense that is largely responsible for our color preferences. When students are given a particular object to paint, no two of them use color alike. In watercolor painting, it is usually color combination rather than painting style that becomes an artist's trademark, though the two are related. Similarly, the use of color in a painting is as individual as the personal movements which distinguish us from afar, before details of the face can be recognized.

Since color preference is so individual, I often hesitate to suggest to students which watercolors to choose. I tell them, of course, the colors that exist and their names. (See Appendix.) For many colors there are as many as four or five different hues, and, as was previously pointed out, even colors with the same name vary according to brand. Using a

color chart is also misleading because it misrepresents how colors look on watercolor paper. I suggest that you get the basic watercolors listed in the appendix and also make a chart of color samples from your classmates' paints, labeling each color with name and brand. Eventually you will have a guide for buying colors.

Color Chart

By learning about color interaction and color behavior, you can increase your painting skill. Since watercolors are subject to such variations, it is very difficult for beginners while painting to predict their appearance and combinations. Of course, trial and error will eventually produce a degree of predictability.

To facilitate this learning process, make a color chart from colors on your palette, indicating their mixture and interaction. Mix primary colors into secondaries. Then apply small areas of color next to each other, letting them flow together to produce additional combinations. You will experience the important watercolor principle of *one and one making three colors.* You can also do the same with the analogous colors, creating different harmonies. Try to be as even with your proportions as possible.

This color reference chart is especially relevant for complementary colors, since they neutralize each other, producing muted hues. Remember, paintings that lose clarity and brightness and turn muddy are usually the result of wrong color combinations or overly zealous color mixing on the palette or paper. Even though some students have an

exquisite color sense and intuitively pick and mix colors that retain their luminosity and brilliance, for most beginners familiarity with the properties and qualities of all watercolor materials will facilitate learning watercolor technique. The color exercises in the following chapter will introduce you to basic techniques and exercises for watercolor painting.

SINCE WATERCOLOR CAN PRODUCE a myriad of visual effects, beginners are often seduced by its effervescent, fluid behavior. Achieving interesting color–form combinations seems effortless. Controlling and predicting watercolor behavior, however, is essential for mastering watercolor technique. This necessitates developing the skill to determine what kind of visual effects and colors the brushstrokes will yield. Color formation and interaction are the most exciting aspects of watercolor painting, but they are also the most difficult to achieve technically.

Basically, there are two techniques of watercolor application: washes and glazes. They both reflect the uniqueness of the watercolor medium and could be described as the two poles around which watercolor painting revolves. Fundamentally, all watercolor effects are derived from these two

CHAPTER FOUR

Watercolor technique and exercises

techniques. Washes are watercolors in a wet stage (Figure 4.1). The colors are applied on a moistened surface or on previously applied wet colors. Glazes are layers of colors, one floating on top of the other, always applied on a dry surface or on dry colors (Figure 4.2).

Color washes, often called the *wet in wet* technique, yield softly blended, hazy colors merging and flowing into one another. Watercolor's reputation as a spontaneous, easy-

to-use and technically undemanding medium is based largely on this effect. Color washes can be applied quickly, while the artist stands by watching their transformations and visual effects. Indeed, the transparent *color wash* most distinguishes watercolor from other painting techniques. When watercolor became popular in the beginning of the nineteenth century, the *wet in wet* technique was also called the *English technique* because it was

Figure 4.1
RENÉE KAHN
Watercolor Wash.
The brushstroke is soft and diffused and seems to inhale
the colors, erasing its tracks.

Figure 4.2
ELIZABETH BOWERS
Watercolor Glaze of a Butterfly.
The brushstroke is visible, crisp, and hard-edged and has a
definite shape.

favored by the British painters. (See Figure 1.5.)

Color glazing is often referred to as the *wet on dry* technique. It accounts for the transparent, see-through quality of the colors, giving the painting the illusion of depth. The term *glaze* refers to a substance resembling glass which is applied thinly on a surface (glazed earthware). In painting, a glaze is always a transparent (or semitransparent) color applied on a painted surface or color. *Glazing* your watercolors means applying them in transparent layers (like sheets of glass) over one another. A crisp, hard-edged brushstroke that is transparent but does not modify the colors underneath (such as the cubistic shapes of the landscapes in Plates 3 and 18) is also a glaze.

Glazing is not unique to watercolor paint. It was used centuries ago with oil paint and is frequently seen in details such as the veil of the Virgin in fifteenth-century Flemish altarpieces or the painted glassware in seventeenth-century still-lifes. Color formation and alteration as a result of transparent color layering, however, were byproducts rather than intentionally explored effects. Color glazing to create additional colors on the painting surface, such as yellow over blue to make green, was used in the late eighteenth and early nineteenth centuries and coincided with the growing interest in color during those times. The Impressionists applied pure colors in tiny patches, often superimposing colors and allowing the color underneath to show through. (See Figure 3.3.) Although used primarily in oil painting, this also influenced watercolor technique, especially that of Cézanne. The exploration of color interaction as an end in itself, in the abstract or nonrepresentational sense, became popular only in our century.

In watercolor painting you usually use a combination of glazes and washes. In the work of an accomplished watercolorist, such as Emil Nolde (see Plate 2) or August Macke (Plate 3), there is always a delicate balance between the two techniques, creating tension between crisp and soft, crystalline and hazy. Of course, additional color and visual effects can be achieved by manipulating colors with a variety of tools such as sponges and toothbrushes, as seen in Paul Klee's watercolor (Figure 4.14). Furthermore, water-soluble paints and inks, such as gouache, acrylic paint, or India ink, as well as various glues, solvents, and stains, can be applied to watercolor paper with interesting visual results. As many contemporary paintings show, the use of mixed media creates fascinating visual effects, but often delays one in mastering basic watercolor skills and techniques. Mixing too many colors or too many paints during the learning process makes it hard to achieve transparency and may result in overworked, muddy-looking paintings. Since visual effects are no substitute for learning to control the watercolor medium, I suggest that you limit yourself at first to washes and glazes.

Preparation for Painting

Set up your table with the basic tools and materials. Squeeze your colors onto the palette, tape your paper with masking tape, and have an adequate supply of clean water in your containers. Paper towels might be handy to soak up spills. One of your watercolor containers is for rinsing your brush, the other for diluting your paints. Make absolutely sure you keep the two procedures separate.

Even though separating the brush-rinsing and diluting procedures seems obvious

and elementary, its importance cannot be stressed enough. Dirty water instantly contaminates your colors, thus thoroughly muting their brilliance. Too much water in your brush (even if it is clean) dilutes your paint and makes it difficult to judge color values. Therefore, after rinsing your brush, squeeze excess water from it with your fingers (do not pull on the hair, however), or blot it on a rag or paper towel. When taking clean water from your container, make sure that your brush picks up only as much water as you need. If you are painting a small detail, just moisten the tip; if you are laying in a wash, you might need a full brushload of water. Frequently, when colors are already mixed on your palette, you can just dip into them with a clean, squeezed-out brush. It is a good idea to have a piece of scratch paper (watercolor paper or some other kind of white paper) on which to test your color before applying it to your painting. This will show you its intensity, and whether it needs more water or more paint for your particular work.

Brush Movement

Remember, watercolor brushes are designed to hold water and to be used in the fluid, gliding motions of continuous strokes. This movement should be initiated by the arm, not by the wrist. In this respect, watercolor painting differs markedly from oil and acrylic, in which the rather thick paint is usually spread by stiff bristle brushes in a series of choppy strokes. The arm movement used for watercolor painting is to the wrist movement used for oil painting as arm movements in tennis are to those in Ping-Pong. Students with a background in oil or acrylic often have difficulty adjusting to the gliding

movement of the watercolor brush, but with practice this becomes second nature.

The following exercises introduce you to various watercolor techniques and color effects and help you to practice brush movement during color application, and color formation and interaction in washes and glazes. Each exercise explores important characteristics of the watercolor medium and explains the principles behind them.

Glazing Technique: Circle Exercise

Paint circles in various sizes but limit yourself first to the three primary colors (red, yellow, and blue). Let each color dry. Continue this process to see how many colors you can create. Whenever colors intersect, secondary colors are formed. Theoretically, it would be possible to construct the whole color spectrum from the three primary colors. Purists among watercolorists often suggest this as an exercise (Plate 4).

The circle exercise will give you a feeling for the transparency and depth of watercolors. Start out by applying the colors in light, almost pastel layers, because in subsequent overlays they become darker. This technique is basic to working with watercolor pigment and must be kept in mind throughout the painting process. Brush movement should be kept to a minimum, preferably to two strokes, applied like parentheses around a center, as in a circle with the color filling in the middle. Take care not to twist the brush when painting a circle; this is a common beginner's mistake. Excess color can be soaked or mopped up with a squeezed-out brush or a sponge. Too much color and water left in the circle will puddle, perhaps settling unevenly,

and prolong drying time. The choice of paper for this exercise makes a big difference. If the texture is rough, the circle's edges will not necessarily be straight. The brush might glide over it, catching only the top surface and leaving a rough edge. Retracing the circle with the brush with either more color or more water will straighten the edge, but I do not usually recommend this, because the roughness can be quite attractive.

The circle exercise, as simple as it seems, offers a number of possibilities for artistic exploration. For instance, you can introduce other color tonalities and vary the circles' sizes and intensity (Figure 4.3). Note how colors of equal value but different hue (warm and cold) seem to advance or recede. Also, observe color weight. Visually, a tiny dot of intense color can weigh as much as a larger circle of light color. Furthermore, overlapping circles suggest that one is in front, the other in back, whereas the change of size (small and large circles of equal value) conveys the illusion of distance and space. Objects closer to us appear larger and get smaller the farther away they are. You will encounter all of these visual effects again in still-lifes and landscapes.

Importance of Paper

Your paper's quality, especially its texture and absorbency, will influence your brush work and your color's behavior. Rough paper has a tendency to inhibit the brush movement because its surface produces friction

Figure 4.3
ELLEN MARCUS
Circle Exercise. Variation in color intensity and circle size.

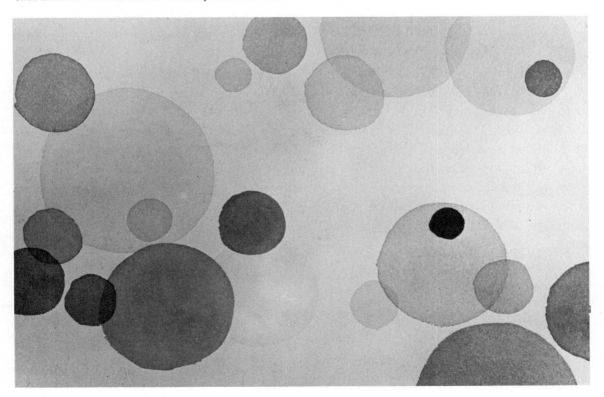

and prevents smooth gliding. The brush may leave certain parts uncovered, giving the surface a sparkling effect which can be quite effective. On the other hand, smooth paper, either hot-press watercolor paper or any other suitable nonporous variety, will yield smooth lines because the brush glides easily over its surface.

The absorbency of the paper, however, is more important than its texture. Whenever the wet in wet technique is used, your paper is, so to speak, put on trial. Will it absorb the water without buckling? Does the pigment sink into the fibers? How quickly does it absorb water? Often a hot-press paper has absorbency, but, due to its sleek surface finish, the watercolor will sit on top of the paper a while before penetrating it. Uneven tension between dry and wet areas causes buckling. Any paper with poor or no absorbency will be difficult to use with the wash technique. At best, the watercolor will stay on its surface, collecting in puddles and drying in uneven patches. At worst, the paper will not hold up to the moisture and the brushwork and will start to unravel and fall apart. Glazing is kinder to poor paper, provided that the watercolor is applied very lightly. Since only part of the paper is moistened, it simply will not have to absorb that much pigment. Drawing and sketching paper, usually unsuited for watercolor painting, can be used for exercises when these limitations are observed.

Wash Technique: Wave or Stripe Exercise

Paint a series of horizontal bands of color in the wet in wet technique. Apply your color in either straight or wavy lines, moving a brushload of color across the paper. While the color is still wet, add another color on top of or next to it. Notice how the two colors fuse and blend, producing additional hues (Figure 4.4).

Painting stripes instead of mixing wet colors randomly on the paper gives you the chance to practice horizontal brush movement. The distance that your brush can travel depends on how much paint it can hold, which depends on the size and the type of brush and the absorbency of its hair. A flat, 1″ brush holds much less water than a round, bushy one. The soft, pliable hair of watercolor brushes is more absorbent than nylon or bristle. The width of a stripe is determined automatically by the size of your flat brush, whereas the pressure you exert on a round brush controls the width. For a fine line, glide just the tip of a round brush across the paper. Press down for a wider line, or alternate the pressure for variety. Watercolor flows because of its liquid nature. The brush movement should therefore be continuous and flowing.

One of the most important aspects of painting with watercolors is guiding the brush with your arm. Beginners often bend their wrists, making short, choppy movements, especially if they have painted with oil or acrylics before and have used bristle brushes. At first apparently little effort is required to spread the watercolor paint. Excessive movement and retracing (which I call erasing the tracks of the brush) often causes too much mixing, which, in turn, creates dull colors. Since color purity is mandatory for color transparency, *mastery of watercolor technique is knowing how to apply colors so that they retain their clarity and individual identity.*

The stripe exercise can also be combined with the glazing technique. If you let the stripes dry first, each subsequent color layer will be crisp. (See Plate 5.) There are

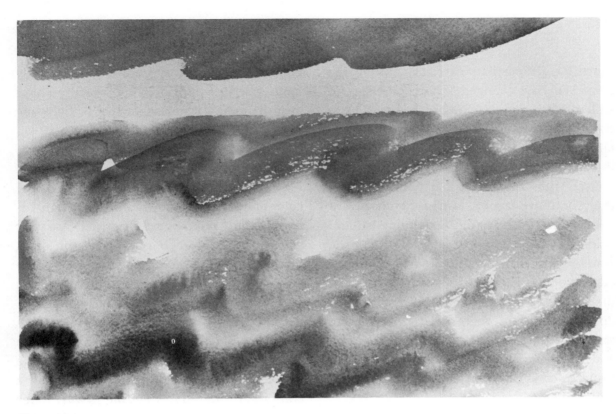

Figure 4.4
CHRISTINE CORTIZAS
Wave or Stripe Exercise. Wet-in-wet color application.

limitless combinations of washes and glazes. You can start out with a wash, allow it to dry and glaze over it, or you can glaze first, then remoisten your paper with either color or just water and paint wet in wet. If you plan to do many layers, remember that each color will alter the color underneath by either making it darker or changing its hue. Consequently, you can achieve many subtle color combinations by careful color layering, or you can lose your colors' brilliance with the wrong color combinations. No matter how many colors you apply, make sure you leave some white; it will function as the lightest value and give you an original surface to return to.

Even though the stripes are designed as exercises and have a primarily decorative appeal, they can also be explored for their artistic potential. Experiencing color interaction in washes and glazes introduces you to the nonobjective use of watercolor and the liquid dynamics of the watercolor medium. Note what Morris Louis did with acrylic paint on unprimed canvas (see Figure 1.6); similarly, you can explore the expressiveness of watercolor stripes on paper. Alter their color and rhythmic flow in a variety of undulating patterns.

Dual-colored Stripes

The watercolor brush is a versatile artistic tool that can be further explored in this exercise. You can create fancy dual- and triple-colored stripes with one brush stroke by dipping the brush into more than one color.

Immerse the brush in red, then yellow, then blue, and the colors will start to fuse while in the brush. Run the brush across the paper, and the brushstroke will be a fusion of these colors. It should not be retraced, be-

cause the proportions of each color in the brush will have changed. It takes practice and skill to judge how wet the brush should be to cover a certain area or travel a certain distance. The multiple color effect achieved with this technique can be quite extraordinary, but if used indiscriminately can become something of a *tour de force*. Usually, a dual-color application is used in figure painting. A light color is dipped into a darker color, and the resulting brushstroke is a line with a dark edge, which is an interesting way to describe the contours of the human body. This was done to a certain degree in the movement studies in Plate 29. Chinese brush painting and Japanese Sum-i painting use dual- and triple-color application for painting vegetation and animals.

Exercise in Color Gradation and Color Isolation

After experiencing color formation via color fusion and brush movement, in this exercise you will deal with color control. You will practice the ability to isolate colors, shading them within a limited area (Plate 6).

With a soft pencil, draw a rectangle on your paper, leaving one-inch margins. Divide this square with horizontal and vertical lines, making a fairly large-sized grid pattern. Now draw a few diagonal lines every so often, to break the squareness and introduce some rhythm. Do not use a ruler; do it freehand with a light touch, varying the width for added interest.

Fill these rectangles and squares with color, shading from light to dark so that there is uniform gradation of color in each. Your aim is to stay as closely as possible within the given shapes. Be careful not to overstep the

margins, especially if your brush is fairly large. Use just the tip of the brush, perhaps even flattening it out somewhat to help you apply color in these areas.

Although there are various methods of shading watercolor, I have found the following two to be the most effective: (1) Apply color of one consistency in a medium light tonality evenly onto the whole area. Rinse your brush and squeeze it out. With the clean brush, soak up the color from one side of the area, and note how it gets lighter. Do this until you get the desired shading from light to dark. (2) Apply a medium dark color on one third of the area. Rinse your brush and apply clean water to the edge of your color (make sure that it is still wet), stretching it into the empty part, literally extending it with water until it covers the whole area and has the light-to-dark appearance. Be careful not to use too much water, and apply it only on the edge of the color.

To prevent colors from running into one another, paint the squares or rectangles in a checkerboard pattern. Move from one area of your paper to the other without hesitating to turn in various directions if you have to. If you want to paint colors adjacent to each other while they are still wet, leave a tiny white line between them. This is a common practice, especially when the artist is working fast. The white line allows color control; by separating the colors physically, you prevent them from running together. (See Plate 28.) Visually, however, the white line gives each color an increased intensity, a highlight, adding to its luminosity (Plate 35). Furthermore, it separates two colors of similar value when they are placed next to each other, and prevents them from visually merging.

This technique of *extending* and *subtracting* color is basic to watercolor application. In

this exercise you are separating the two procedures. Once you start painting subjects, however, you will move quickly from one to the other and apply them as needed. If you paint a landscape with a heavy wash, you will probably extend your colors with additional water to cover certain areas (as in Plates 27 and 28). On the other hand, the plants and vegetables in a delicately defined still-life are usually painted by subtracting colors in order to achieve subtle tonal modulations. (See Plates 8 and 13.) Eventually, your personal painting style will dictate your brushwork.

As you have probably noticed, glazing is a much more methodical technique of color application. Washes can be more spontaneously put on your paper, but they also take more control. For beginners it is often difficult to plan the various steps in the painting process, to know when to let colors dry or when to separate them with a thin white line. This difficulty often causes impatience and provokes the somewhat justified remark that watercolor is, after all, not a very spontaneous medium.

Indeed, you must often wait for parts to dry, but this also has its advantages. It increases your awareness of your painting's components and allows you to work on all parts of your subject simultaneously. You cannot work one area to death, or inch yourself from one corner to the next. Both approaches are bad compositional technique, anyway. Ideally, all parts of your subject should be in the same state of definition, which means that if you are painting a landscape you should immediately lay in all the components with color, even though they are not yet spelled out or defined. Remember that you are working additively with watercolor; you must keep the overall composition constantly in mind. Painting with watercolor,

perhaps more than working with any other painting medium, can be compared with directing an orchestra. You, the director, signal the various instruments to play, pointing in this or in that direction. Confronting your watercolor paper, you fill it with one color at a time, area after area, orchestrating its surface, deciding which color to introduce first, which next. In this manner, your composition grows from the general to the particular, one layer at a time.

Space and Depth Exercise

Tape the edges of your paper with masking tape. Now divide the area with a horizontal plane line. Do not draw it right in the middle, but rather off-center, and do it freehand. Take two colors, of roughly the same intensity, and apply one on the top area and one on the bottom. Estimate the amount of color needed to cover each area. As you did in the color isolation exercise with the squares and triangles, shade each area. The top will be shaded from dark to light. Starting at the top, work the color down so that it becomes lighter as you meet the pencil line. The bottom area will be shaded from light to dark. Starting at the bottom of your area, work up so that the darkest portion meets the pencil line. Take extreme care to keep the two colors separate. If you allow them to fuse and blend, make sure that you retain their identities. Color application here is the same as in the squares, but since you are dealing with a rather large area—a big square, so to speak—mix an adequate amount of paint to cover it (Figure 4.5).

To make sure that color will spread easily, lightly moisten each area. The color will flow and spread on the paper, leaving no

Figure 4.5
INESSA DERKATSCH
Space and Depth Exercise. This can be used as a preliminary study for a landscape.

sharp edges. Move your brush horizontally back and forth with continuous strokes while you apply color. Actually, the even shading of the color is less essential than the progression of dark to light in each area, and the sharp color contrast at the pencil line.

Shading an area in this manner makes your paper, a two-dimensional flat surface, appear to have depth. This is a pictorial device used by artists to create the illusion of distance and space. If you were painting a landscape, for instance, this might create the appearance of land and sky. (See Plate 7 for quick landscape studies.) The line where the two colors meet would be the horizon line, indicating the point farthest away in space. Your watercolor paper thus simulates an environment in which objects can exist. If you want to add trees, houses, and highways to your landscape, the illusion of space provides the context. Such a landscape is fairly realistic and approximates the way we see and experience our surroundings.

Exercise in Line and Plane

Watercolor has the ability to exist simultaneously as line and plane. This is part of its fluid nature, and in this respect it does not differ from other water-based media. When you apply color as a thin line, and while it is still wet, extend its edge into a plane, you are basically using the *extending* technique of watercolor application, but here it is more controlled and will yield a crisp edge.

To practice this, draw a series of short pencil lines randomly on your paper. Now color them by applying a fine watercolor line on each. Do one line at a time. As soon as you have applied the paint, rinse your brush and apply plain water to one side of the line. Notice how you can extend, or literally *pull out*, the color into a plane. The colored areas will have a crisp, sharp edge on one side and a soft, gradated color definition on the other (Figure 4.6).

This technique allows you to move

quickly between linear definition of forms or objects and three-dimensional description. For instance, you can sketch with swift watercolor lines the contour of an apple, and then proceed to extend the lines with water or color into planes, thus creating the *roundness* of an apple's shape.

Erasing one edge of the watercolor line leaves a chiseled appearance on the other side. This happens because the pigment has settled and coagulated in this area. If you look at the circles or waves in the previous exercises (See Plates 4 and 5), you will see that some of them have sharp edges. You achieved a similar effect when you applied a fairly strong color and then soaked it up with your brush. In this case you are subracting color. By creating a crisp edge (or color density) on one side and a color wash of lighter

value on the other, you are giving a light–dark appearance to your object. If you were painting a round shape, you could actually give it a three-dimensional appearance with this color effect. This light–dark combination can be used as a structuring device for a variety of delicate and sturdy objects, such as the face and attire of the figure in Plate 32, or the architectural planes of the house in Plate 26. Often this technique serves as a preliminary color definition of an object, and thus as a basis for subsequent color formation.

Frequently in watercolor painting, instead of shading an object, the artist uses color to give it dimensionality. The cool and warm colors, with their receding and advancing effects, can be used for this purpose. This actually makes use of the unique prop-

Figure 4.6
INESSA DERKATSCH
Exercise in Line and Plane. Watercolor has the ability to be applied as a line and then extended into a plane.

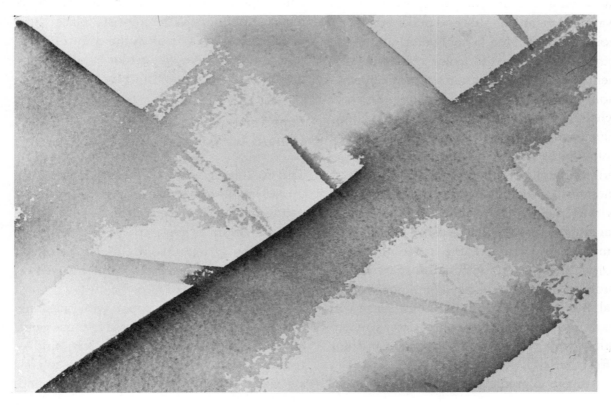

erties of watercolor paint, its ability to interact in washes or glazes and form new colors. I would like you to experience this in the following exercise.

Exercise in Color Structuring

Draw a series of circular lines on your paper. Apply a primary color to one side of the circle, extending it with water to the other side. Stay within the confines of the forms. Over the primary color, apply a warm color on one side of the form and a cool color on the other. Keep your color values and intensities as similar as possible in both cool and warm colors. Otherwise, the intensity of one color will advance over that of the other, throwing off the cool and warm color structuring principle (Figure 4.7).

The preliminary color applied to your form acts as the base, determining what colors can be created. If, for instance, you used red as a base, you can apply yellow (a warm color) on one side and make orange, or you can apply blue (a cool color) and make purple. (See Plate 12.) Color structuring depends on color interaction and color formation, so you might be sent back to your color wheel. Remember, primary colors (yellow, blue, and red) interact to form secondary colors (green, orange, and purple). Mixing a primary and a secondary color yields a harmonious, or analogous, color. It is best to stay within the primary and secondary color ranges, because they allow more mixing possibilities. Remember, the more you mix colors, the darker and less transparent they become. You do not have to get too theoretical. See how much intuitive color sense you have. Trust your first responses; later you will know why you achieved a particular color effect.

Learn to predict color formations so that you can use them purposefully for specific forms or visual effects. To do this you must think in color relationships. Pay special attention to those complementary colors that cancel each other's brilliance, because they are the most difficult to control. However, more is necessary than the theoretical knowledge that mixing complementary colors such as violet and yellow creates mud. When looking at your painting, know intuitively that this specific violet when mixed with that particular yellow will yield approximately such and such a muted hue. *Controlling color formation is an extremely important watercolor skill that will influence the quality of your work.* The sign of an accomplished watercolorist is the ability to paint with a variety of contrasting colors that retain their identity, no matter how much they interact with one another in new color combinations. The mastery of this aspect of watercolor painting is much more crucial than the ability to define the recognizable appearance of an object, on which so many traditional watercolorists place their primary emphasis. Look at the color illustrations and note that watercolor is *color* in addition to houses, boats, and trees.

Experimentation with Watercolor Textures

The final exercise is designed to loosen you up and enable you to discover the many fascinating and surprising effects that are possible with a medium as lively as watercolor. In this exploration of textures, the tools, the paint, and the paper interact and come into active play.

Again, tape your paper with masking tape into four or six squares. Now use your tools or any other object you can find—toothbrush, paper towel, cardboard—to create visual effects. Explore both glazing and

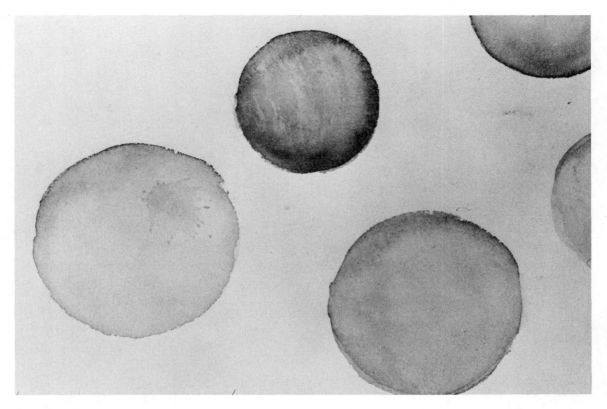

Figure 4.7
INESSA DERKATSCH
Exercise in Color Structuring.

washes. Wet only part of the paper so that you can observe various forms and colors behaving differently on different surfaces. The squares give you separate areas for each color and textural effect (Plate 7).

At first, be aimless. Splatter, dot, twist, or glide your brush, sponge, or even fingers across the paper to see what happens. Drip, doodle, fuse color all over it; then let it run. Tune into color behavior, water influence, and brush interaction. In short, observe what can happen to the paper when you interfere, and how you can guide color and form. Your brush movement can determine the color flow and the amount of water. You can vary the position of the watercolor paper, tilting it in different directions to influence its flow. Actually, you are both a spectator to the happening and a participant. (Figure 4.8 shows a variety of possibilities.)

Here are a few more suggestions:

1. Dab color on your paper with a wet sponge or soak it up from the paper.

2. Apply color with a rather dry brush that has been flattened out with the hair pulled slightly apart. Make a series of lines, curved and straight, varying the direction. (See Plate 5.)

3. Take an old toothbrush, dip it into color, and spray the color on both a dry and a moist surface. Observe the different color fusions (Figure 4.9).

4. Use pieces of cardboard or mat board to block out areas on your picture areas. Spray or paint color around them. Cardboard can also be cut into many other interesting shapes and worked like a stencil.

5. Sprinkle ordinary table salt or, better yet, rock salt on the wet colored surface of the paper. Notice how the salt melts as it attracts water and leaves very delicate star-shaped marks (Figure 4.10). Brush off the salt when the surface is dry. This effect has been used to depict snowflakes in a hazy winter atmosphere. (See Plate 21.) Instead of salt, take sand or cornstarch; just remember to let the surface dry before you brush it off.

6. Moisten your paper with either watercolor paint or just plain water. Wet it until it is fully saturated (wait three to four minutes). Now with the back of your paintbrush or with a pallet knife, press into the moist surface, making a series of slashing strokes. Notice how some areas are lighter, others darker. This is caused by color displacement. Color, or even just moisture, has been

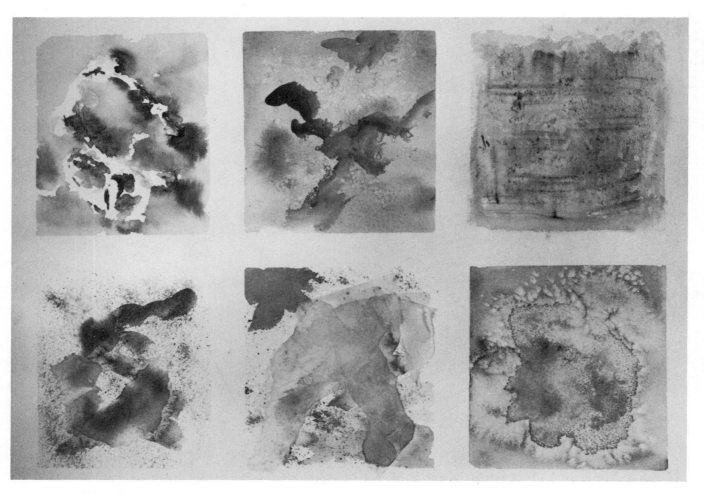

Figure 4.8
INESSA DERKATSCH
Experimentation with Watercolor Textures.

squeezed out of the areas where the paper has been compressed, or the color has run back into the areas if your paper is too wet. This effect is often used to depict grass in meadows or branches on trees (Figure 4.11). When done with care, it can be a very subtle surface delineation, depicting such delicate features as the veins on leaves or the petals on flowers.

7. Rubber cement or masking solutions called *Miscit* or *Mascoid,* designed to be used especially with watercolors, are painted either directly on the paper or on previously applied color. They prevent color from penetrating and, like wax in batik work, they block out whatever is on your paper (Figure 4.12). In the nineteenth century, wax was used on watercolor paper for the same purpose. Wax is still often recommended by traditional watercolorists to create such effects as moss on stones, or tree bark.

You can paint these blocking-out agents on your paper into specific forms and shapes,

as in the background in Plate 37, or just drip them into free-form patterns (as in Figure 4.12). Since they are water-soluble at first, be sure to let them dry thoroughly before painting over them. After they are dry and you are finished with your designs, simply rub them off to make your colors underneath appear. By necessity they will be lighter than the colors around them, because every watercolor layer darkens previously applied colors. There is no limit to how many times you can repeat this effect.

You can paint over blocked-out colors, or block out new areas. Even though these masking solutions can be quite effective in creating interesting negative space, I should interject a word of caution. Be sure that you remove (rub off) every trace of them from

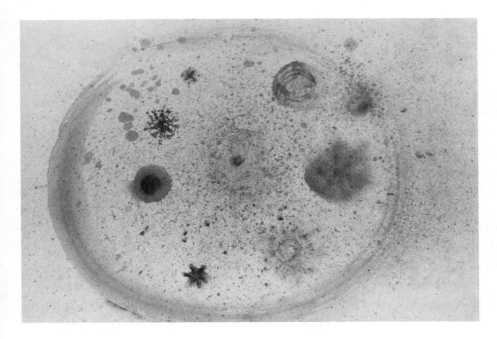

Figure 4.9
INESSA DERKATSCH
Texture Detail: Color Fusion.

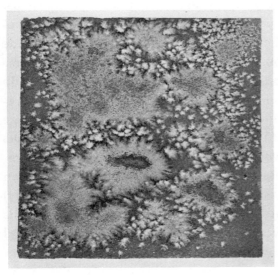

Figure 4.10
INESSA DERKATSCH
Texture Detail: Salt.

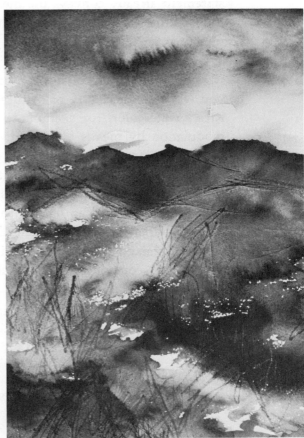

Figure 4.11
TRINE BUMILLER
Landscape. The foreground shows the use of slashing strokes and water displacement.

Figure 4.12
BEA WARREN
Abstract composition using masking solution, such as Miscit.

your paper. Because they are high in chemicals, they can be detrimental to the permanency of the paper and the color. Their archival quality is rather questionable. Also, if you allow them to dry in your watercolor brush, they can ruin it. Use an inexpensive small brush for them.

Experiment with a variety of methods of paint application and also with collages to produce textures (Figure 4.13). Only your imagination is the limit. Textures are a very personal thing; they can be compared to a gesture that underlines a statement. The statement already conveys the message, but the gesture adds the personal touch. In painting, textures frequently add liveliness and personality. Look at some of our great watercolorists, traditional or modern, and you will see the vitality of textures. In Paul Klee's watercolor, for example, the surface modulation by means of textures gives the girl immediacy and the simple geometric forms great individuality (Figure 4.14).

Textures are a means to enhance the surface and are also an end in themselves. Artists interested in textures usually experiment with mixed media, as did Paul Klee. It is beyond the scope of this book to discuss the expressive and artistic merits of various paints and materials. But even though I emphasize the transparency of watercolor and focus on its unique features, I am no purist. If you are interested in textures, explore their artistic potential.

Test Your Imagination

Paint a variety of colors, forms, and shapes randomly on your paper. Abandon yourself to this process by working quickly and intuitively. Apply all the techniques you have just experienced. Do not aim for anything specific. Let the watercolor take over and guide you. Now, stop and observe your configurations. Using your imaginative cognition, do you recognize objects, spaces, vistas that remind you of something realistic? (See Figure 4.1.) During the learning process, students frequently forget to tune into the suggestiveness of watercolor shapes and forms (often most suggestive if they are created aimlessly) and recognize their artistic potential. This awareness is basic to painting in general, and to watercolor in particular.

In watercolor, perhaps more than in any

Figure 4.13
INESSA DERKATSCH
Textures with Tissue Paper (collage).

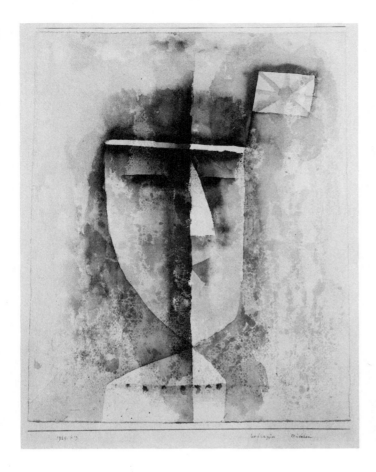

Figure 4.14
PAUL KLEE
Beflaggtes Mädchen (1929) (watercolor,
19¼ × 21¼ in.).
Kunstmuseum Basel, Kupferstichkabinett
(Emanuel Hoffman-Stiftung, 1935.3).

other medium, not only do you do things to the paint, but the paint also does things. No matter how knowledgeable and accomplished the painter, each brushstroke has a certain degree of unpredictability. There will always be the quick stroke, the quivering hand, the moment of action that will not be fully under control. A pencil line drawn on paper stays put; a watercolor line moves and is metamorphized. (See Figure 4.15.) This is part of its beauty and fascination. Mastering watercolor skill requires the ability to move quickly between predictability and chance. Predictability grows from the artist's experience with watercolor's behavior. In this respect, accidents actually teach a valuable lesson, because they reintroduce the laws of the medium.

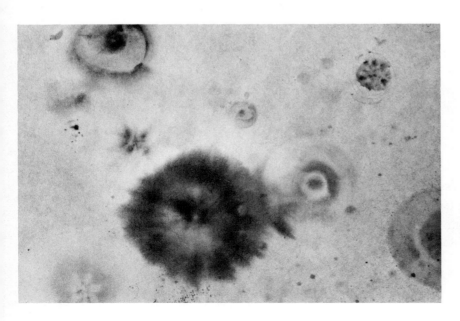

Figure 4.15
INESSA DERKATSCH
Textures on Oriental Paper.

DRAWING IN WATERCOLOR PAINTING serves not only as a blueprint for your ideas but as a pre-color layout for your composition as well. Preliminary sketching can help you define the shapes and forms of your subject and decide on their compositional arrangement. This process, in turn, facilitates color application. Usually watercolorists draw, whether they paint in a realistic or an abstract style; it is, however, more important for realistic painters.

Beginners often think that a mastery of drawing is an absolute prerequisite for watercolor painting. This is not entirely true. For watercolor, its importance depends on your experience with the transparent medium, your painting style, and in many cases your subject matter. Drawing, for the watercolorist, is primarily a tool for visual thinking and artistic decision making.

CHAPTER FIVE

Drawing

In all the visual arts, drawing and sketching play important roles, serving as notation for visual contemplation. Quick lines made impulsively on a napkin, or more officially in a sketchbook, record observations, speculations, imaginative leaps—in short, information that can later be retrieved and reworked into other artistic media. In this respect the drawn line often represents the genesis or germination of an idea (Figure 5.1).

The sketchbooks of some of our most famous artists take us a long way towards understanding their creative methods. Of course, a camera, a diary, or even a tape recorder can serve the same purpose, and artists have come up with the most unusual devices for recording their observations. The sketchbook, however, is the visual artist's trusted companion, demonstrating his or her ability to convert sensory perception into pictorial form.

Figure 5.1
BETH STEWART
Drawing of an African Violet.

Whether you draw for pleasure or for a specific purpose, drawing tests your powers of observation and comprehension. When looking at a landscape, for example, most of us register only a general impression. When you decide to draw what you see, you must learn to sort out those impressions and make decisions: to draw the forest or the individual trees, the surface texture of the mountains or their three-dimensional structures, the precise shape of houses or their general positions in space. Inevitably, you will discover that sketching helps you to group objects and see them in relationships: how the parts of your subject relate to the whole, the foreground to the background, the surface to the structures. Furthermore, you will be forced to simplify what you see, to reduce impressions to salient aspects. You may find, for example, that fruit and vegetables in a still-life share geometric forms, even though they differ in size, color, and surface texture. Grouping basics is an artistic deciphering process which teaches you the visual order beneath the appearance of things (Figure 5.2).

When you begin work on the watercolor paper, the need for a preliminary drawing depends, first of all, on what you are trying to accomplish with watercolors. If you are interested in the fluid dynamics of the medium,

you can dispense with sketching and allow the colors to flow in unpredictable directions, taking their own shapes and forms.

With a realistic subject, such as a landscape with architecture, profuse vegetation, and complicated perspective, drawing your composition first helps you decide what to include or delete, and how detailed or defined you want your painting to be. Accordingly, your drawing will be more or less specific, depending on whether you want a quick impression of your subject or a detailed one. Some realistic watercolorists rely on very careful drawings, while others trust their ability to translate subjects directly into

paint. When working with a scene they have painted before, they may use the previous painting as the model.

In addition to the choice of your subject, your personal painting style will influence your drawing decisions. If you paint with dark and heavy, bold and gutsy color washes, you can hide pencil lines, especially if your colors are opaque, as in many traditional landscapes. Since details of a preliminary drawing are largely obliterated, extensive sketching may be used. On the other hand, in transparent portraits, delicate color glazes applied with a light touch let every line show through. In this case, your subject dictates a

Figure 5.2
LEONARD NEWCOMB
Drawing of Heads.

light pencil line. If your drawn lines are too heavy, they may compete with subtle washes and glazes used for the features of your model, since they remain visible after the watercolor is finished. Use your lines to mark the position and size of features, but do not sketch out their intricate shapes or shadings. The purpose of the drawn lines is to guide watercolor application. They are reminders, not substitutes for the features. Practice in drawing the features accurately will help you to understand their intricate shapes, but for watercolor painting you must learn to create them using the visual dynamics of the watercolor medium itself.

A skillful drawing, therefore, does not guarantee a successful watercolor. Pen or pencil lines have different visual qualities and can be controlled as no liquid medium can. Too much drawing prior to painting may prevent you from taking advantage of the fluid character of colors, and force you into too much control. As does drawing, watercolor has its own methods of visual rendering, its own conventions of creating, for example, the illusion of space in a landscape or the three-dimensional appearance of an apple. No matter how skillful you are with your pen or pencil, you will need to practice your subjects with watercolors to learn the lines, planes, and textures that reproduce the contours of a specific geographical region or, more simply, the configurations of a chair. Trial and error, classroom instruction, and careful study of the examples in the following chapters will teach you how to create the visual equivalents of a variety of subjects.

The amount of drawing necessary for transparent watercolor, then, is a personal decision you must make based on your artistic style, technical skill, subjects, and materials. Traditional art education required a thorough training in drawing as a basis for any artistic endeavor. A similar tradition held ballet training to be *de rigueur* for the study of any type of dance. Today modern dance, as well as transparent watercolor, can be practiced without this classical foundation, and both may be more expressive and experimental for having been freed of such requirements. Both artistic disciplines have their own techniques and styles that can be explored for their own sakes. Nevertheless, *line quality* in watercolor, produced by colored pencils, inks, or crayons, has its place (see Plate 33). When pen or pencil lines are introduced in addition to washes and glazes and are allowed to "bleed" or blend with the watercolors, they can have a striking visual effect. When used sensitively, the drawn line in transparent watercolor can be exquisite, just as classical ballet movements can enhance the movements of an avant-garde dancer.

Historically, there are numerous examples of watercolors in which the pencil line adds to the visual appeal of watercolor and carries equal expressive weight. Cézanne's landscapes and still-lifes come to mind. They are in the tradition of colored drawings but depart significantly from the use of watercolor as simply a filler for line drawings (see Figures 3.4 and 6.2). Visible beneath colors and shapes and often extending beyond color boundaries, his lines can be read as preliminary responses to the subject, or as visual tracks breaking ground for the journey ahead. Technically, they act as supports for the delicate color layers structuring the composition. Visually, they allow us to participate in the evolution of his painting.

For drawing prior to watercolor application, use a soft pencil and a light touch. Sketch quickly, work from the general to the

particular, and remember that it is better to draw less and define later with watercolor. When you begin to paint, you do not need to keep within the boundaries of your lines. Some artists ignore pencil details of their composition and simplify forms during color application. Keep erasing to a minimum. When necessary, use a soft, white, or clear eraser to lift the pencil from the paper, but try not to wear out your paper's surface. If you want to experiment with pen and ink, avoid ball point or felt tip pens. Aside from their questionable permanency, their line quality cannot easily be controlled and is frequently so prominent that it competes with subtle watercolors. They also have a tendency to bleed erratically and, unless you are prepared for a lot of surprises, are unnecessarily complicated for beginners.

Drawing for the watercolorist, then, is a tool that can be used to sort out ideas, test technical skill and comprehension of focus, selectivity, and composition. Serious artists draw continually to sharpen their visual acuity and to practice visual rendering. Beginners, however, should feel free to explore watercolor fully, in spite of limited drawing experience.

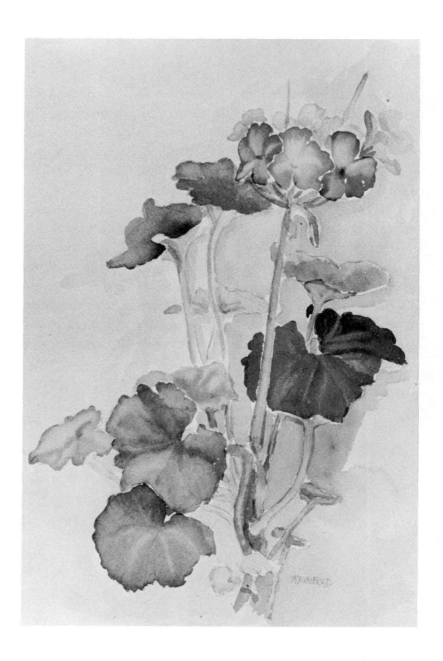

A PLANT, A BOTTLE, A FEW PIECES OF FRUIT are spread out on a tablecloth and lit by the afternoon sun. No, this is not the setting for a luncheon in the artist's studio. Rather, these are a few objects making up a *still-life:* simple, common, everyday objects that the artist has selected for their visual interest, in order to capture them in a painting.

The term *still-life* is usually reserved for inanimate things, either of animal (dead or stuffed), vegetable, or man-made nature, depicted indoors. The French call it *nature morte,* that is, nature arrested or inanimate, rather than "dead" nature, signifying perhaps the stationed or arrested condition of these objects. Flowers and fruit, obviously quite alive, are often gathered and arranged into still-lifes (Figure 6.1).

In the repertoire of beginners and amateurs, still-lifes are popular subjects. Con-

CHAPTER SIX

Still-lifes

venient to set up, they provide for the exploration of basic, artistically interesting, technical problems. The intricacies of color modulation, form definition, space, and three-dimensional rendering can all be practiced with a subject matter that is manageable. The complexity of a still-life can be controlled and varied according to the artist's wishes and needs.

But even mature and accomplished painters, whether they paint in a realistic or an abstract style, are attracted to still-lifes because of their visual appeal and because they offer the opportunity to resolve various color–form and compositional problems. In this respect, still-lifes continue to serve an artistic function. However, when they are seen as carrying a great "message" or philosophical "meaning," they become somewhat suspect. Can fruit and flowers still speak to us

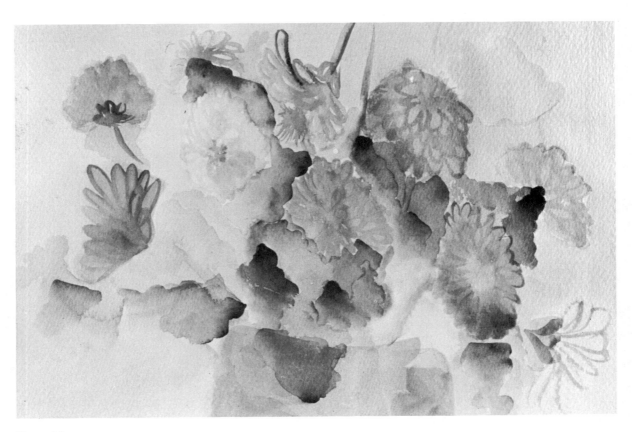

Figure 6.1
INESSA DERKATSCH
Flower Bouquet.

about nature? Do the pots and vases in our kitchen signify something about our life style? It seems that they are quite benign examples of material goods in our present existence. Pop Art of the 1960s brought this point home with Andy Warhol's overinflated *Campbell's Tomato Soup* or Claes Oldenburg's deflated *Hamburgers*, symbols of our consumer society. It can be argued that these works embody moral lessons; they seem to be excuses for paintings rather than emblems.

Traditionally, however, still-lifes had quite complex meaning and significance. When they became popular in the sixteenth century, they incorporated objects that were symbols of religious and moral beliefs. The inclusion of bread and wine, for instance, signified the Passion of Christ, while the appearance of the human skull or the hourglass served as a *memento mori*, a reminder of the vanity and transience of life. These *Vanitas* paintings, even though predominantly symbolic in content, often depicted objects which were challenging to paint. Flower bouquets, in that respect, are especially rich in meaning. Depending on the flowers, they could be either religious, such as lilies, symbolizing virginity, or seasonal, indicating the passage of time. And some were chosen simply because of their visual appeal.

The most elaborate still-lifes were painted by the Dutch and Flemish painters in the seventeenth century. These large and impressive compositions often show minutely detailed and ultrarealistic depictions of an almost surrealistic combination of things: a dead hare and fruits and vegetables partially peeled or still moist from morning dew are flanked by an antique clock, and reflected in a convex mirror. Such an arrangement probably had many symbolic meanings at the time.

80

Today, we note primarily the artistic virtuosity of these paintings, even though some art historians recognize deeper meaning in them. Still-lifes painted in watercolor are seen infrequently in the seventeenth century, although paintings of individual plants and animals, fruits and flowers, exist. These were done, however, mostly as studies for colored etchings, which in the eighteenth century served as models for encyclopedic documentation.

A quick survey of the nineteenth-century shows that still-lifes play a somewhat minor role. The Romantic artists, with their emotional convictions concerning political change and individual expression, had little use for them. Some mid-nineteenth-century social and political Realists painted still-lifes, but most of them observed with astute vision their environment and portrayed social changes rampant at that time. Not surprisingly, the Impressionists did not especially favor still-lifes either, and only with rare exceptions do they appear among those painters' numerous landscapes. They were proba-

bly not excited by what they called *nature morte*, for there were more lively subjects to be observed, studied, and recorded.

Interestingly enough, in the last part of the nineteenth century, still-lifes surfaced again, not so much as message carriers but as a means of investigating a variety of purely artistic concerns, such as color, form, space, and composition. Paradoxical as it seems, the closer we come to nonrepresentational art—the emancipation of artistic media from objects—the more popular still-lifes become. Perhaps it was the absence in still-lifes of deeper meaning that appealed to the artists of the time, allowing them the depiction of common objects from a purely visual (color and form) point of view, and the exploration of a variety of other artistic problems.

The decades immediately before and after 1900 show still-lifes painted by such well-known artists as Van Gogh, Matisse, and especially Cézanne. Still-lifes became for Cézanne the ideal subject matter (Figure 6.2). He painted apples, flowers, and even human skulls in a technique of successive color

Figure 6.2
PAUL CÉZANNE (French, 1839–1906)
Still-life with Pears (watercolor over pencil, 11 × 18¾ in.).
Courtesy of Cabinet des Dessins, The Louvre, Paris; 28.115.

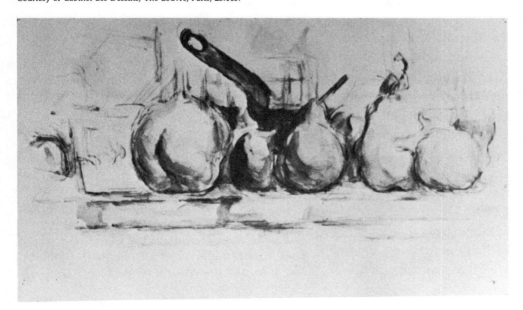

layering, structuring the paintings' surfaces to convey space and depth. Compared with his still-lifes in oil, his watercolors are the most sublime achievement of his pictorial concerns. Art historians maintain that Cézanne deals even with his human figures as if they were still-lifes, giving them the same stationary appearance. It is said that he once told his wife, who would not hold still while he was painting her, to behave like an apple.

The Cubist painters saw in still-lifes challenging possibilities for painting objects from multiple points of view. Both Picasso and Braque explored the fragmented and fractured appearance of musical instruments like mandolins and guitars with mixed media collages, preferring, however, opaque body paints to transparent watercolors. Still-lifes do not make up a large part of the visual repertoire of the German Expressionists. Notably, Emile Nolde painted flowers and animals, and, although these can be grouped as still-life components, the classification is hardly applicable to them. He vitalized their appearance, animating them with brilliant colors and exuberant brushstrokes. His watercolors represent veritable gems in the history of any subject matter, and challenge our notion that still-lifes are uninspiring and elementary (Figure 6.3).

Today, many abstract and nonrepresentational artists rely not so much on set-up still-lifes, but rather on artistic inspiration derived from common objects found around the studio or house, or those blatantly bombarding our senses via the media. The notion that simple, everyday objects can inspire an artistic statement that delights in its limited but sincere expression continues to be a part of our century's artistic vision.

For the beginning watercolorist, the still-life provides an extension of the color–form exercises. It allows the practice of

brushstroke technique and color interaction in objects that are manageable rather than overwhelming. Thus, simple pieces of fruit or more complex arrangements of plants and flowers can be chosen for the practice of basic watercolor methods and skills. (See Plates 8 and 9.) Most students like to test their artistic skills by painting something realistically at first. In a nutshell, still-life objects offer an encounter with visual problems such as proportion, three-dimensional design, perspective, and compositional unity.

But just because still-lifes are manageable does not mean that they have to be boring. In most classes, unfortunately, they are set up out of convenience and often composed of very uninspiring objects. Too often we see the standard glass bottle amidst pieces of fruit placed on some neatly folded drapery. When students are asked to paint the set up, they feel overwhelmed by the technical demands of such a complex subject and frequently are not even inspired enough to want to learn the skill. This situation can be very trying for beginners who do not know how to compose the objects on their paper or have the necessary watercolor technique to paint them. In my experience, one way of getting them started is to proceed from the general to the particular. Paint simple, individual still-life components first, and then go on to more complex still-lifes. Actually, this type of procedure is basic to any learning process, and especially to one that involves technical and manual skill.

In my approach to still-lifes, I like to start with a piece of fruit or a plant and make four distinctions (Figure 6.4):

1. The basic (generic) *shape* of the object and its most general three-dimensional appearance;
2. The *surface texture* of the object, the *skin* of fruit, for example, which can be part of its basic shape or transitory in appearance;

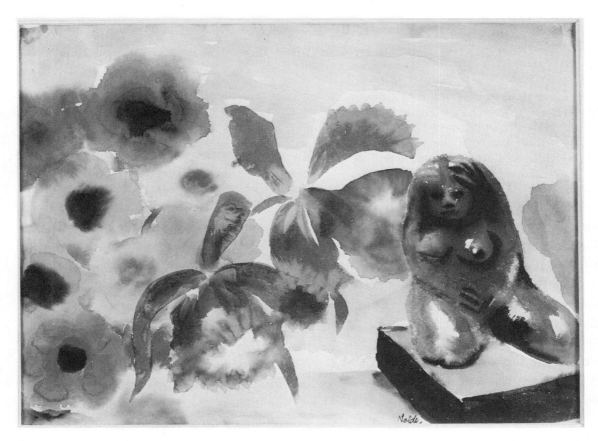

Figure 6.3
EMIL NOLDE (German, 1867–1956)
Orchids and Anemones with Bronze Idol (watercolor, 13¼ ×
18¼ in.).
Courtesy Museum of Fine Arts, Boston; 62.210.

Figure 6.4
INESSA DERKATSCH
Red Pepper.

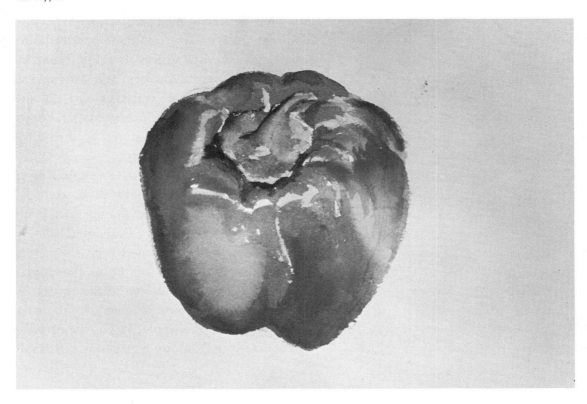

3. The *contextual*, or environmental, influences acting on the object, such as sunlight, which may influence or alter its appearance; and

4. *The pictorial context* of the still-life components, which is also an environment and determines the visual appearance of objects.

Thus, drawing or sketching these observations first tests your visual comprehension (Figure 6.5). Your ability to recognize a still-life's salient features and translate them into visual equivalents precedes watercolor technique and its intricacies of rendering the appearance of its objects.

Let's start with a piece of fruit, break it down into the above points, and show step by step how they can be approached by the watercolorist.

An apple might attract you because of its luscious color and succulence, or a spider plant because of its healthy abundance of foliage. You are stimulated by these features and want to capture them in a watercolor painting. First, train yourself to see the *general* overall shape of objects, their basic forms; then notice particulars, such as surface

Figure 6.5
INESSA DERKATSCH
Drawing of a pepper.

variations of colors and textures. Sort out what is basic, or *generic*, to each object from what is transient and changeable. This means noticing the structure before you observe the surface. You might even test your imagination to discover how much you know about an apple without actually seeing one. Then verify and expand your imagination by actually looking at one. Psychologists believe that our memory stores the generic aspects of a known object, and that we retain its salient features in our mind's eye.

If you want to depict the identity of fruit or plants, you should emphasize aspects that connote what is particular to each. When painting an apple, for instance, you should define the qualities that connote "appleness" to convey its physical reality, or, as the philosopher would say, its *ontological presence*. As you will see, these features are independent of the environment, or *contextual setting*, of the apple. Environmental conditions are transient, influencing appearance, altering color, and even distorting our vision; but they do not influence the *essence* of the object. The difference between the two indicates the important change that Cézanne introduced into the Impressionists' vision of reality. Remember, he emphasized the form and structure of an object, which are constant and do not change, whereas the Impressionists focused primarily on surface variations produced by the change of light.

For the watercolorist, an apple is a round, geometrical solid, with shape and coloring similar to those of an orange. (See Plate 12.) But an apple has very individual, identifiable features that do not change, no matter what other influences act upon the apple. Sunlight, shadows, and various sources of light can cause color changes, influencing your vision of the apple. If you paint only what you "see," the apple may look distorted.

On the other hand, if you paint what you "know" of, those aspects that all apples share, then you are painting the permanent and lasting qualities: the pictorial logic underneath an object's surface.

This is, of course, a very rational approach to artistic thinking, and when applied to painting will yield fairly realistic renderings of objects. Obviously, it is not the only possible approach. For transparent watercolor painting, however, it can be used as a point of departure for different still-life objects, as well as painting styles (Figure 6.6). When confronted by a still-life and told to paint its components, students are often confused, even though they manage to depict and emphasize what strikes them. My method helps them to sort out the still-life's visual information and group it meaningfully. Since our educational system places so much emphasis on verbal and mental facilities, my technique trains students to let go and get in touch with their *visual logic*, which is also a form of intelligence and an equally valuable one, especially for artistic creation. Visual awareness and pictorial comprehension can be learned. What cannot be taught (or learned) as easily is the making of successful artistic compositional arrangements of objects into a *pictorial context*, as I prefer to call the painting's composition. And this is the most crucial artistic achievement, no matter what the subject or the painting style (Figure 6.7).

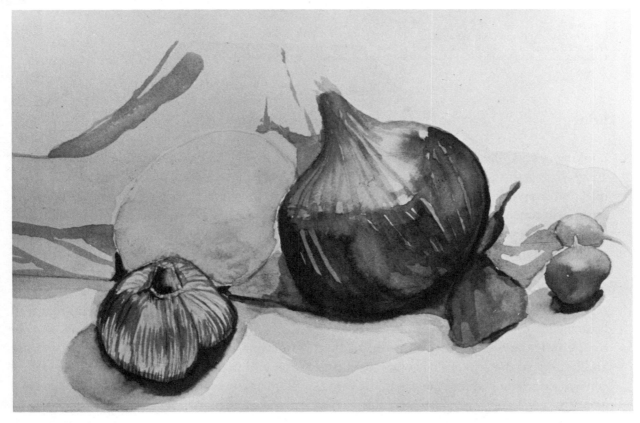

Figure 6.6
LAURA BROADDUS
Purple Onion and Garlic Still-life.

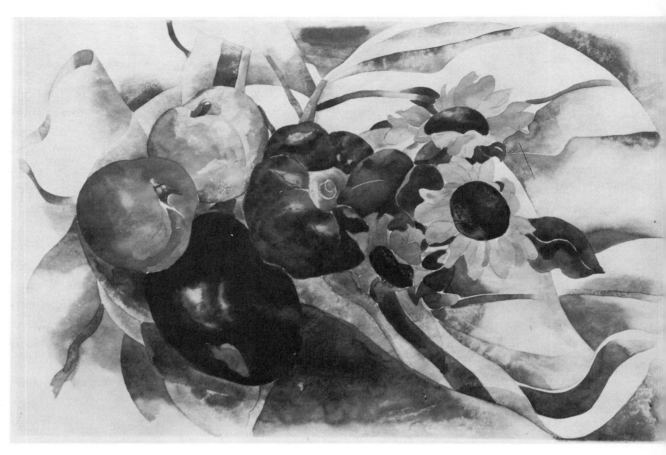

Figure 6.7
CHARLES DEMUTH (American, 1883–1935)
Fruit and Sunflowers (ca. 1924) (watercolor) (448 × 290 mm).
Courtesy of the Fogg Art Museum, Harvard University (Purchase—Louise E. Bettens Fund, 1925.53).

Fruit

Looking at an apple, note the general form of an apple and the generic aspects that make it different from other fruit (see Plate 12): which parts are consistent, stable and part of all apples; which parts are transient, changeable, and peculiar perhaps to a specific variety of apple. First draw a circle, indicating the round shape, and then make the required adjustments to create an apple as in Figure 6.8. Note how the shape of the apple can be identified by the indentations, the two dips on the top and bottom of the apple. These represent the central axis from which the middle bulges and are constant and particular to every apple. What differentiates apple varieties is the shape of the middle section. In a Deli-

cious, for example, the middle is more conical, narrow, and oblong, whereas in a Macintosh, it is somewhat more spherical. Furthermore, color and texture are also distinguishing aspects of an apple. Compare the deep, purple red of the Red Delicious with the pale, yellow green of the Golden Delicious, for example. Textures, such as the rough skin of a Baldwin apple, can also be salient features, but textures are usually transient aspects that change as fruit matures.

If you carry these observations further and apply them to other fruit, you will see that within a fruit family (such as citrus fruit), skin textures are very particular to each member. Colors are also important, a fact which names such as *orange* or *lemon* point out. Color, even though it is often linked with

Figure 6.8
INESSA DERKATSCH
Drawing of an apple.

Figure 6.9
SUSAN ALTSCHULER
Red Cabbage.

surface distinctions, can become an individualizing element and an integral part of an object's identity as in the red cabbage in Figure 6.9. Other examples of this are eggplants, which in French is the name of a color, *aubergine,* and to a lesser degree *purple* onions or *green* and *red* peppers, distinguishing the members within a species. Pay attention to these features, because they make an important statement about how we perceive and categorize visual information. Language often encapsulates semantically these important distinctions.

To learn more about the generic shapes of fruits, try to schematize their general appearance. First draw their basic shapes, then make the adjustments for particular kinds, as seen in the apple, Figure 6.8. Almost all fruit can be reduced to the elementary geometric

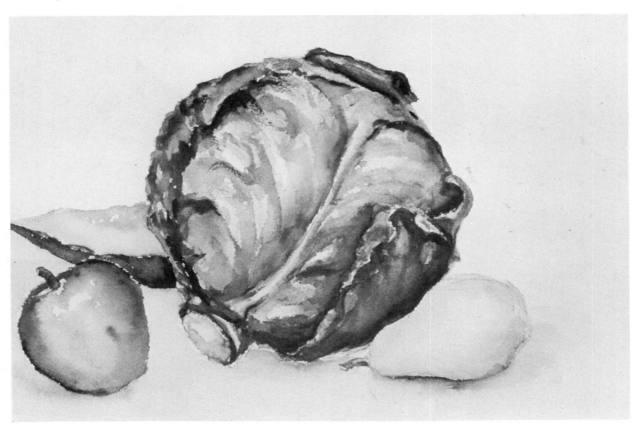

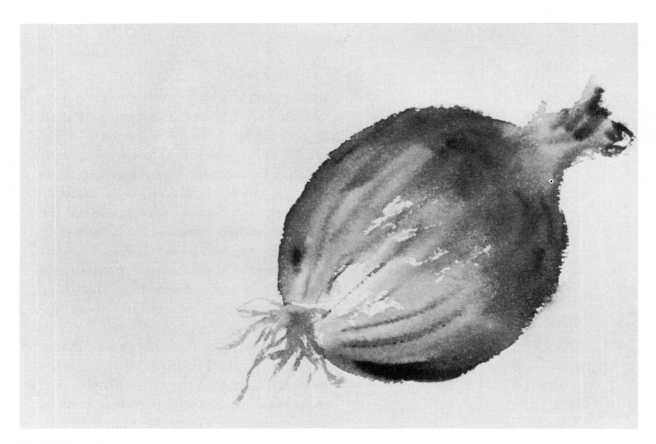

Figure 6.10
INESSA DERKATSCH
Purple Onion.

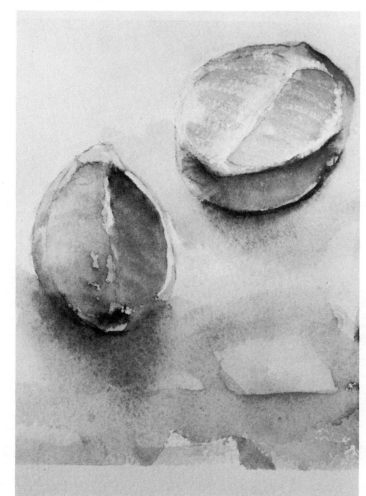

Figure 6.11
LESLEY COOPER
Cut Lemons.

shapes of cylinder, sphere, and cone, and these can serve as guidelines.

Like color, shape is sometimes a distinctive feature of a particular object. *Pear shape* or *tear drop* are good examples. Adjusting a general form to the particulars of a specific object demands observational skills. How do you adjust a round circle to look like a turnip, or squash, or an onion (Figure 6.10)? How do you distinguish a lemon from an orange or a grapefruit (Figure 6.11)? Look at the illustrations and you will see how these identifiable features are often exaggerated. Like a caricaturist, you overdramatize for emphasis.

Plants

Just as the shapes of fruits and vegetables are indicative of their generic distinctions, so the growth pattern is particular to plants, determining their appearance. Plants are more difficult to comprehend visually, because they do not have solid forms but open structures that can vary in complexity.

As you reduced fruit to simple geometric forms, try drawing the plants into simple patterns. To understand the growth pattern, you should schematize it (Figure 6.12). Sometimes I ask students to describe these patterns with words, and often they come up with

Figure 6.12
BETH STEWART
Drawing of Swedish Ivy (growth pattern: parallel leaf arrangement).

vivid examples, such as a fountainhead for the spider plant, or a cascading waterfall for the swedish ivy. Ask yourself how much you know about a particular plant; this will test your mind's eye and show you if you have an image before you actually confront the plant. When you start painting, use the same observational skills. They function as the basis for your individualization of a particular kind of plant (Figure 6.13).

After comprehending the growth pattern, look at the individual leaves and observe their particular shapes. Note the similarities and the variations in color, texture, and size. Even though the leaves may be similar to one another, some of their shapes may vary, showing possible distortions. Also examine the junctures where leaves connect to the stem of the plant. How do they connect?

Do they jut out at an angle or spill and unfold from the stem? This important feature accounts for the plant's movement and the appearance of its growth pattern (Figure 6.14). Thus, some plants, such as poinsettias, have a certain stiffness, because they grow in angular directions, and others, such as the philodendrons, have a sinuous, twisting and winding gracefulness, making them resemble flags blowing in the wind (Figure 6.15). A spider plant has a rather simple structure, and its leaf's shape varies in width, length, and sometimes color (Figure 6.16). The poinsettia, on the other hand, has a more complex structure, and its leaves, radiating from the stem at a 90° angle, vary in shape, size, and color. Notice how the rosetta is almost flat, with the arrangement of its leaves resembling the spokes of a wheel. (See Plate 13.)

Figure 6.13
CHRISTINE CORTIZAS
Swedish Ivy.

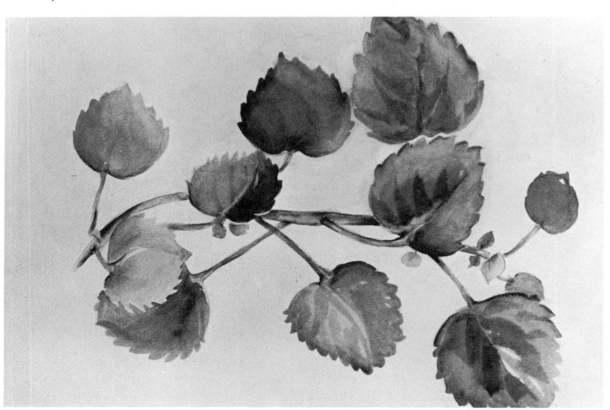

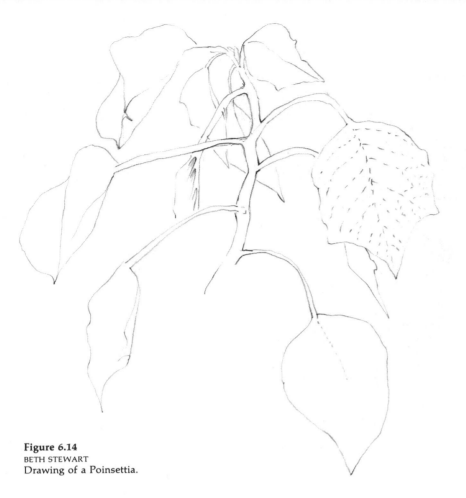

Figure 6.14
BETH STEWART
Drawing of a Poinsettia.

Figure 6.15
ELLEN MARCUS
Philodendron.

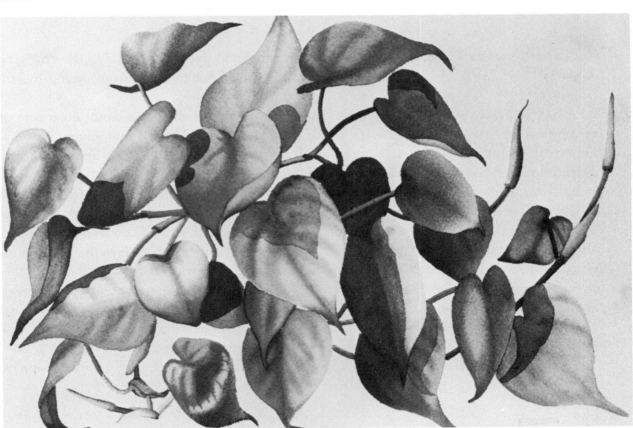

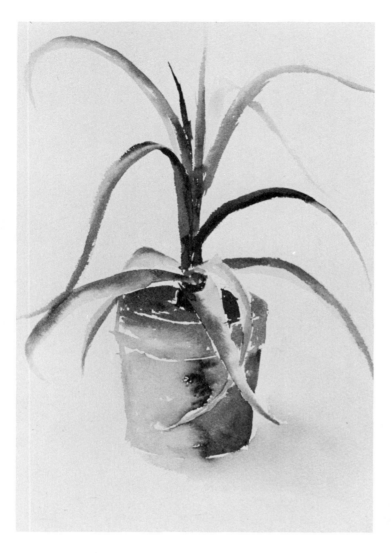

Figure 6.16
INESSA DERKATSCH
Spider Plant.

Permanent versus Transitory Aspects

As in fruit, the color and texture of plants can be a transitory or a permanent aspect, identifying the specific type of plant. Some colors or textures are synonymous with the name of a plant, such as the violet, or the rubber plant. In these cases, texture and color should be introduced as salient features of these plants. Usually, however, colors and textures change—thus the "greenness" and smooth skins of unripe apples, or the brownish red and wrinkled skins of overripe apples. Plants generally increase their colors, becoming deeper greens or richer rusts and browns, as they grow older or as the seasons change. The most vivid example of this is the changing foliage of maple trees, from spring to fall. (See Plate 25.)

Again, essential to your depiction of both plants and fruit is that you make a distinction between the two attributes. The transitory aspects are descriptive and qualifying, comparable to adjectives describing a noun. In addition, they may also say something about the individual variations of a particular kind of plant, such as the green poinsettia in Figure 6.17, or about the visible changes caused by seasons or environment. But because a painting makes a personal statement, one artist's ripe apple might look quite sour to another, even though a consensus could be reached that both are apples.

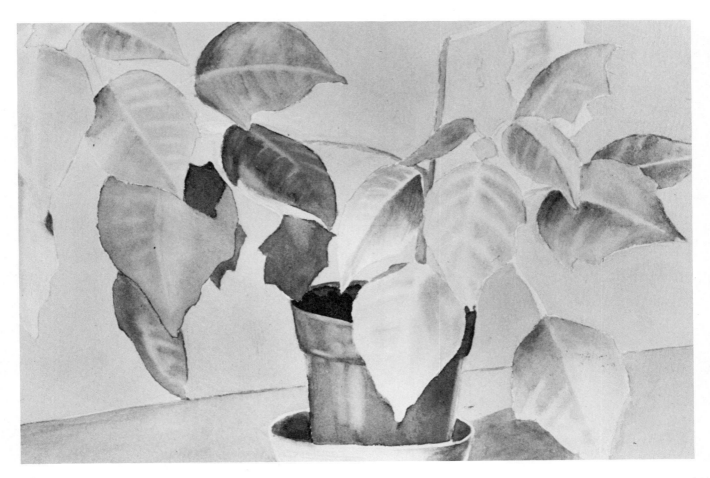

Figure 6.17
ANN GIBSON
Green Poinsettia.

It is said that Cézanne, our most famous apple painter to date, became very impatient with the transitory qualities of his apples. They changed color and rotted over the long weeks he painted them. Finally he used wax fruit to provide the basic reference. Texture and color he may have added from memory.

Color Structuring

In an exercise in Chapter 4 (Figure 4.7), you structured a round form with cool and warm colors to give it a three-dimensional appearance. Use the same principle for fruits, vegetables, and plants. This defines their most basic structures and allows exploration of

watercolor's unique quality: *color formation via color interaction.*

A common practice of beginners is to use only one color, like red, and to shade it from light to dark to give an apple a round appearance. Not wrong in itself, it is the principle of the monochrome media, such as pencil, charcoal, and ink, and does not capitalize on watercolor's uniqueness. Watercolor has *color*, and warm yellows, reds, and oranges can give the illusion of advancing areas while cool greens, blues, and purples give the illusion of receding planes. Surfaces of round objects such as fruits and vegetables can be modeled and structured with color to give them a three-dimensional appearance (Figure 6.18).

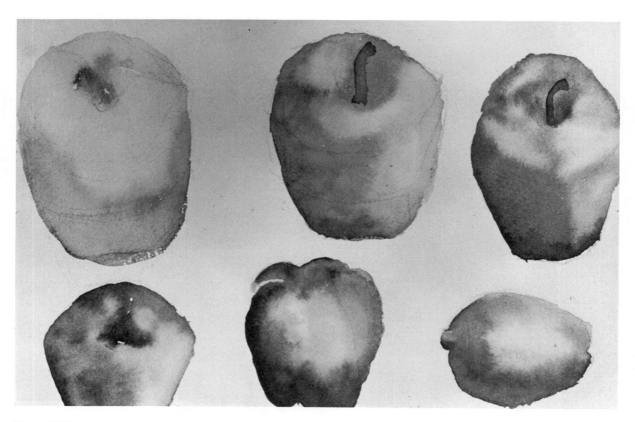

Figure 6.18
ELLEN MARCUS
Series of apples: demonstrates the process of structuring their shapes with color.

To be more specific, let us say that a pear is predominantly green, with red in a few places and some yellow and brown spots. The most natural urge is to paint it green first, and then add the other colors. However, this would limit color formation and subsequent color mixtures. Start with as pure a color as possible, *a primary color* that can create many color combinations. By giving the pear the preliminary undercolor of yellow, for example, you can add not only green but also blue which will yield green when it mixes on the painting's surface. Red added to yellow will create orange or brown when it comes into contact with the green, or purple when it is mixed with blue. Purple (red and blue) mixed with yellow yields a different brown. Even though the "Pair of Pears" (Figure 6.19) is not in color, take a look at Plates 11 and 12 to get the idea. By using just primary and secondary colors, you can witness the process of color formation and interaction. The proportions of each color will, of course, determine the overall appearance and predominant hue of the fruit.

Unlike fruit, plants do not vary dramatically in color. But even if they are predominantly green, vary the color to convey their three-dimensional, space-occupying shape. Again, relying on the principle of color structuring, use warm and cool colors to indicate front, side, and back. You can give variations to green foliage by modifying the green (which has the ability to be pushed into both cool and warm color directions), by adding blue and purple for cold, or yellow and orange for warm green. Thus, the warm tonality of green will advance it, whereas the cool will recede it. You can also vary the color's value, making it appear darker in the foreground and lighter in the background, as in Figure 6.20.

94

Figure 6.19
INESSA DERKATSCH
Pair of Pears.

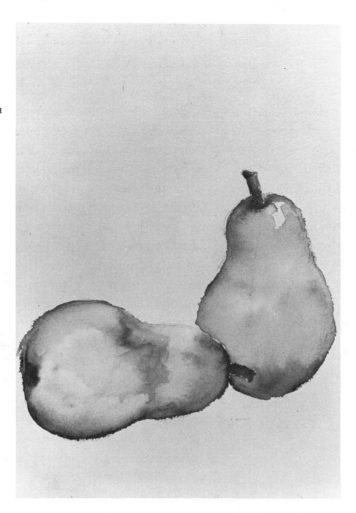

Figure 6.20
JOANN WILSON
Plant Leaves.

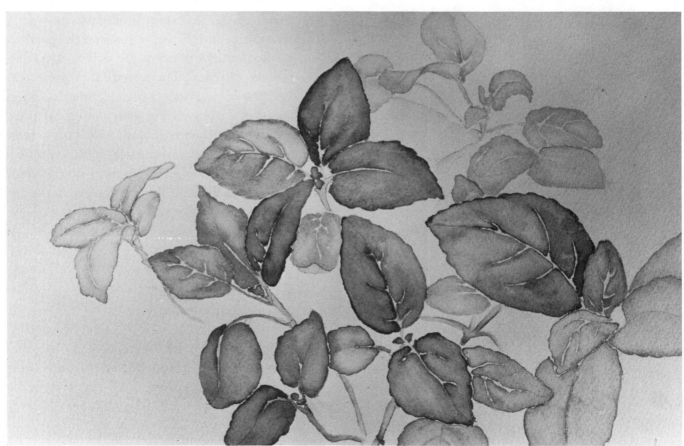

This is an atmospheric color description that relies on the fact that colors become lighter and less distinguishable the farther away they are. The same holds true for forms, so that you can actually paint the leaves in the background less precisely. Reducing the sizes of objects in the background is usually combined with the loss of their precise outlines. The coleus is a good example of this practice, and so is the tiger lily and its surrounding flowers (Figures 6.21 and 6.22). Foreshortening and overlapping are other important methods of positioning plants in space. Depending on the type of plant and the intentions of the watercolorist, usually a combination of all these methods is used.

Like those of fruit and vegetables, the surface textures and colors of a plant have to be distinguished in terms of which are generic and part of the plant, and which are just topical variations. Thus, the aging brown leaves in a green plant can be formed by complementary colors, such as red to green or purple to yellow. Spotting can be done with a dry brush or glazed layers. Which technique to use depends, first of all, on the particular appearance of the leaves. For example, the philodendron in Figure 6.15 has very soft tonal modulations achieved by washes and color fusions of greens, blues, and purples. The crab-apple branch in Figure 6.23, on the other hand, shows leaves as they appear when the fruits have matured and before they fall off. Greens turn red and then brown. This color modulation is purely transitory, and the color areas on the particular leaf, unlike those of the coleus, are completely random. The coleus in Figure 6.21 isolates color areas, which define the outer shape of the leaves, but their centers are filled by such contrasting colors as yellows, reds, and purples. As you can see, in this case it is not so much the configuration of the color patches, but rather the particular *color combinations* within the basic shape of the coleus leaf that give it identity.

Figure 6.21
SANDRA REINBOLD
Coleus.

Color Mixing and Transparency

Even though I have stressed the realistic features of both plants and fruits, I want to stress equally the importance of the watercolor

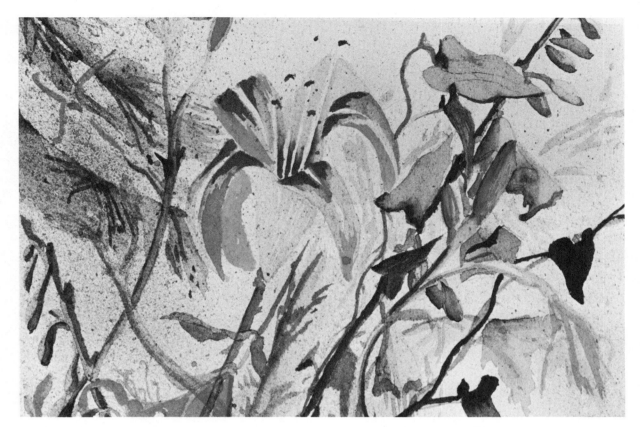

Figure 6.22
LAURA BROADDUS
Tiger Lillies.

Figure 6.23
SUSAN ALTSCHULER
Crab-apple Branch.

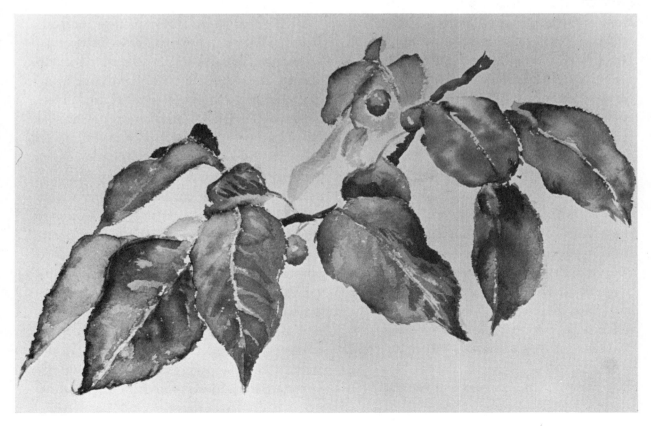

medium. In more traditional watercolors, you often see a red apple with opaque brown spots, or green plants with grey ribbing. This color approach neglects watercolor's ability to form colors directly on the paper's surface. When two colors are mixed on the palette, the resulting color is fixed and thus limited in its ability to form new hues. The brilliance of brown, for instance, is already cut, and when mixed will create even more muted hues. In transparent watercolor painting, however, you can create brown by adding green to red or yellow to purple, thereby achieving *three* colors, instead of only one: *the two original colors and the mixture.* (Plate 16 demonstrates this vital principle especially well.)

In order to take advantage of watercolor's ability to form colors on the paper surface, start with primary colors, which can be mixed more often into additional hues. For instance, when yellow is applied to blue, you are using two primaries that will yield a secondary color, green. If green is applied to blue (the third mixing stage), blue green, the result, is a harmonious, or analogous, color. (A good example is Plate 12.) When analogous colors are mixed, they create muted and less brilliant hues. Transparency and color depth, however, depend on the visibility of each color that creates a color mixture on your paper. So try to retain the identity of all your colors. Structuring objects with color shapes their dimensional appearance by utilizing watercolor's unique potential, giving your subject matter balance, and allowing it to speak an additional message. Your plants and fruits, therefore, will not only be realistic renderings, but also, foremost, *watercolors.* (Take a close look at the still-lifes in the color plates.)

The following section will use still-lifes as a reference to discuss separate processes that, in actuality, occur simultaneously during the painting process. This is intended as a guide to your vision of watercolor procedures.

1. Choosing a Frame

If you want to paint a still-life, the setup does not have to be elaborate: A few mushrooms tossed on a table, as in Figure 6.24, can be as attractive as a more deliberate arrangement of fruits or flowers. Specific plants or fruits might have attracted you because of their colors, shapes, or delectable qualities. Choose which aspects you want to capture in your painting and translate these into a pictorial composition. Decide, first of all, on a point of view to take.

Photographers frame a picture automatically by focusing their cameras. Telescopic, wide-angle, or close-up lenses enable them to change viewpoint instantly without even changing position. Their view of the subject matter depends on a mechanical device that translates reality into a picture frame. In painting, the artist's picture-taking device is the eye, and the viewfinder is the mind. A painting's composition, therefore, represents artistic decisions, and these are as varied as artists. What prompts the selection of a particular view of a subject matter is difficult to pinpoint because it depends on so many variables. The artist's conditioning, or "programming," as modern jargon would have us say, as well as his or her experiences, sensitivities, and imagination enter into the choices. Each painting is composed with different artistic and expressive intentions. And

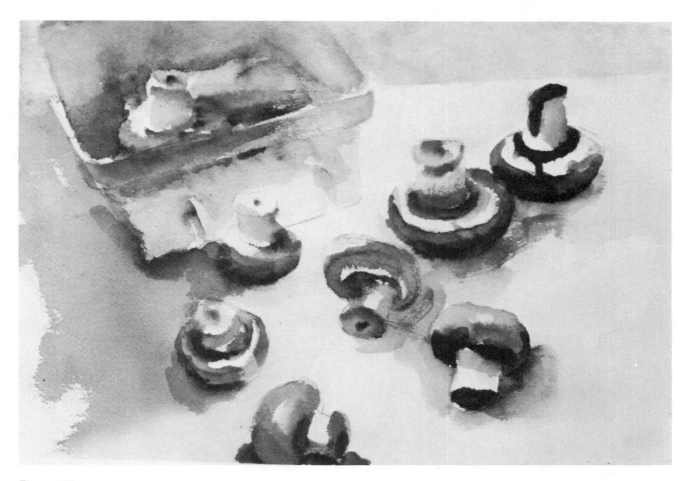

Figure 6.24
LESLEY COOPER
Mushrooms.

even though there are certain guidelines, you make the final decision and paint what is of greatest interest to you. The photograph of tomatoes shows you what the artist might have seen (Figure 6.25); the painting (Figure 6.26), one element selected from it.

Beginners often have trouble choosing a composition, because they think that there must be a "right one." There is not. Basically, the viewpoint is as expressive as what is painted. A distant or close-up representation, a detail or a whole display, can be equally attractive. However, they might vary in complexity and present different challenges in terms of watercolor technique. Still, a complicated point of view is more difficult to paint than a simple one, which represents a few still-life elements instead of a whole display.

At first, select a rather simple view of the still-life. Paint a close-up of one object or just a few items. Watercolor is easier to control when you are painting large and do not have to consider too many details.

Figure 6.25
Tomatoes.
Photograph by Philip Podrid.

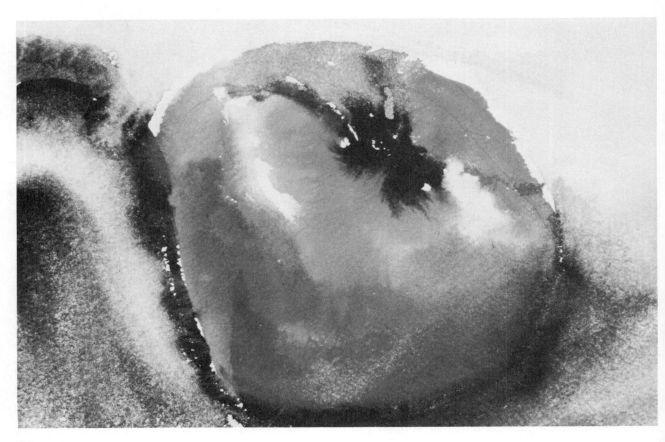

Figure 6.26
SHEILA WELCH
Tomato.

100

2. Three-dimensionality of an Object versus Environmental Influences

Composing means putting together parts to make a whole (from the Latin *com-poser*, to place together). A watercolorist has various choices in this respect. You can arrange your objects in a realistic environment, or in just a pictorial context. Thus, fruits and vegetables can be shown as resting on a tabletop (Figure 6.27) with fairly realistic shadows underneath them, or as individual pieces against a colorful background that indicates no particular environment (Figure 6.28). The colored shadows around each might function as its *visual environment*.

If you paint just the three-dimensional appearance of your objects, their volume will indicate that they occupy a certain amount of space. Thus, an environment is suggested though not actually depicted. (See Figure 6.29.) Shadows are another means to give your objects reality, because they can suggest atmospheric condition. Traditionally, shadows were painted with dark colors such as grey, brown, and black. It was assumed that shadows were dark, and in dark-colored or unlit objects they usually are. However, the nineteenth-century painters discovered that colors throw complementary colors as shadows, and that this fact could be introduced into their paintings. This means painting shadows can give your composition more color. Thus, red apples can have green shadows, and purple onions can have yellow shadows. Furthermore, shadows can also modify the colors in their proximity. A good example is the purple passion plant, illustrated in Plate 9. Note how the leaves are

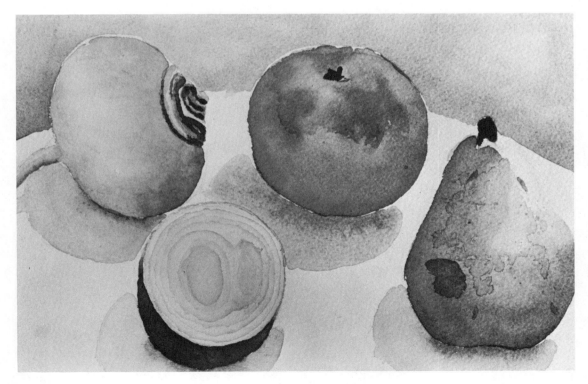

Figure 6.27
ELLEN MARCUS
Still-life with Cut Onion.

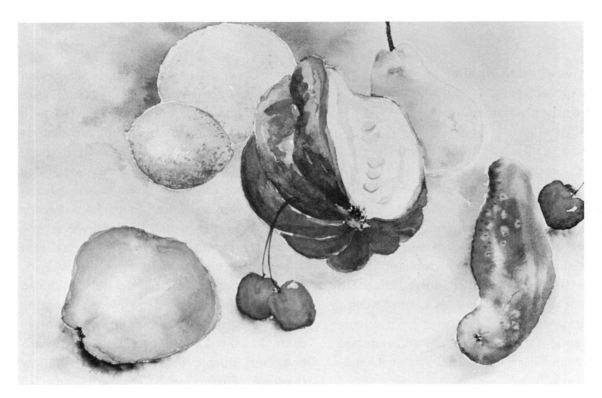

Figure 6.28
ANDREW MIAO
Still-life with Squash.

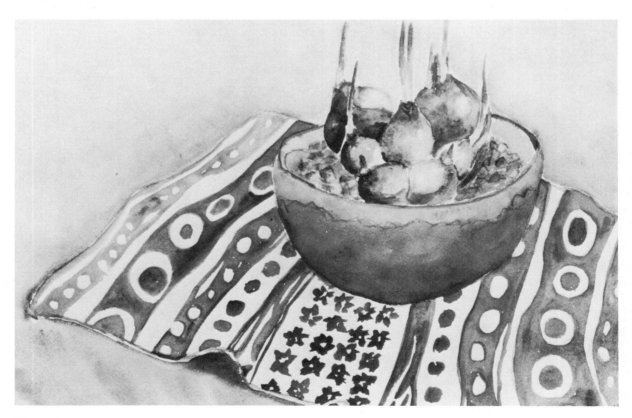

Figure 6.29
RENÉE KAHN
Growing Bulbs.

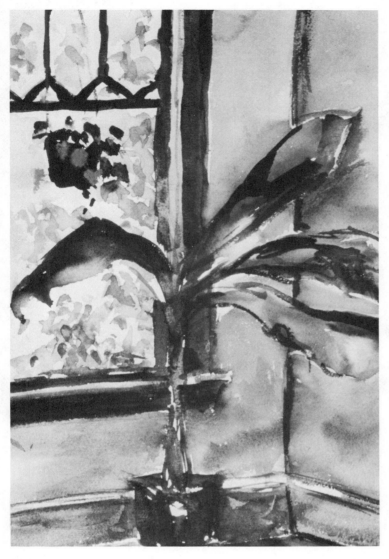

Figure 6.30
TRINE BUMILLER
Plant Near a Window.

transformed by the red spilling over and creating new colors. Similarly, the spring violets in Plate 14 are enveloped in yellow, perhaps indicating their complementary shadows and brightening the green of their foliage at the same time.

Thus, in addition to the three-dimensional reality of an object, you can paint the environmental conditions which modify its appearance. Sunlight falling on a plant, as in Figure 6.30, may change the colors of its leaves just as much as does the indoor environment in which it exists. It could be next to a window with fancy curtains acting as a background, or on top of a table covered by a colorful tablecloth draped around its individual components. As you will see in the illustrations, there are many solutions to representing an environmental context of your still-life. As a beginner, you might not even want to consider having to deal with the background (Figure 6.31). In this case, just paint individual still-life pieces and introduce colored shadows only to gain familiarity with the intricacies of shape, color structure, and textural variations (Plate 15).

Figure 6.31
STEVE GLAZMAN
Paint Cups on a Palette.

3. Drawing

In preparation for painting, drawing defines your composition and facilitates color application. It helps, for instance, to draw the growth pattern of your plant and the position of its leaves (as in Figure 6.12), especially if the plant is complicated and its structure distorted or obstructed from view. To study various compositional solutions, make a series of thumbnail sketches (Figure 6.32). Letting your mind study alternative compositions helps you to decide how to frame your objects. Beginners often settle on the first composition that comes to mind; however, there are always more (and often better) solutions to a problem.

Do not hesitate to simplify your still-life for the sake of clarity and a more interesting composition. For instance, you do not have to paint every leaf on a plant to convey its shape, as long as you convey its structure and give an indication that it exists in space. Remember, leaves are movable parts; they wither and die or can simply be plucked off. You decide how many leaves should be on a plant in order to convey its identity. After all, no one will compare your paintings with the real thing. Beginners often forget this important artistic license.

4. Painting from Light to Dark

Just as I have been emphasizing painting from the general to the particular while you define your still-life, I also want to emphasize painting from light to dark with your watercolors. Watercolors are transparent and are

104

Figure 6.32
INESSA DERKATSCH
Drawing of a pear (thumbnail sketch).

worked additively. The picture surface is built up in layers, each color modifying, changing, and transforming the other. The white of the paper is the lightest value, since I do not recommend using Chinese white or any other opaque white paint. The more color you add, the darker the painting becomes.

Obviously, experienced painters do not follow an outline procedure, but choose intuitively the color sequence that works best. They start with various color values (provided that the whole picture surface is not covered), and work into the lighter or darker shades as needed. For beginners, however, I recommend painting from light to dark until you are sufficiently familiar with color interaction and color formation. The reason for this, of course, is the fact that in transparent watercolor it is impossible to return to a light

hue again. Colors only get darker. Lighter opaque color can be applied to areas which were prematurely obliterated, but that blocks out the transparency of the colors. Scratching the paper with a knife to bring out highlights, as is so often done by the traditional painter, is a remedial measure I discourage, even though sometimes it is helpful. If this measure is practiced during the learning process of watercolor technique, you will not learn how to budget color application in order to leave the white of the paper showing for desired visual effects.

Painting additively is a rather slow painting technique. If you want to paint quickly and respond spontaneously, without building up layers, you have to paint your still-life components so that they do not flow together. Leave a tiny white line between color areas, as you have practiced in the color

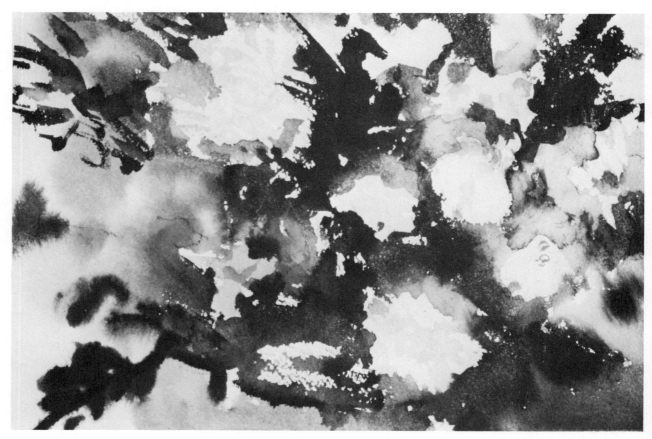

Figure 6.33
SHEILA WELCH
Flowers.

isolation exercise (Plate 6). This separates colors technically and visually from a background of similar color values. The white acts also as a highlight around your shapes and forms, emphasizing their contours (Figure 6.33). This is especially noticeable in the poinsettia plant (Plate 13), where overlapping leaves are separated by white lines. In Plate 17, "Still-life with Chianti Bottle," the shadows underneath the orange and the apple, being of the same value, are made visually distinct in the same manner.

Glazing layers of individual colors, therefore, is more methodical and allows a careful step-by-step procedure. Washes, on the other hand, are more spontaneous, al-lowing immediate response to the liquid medium. Usually a combination of both techniques is used in a painting. It is difficult, if not impossible, to give prescriptions about which one is best. As the illustrations show, students pick and choose, depending on their individual temperaments.

5. Extending and Reinforcing Colors

The basic technical movements you will go through while painting can be described as *extending* and *reinforcing* colors. Extending means diluting strong colors with water on your paper, as, for example, drawing a line

106

and extending it into a plane (as you practiced in Figure 4.6), or simply applying additional water to an area that is still wet to broaden it, as when you are laying in colored shadows around an object. (See Plate 16.) Reinforcing means adding color to an area or an object, literally outlining it. The line remains visible, but it is integrated into the color underneath by extension with water. You are actually erasing its edges by washing-in a surface. This is important if you want a smooth rather than a sketched appearance of an object (Plate 17).

These techniques also function as a preliminary definition for cut fruits and vegetables. The very crisp look of the cut onion, as seen in the still-life in Figure 6.27, is achieved by first drawing a watercolor line to define its periphery. Then, while the line is still wet, water is applied only on the inside of the line, erasing its inside margin and extending the surface into a plane. Now, additional rings are applied to this surface, making each into a plane, until the cut surface is filled with concentric circles.

The same procedure works for the cut-up pear and the orange half (Figure 6.34). Thus, the inside of the pear started out green, but while it was still moist, reds and yellows were added and allowed to fuse into the plane, thus giving it the mottled look of fruit that has been exposed to air. Its core and stem definition were added later, when the surface was dry. Similarly, the orange half was first defined with a light orange surface and allowed to dry, before the sections were painted, each separated by a tiny white area indicating the pulp of the fruit. (See the cut orange in Plate 8.)

Actually, the same principle can be used for painting the leaves of plants. First, define the outer shape of the leaf with a watercolor line, then fill it in with water. This establishes the basic shape on which you can work in either a dry or a wet state. The philodendron (Figure 6.15) was painted in a wet stage, its colors modified by allowing cool and warm tones to fuse with the base colors. The ribbing of each leaf was then defined in a similar wet in wet technique, adding more color to bring out each leaf's individual appearance. Also note the crisp outer edge of the geranium (Figure 6.35), which was first defined by a line, then pulled into a shape and later reinforced for added contrast and crispness.

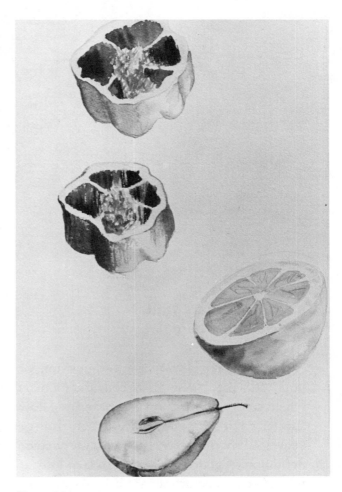

Figure 6.34
INESSA DERKATSCH
Cut Pear, Pepper, and Orange.

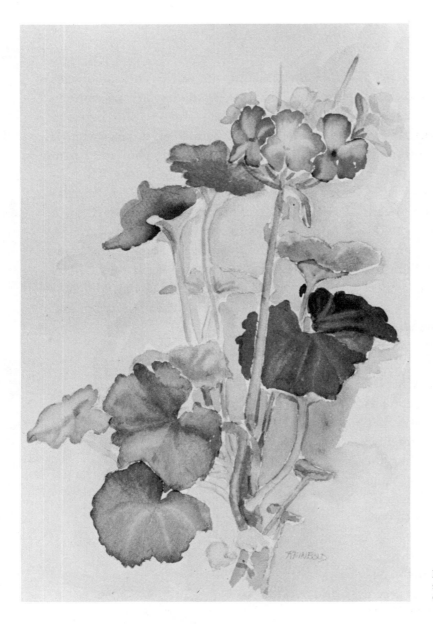

Figure 6.35
SANDRA REINBOLD
Geranium.

6. Which Colors Will Function as a Base

After you have drawn the composition of your still-life, your first consideration is which color will function as a base and allow further color formation. Thus, each fruit or vegetable should receive a preliminary color definition. A good rule of thumb is to look at the general, most prominent primary color of the object. Then decide which colors it will yield when color interaction takes place.

Keep color formation constantly in mind, and when necessary refer to your color wheel.

If you are painting a green apple, your color choices are probably the same as for a green pear, but the shape identifies the fruit. You can start by applying green as a preliminary color, or you can start with yellow and allow it to mix with blue to make green. Then add further cold and warm colors to indicate advancing and receding parts. For a red apple, on the other hand, a preliminary red base allows formation of orange, purple, and

the muted tones of brown. (See Figure 6.18 for a progressive view of this.) The cool colors (blue, purple) indicate shadow sides, whereas warm colors (red, yellow, orange) indicate highlight sides.

As a preliminary base for a yellow fruit or vegetable, like a lemon, pear, or squash, a light yellow base can be modeled with blue to create green areas, or with red to bring out orange. In addition, green and orange can be added to the already existing colors and make the yellow warmer. Should red and green mix accidentally, they will cancel each other out, thus resulting in muted colors such as brown, which might indicate bruised or rotten spots. For a banana, yellow can be used as a base with blue added to yield green, indicating areas that are not ripe; while purple, the

complement of yellow, would cancel it, giving the bruised appearance of an overripe banana (Figure 6.36).

For a purple onion, you should start with a red base. Adding blue to red will yield purple; adding yellow will result in its complementary orange. If the yellow touches the purple, it will produce a muted hue. If all these colors merge (as in a wash), they should yield the deep, dark bluish purple of the onion seen in Figure 6.10, or the iris in Figure 6.37, with perhaps a few yellow highlights left uncovered. As the illustration shows, it is important not to cover your object entirely with one color; let the identity of each color remain visible. Usually beginners quickly learn the endless color combinations that are possible with this type of color application,

Figure 6.36
FRED CASSELMAN
Banana.

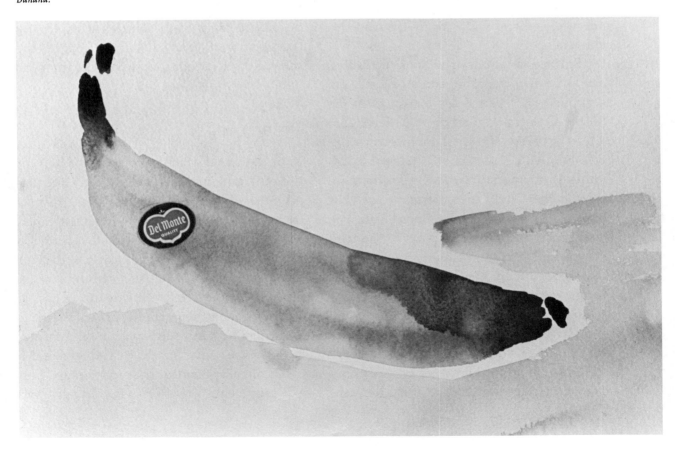

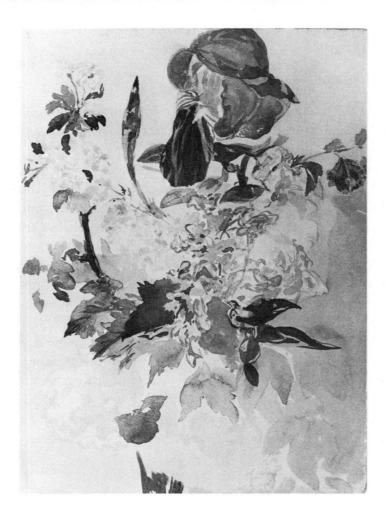

Figure 6.37
EILA PELTOLA
Iris.

and apply them with ingenuity and inventiveness.

Surface variations on fruit or vegetables, such as bruises, spotting, and striations, can be applied last, with a dry brush, as in the "Purple Onion and Garlic" still-life (Figure 6.6), or sprayed on with a toothbrush as in "Still-life with Cut Onion" (Figure 6.27). Decide how important surface definitions are to the identity and generic structure of your objects. The pineapple's sections (Plate 10), for instance, are structural parts of the fruit and planned into the painting process from the very beginning. Visually and structurally, they are very important aspects of the fruit's appearance. The same holds true for the red cabbage and its ribbing. However, the strongly marked sections of the green squash (Figure 6.28), were more in the nature of a personal statement exaggerated by the artist. Remem-

ber not to sacrifice the particular aspects of the identity of your still-life objects for the sake of their surfaces and textural variations.

7. Watercolor and Surface Textures

Your choice of watercolor paper (rough or smooth) can influence significantly the appearance of your still-life. However, the surface texture of an object can best be defined by the way the paint is applied. Glazing is used for a crisp look, washes for smooth color blending. Usually, you use a combination of the two. Decide whether the texture is part of a fruit's general appearance or whether it is particular to that individual piece. Peaches, for instance, have a velvety softness and a blend of color nuances that are perhaps best expressed with color washes. Oranges and

lemons, on the other hand, are usually quite uniform in color, but have the skin texture unique to all citrus fruit. Their texture can be created with dabs of a sponge or spray from a toothbrush. Apples, which are colorful and smooth, and often have a shiny surface that reflects many highlights, are best portrayed with a glazing technique. These suggestions are not meant as prescriptions, but rather as observations that might guide your artistic decisions.

8. Importance of the Background

The area surrounding your still-life, the *space* around or behind the fruit or objects, can be defined as the background. This is the com-

positional context in which the objects exist, and it can be painted as a realistic space; for instance, a kitchen table on which fruit rests, or as a purely pictorial space, such as colored areas or fantasy forms surrounding the fruit. How you compose the background and the degree of realism that you give it are very personal choices. I only wish to stress that the background is an extremely important visual element in the painting. Compositionally, it is as important as the foreground. Manet's flower piece (Figure 6.38) is a good example.

Beginners often forget the background, then hastily fill it in, almost as an afterthought. Perhaps this is because they are still struggling with technique and with defining their subject, the foreground, or because they place too much emphasis on rendering ob-

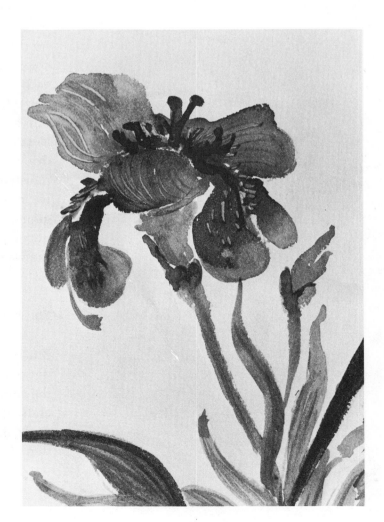

Figure 6.38
EDOUARD MANET (French, 1832–1883)
Flowerpiece with Golden Rain and Iris (watercolor, 351 × 256 mm).
Graphische Sammlung Albertina, Vienna.

jects realistically. Many times I also sense that they feel lost, in that they simply do not know what to do with the background. When you are in doubt, add neutral tonalities, such as light blue or grey, or eliminate the background altogether, if you are just painting individual objects. (See Figures 6.19 and 6.34.)

As mentioned, colored shadows are also a possibility. Since they are optical phenomena, they are used by ultrarealists, and can create very lively and effective backgrounds. Remember that the background, or the pictorial context, as I prefer to call it, is an area where you can experiment and use your imagination without struggling with realism or precise definition (Figure 6.39).

Figure 6.39
CHARLOTTE MAZMANIAN
Spring Flowers.

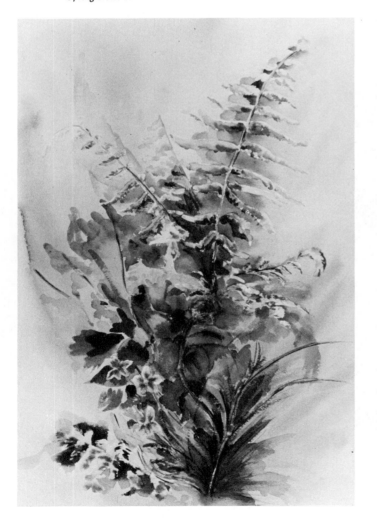

9. Compositional Thinking

When you do not see the painting as a compositional whole because you are busy focusing on its parts, you are missing the forest because of the trees. One way of training your vision to be comprehensive is to see the picture surface as a structure that is going to build up, color upon color, into a final composition. This is good artistic thinking regardless of the medium being used, and it can be learned just as brushstroke and color interaction can be learned.

In watercolor painting, however, compositional thinking is almost mandatory, because it is vital to achieving transparency. Watercolor painting proceeds additively, and from the general to the particular. From a technical point of view, this makes sense. Working on several areas at once allows time for the colors to dry, an absolute necessity for color glazing. When colors are placed next to each other while one of them is still wet, it is perfectly acceptable to leave a small white line between them, as practiced in the color isolation exercise (Plate 6). If a color becomes dry when you are doing a wash, you can remoisten it with water. These methods allow for more spontaneous color responses; beginners will implement them more frequently as they become more familiar with the watercolor medium.

10. Knowing When to Stop

Building up the picture's surface eventually develops the parts in equal degree, defining the compositional structure. The painting literally grows as each part evolves. Ideally, all areas should be in the same state of definition. Awareness of the compositional unity of

your painting also means maintaining perspective, knowing when the painting has reached a stage that might be considered finished. This, again, depends on your artistic judgment. The decisions involved are personal, so my advice would sound, at best, totally abstract and, at worst, terribly academic. I am offering, therefore, only a few very general guidelines.

Knowing when to stop is often intuitive. The painting looks done. Also, all of the parts really seem completed. I caution you not to be compulsive and cover the entire paper surface, defining all parts of the subject. People who are very conscientious and thorough are inclined to do this.

In watercolor painting there is a point of no return, so it is better to stop too soon than too late. Because watercolor is painted in the additive manner, there is always the possibility of returning later. In the classroom, we often see what I call hypnotism of the subject matter: Students become transfixed by their paintings, able to see only the details that still need to be added, but not what the watercolor already has. It is helpful to step away from both your painting and the subject matter, take a break, and, upon returning, concentrate as much on the painting as on the subject matter.

Part of the hypnotic power of the subject matter is excessive reverence for it and an overriding concern to paint exactly what one sees. Remarks like "I still have to paint that tiny spot on the left side of the apple," or "There is also a dark shadow on the right side of the bowl" ignore artistic license. Paint details only if they make sense in your painting's composition. "But it does not look like that" is a common exclamation. Who will know, as long as the painting stands by itself? No one will have the actual still-life set up as a reference, and the subject itself will not remain. The shadows change, the apples rot, and so on, so why worry about veracity? Usually students who are overly preoccupied with realism are most concerned with exactitude. Those with a healthy respect for abstract principles and for the purely visual elements of a painting's composition will feel quite free to adjust, embellish, exaggerate, subtract, and alter their observations to fit their paintings. The subject matter becomes a point of departure rather than a dependence.

Overdone and overfilled paintings have what art historians call *horror vacuii*, or a fear of emptiness. Defining every detail and filling every space lead to overstatement. And in watercolor, overstatement is overkill. It deprives the viewer of an essential artistic experience, the participation in and completion of the artist's statement. Suggestiveness and inconclusiveness can be magical, a way of saying more with less. Some of our greatest masterpieces merely capture the hint of a smile, a gesture, a scene not quite spelled out. And art lovers are still trying to decipher these mysteries.

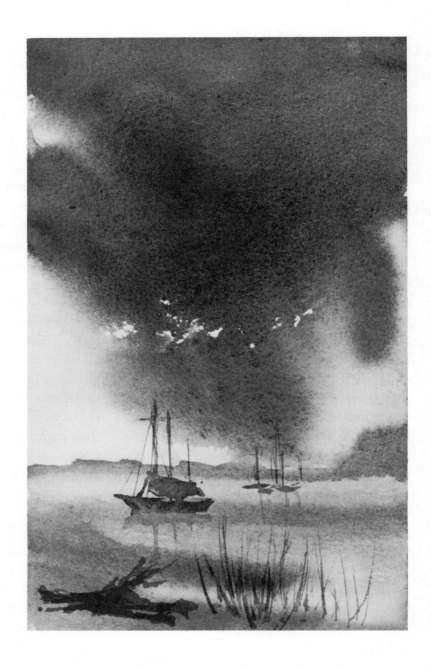

IF YOU ARE ATTRACTED to the pattern carved by waves into the Atlantic shore, or simply to the luminous glow of an evening sky, landscape painting is for you. The landscape has long been watercolorists' most popular subject. Indeed, the colors' fluid dynamics have often been compared to the behavior of nature itself. Happily, landscapes are also easiest to paint, and, depending on how ambitious you are, they can be simple or complex. With few washes you can capture a cloudy sky; with more precise glazing, the panorama of a city. As the nineteenth-century artists discovered, watercolor is in many ways the perfect medium through which to express observations about nature.

As a source of visual stimulation, nature is inexhaustible. It provides endless material for contemplation, study, reference, and inspiration. Throughout history, artists have

CHAPTER SEVEN

Landscapes

used a variety of media to record their special communication with nature. In ancient times, frescoes of fanciful gardens embellished the interiors of palaces and homes. Manuscripts in the Middle Ages depicted nature in charming patterns and vignettes that separated the realms of earth and sky in Biblical scenes. And, of course, oil paintings and watercolors in the past four hundred years have captured an increasingly individual and realistic view of nature's forces and dynamics. Thus artists' perceptions of subject matter and their painting styles are important indications of a particular culture's vision and orientation. Since choices concerning nature also make a statement about human nature, significant changes in landscape painting usually indicate a reorientation at the deepest philosophical and psychological levels.

Our Western tradition of landscape

painting extends back into classical antiquity, but except for a few isolated examples, it played only a minor role in Greece and Rome. Renaissance man is actually credited with having discovered nature. The fifteenth century experienced nature as the great context of man's existence, and his relation to it was carefully observed and studied, and often fancifully shown. This shift from a celestial emphasis to a terrestrial focus on man's existence *here and now* signaled a profound change in the conception and depiction of nature. Since man was seen as the center of all things, he became the reference point, and reality was seen and experienced from his point of view.

In the landscapes of the fifteenth century, nature was observed by the senses but filtered through reason. Paintings represented a setting, almost a stage, for religious, historical, and political dramas. Human figures were painted as performing actors who played their roles convincingly. The joyful, exuberant celebration of nature, including human nature, was, however, carefully balanced by studies of human proportions and physical movement. In contrast to medieval man, who was not interested in such scientific considerations and depicted humans in a flat and unconvincing space, the Renaissance artist showed an awareness of how figures fit into their environment. Consequently, he devised methods to show man in a realistic, spatial setting. This led to the discovery of the laws of linear perspective, and to the ability to portray nature as we see it in what we consider "realistic" landscapes today.

Basically, linear perspective is one pictorial means of showing distance and space on a picture surface. The rational thinking that evolved this system mathematically calculated how objects and figures should be painted in order to convey that they have three-dimensionality and exist in a convincing space. One way was to show objects in the distance of a painting as being smaller than those in the foreground, and to decrease their size in proportion to that distance. *Lines* (hence linear perspective) are drawn as preliminary references to plot the position of the objects in relation to their decreasing size. They become narrower and meet at the horizon, giving the painting a funnel effect and creating the illusion of picture depth and space. (As an example, see Figure 7.8.) The horizon line represents the viewer's eye level, and, therefore, the most distant point in space. In a painting with linear, one point perspective, all objects and forms are relative in size and placement to one another when they are seen from one point of view.* From this pictorial reasoning emerged classical *perspective thinking,* a manner of simulating reality by means of rules and conventions that influenced Western landscape painting for the next four hundred years.

However, just because a set of rules serves a function does not mean that alternatives do not exist. A look outside our Western culture reveals that Chinese and Persian artists, for example, had a totally different manner of depicting space in landscapes. Like those of medieval paintings, their objects and figures are not calculated in relation to one another, but are large or small, placed in a central or marginal position, according to their significance. Thus, relative *importance* rather than relative *proportion* accounted for their position and size. This was, of course, a much more intuitive conception of space based on the culture's philosophical and psychological framework. When Renaissance

* There is also *two point perspective,* which takes two reference points for depicting objects in space.

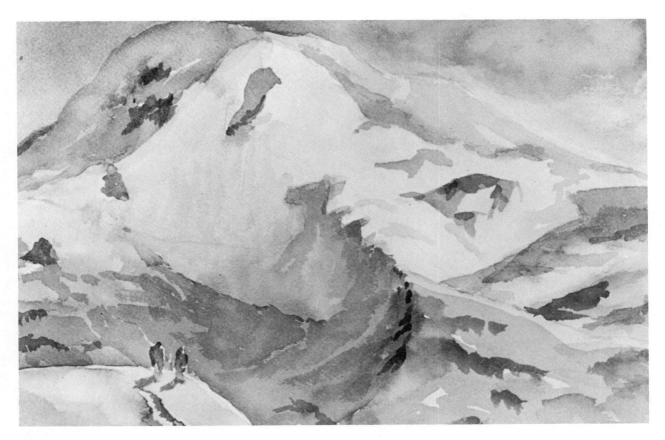

Figure 7.1
ANDREW MIAO
Romantic Landscape.

conventions were challenged in the nineteenth century, perspective thinking started to be questioned. What emerged was a new way of depicting nature and man's position in it. This signaled a reorientation of how man related to his surroundings and how he experienced himself.

The Romantic artists of the late eighteenth and early nineteenth centuries profoundly influenced how we see and experience nature today. Their landscapes were the most adventurous, and, as mentioned earlier, their use of watercolor was the beginning of a new way of depicting nature. For these artists, nature was an immense repository of visual, sensual, and inexplicably mysterious forces. Depicting nature served, first of all, a personal need, and their landscapes became visual equivalents for complex sensations. Confronting nature with awe and reverence, these

artists saw man no longer as the center of the universe, from whom all comprehension radiated, but rather as a small entity enveloped by a dynamic force. This is similar to the two small figures overpowered by the mountains in Figure 7.1.

Loss of a comprehensive and idealized view of nature is seen in the artist's willingness to acknowledge not merely the grandiose and significant, but *all* aspects of nature. Images could be extracted from the most common subjects, chosen because they struck reverberations, and evoked feelings and moods. The sky, especially, became an agent for sentiment and devotion, and countless studies of its changing appearance were painted by watercolorists (Figure 7.2). In northern Europe, some landscape paintings show overpowering stretches of land and shore in which man is shriveled to a small,

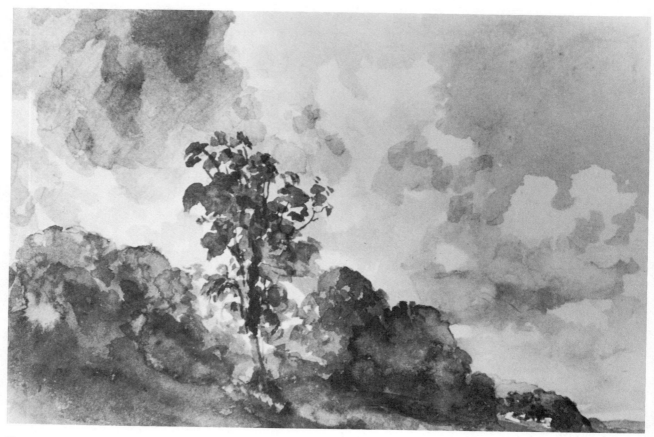

Figure 7.2
JOHN CONSTABLE (English, 1776–1837)
Study of Clouds and a Tree (watercolor, 6¾ × 10 in.).
Reproduced by permission of the Trustees of the British Museum, London.

almost incidental entity. In France, landscape painting evolved with the naturalistic and realistic movement, a liberating force which elevated any occurrence in nature (including human nature, as in the realistic novel) to the stature of being worthy of being depicted. Thus, nature's less delightful aspects, such as sickness and decay, were stressed equally with its growth and regenerative forces.

This was quite a contrast to the great tradition of landscape painting that served as a model to the nineteenth-century artists. Landscapes in the seventeenth and eighteenth centuries were firmly rooted in Renaissance tradition. Classical perspective dominated these grandiose compositions of land and sea, in which we see distant views of ancient cities, idyllic meadows, and forests representing the dwelling places of nymphs and gods. Dutch and French paintings during this

period best exemplify nature's heroic grandeur, and their landscapes represent idealized settings for activities that were mythological, religious, or historical (Figure 7.3). Seldom do we see in these large paintings the movement and pulsation, the flow and sensation of nature's forces that the landscapists recorded in their preliminary studies and sketches. (See Figure 1.2.) These spontaneous and intimate responses to nature served as bases for large and ambitious studio creations and, interestingly enough, inspired the following generations of landscape painters and watercolorists.

In the nineteenth century, direct observation of nature accelerated with the introduction of photography, which could expose and explore nature as no artist could. Instead of making landscape painting obsolete, it rerouted its course and shifted the artist's vi-

118

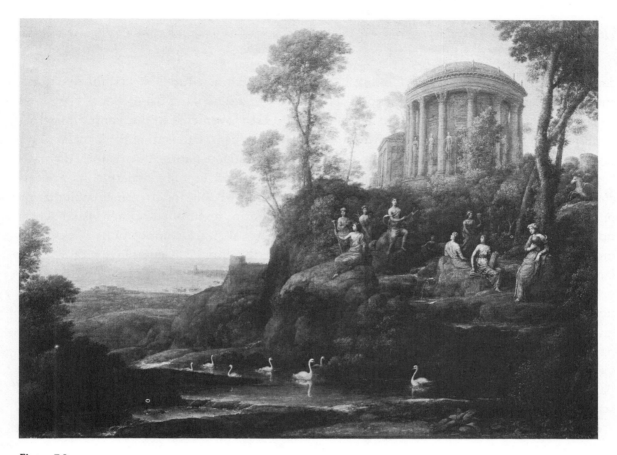

Figure 7.3
CLAUDE LORRAIN (French, 1600–1682)
Parnassus (oil on canvas, 38½ × 53 in.).
Courtesy of Museum of Fine Arts, Boston (Purchase—Fund for the
Collection of Paintings, 12.1050).

sion to other essentials. Color became the most powerful agent, and was studied and analyzed as few other artistic elements had been before. The Impressionists made the study of nature a total obsession. Mid-century Realists had paved the way for them by eliminating fantasy and emotions, by insisting that artists paint only what they see. The Impressionists took this one step further in their fascination with visual reality and with nature as the repository of optical sensation. The eye of the artist became the great reference point, functioning as the "visual truth seeker," unaided by emotions. (See Monet, Figure 3.3.)

The Impressionists' focus on the transient and fluctuating character of the environment, as seen in the sensuous playfulness of color when teased by sunlight, acknowledges, perhaps, that artists compre-

hend only a small part of nature's behavior. Artists who record their feelings with watercolor choose this medium because it encapsulates the very essence of this experience of flux. The colors' fluid dynamics signal constant change and transformation, which is arrested only by the painter's intervention. One artist, and most of all a great watercolorist, Paul Cézanne, introduced our modern visual thinking about nature. At the conclusion of the nineteenth century, he started the pendulum swinging in a new direction, and thus is often called the father of modern art.

Displeased with the ephemeral effects of light and with nature's constantly changing appearance, Cézanne painted landscapes with forms and objects that appeared the same under any circumstance. What appealed to him were nature's solidity and permanence, which he had seen in seventeenth-

119

century heroic landscapes. Thus, looking at a subject matter, he wanted to go beyond its visual character to depict its more lasting qualities. He extracted color and form and distilled them into basic geometric shapes of "cylinder, cone, and sphere," which he claimed were the elementary building blocks of nature. Painting pure color layers, building up individual forms, he composed his painting into a tightly interwoven structure. Focusing on the indigenous (generic) quality of objects makes them independent of time (light) and environment (space), and grants them an existence in a new context, namely, the painting's own "picture space." Cézanne's statement that "art is a harmony parallel to nature" indicates that his landscapes do not resemble nature's visible, or "realistic," character, but are self-contained units built on nature's structural dynamics. (See Cézanne, Figure 3.4.)

Art movements in our century, such as Expressionism, Cubism, and Surrealism, are all inspired by nature but distort, displace, disfigure, and literally denature its appearance (Figure 3.5). Modern artists capitalize on color, form, texture, and other visual sensations for abstract compositions. They thus depict the immense complexity of what is around us and especially of our extended vision, provided by machinery such as the microscope and the telescope. Abstract landscapes, therefore, are not easily identifiable with what we "see" outdoors. They no longer depict vistas of nature or represent a scenic sight. Rather, the paintings are self-contained "picture spaces," abstracting the drama of nature's forces (Figure 7.4). They represent a

Figure 7.4
AUGUST MACKE (German, 1887–1914)
Kairuan III (watercolor).
Courtesy of the Erbengemeinschaft Dr. W. Macke.

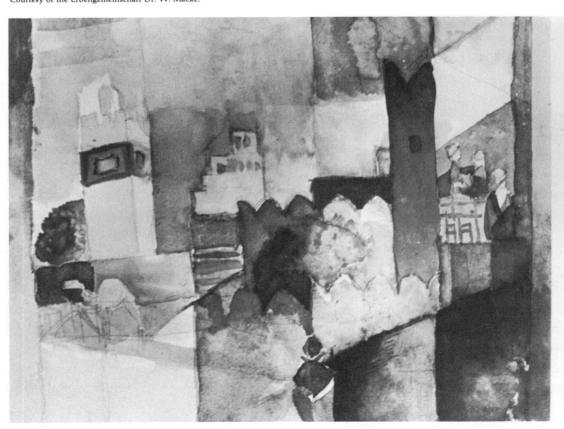

pictorial reality of a visual phenomenon, an artistic problem, or perhaps just the landscape of the artist's mind. This change in orientation toward nature and artistic vision is not surprising when we consider how mathematics and physics, medicine and psychoanalysis have redefined our concepts of inner and outer space.

The artist, as in any epoch and culture, becomes the spokesperson for a new orientation and vision. Today's complex conception of nature and wealth of artistic styles can be confusing and overwhelming for a beginner. Use them as points of departure, as examples of multiple solutions to landscape painting, and from these create your own painting style. In the following section, we will begin with very basic observations and the elementary procedures involved in landscape painting.

Basic Elements of Landscapes

A landscape can be painted with very few pictorial elements. All you need is sky and land or water. Some of our finest watercolorists, Turner, for example, painted very simple landscapes and seascapes with few details. (See Figure 1.3.) Objects and descriptive details such as houses, trees, boats, and vegetation can be included for more definition, but they are not essential to a convincing landscape. Essential for a recognizable landscape, however, is the indication of space and depth, no matter how much the other elements are abbreviated. This creates an environment and a context for whatever objects you decide to include.

Linear, atmospheric, and color perspectives are the most important illusionary devices in landscape painting; they make the flat surface of your paper appear to have space and depth. They are necessary for a realistic depiction of a landscape and are pictorial equivalents of what we see and experience outdoors. Often, the picture plane is compared to a windowpane, with the painting representing the view when we look through a window. A traditional landscape can also be thought of as a stage to illustrate the spatial setting for objects. Objects on stage can be shown by various types of perspectives. Figures bathed in light, for instance, become hazier the farther backstage they are. This is atmospheric, or aerial representation of space. In such a depiction, objects of apparently equal size get fuzzier and less distinguishable the farther away they are (Figure 7.5). On the other hand, if a row of chairs is placed onstage in fairly even light, the chairs become smaller in appearance the farther back they are. This is linear perspective. The watercolor of the boats on a lake shows this clearly (Figure 7.6).

Where you are as the viewer, either high in the balcony or low in the orchestra, establishes your point of view. If you were outdoors, the position of your body would establish the eye level. Thus you might be on top of a mountain looking into a valley, or lying on the beach looking at the ocean. Drawing a horizon line on your picture's surface indicates in your landscape your point of view. Both perspective and horizon line are crucial aspects of a landscape painting, and necessary for a fairly realistic depiction of an environment. Look at the illustrations and you will see their importance.

Traditional art education usually includes a thorough training in perspective, emphasizing the ability to render objects in their correct positions in space. This is an important skill but not an absolutely neces-

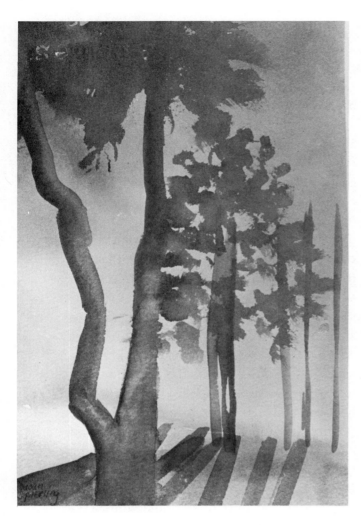

Figure 7.5
SUSAN SPIERLING
Trees.

Figure 7.6
ANDREW MIAO
Lake with Boats.

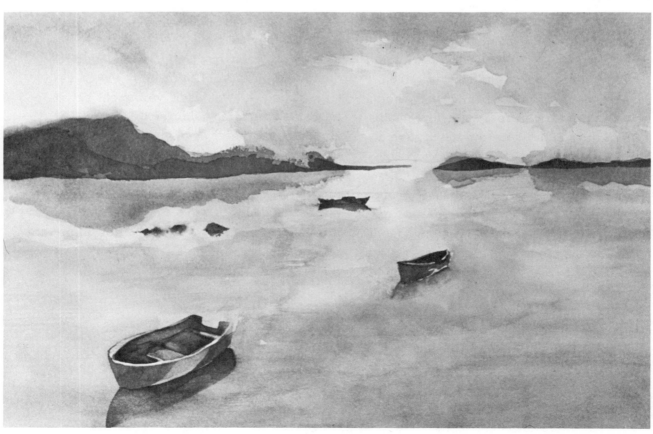

sary one for creative work. Still, I would like to discuss briefly the various visual means of achieving convincing and "realistic" space. Usually students find their own exceptions to these basic rules, as the illustrations show.

Linear Perspective

Linear perspective is scientific perspective. The depth of the picture plane is defined by lines, or by forms that can be connected by lines (Figure 7.7). For example, a highway or a pair of railroad tracks traveling into the distance are usually painted as lines moving away from us and becoming progressively closer together. These lines give the illusion that they will meet in the distance. Actually, scientifically, they never do, but the picture shows them as if they will. A *funnel* effect gives the feelings of depth and of space in the

painting. Objects or figures become smaller as they recede into the distance, and visually they can be connected by lines. Thus, gradation of size is also linear perspective. The photograph of the Taj Mahal illustrates this point (Figure 7.8); an artistic adaptation of this type of perspective can be seen in Figure 7.9 and Plate 24.

Atmospheric, or Aerial, Perspective

Atmospheric perspective is space created by light changes. It attempts the same thing as linear perspective, but instead of lines it uses light-to-dark tonality changes. Thus it is similar to what we discussed in the section on modeling a three-dimensional object. Modeling one side light and the other dark brings out an object's roundness (volume), and

Figure 7.7
Drawing demonstrating linear perspective.
Illustration by Susan Aron.

Horizon Line

Figure 7.8
The Taj Mahal.
Photograph by Philip Podrid.

Figure 7.9
CHARLOTTE MAZMANIAN
Winding Road.

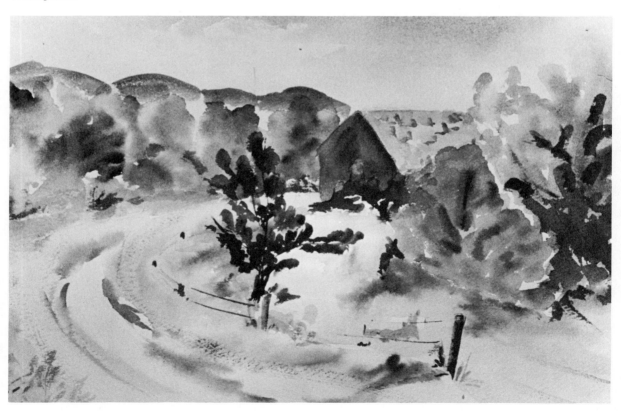

therefore its space-occupying nature. (See Figure 6.7.) In a landscape, instead of roundness, color gradation (light-to-dark changes in the sky and on the ground) reveals space and depth. (See Figure 4.4.) Light, again, is responsible for this effect. I usually urge students to observe this on a clear day at the beach. The unobstructed sky will be lighter at the horizon line, where it meets water or land. And the land or water will be darkest at this point, becoming lighter the closer it is to you.

This is not just an optical illusion, although it might seem that way because of the strong color contrast between sky and ground. In reality, it is due to the variation of the density of the atmosphere surrounding the earth and the angle from which we look at the sky. When you look straight up into the sky, you see a less dense atmosphere that is purer and therefore darker. When you look at the horizon, your view is angled toward the ground and consequently passes through a thicker and denser atmosphere that is lighter. Something similar, but in reverse, happens on the ground. It can be seen most clearly on a flat, uncluttered surface or ground. Water or a meadow in front of you appears lighter, and as it moves back into the distance, it may become progressively darker. A combination of atmospheric and linear perspectives are usually responsible for this effect. In the distance, objects become smaller in size and surfaces hazier.

Color Perspective

Color perspective is probably the most intuitive and the most contemporary means of creating space. Warm and cool colors and their advancing and retreating qualities are used to create space and depth in a picture. But the ability of colors to advance and re-

cede depends on many factors, including color intensity (saturation), the size of the colored areas, and the size and shape of the objects. It is difficult to give general guidelines on achieving color space, because it depends on not only optical but also psychological factors. Usually color perspective is combined with other types of perspectives, as illustrated in the section on plants and fruits in the still-life chapter. It is most often used on objects such as vegetation that have no precise contour. The shape of a tree, for instance, can be painted with cool and warm colors, like the trees in Plate 26. For architecture a combination of perspectives is most effective. The various planes of construction can be modulated with warm and cool colors, but linear perspective should also be employed to achieve convincing space and depth, as demonstrated in Plate 18.

Horizon Line

When you observe nature, the point where the sky meets earth, whether water, mountains, or land, is the horizon line. When we look at our environment, the horizon line is not always easily discernible because it is disguised by objects in our most immediate surroundings. Even though you might see only a flicker of blue through branches, a horizon line exists beyond those trees in front of you. In a city such as New York, you have to look up and above to see the horizon. Still, where the sky meets the skyscrapers is your horizon line. Standing on a hill or looking down from a high building, you see the horizon line fairly easily. Thus, placement of the horizon line indicates your point of view. And depending on where you place it in your painting—high, low, or right in the center—it directs your viewer's point of view.

Figure 7.10
Beach in Antigua.
Photograph by Philip Podrid.

Figure 7.11
EILA PELTOLA
Seascape.

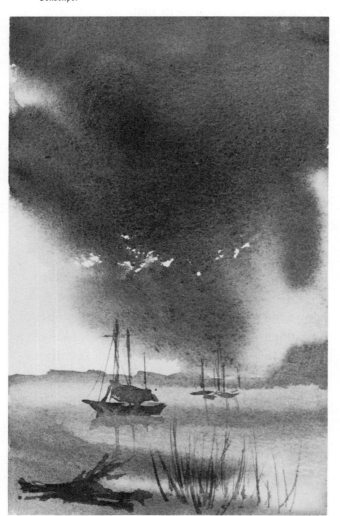

Center-Horizon Line

A horizon line placed right in the middle of your painting indicates that the viewer is seeing things at eye level. If you stand in an open space like the beach, a space uncluttered by architecture or vegetation, the horizon line is even with your eye level (Figure 7.10).

Low-Horizon Line

A painting with a low-horizon line has more sky than land or water, and indicates a point of view from below. The lower the horizon line, the closer the viewer is to the ground. If you are lying flat on the beach looking at the ocean, there is only a sliver of land and water, and predominantly sky. In the jargon of art history, this type of perspective is called "frog," or "worm-eye," perspective. We are literally on the ground, observing our environment from a frog or a worm's point of view (Figure 7.11 and Plate 20).

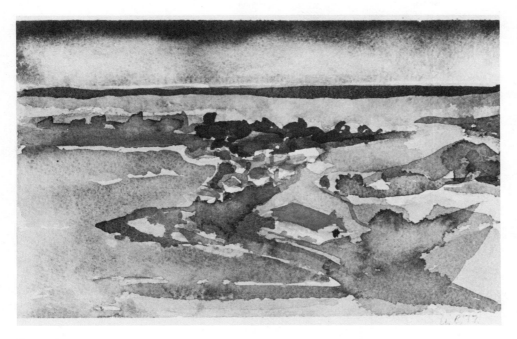

Figure 7.12
ELIZABETH BOWERS
Landscape with High Horizon Line.

High-Horizon Line

A painting with a high-horizon line has more land or water than sky. The viewpoint is from above, looking down. Thus, the higher you are in the air, whether you are in an airplane or on top of a mountain, the more land and the less sky you see. Of course, looking straight down from a high altitude gives you no indication of a horizon line at all. This would also be the case if you were lying flat on the ground, looking down in front of you. The view from above is called by art historians "bird's-eye" perspective (Figure 7.12).

No Horizon Line

When looking at our surroundings, we can, of course, change our perspective by altering our eye level. Similarly, in a painting you can paint more than one point of view. Most ab-

stract landscapists do this. Even though Renaissance artists perfected a rational, quasimathematical *one-point-of-view* perspective, many paintings before and after the Renaissance depicted more intuitive spatial relationships and often multiple points of view (Figure 7.13). Some medieval artists, for instance, would show a city from above (bird's-eye view), but the activities going on at eye level, and the vegetation in its garden from below (frog's-eye view).

I have already stressed the importance of perspective in artistic work and its significance in showing an age's grasp and understanding of reality. Cultural historians believe that the portrayal of man as the center of the universe, as seen in classical Renaissance perspective, has been severely undermined in our century. Abstract and nonobjective painters are obviously not interested in depicting realistic geographical distance in their paintings. Nevertheless, they are concerned

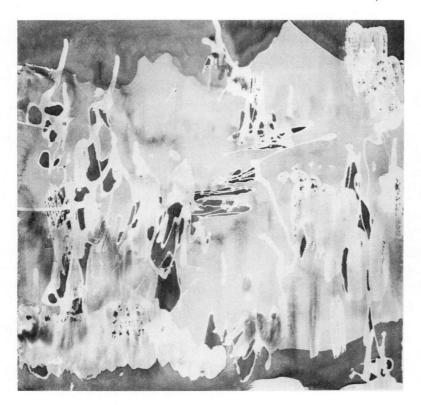

Figure 7.13
BEA WARREN
Abstract Landscape (no horizon line).

with space, as it is created by pure color and form on the picture's surface. This *picture space* is perhaps our modern way of experiencing reality and may be comparable to the traditional *window space.* It deals with the visual and compositional relationships among colors and forms instead of with proper dimensional relationships among objects outdoors.

Painting Outdoors

Ideally, landscapes should be painted outdoors. The confrontation with the environment's colors, forms, textures, smells, and noises gives the artist sensory input that is an exciting stimulus. Using paint to translate what you see (reality) onto the surface of the paper is a challenge. In watercolor painting, it is often regarded as the ultimate accomplishment.

Most landscape painters, especially those interested in specific geographical regions such as New England, paint outdoors. In the winter and in bad weather they paint indoors, looking through a window, or they paint from sketches and photographs. Sometimes artists even compose their own version of a landscape, relying only on memory and imagination. Today the purist, a watercolor artist who paints only on location, is almost extinct. Cézanne was perhaps the last great painter who insisted on painting landscapes on location, or *sur le motif,* as he called it.

Frequently, students feel that they are cheating when they paint from photographs or other visual aids rather than from "live" landscapes. There is, of course, a difference, but mainly one of difficulty, challenge, and perhaps inspiration. Painting outdoors instead of from a photograph demands different skills from the artist. The composition in a photograph, for instance, is already fixed;

the frame is taken; the point of view has been chosen, and everything is neatly composed on the picture plane. Unless it is your own photograph, it is someone else's conception of nature from someone else's point of view. Since these choices have already been made, important decision making has been eliminated.

Another crucial difference is that a photograph is usually a fraction of the size of your watercolor paper. Consequently, painting from it involves a significant adjustment in terms of moving from one scale to the other. You basically have to reinterpret the photograph, and this is where your artistic imagination and ingenuity enter. Translating one medium into another demands careful judgment in the selection of your visual forms, because the photograph is just a point of departure, a means to an end. A successful copy of a photograph or even of another painting is always a *reinterpretation*, expressing the artist's response to the subject. Ideally, an original painting is made. Thus, the source of inspiration is really not that important; a finished painting will be judged on its own merit. Compare the photograph of the New York skyline (Figure 7.14) with its watercolor interpretation (Figure 7.15) and note the artist's adjustments.

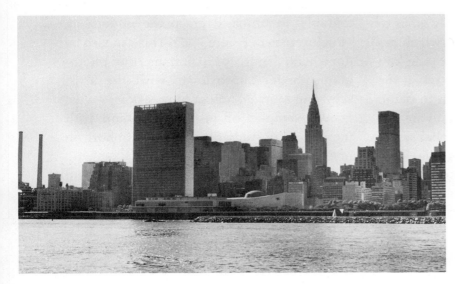

Figure 7.14
New York City Skyline.
Photograph by Philip Podrid.

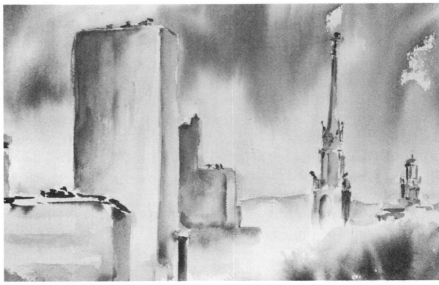

Figure 7.15
DAVID HALVORSON
Skyline of New York City (adaptation from photograph).

Inspiration, like a good intention in any endeavor, is only the beginning of the creative process. If you are interested in nature, go outdoors and experience the ambiance, not just colors and forms, but light, smells, sounds; in short, the total vibrancy. A beginning watercolorist often becomes confused, overwhelmed, and overexcited by the intense sensory input. Too much stimulation interferes with the act of creation, unless you develop a certain detachment. You must learn to switch your focus from the stimuli to your artistic materials, to shift gears from the emotional experience to the act of painting. As Wordsworth said about poetry, so painting is also a recollection in tranquility. You break down experiences and decide what to include or what to leave out, and which aspects are essential and worth translating into a composition. And here we are back at the selection process. Before we begin to paint, our vision and imaginative cognition are put on trial. Confronting nature is probably the most challenging experience possible for a landscape painter; it therefore helps to know what to look for.

General Guidelines for Landscape Painting

When confronting a specific scene, you may be confused by the complexity of individual elements. One way to proceed is to work from the general to the specific. Divide your paper surface into broad, general areas first, and then introduce more detailed and particular units.

Drawing first will help you to define and structure the various areas and details of your landscape and design its composition. How much you should draw depends, again, on how complex you want the landscape. Certainly the minimum is the horizon line dividing the foreground from the background. Since a combination of washes and glazes is usually used in a landscape, the pencil lines act as a reminder, or borderline, signifying which part will be filled with color.

As a preparatory exercise, you can study the various parts of landscape paintings, such as the positions of the horizon lines, the various divisions of foregrounds, middle-grounds, backgrounds, and the uses of perspectives, by looking at magazines such as *National Geographic*. These contain superb landscape photographs from many different parts of the world. A useful preparatory exercise is to strip the details from a few photographs in order to grasp the underlying structures (as in Figure 7.17). This can also be done with landscape paintings, but photographs better approximate what the artist sees outdoors. Photographs also provide many examples of perspectives, and with these you can study the variations in horizon lines.

Look at a landscape photograph and train your eye to see essentials; then do a few pencil studies, extracting the major divisions of the landscape (Figures 7.16 and 7.17). Stay simple. This is an extremely important visual practice and will eliminate confusion later, when you are confronting a real landscape. Try to see the forest first, then the trees. Once you understand how a landscape is divided into various parts (see the example in Figure 7.17), and how space and distance are created, additional details such as vegetation and architecture are just trimmings. They can be practiced individually until comprehended, and then painted into the landscape composition or left out. In watercolor, in fact, the darker objects are indeed "put into" the landscape last. (See the rocks and trees in Plate 23.)

Figure 7.16
Landscape.
Photograph by Miriam Truslow.

Figure 7.17
INESSA DERKATSCH
Drawing from landscape photograph.

Layout of Composition

Our environment can be roughly divided into basic elements: sky, water, land (mountains, rocks, stones, pebbles), vegetation (plants and trees), animal life, human life and activity, and man-made objects and constructions. However, you can paint a convincing landscape with just sky and water (as in Figure 7.18), or sky and vegetation, and few other elements. See Plate 7 for several examples of quick landscape studies.

You do not have to paint everything you see. The most successful landscapes, in fact,

often show just a few elements, but in an interesting and unusual manner. Again, what counts is not what you paint, but how you interpret it. Part of the captivating quality of your landscape will be in your paint quality and in the point of view that your composition represents. A few pebbles on a beach, or rocks, in themselves not extraordinary, can be painted in such an interesting manner (as Sargent did in Figure 7.19) that they give us a totally new insight into nature. The painting makes us see these objects as we have never seen them before and subsequently changes our view of them if we do encounter them

131

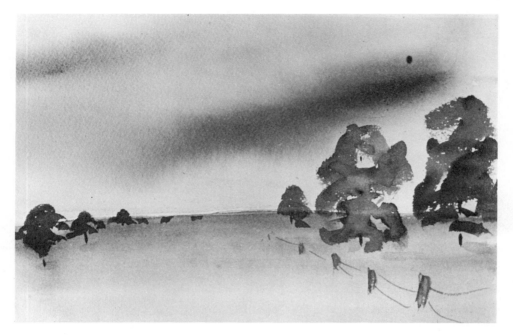

Figure 7.18
EDITH BURGER
Landscape with trees (simple two-part landscape also showing
linear perspective in the gradation of the size of the trees).

again. This insight into nature via the artist's imagination makes a painting arresting, captivating, and memorable. And that is what landscape painting is all about.

The compositional frame that an artist chooses represents a point of view, regardless of the subject matter. In a landscape, however, this is literally true, because if the artist paints outdoors, he or she is looking from somewhere while painting, and the composi-

tion represents this point of view. First define the horizon line to indicate your viewpoint. Whether you paint it as seen in reality or compose it because it makes a more interesting painting is up to you. The pencil line dividing foreground from background will serve as a reminder. It does not have to be a continuously drawn line. After you start watercolor application, retain its visual continuity, especially if you decide to obliterate it

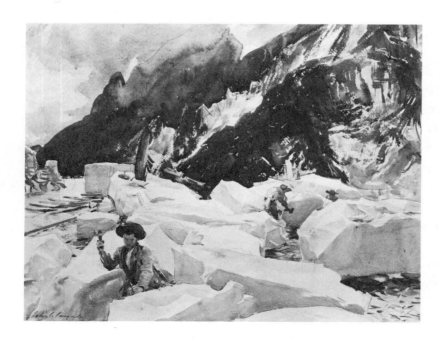

Figure 7.19
JOHN SINGER SARGENT (American,
1856–1925)
Carrara: Wet Quarries (watercolor, 16 ×
20¾ in.).
Courtesy Museum of Fine Arts, Boston, 12.241.

with fog, foliage, or something else. Leave it visible, or have it at least suggested by leaving some white paper showing, to convey the feeling of separation between foreground and background (sky and land or water). (See Plate 21.)

Always paint sky and foreground separately. Your pencil line acts as a divider in color application. If you moisten your paper first to facilitate color spreading, do one area at a time. Start with fairly concentrated color at the top of your paper where the sky is darkest, then thin it with water, working into a color gradation. As you meet your horizon, leave a tiny white line to separate the sky from the foreground, and then proceed to work from the horizon line down. You have already practiced this color application in the space-depth exercise (see Figure 4.5), so you might want to check it for reference. In a more complex landscape where the foreground has subdivision, perhaps a forest with a lake and mountains, the shading from light to dark does not have to be that exact. You will have to adjust it and also consider your light source, that is, the angle from which the sun is shining. In the foreground, therefore, you are more flexible. Shading the sky from dark to light, however, is a rule which applies to every landscape, as you can note in the illustrations.

A landscape representing just foreground and background is often just the skeletal frame for the additional pictorial elements, such as mountains and trees, that give your landscape interest and individuality. Complex landscape compositions include water, vegetation, and architecture, in addition to atmospheric conditions such as rain, mist, and thundering clouds. In the following section I will discuss the most important pictorial elements frequently included in land-scapes. Again, I will not approach them stylistically, but rather in terms of how they can be achieved with watercolor technique, the color interaction and brushwork involved—in short, in terms of the intricacies of the watercolor medium. You can paint them in your own style. The illustrations provide examples of various approaches.

Mood in a Landscape

The ambiance or mood of a landscape is largely the result of light. Early morning light chisels every form, throwing crisp shadows. Fog on an overcast day envelops and cradles everything in a hazy mist. You have probably noticed how the setting sun imbues the entire landscape with a glow, blurring the hardness of objects. You can alter the mood in your home by flicking a switch.

Color also conveys mood. Your palette, an indication of your personal color preferences, will account to a large degree for the tonalities in your paintings. In painting landscapes, however, be particularly aware of the way light affects moods by transforming colors. Textures, by the way, are brought out mainly by illumination. Bright daylight hides nothing, mercilessly revealing every crack and crevice. (See "Rocks on a Sunny Day," Plate 22.) Evening or artificial light is kinder, but also more subversive. It envelops, blurs, and easily deceives (Figure 7.20).

In the Orient, white paper is sometimes stained with tea to give it a golden glow. All the colors applied to it become muted. Remember how the early nineteenth-century watercolorists *washed out* their watercolors, giving the paper several color layers, before they started to paint? Many traditional watercolor paintings, however, have a yellowish tone because the paper has deteriorated.

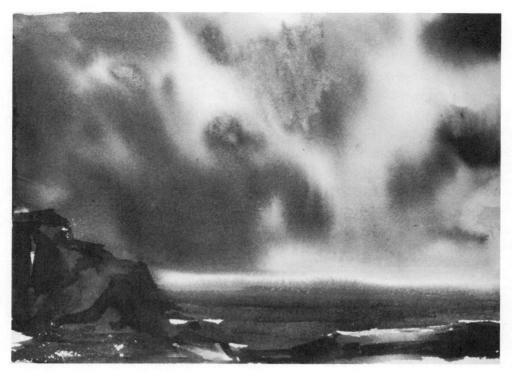

Figure 7.20
EILA PELTOLA
Evening Sky.

The Sky

Clear blue or stormy, brightly lit by the summer sun or dark and overcast, the sky offers countless moods for you to capture in a watercolor landscape. The sky is also an ideal subject for experiments with color washes, color interactions, and textural effects. (See Plates 19 and 20.)

Ask yourself two important questions before you paint a sky: What is my perspective? How will the sky balance with the foreground? Obviously a frog's-eye view gives you much more sky to work with than does a bird's-eye view. Skies also take on a special character above a lake or the ocean due to the mist created by the evaporation of water (Figure 7.21). A body of water is also a reflective surface and will pick up colors from the sky. Thus, color unity of foreground and background (sky and water) is essential for a harmonious composition. Beginners often paint

the sky in just one blue tone, claiming that this is how the sky looks. But you must introduce a variety of colors into both sea and sky. Remember their reflective natures (Plate 21)!

Clouds are dense vapors which screen light out of a landscape. Paint them light on top and dark below. Specific clouds—cumulus, fractocumulus, stratocumulus, and cirrus clouds—are a challenge to paint. You do not have to paint them realistically in watercolor. Be willing to improvise, experiment with washes, let the colors run together, or direct their interaction by blending them with your brush or tilting your paper. Interesting shapes can also be achieved by soaking up color from the paper with a sponge or paper towel (Figure 7.22). Paint sprayed from a toothbrush or color dripped onto a semi-dry surface gives a curtain effect and can suggest a hazy sky (Figure 7.23). Combine washes and glazes for contrast, giving your clouds

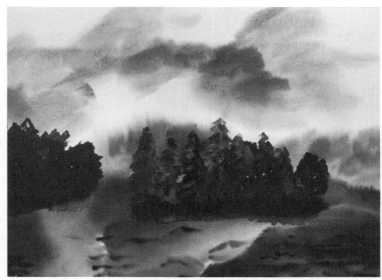

Figure 7.21
FRED CASSELMAN
Summer Day.

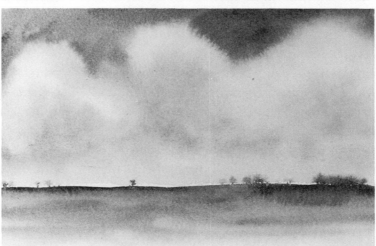

Figure 7.22
ELLEN MARCUS
Landscape with Fluffy Clouds.

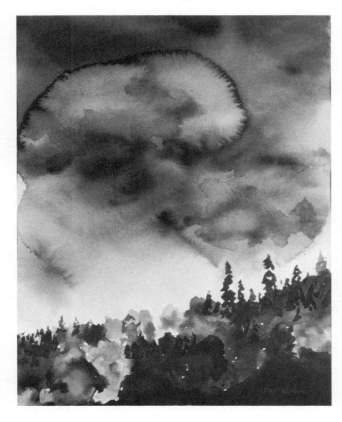

Figure 7.23
FRED CASSELMAN
Trees and Clouds.

depth. Allow crisp color layers to float over a soft and misty sky, as in Plate 19.

Since clouds are fluffy bodies floating in space, they must be represented three-dimensionally. The biggest and fluffiest are cumulus clouds, which usually are lighter on the top than on the bottom. (See "Beach in Antigua," Figure 7.10.) These are very dense vapors, and their shapes change slowly because of slower wind currents in the sky. Paint them in light–dark combinations, to suggest the roundness that they actually have, and smaller in the distance (Figure 7.24). A common mistake made by the beginner is to paint them in just one color, without contrast. Since they are white, it is tempting just to leave patches of white watercolor paper showing. A white patch can serve as your lightest color value, but from it you will have to gradate colors into darker shades. More exciting visually is the use of cool and warm colors for advancing and receding effects. Thus the tops of these fluffy bodies can be cream or pale pink, and their undersides a cool purple, blue, or grey. You can see such clouds in Plate 19.

When cumulus clouds get tossed around by strong wind currents, they become fractured and are blown into smaller units called fractocumulus clouds. Still further up in the atmosphere, stratocumulus clouds appear in rows or bands (Figure 7.25). When these combine with other types of clouds, they form cirrus clouds: thin, angular clouds that can be painted easily with swift brushstrokes of concentrated color allowed to fuse into a moistened surface.

The most dramatic clouds are those created by a storm. They can darken a landscape as if smoke from an unseen fire were rolling across the sky. Use heavy, concentrated colors, allowing them to diffuse on the wet surface as in Figure 7.26. Decide what kind of illumination you want and choose your colors accordingly: dark, grey blue tones or the warmer tones of burnt or raw sienna. You might even choose a combination of the two, or work with complementary

Figure 7.24
INESSA DERKATSCH
Fluffy Clouds.

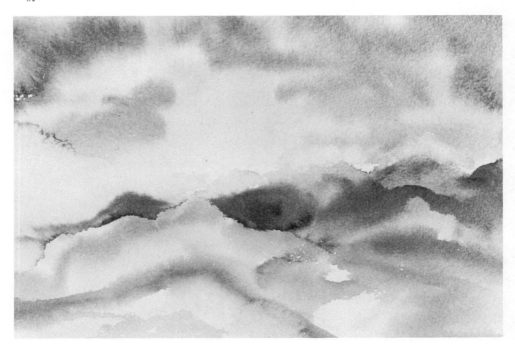

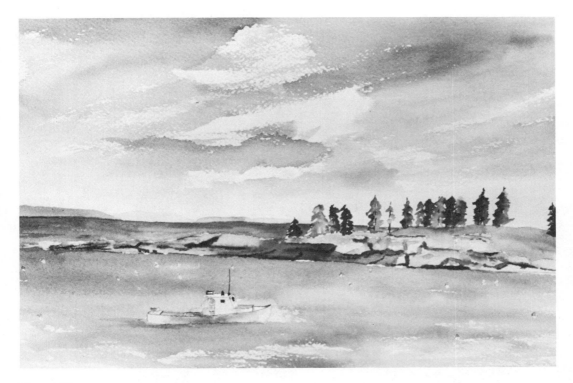

Figure 7.25
MIRIAM SWAFFIELD
Ship with Island.

colors such as ultramarine blue and yellow or ochre, for a murky effect. Always retain the identity of both colors in addition to their mixture.

Because they fuse and flow with such ease, color washes lend themselves especially well to overmixing and indiscriminate application. Beginners often find them difficult to control. Careless mixing of complementary colors can produce a dull and muddy sky. Remember that each color, no matter how much it is mixed, should retain its identity. (See Plates 19 and 20.) Too much color fusion through overactive brushwork causes dullness, uniformity, and loss of color transparency. Ideally, colors should be allowed to mix themselves on the wet paper. However, too many colors can be as big a mistake as too

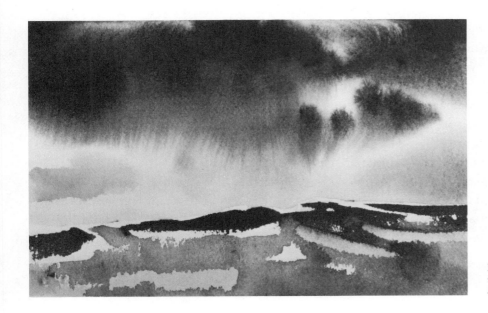

Figure 7.26
SHEILA WELCH
Stormy Sky.

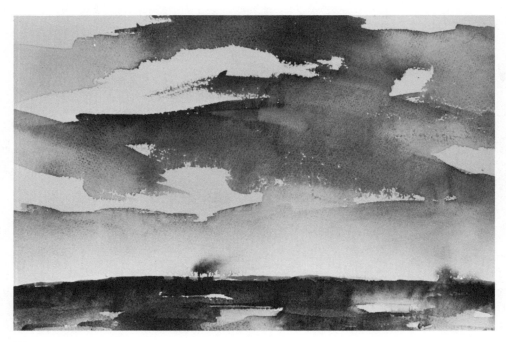

Figure 7.27
TRINE BUMILLER
Morning Landscape.

few. Colors should reinforce, harmonize with, and support each other, even when they come from opposite ends of the spectrum.

When you are applying color for a sky, work additively. Start with a light color and build up layers of stronger ones (Figure 7.27). Since the sky is seldom one color, introduce reds, yellows, and rusts to give it more interest and a livelier glow. The Impressionists used complementaries, orange and blue, for a warm sky. Skies offer opportunities for striking color combinations, in the orchestration of a sunset or the mysterious illumination of the moon.

There are few rules in creative work that you could get artists to agree on. However, on this they all agree: monotony is a no-no! This rule is so general that it holds true for practically everything, not just for art. In landscapes, a blue sky painted with just *one* blue is monotonous. Always use a variety of blues to create an interesting sky. Mix cobalt, ceru-

lean, and ultramarine blues and modify them with colors such as alizarin crimson, yellow, and burnt sienna (Plate 27). Vary your values; this also prevents monotony. Introduce a variety of surface textures to modify your colors. (See Plate 21.)

Use colors of various strengths and saturations. Strive for diversity. When applying colors on a premoistened surface, you should use fairly concentrated paint. The wet surface automatically dilutes colors. (See Figure 7.20.) Do not cover the whole surface of the paper, but leave some dry white areas so that you will have a primary surface to come back to when you want to bring out the transparency of the colors. In glazing, however, apply the paint light because colors become darker as they intersect.

Whatever the specific condition of the sky you are trying to paint, remember that compositional unity *within* your painting is your primary goal. I cannot stress this

enough. One way of achieving such unity is to carry the mood of the landscape into the smallest details. If you paint the sky a bright, clear blue, clearly define the rest of your composition also: show sunlight bouncing off the surfaces of objects, casting crisp shadows. (See Figure 7.25.) Renaissance artists of the early fifteenth century painted clear daylight, documenting their surroundings in an almost encyclopedic manner. Late afternoon sun, on the other hand, conceals more. Contours blur, shadows grow longer and colors more disguised. Leonardo da Vinci mastered a delicate balance of light and dark tonalities emphasizing shadows, an effect called *chiaroscuro* (Italian for light–dark, in French, *clair-obscure*). Sixteenth-century artists capitalized on strong color contrasts, not only on combinations of light and shadow but also on the bright, flickering light that emanates from a sunset or shines through thundering clouds. This is celestial light, the illumination of the spirit, radiated by religious faith. The painting carries a divine message throughout its composition.

Water

The blue of water varies as much as the blue of the sky. In fact, its color depends on the colors of the sky as well as on what is beneath its surface. Perhaps the best examples of water's varied appearance are seen in Homer's watercolor landscapes. In his "Rocky Shore, Bermuda" (Figure 7.28), the water is a vivid blue because the sand on the ocean's floor acts almost as a mirror, augmenting the water's ability to reflect blue from the sky. The lakes in Maine, however, are a deep, dark green because of the thick vegetation on the bottom.

Homer's crystal-clear water in "Trout Fishing, Lake St. John, Quebec" (Figure 7.29) has a glassy finish and is highly reflective of its surroundings. Turner's "Little Liber" seascape (Figure 7.30), on the other hand, shows breakers in a churning sea scattering light into a multitude of dancing specks. The ways in which different surfaces reflect light are a lesson the Impressionists have already taught us, so I will not repeat it here.

Figure 7.28
WINSLOW HOMER (American, 1836–1910)
Rocky Shore, Bermuda (watercolor, 13¾ × 20 in.).
Courtesy Museum of Fine Arts, Boston (bequest of Grenville H. Norcross, 1937; 37.487).

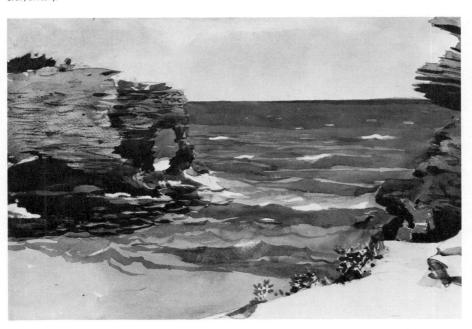

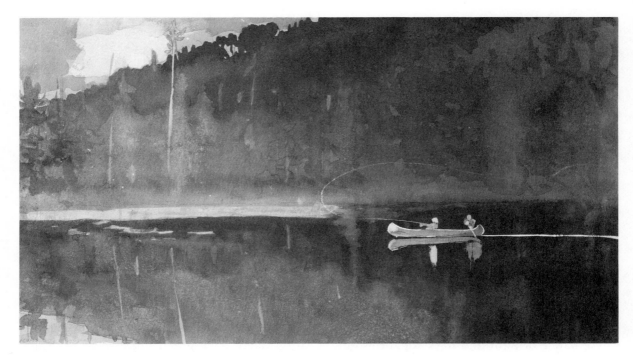

Figure 7.29
WINSLOW HOMER (American, 1836–1910)
Trout Fishing, Lake St. John, Quebec (watercolor, 11 × 19¾ in.).
Courtesy Museum of Fine Arts, Boston (Warren Collection, 29.29).

Whether you paint the ocean or a lake, you will need to portray movement on the surface of the water. The ocean is much more dynamic, due to its size and depth and the tides and strong currents that move it from beneath. Winds also have a powerful influence, as anyone who has ever gone on an ocean voyage knows. Thus, it is the combination of internal and external forces that gives the ocean its characteristic appearance.

In watercolor seascapes, the general atmosphere is more important than surface distinctions like waves or splattering foam. You are after an overall effect. In stormy weather, an overcast, misty sky blocks out sunlight and casts everything into murky grey. (See Figures 7.11 and 7.20.) The water, regardless of its kinds of waves, will be less blue. Be conscious also of your point of view. This will determine how much detail will be

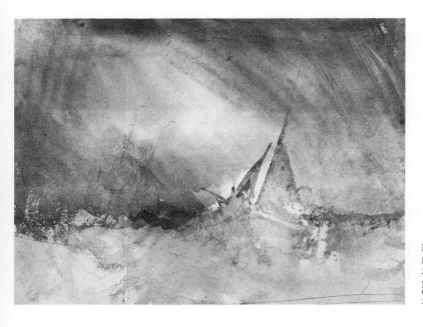

Figure 7.30
J. M. W. TURNER (English, 1775–1851)
Study for "Little Liber": Ship and Cutter (watercolor and pencil, 9⅜ × 11⅜ in.).
Courtesy Museum of Fine Arts, Boston (gift of William Norton Bullard, 23.1240).

necessary for your representation of waves, bubbles, and foam. Try painting a close-up, drawing your viewers into the moving water, and enveloping them with mist to heighten the experience, as does the artist in Figure 7.31. Turner's seascapes, painted more than a hundred years ago, still manage to captivate the viewer because they allow such intimate participation in the scene. (See Figure 7.30.) Instead of trying to simulate a particular scene, discover the special qualities of watercolor that best express the moods and forces of the ocean. Seascapes offer an almost ideal opportunity for watercolor experimentation.

Lakes are nestled into landscapes, surrounded by meadows, mountains, or trees (Plate 23). They are commonly referred to as *still waters*, but if winds are rippling their surfaces, they may be far from still. If you stand and observe a lake when the water is in motion, you will see that the waves seem smaller in the background (toward the horizon) than in the foreground. This exemplifies a basic principle of perspective: Objects of equal size appear smaller in the distance than in the foreground. The same is true for waves in the ocean or on a river winding into the distance. (This is illustrated in Figure 7.32, though not realistically!)

Reflections in lakes with still water are usually mirror images. But again, this depends on your point of view. A stick seen reaching out of the water at a 45° angle will be reflected at roughly the same angle. If it is bent toward you, however, the reflection is foreshortened. Even though the water may seem as smooth as a mirror, it does refract images, and thus an object's reflection in the water will always be darker and somewhat hazier in outline than the object itself. (See Figure 7.6.) This also depends, of course, on the clarity of the water and its surface movements. As the painting "Rice Pickers" (Figure 7.33) shows, images can be distorted by moving water. "Landscape with Distant Shoreline" (Figure 7.34) shows a hazy mirror image due to fog over the water and an indirect light source, the setting sun. You do

Figure 7.31
CHARLOTTE MAZMANIAN
Sailing the Sea.

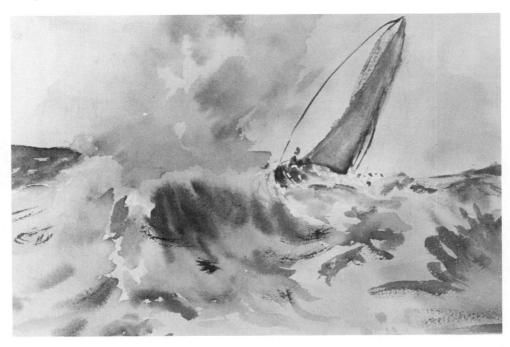

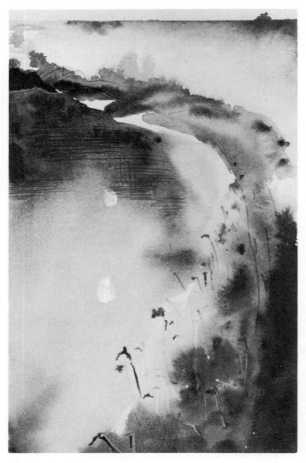

Figure 7.32
MARTHA WALKER
Winding River.

Figure 7.33
SANDRA REINBOLD
Rice Pickers.

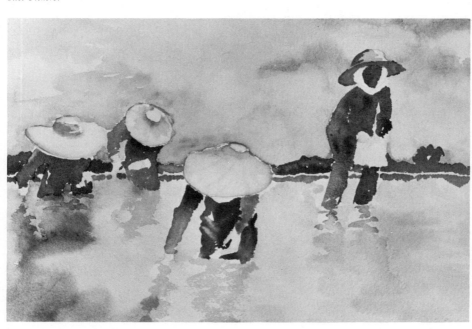

not have to be precise in painting reflections. Your primary goal is to suggest that water has depth and is transparent, and therefore reflective (Figure 7.35).

Water is usually painted with washes. A light blue value makes a good base since, as a primary color, it permits further color mixtures. Cool colors, such as purples and greens, give the water depth. Try mixing your colors directly on the paper, adding yellow to blue for green, and red to blue for purple. Yellow areas floating over green may suggest patches of vegetation below the surface of still water. Remember not to cover your whole paper with color. Leave some white spaces to return to in case you want to introduce other colors and textures. If you want to paint reflections as precise as those in "Lake with Boats" (Figure 7.6), glaze over the water with the same color you have used to paint the reflected objects; in this case, the color of the boats. (See also Homer's watercolor, Figure 7.29.)

The colors of water in landscapes change with point of view. When looking from high above, you will see a lot of sky reflected in the water, as in Plate 23 or the "Ship

Plate 1
Johannes Itten
Color circle.

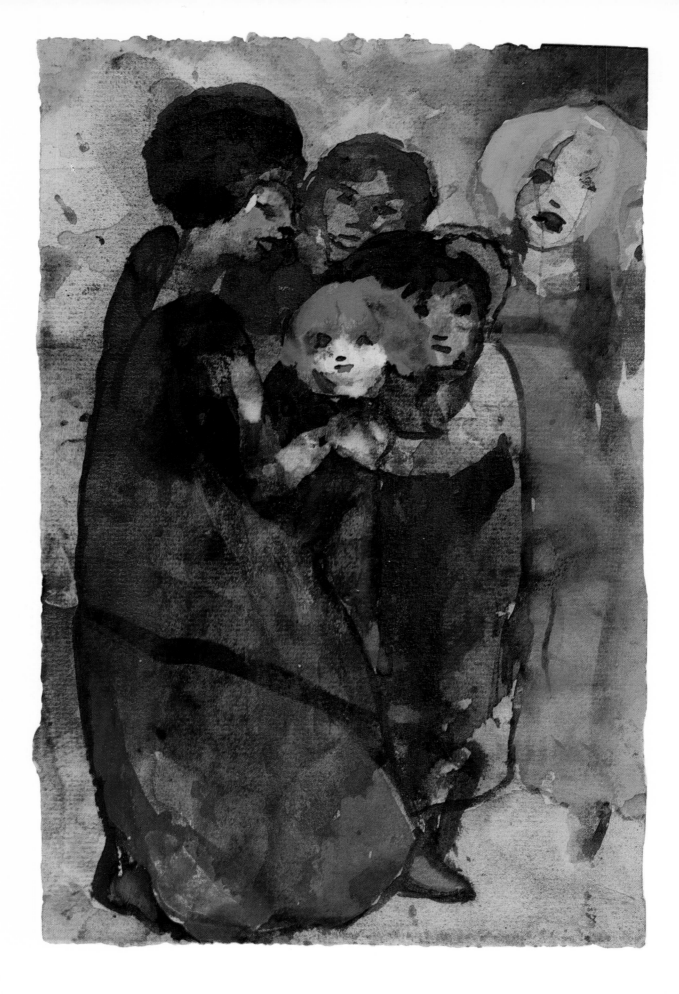

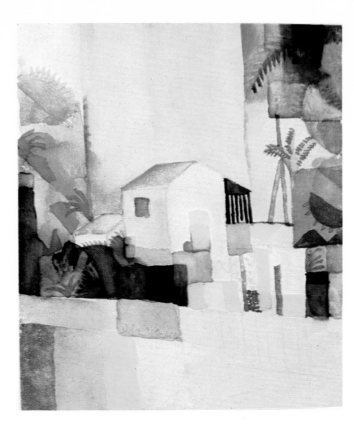

PLATE 3
August Macke
Helles Haus [*light house*].

PLATE 2
(opposite page)
Emil Nolde
Gruppe mit Kinder [*group with children*].

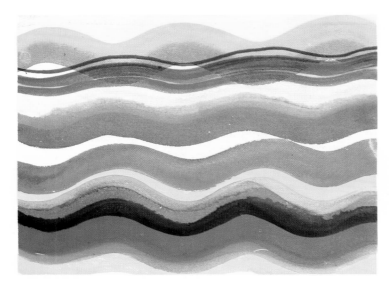

PLATE 4 (above right)
Inessa Derkatsch
Circle exercise (*color glazing*).

PLATE 5 (left)
Carol Hoover
Waves (*color glazing*).

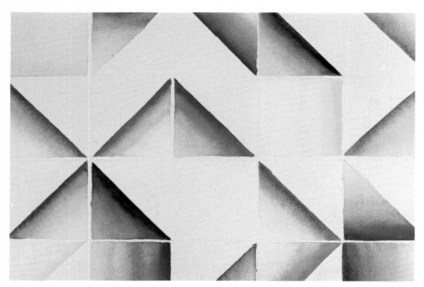

THIS PAGE

PLATE 6 (left)
Inessa Derkatsch
Exercise in color isolation.

PLATE 7 (bottom)
Inessa Derkatsch
Nine areas of texture.

OPPOSITE PAGE

PLATE 8 (top)
Brooke Kolton
Still-life with asparagus and cut orange.

PLATE 9 (bottom left)
Sheila Welch
Purple passion plant.

PLATE 10 (bottom right)
Christine Cortizas
Pineapple.

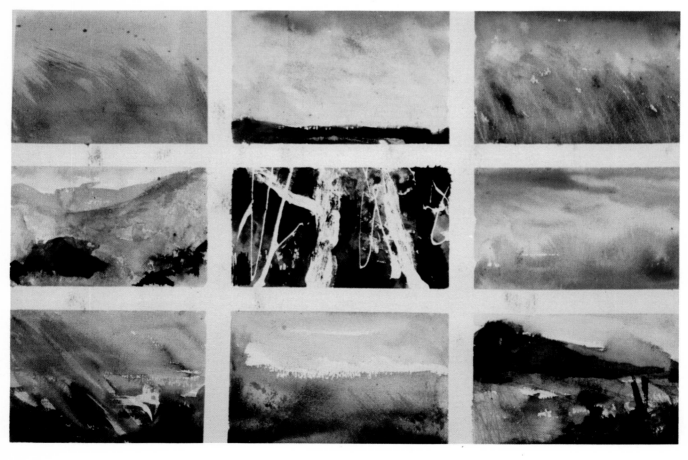

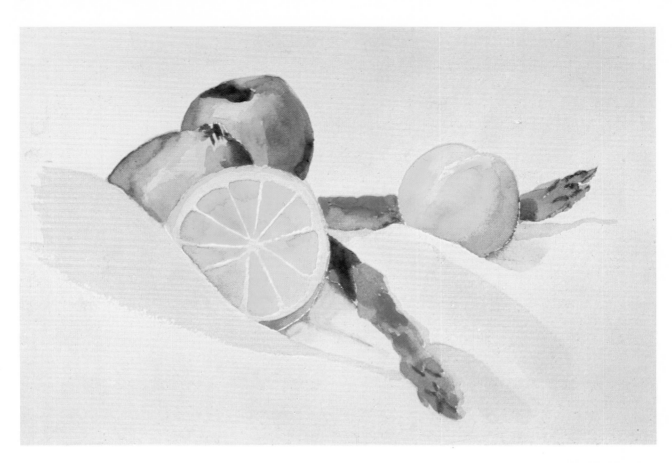

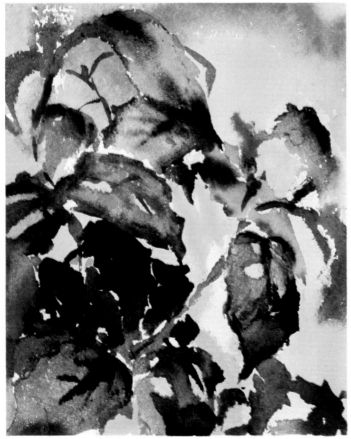

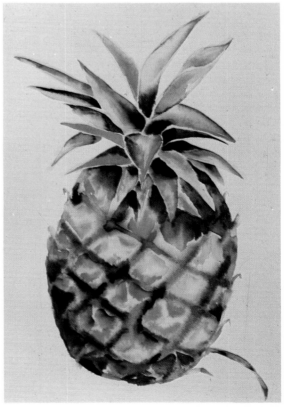

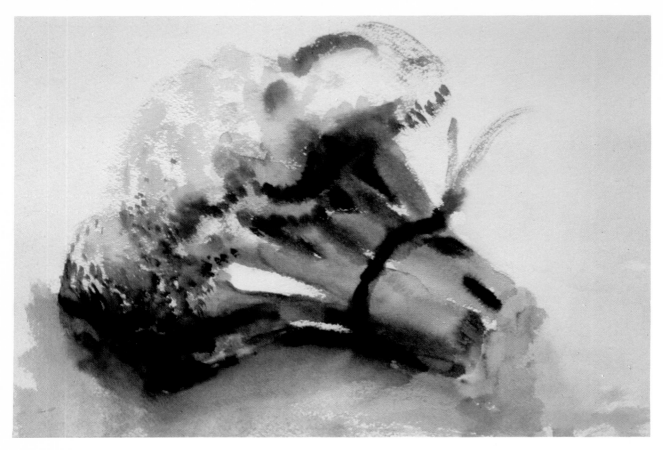

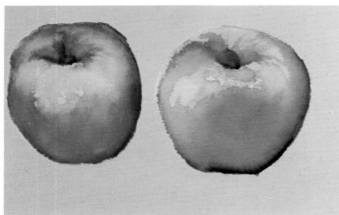

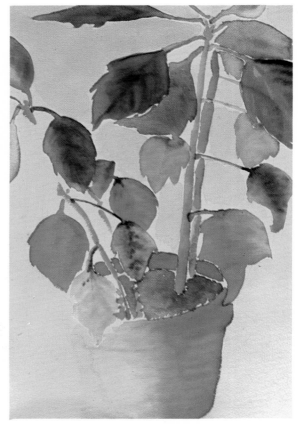

Plate 11 (top)
Lesley Cooper
Broccoli.

Plate 12 (below left)
Inessa Derkatsch
Two apples.

Plate 13 (right)
Ellen Marcus
Poinsettia.

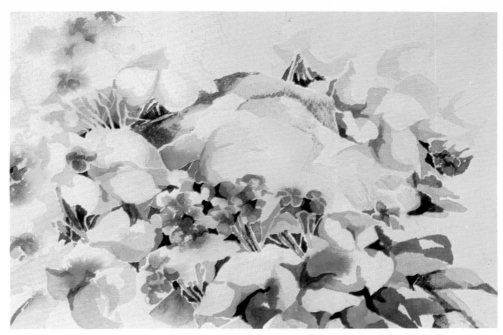

PLATE 14
H. Rafferty
Spring violets.

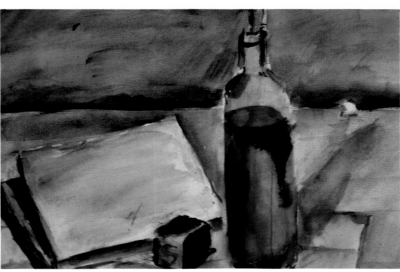

PLATE 15 (above right)
John Beerman
Still-life with bottle and book.

PLATE 16 (left)
Sheila Welch
Shell.

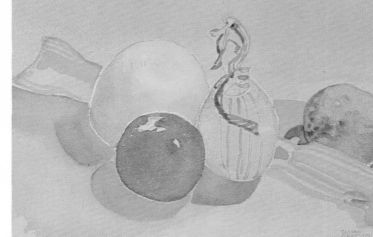

THIS PAGE
PLATE 17 (top)
Susan Spierling
Still-life with Chianti bottle.

PLATE 18 (middle)
Betty Youse
Cubic landscape.

PLATE 19 (bottom)
Inessa Derkatsch
Cloudy sky.

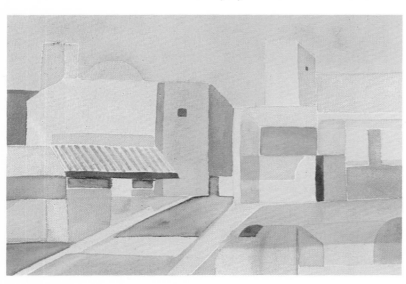

OPPOSITE PAGE
PLATE 20 (top)
Alexa Thayer Fuller
Thunderclouds.

PLATE 21 (bottom)
Martha Walker
Frosty-night snowscape.

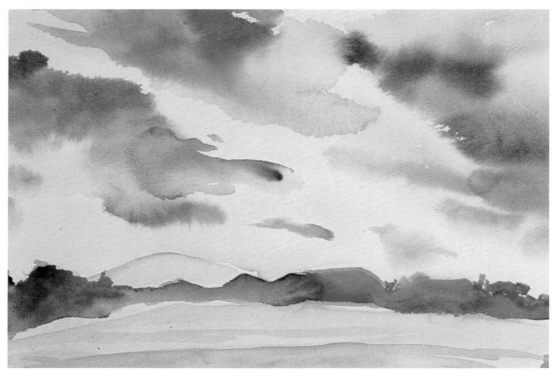

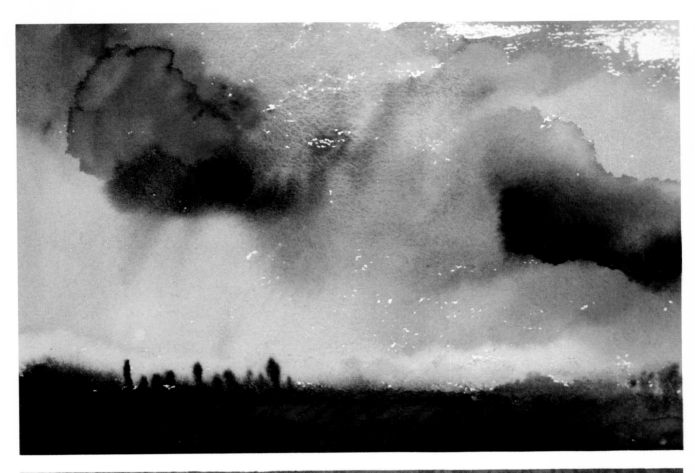

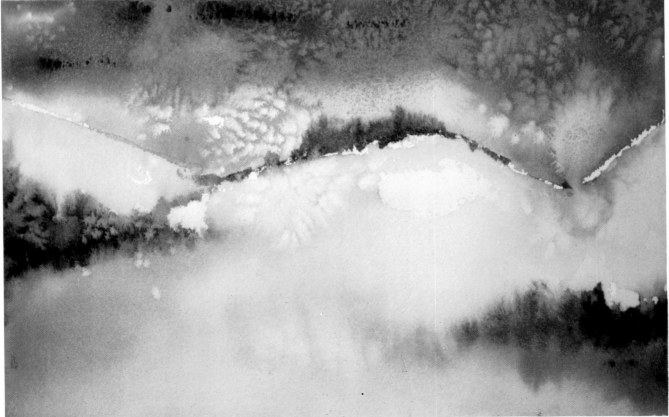

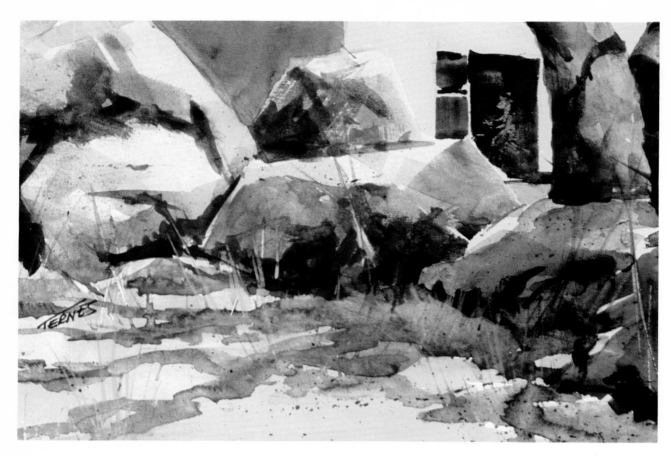

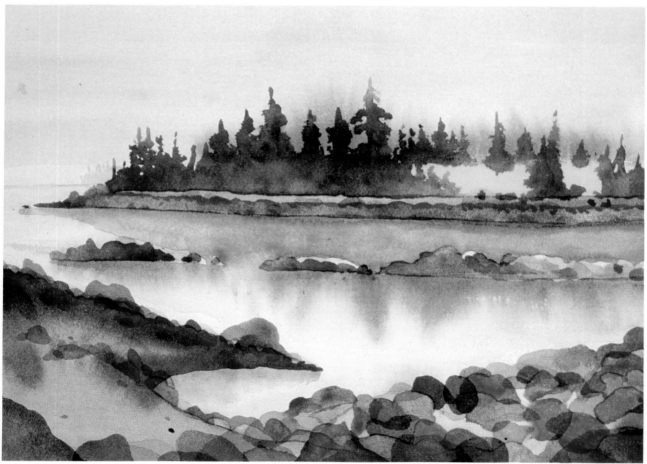

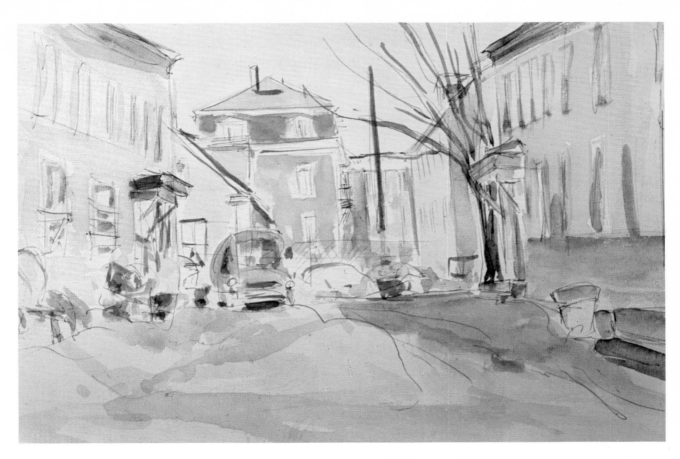

PLATE 24
Edith Burger
Street in the North End of Boston.

OPPOSITE PAGE
PLATE 22 (top)
William Ternes
Rocks on a sunny day.

PLATE 23 (bottom)
Jonathan Prince
Great Granberry pool.

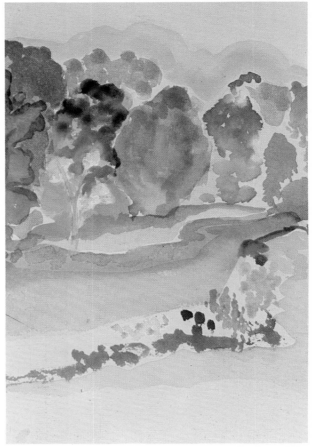

PLATE 25
Susan Spierling
New England in the fall.

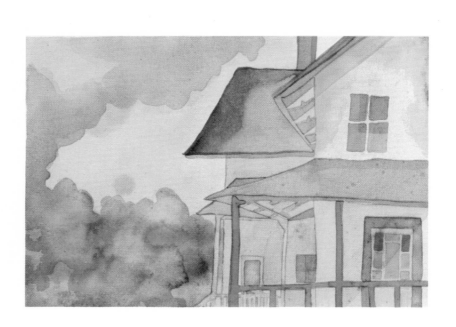

PLATE 26
Jonathan Prince
Nick's porch.

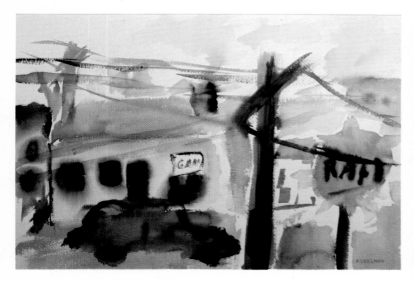

PLATE 27
Fred Casselman
Corbin.

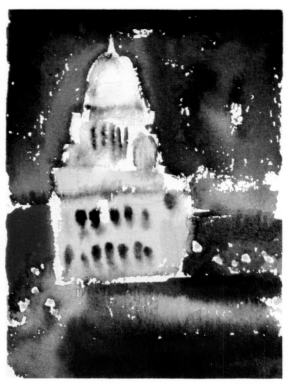

PLATE 28
Valerie Bolger
State capitol, Providence, Rhode Island.

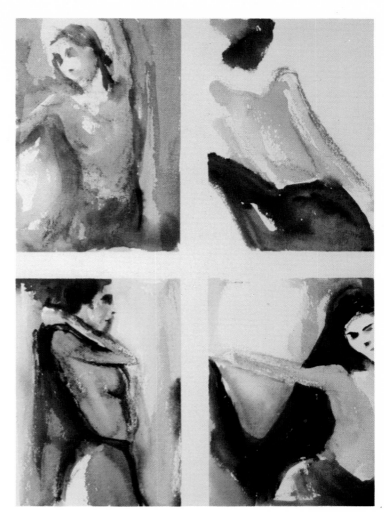

PLATE 29 (right)
Michael Bowie
Four movement studies.

PLATE 30 (bottom)
Richard Terrio
Woman on a couch.

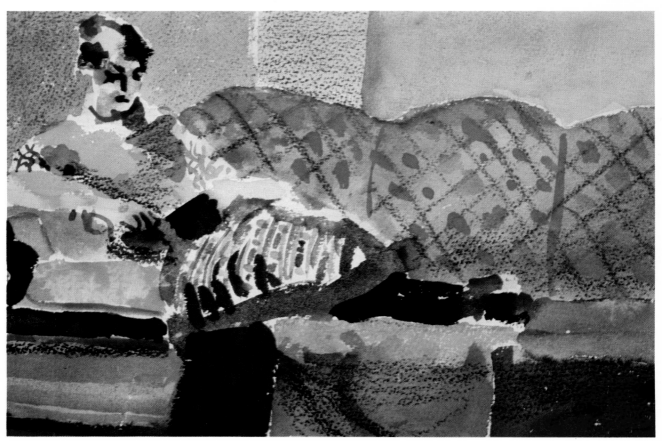

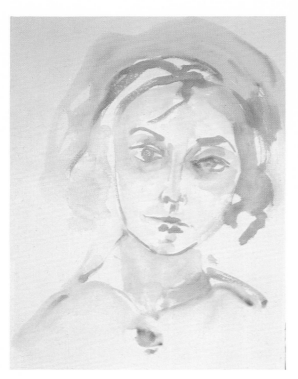

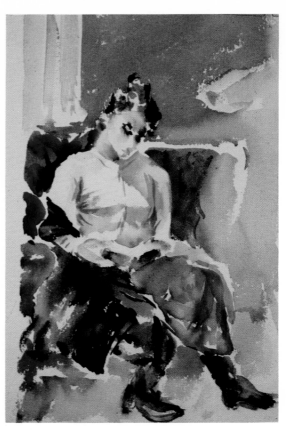

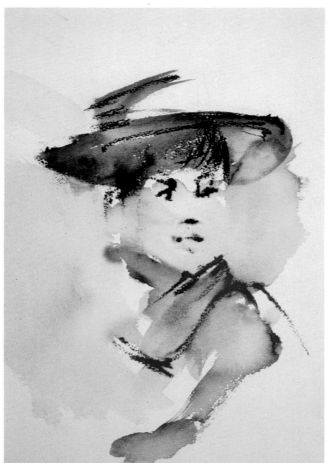

THIS PAGE

PLATE 31 (top left)
Inessa Derkatsch
Portrait of Irina.

PLATE 32 (top right)
David Halvorson
Girl reading.

PLATE 33 (right)
Hope Epstein
Woman with green hat.

OPPOSITE PAGE

PLATE 34 (top left)
Deidre Menoyo
Portrait of a young woman.

PLATE 35 (top right)
Paul Flanagan
Woman with flowers.

PLATE 36 (bottom)
Jonathan Prince
Jamaican festival.

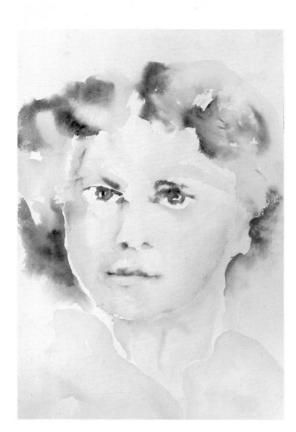

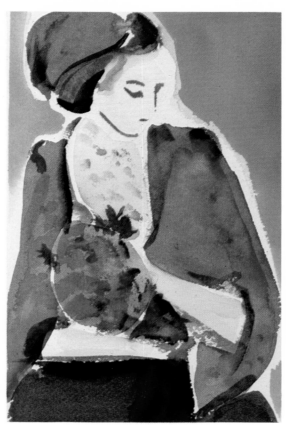

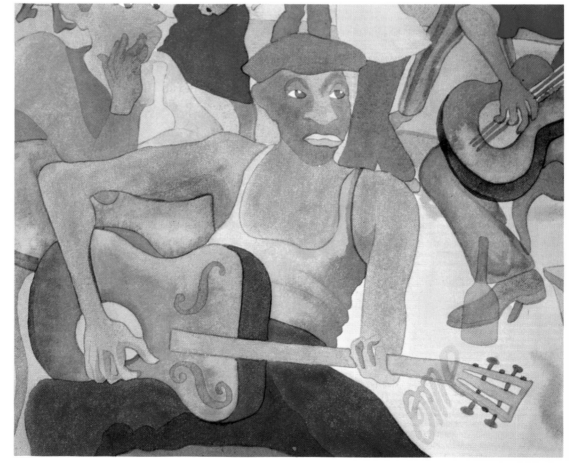

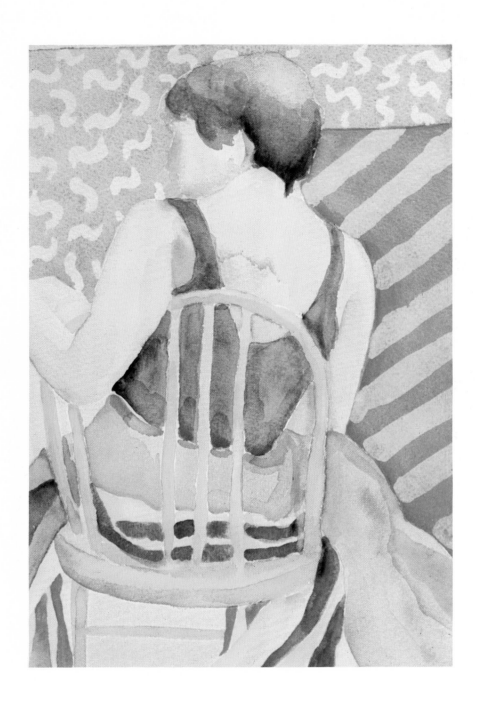

PLATE 37
Brooke Kolton
Woman in a chair.

with Island." (See Figure 7.25.) If you are close to the water, as in the depiction of "Sailing the Sea" (Figure 7.31), the colors of the water and the objects on land predominate.

Sky, water, and land all become more convincing when differentiated texturally. Your choice of watercolor paper can emphasize special effects. Usually the landscape painter uses very heavy, rough paper, because it absorbs lots of water and pigment and expands easily without buckling as it dries. The rough texture allows the pigment to settle into the fibers, creating interesting visual effects. Swirl a variety of colors through very wet areas, and you will have the semblance of windblown clouds. But rough paper is also good for glazing and drybrush work. Leave some of the white showing and your painting will sparkle. (See Figure 7.27.) This is particularly effective when you are painting reflections.

Furthermore, you can achieve a variety of watercolor textures using a sponge, paper towel, toothbrush, or by manipulating your brush in new ways. Roll, striate, or skid it

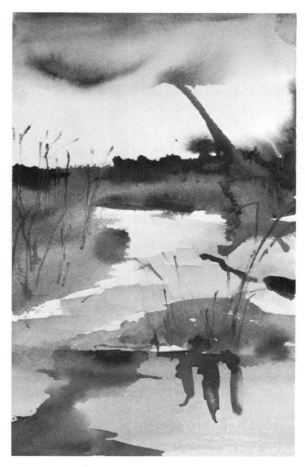

Figure 7.34
MARTHA WALKER
Waterfront.

Figure 7.35
MARTHA WALKER
Landscape with Distant Shore.

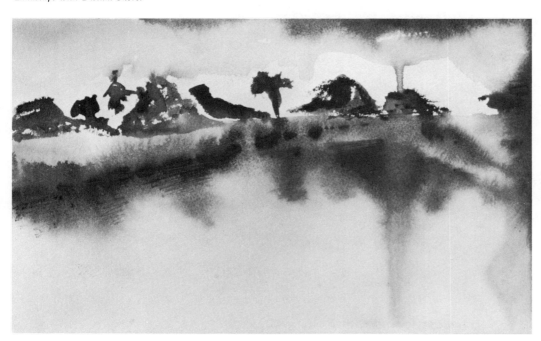

over the surface of rough paper, and you will leave behind many interesting textural distinctions. If sky and water fascinate you, work until you can evoke their different moods, happy and inviting, dark and forbidding.

Atmospheric Conditions: Fog, Mist, Rain, and Snow

Atmospheric conditions in landscapes can be great fun in watercolor. Whether you aim at something specific, like fog rolling in over the beach (as in Figure 7.36), or at something from memory or even from imagination (as in Figure 7.37), watercolors can provide you with a wide range of special effects. Use color washes, applying them to dry or premoistened paper. Allow them to mix and fuse, and you will have softly blended or diffused tonal ranges, suggestive of misty atmospheres. This technique gives watercolor its reputation as a spontaneous medium, easy to use and requiring little technical know-how. On a simple level, washes are easy to explore, and for most amateurs they serve as an introduction to the medium.

Here is your chance to apply some of the techniques you have already practiced in the exercises (Chapter 4). Now you can apply them and paint specific subjects. But no matter how specific you intend to be, try to follow the movement of the watercolor and be responsive to its behavior. Remember, in watercolor painting there is always a delicate balance between purpose and accident. In some of the best paintings, it is a combination of the two that accounts, finally, for the most pleasing effects. This goes especially for the use of a technique as fluid and unpredictable as a watercolor wash.

To portray atmospheric conditions, you can either define a scene realistically or let the watercolor make its own powerful suggestions of the forces in nature. In the two landscapes (Figures 7.38 and 7.39), the watercolorist retained basic elements of the landscape (horizon line, sky, and shaded foreground) but allowed the colors to play out their own drama as they interacted in both washes and glazes. Note especially the range of values, from light to dark and cool to warm colors. This strong contrast accounts for much of the drama, as does the fusing of complementary

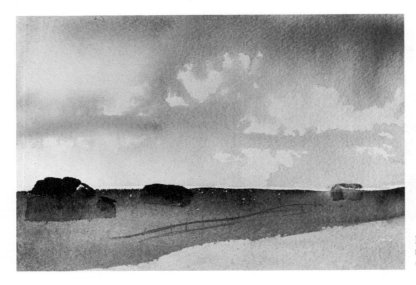

Figure 7.36
EDITH BURGER
On the Beach.

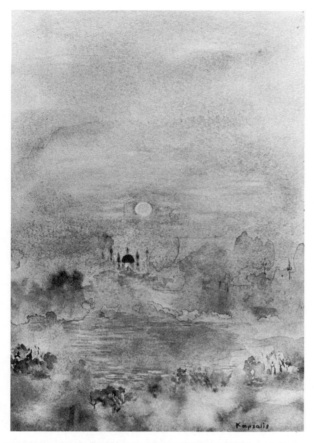

Figure 7.37
JOHN KAPSALIS
Fantastic Landscape.

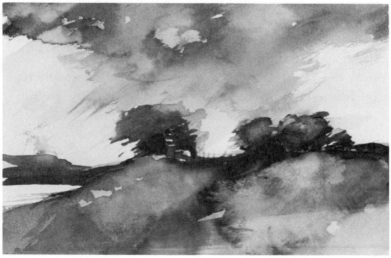

Figure 7.38
LAURA BROADDUS
Rainy Landscape.

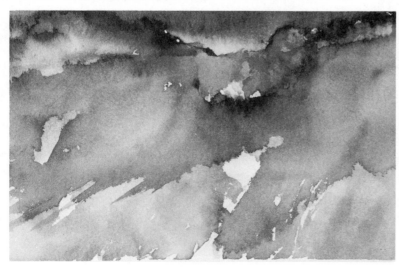

Figure 7.39
LAURA BROADDUS
Atmospheric Landscape.

colors (blue–purple with yellow–orange). Washes of fairly concentrated colors were laid on with quick strokes and thinned out with water into lighter values. The collision of cool and warm colors produces muted tonal ranges, softening an otherwise extreme contrast.

The manner in which you lay on your colors can suggest something realistic or simply a mood. Faint traces of trees may be detected in "Rainy Landscape," Figure 7.38, but these are secondary effects of techniques that were meant to suggest a larger mood of nature. The foreground in this landscape was allowed (perhaps even by accident) to break through into the sky, creating these delicate treelike shapes. Atmospheric conditions are easily achieved by color manipulation, brushwork, or the application of salt, sand, or spray from a toothbrush. But you must decide whether you want to make such an effect *the* subject of your landscape, or use it in combination with more realistically painted objects. Often such a combination can be very

attractive, as in Figure 7.40, or in "Frosty-Night Snowscape," Plate 21, where the glitter and sparkle in the sky are achieved by sprinkling salt on a moist (not wet) surface.

If you paint realistic objects along with atmospheric conditions, remember that mist and fog have a filtering effect. They blur objects in a landscape, often making them recognizable only as silhouettes. Depending on the quality of light and the time of year, the color of a fog can vary from cool to warm tones. The two fantasy landscapes (Figure 7.41 and Figure 7.37) manage to suggest that mist has enveloped the forms, allowing us only a guess at their shapes. Haziness can be achieved during the painting process, if you apply colors to paper that is still damp, allowing shapes and forms to blur. Or you can apply a mist with a color spray or quick wash over a completed landscape, obliterating precise definition. A combination of both techniques was used in Figure 7.37.

Often it is difficult to paint atmospheric conditions from nature, especially in the

Figure 7.40
JUDITH SCHWARTZ
Snowstorm.

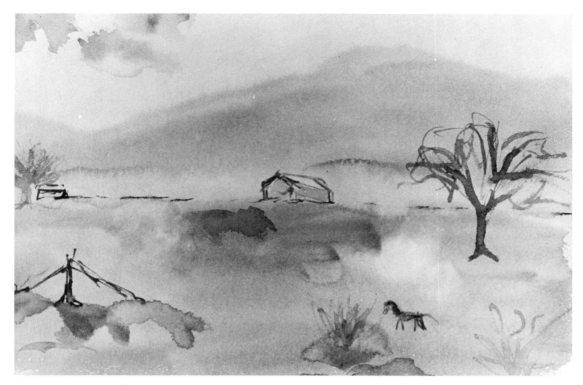

Figure 7.41
DIANE FRAZIER
Dreamy Landscape.

winter or during inclement weather. Rain, certainly, prevents the watercolorist from painting outdoors. In the depiction of ''Downpour'' (Figure 7.42), the misty, moist appearance of the environment is captured effectively, as is the glistening, highly reflec- tive surface of the pavement. The artist achieved a delicate balance between precise, recognizable objects and diffused color washes. Students sometimes choose to paint atmospheric conditions from photographs that have captured extraordinary moments.

Figure 7.42
EDITH BURGER
Downpour.

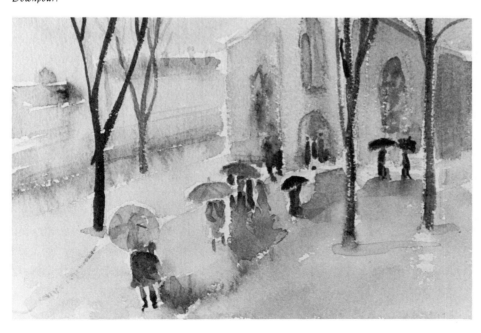

Figure 7.43
ANDREW MIAO
Distant City Skyline.

Memory helps, too. Many artists start out exploring watercolor abstractly for its visual effects and then recognize in their painting a scene that ultimately becomes their subject (Figure 7.43).

Most traditional watercolorists add rain or snow as textures after a painting is finished. Chinese white (gouache) is sprayed or dotted onto the landscape. With an opaque medium such as acrylic or gouache, snow is easy to paint; white added to objects or surfaces blocks out their colors just as snow does in reality. For the transparent watercolorist, it might seem that the white of the paper is an advantage, since white is already present and need not be added. In reality, "painting" snow in watercolor is more difficult, because the white of snow (or of any object) must be defined by omission, and that takes careful planning. Drawing first is a must if snow is to appear on such objects as trees or houses, because its shape on top of these objects must be defined. (See the "Snow-covered Fir Tree," Figure 7.44, or the houses in Figure 7.45.)

But snow also has color and reflects light. The color of snow depends on the qual-

ity of daylight and on the objects in its vicinity, such as buildings or trees. These also determine the shadows visible on the snow and the shape of snow as it is piled up on trees or fences. Although an area of snow can be suggested by leaving the white of the paper showing, you will have to give it some color and define its shape (Figure 7.46). Either cool or warm colors can be used for definition. On a bright, sunny day you will usually see yellow or pink shadows on the snow, while a cloudy, overcast day creates grey, blue, or even purple hues.

Use either washes or glazes to introduce color into the white areas. The character of your shadows depends, again, on the texture and depth of the snow and the type of daylight. (Remember, the texture or surface of an object influences the way in which light reflects from it.) Thus, tracks made by humans or animals in fresh snow on a clear day will have very precise outlines and cast shadows of a warm color. Paint these with a glaze or dry brushstrokes. But the scattered shadows of branches on a hazy day are best painted by washes. Of course, a combination of washes and glazes is frequently used, as in

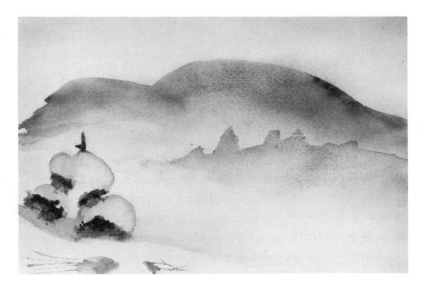

Figure 7.44
JUDITH SCHWARTZ
Snow-covered Fir Tree.

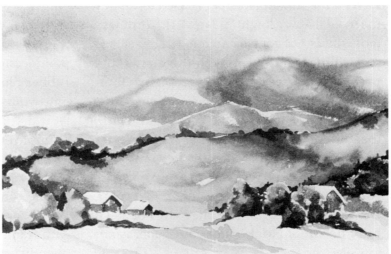

Figure 7.45
KATHY DIDONATO
Winter Landscape.

Figure 7.46
MIRIAM SWAFFIELD
Birch Trees.

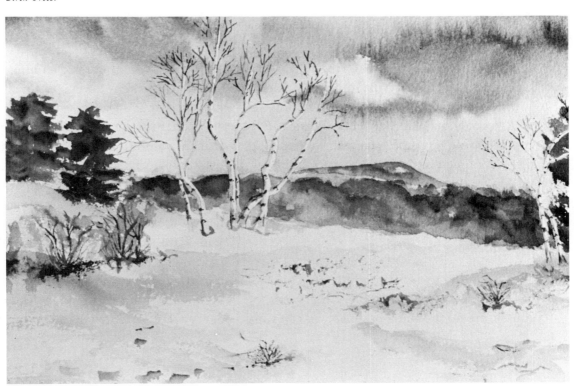

the "Birch Trees" (Figure 7.46) or "Winter Landscape" (Figure 7.45).

A "snowing" effect in a landscape is very difficult to achieve, because you cannot leave a multitude of tiny flakes of space empty on the paper. For an abstract version of this, see Figure 7.40. A dry brushstroke allowed to glide over the surface of rough paper will leave tiny specks of white and may achieve this effect, but more often salt sprinkled on the still moist paper is used to convey the cold snowy night (Plate 21). Ordinary table salt is not coarse enough; kosher salt or rock salt (ground down with the mortar and pestle) works best. Salt is hygroscopic. It attracts water while it dissolves, leaving tiny, star-shaped patterns after you shake it off. (See the section on textural effects, Chapter 4.) These star shapes usually integrate well into a composition, because they are not pure white but show some of the underlying color. Unlike patches of snow, they do not need color definition. Make sure your paper is not too wet, or the grains of salt will dissolve completely, producing only hazy blotches. You can achieve a somewhat different effect by using sand. Sand does not soak up watercolor but gathers it around each grain, leaving behind a tiny light area encircled by a colored rim when the paint has dried. Finally, you can create a snowing effect by dipping a toothbrush into opaque white paint and spraying white onto your painting. This allows you to control the degree of haziness by deciding just how much of each object should be left visible.

Block-out and Masking Solutions

There is a way to get around the difficult task of leaving white paper visible. Large areas, of course, are no problem, because you can sim-

ply paint around them. But how do you leave space for one tiny white seagull in a brilliant blue sky? Having to leave a fraction of an inch of paper empty when you are applying a sweeping wash can be a nuisance and can inhibit your use of the wash. In transparent watercolor application there is a point of no return; once an area is covered with color it can never be made to look white again.

The most obvious solution is to paint the entire sky first and then add the little bird with opaque white paint. Another solution is to block out the area with a masking compound, such as Mascoid, Miscit, or even rubber cement. Paint the masking compound onto your paper in any shape you want and let it dry; it will resist your watercolors. (See examples of this in Chapter 4, Figure 4.12.) Your intricate design will appear magically in white when your paint has dried and you rub off the compound.

These agents are tremendously popular with traditional watercolorists. They are frequently used for the white bark of birch trees or for white sails against the sky. Usually, accomplished watercolorists have no difficulty in leaving these areas empty, but block-out compounds are convenient and make the task easier.

If you are interested in how they work, you can try them after you finish your preliminary drawing of a seascape. Paint in the areas that are going to remain white with a masking solution. (Masking solutions are usually colored a faint pink or grey to make them stand out from the white of the paper.) Allow the masked areas to dry and then just ignore them. Now you can paint any colors you want over their surfaces. When your painting is done and dry, or when you want to retrieve the white of the paper, simply rub off the masking compound. Make sure that every trace is removed, since prolonged ex-

posure to these chemical substances can cause your colors to fade. (See Chapter 2, the section on paper.)

Masking your paper can be a convenient solution, but I do not recommend it for beginners. It can easily become a crutch, preventing you from learning the planning and controlling of sequential color application, an important part of watercolor technique. This technique requires that you make a preliminary drawing to indicate the areas that will be left empty or white, and stick with it. Of course, you can always introduce opaque white, but its visual effect is entirely different from that of transparent watercolor. When you combine the two, you may lose the transparency of your colors. I suggest that you explore opaque color for the visual effects mentioned in Chapter 4, rather than as a shortcut in realistic works.

To the trained eye, a masked-out area is easily recognized. The white area will be crisply defined, particularly obvious in the middle of a sweeping wash. Modern, medium-oriented painters, especially those who use watercolor transparently, consider masking solutions gimmicky. They prefer to use opaque white paint (gouache) if they need white and did not plan for it in their composition. Of course, even more drastic measures exist: You can scrape off colors with a razor blade in order to make the white paper reappear, or displace the colors by pressing into the wet paper with a blunt knife. (Homer used this method in many of his watercolors.) Even though purists reject these and other methods of touching up, I think that the smaller the object, the more forgivable the use of such techniques.

In the nineteenth century, watercolorists blocked out areas with wax or waxlike substances. The wax was heated and painted onto the paper, thus preventing color absorp-

tion. By applying heat and then blotting up the melted wax, or with a chemical solution, the artist then removed the wax. The scrubbing required gave bordering areas a fuzzy and blurred appearance. Today wax is rarely used for masking purposes. A candle is sometimes rubbed onto a painted surface to suggest moss on rocks, the bark of a tree, or other textures. The wax seals in one color, allowing it to show through subsequent color applications. More often, wax crayons are used for linear definition, as will be seen in the chapter on portraits. Crayons create color lines that are intended to remain visible. (See Plate 30.)

Mountains and Hills

Watercolorists whose favorite subjects are mountains and hills often travel to sites they know will inspire them. Think of the Swiss Alps or the Grand Canyon, and their unending attraction. If you paint hills or mountains you can make them the center of attraction in a watercolor, or you may choose to emphasize their basic shapes (smooth and rolling or rough and craggy), their surface vegetation, or atmospheric conditions such as fog, rain, or snow (Figure 7.47).

Indicating the three-dimensional character of hills and mountains is of primary importance. You must show in your painting that these large protrusions have volume and occupy space. (See Figure 7.1.) Use the same techniques you learned in painting fruit and vegetables. Volume is suggested by shading an object from light to dark. Light and dark areas will, of course, be determined by the light source in your landscape. A good example is Plate 22.

Again, do not confuse surface with volume. Mountains and rocks may have a wide

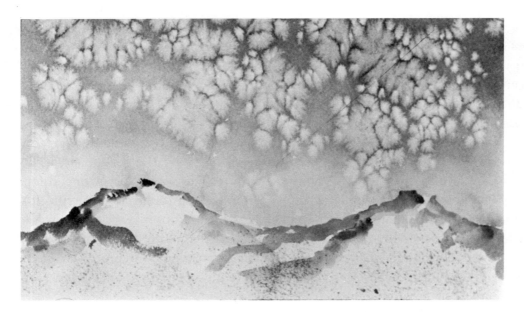

Figure 7.47
MIMI TRUSLOW
Twin Mountains.

variety of appearances, depending on the geographical region or the atmospheric conditions on a particular day. And their size will depend on your perspective. A close-up view of a few slabs of granite may look like the west wall of the Matterhorn, or vice versa. This is a matter of compositional choice. But regardless of size and texture, whether they rise up from land or sea, all hills and mountains must be shown to protrude.

A simple two-part landscape (foreground and background) can be the setting for your mountains. First establish your sky, making sure it is darker toward the top and becomes lighter as it meets the horizon line. The mountains can be placed where sky and horizon meet—the middle ground—as in the alpine landscape (Figure 7.48). Quickly pencil in a general outline of your mountain ridge.

Apply color to define the mountains. Even if they have rough edges (as in Figure 7.47), do not try to outline them with the brush. This would be using the brush as if it

were a pencil or pen. Capitalize on watercolor's ability to be line and plane. Paint a line in watercolor and, while it is still wet, apply water to one side of it, extending it into a plane (see exercises in Figure 4.6). Take into account the texture of your watercolor paper. If it is rough, painted lines will already have a certain unevenness. Your brush may have skidded over the rough paper, leaving a textured surface which can represent a mountain ridge.

Try rolling the brush over the paper to form mountains. First fill your brush with color (Payne's grey, for example), and then roll it along, pressing down firmly on the paper and retracing the penciled outline of your mountains. Now add water to the lower parts of your line and extend the color until it takes on the shape of mountains. (This is how the shapes of the mountains were painted in Figure 7.47.) Using this technique, you will have a light–dark combination almost automatically. The top of the mountains will be dark, contrasting with the sky, and the body

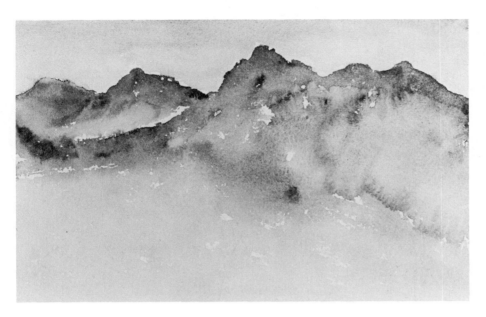

Figure 7.48
INESSA DERKATSCH
Mountain Ridge.

of the mountains will be lighter, indicating volume (Figure 7.49).

Your choice of color is a personal one, and will depend on whether you want your mountains to be realistic (See Figure 7.48) or abstract (as in Figure 7.50). In either case, use a variety of colors to create more interest. Cool and warm hues used together convey the three-dimensional appearance of mountains, just as they do with any other object of volume. The greyish brown color tones usually associated with rocky mountains are more exciting if they are the result of mixing complementary colors. Take blue or purple hues and combine them with warm yellows and oranges. When they interact in washes or glazes, you will get muted tones.

Experiment with brushwork while you are trying various color explorations. Try dipping your brush into more than one color, perhaps complementaries, and allow them to fuse while you are rolling your brush. First

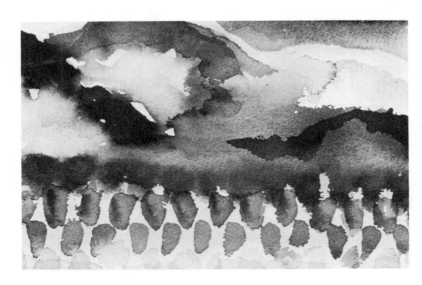

Figure 7.49
ELIZABETH BOWERS
Mountains and Trees.

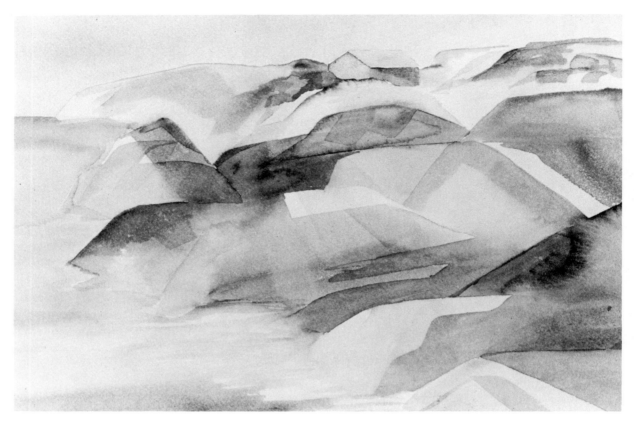

Figure 7.50
ANDREW MIAO
Mountains Near the Shore.

dip into a light blue, and then fill just the tip of it with alizarin crimson. This combination will give you a mountain ridge of a purplish hue. Intuition and practice will help you decide which combinations work best for you. (See the section on dual-color application, discussed in Chapter 4.)

The effects of watercolor brushwork are never entirely predictable. As I have pointed out, watercolor is a medium which metamorphizes colors and forms. Many factors influence this process. The amount of color in your brush, its particular hue or saturation, the pressure with which you apply your brush, the texture of your paper, and your arm movements while you are painting all contribute to the final appearance of your watercolor. These are variables that you must experiment with. I can teach you the techniques, but only experience can teach you to predict the outcome of your brushwork. Chinese brush painting trains artists to plan

brushstrokes by noticing how heavy the brush feels when it is filled with ink. It requires years of training to develop such a sensitive touch.

Pebbles and Rocks

These can remain details of a landscape, or they can become the principal subject in a composition. Macke's watercolor painting of rocks (Figure 7.51) is a good example of rock used as subject. Note how he first sketched in their basic shapes, giving them sharp angularity and determining their positions in the composition. Each is treated as a distinct shape.

As with mountains, you must convince the viewer that these are space-occupying objects by suggesting volume. If you paint your rocks close-up, you will have the opportunity to introduce a variety of surface tex-

154

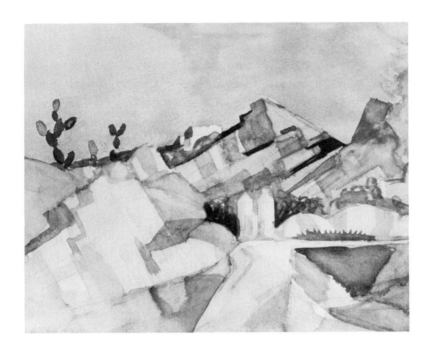

Figure 7.51
AUGUST MACKE (German, 1887–1914)
Rocky Landscape (watercolor).
Courtesy of the Erbengemeinschaft Dr. W. Macke.

tures. (See Plate 22.) The texture should convey something about the region in which you observed the rocks. "Rocky Shore, Bermuda" by Homer (Figure 7.28) has a different appearance from those on the beach (Figure 7.52) or slabs cut in a quarry. Rocks in a moist and shaded environment like the woods will have a different texture than those in a desert. Sargent emphasized the sharply cut, freshly quarried surfaces and the creamy whiteness of the marble in Carrara. (See Figure 7.19.)

Your choice of light, bright or filtered, can also emphasize dimensionality and tex-

Figure 7.52
SUSAN SPIERLING
Rocks on the Beach.

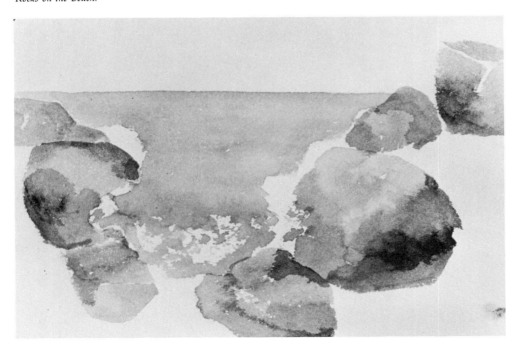

ture. The strongly illuminated rocks in Plate 22 were painted in contrasting (warm–cool) colors to bring out their angularity. The strong light defines the surface of the rocks in great detail, revealing a multitude of textures and color variations. Note the color interaction and how the identity of each color is retained. Here the depiction is realistic; even the grass in the foreground is carefully defined. The hill-like rock formation in Figure 7.50, on the other hand, is more general and abstract. The rocks are seen from a distance, with no precise detail. The same is true of those in Plate 23.

Again, as with fruit and vegetables, define the volume of rocks by shading them from light to dark. After drawing their general shapes (as in Figure 7.53), note their surface appearance: rough, angular, round, or smooth. Your watercolor technique will depend on these surfaces. Glazes applied with a dry brushstroke skidding over rough paper will give rocks a weathered appearance. Color glazing, as used in Plate 23, captures the smooth, shiny appearance of pebbles in a very interesting manner.

The colors you choose for rocks or pebbles are equally important. Beginners have a tendency to use just one color, usually brown or grey. Nothing could be less exciting. Even though rocks or stones may seem uniform in color when compared with fruits and vegetables, you must still introduce colors that will make them more interesting. Browns can be formed right on your paper by mixing complementary colors: yellow and purple, or blue and orange. Even if you want to paint a very realistic looking rock (as in Plate 22), you do not have to forego color. In addition to a combination of ultramarine blue, burnt sienna, and sepia, add complementary colors. Apply them in washes or glazes so that each retains its identity while it is contributing to exciting mixtures. Sargent painted his *white* marble slabs at the Carrara quarries with luscious creams, varying their tones from yellow to orange (Figure 7.19). Macke contrasted his rocks with colors, cool blues, purples, and greys, producing a multitude of harmonious tones. (See Figure 7.51.) Use color structuring with warm and cool color tonalities; let yellows modify browns, use blues to indicate crevices and other dark areas. Make use of the watercolor medium's primary resource, color. It is one that willingly replenishes itself.

Figure 7.53
SUSAN ARON
Drawing of a rock
(note the light/dark
shading to bring out
its volume).

Vegetation

Trees, plants, flowers, and grass are usually included in a landscape to give it variety as well as a personal touch. Some watercolorists like to paint the same landscape in different seasons, emphasizing the changes in vegetation from spring to summer, winter, and fall (Plate 25).

Trees are favorite details in landscapes, as the illustrations show. Use the principles discussed in painting plants for painting trees. What are trees, after all, but giant plants? In a landscape they are usually seen from a distance; thus, their overall shape is more important than are particular details (Figure 7.54). In fact, we can often recognize a particular type of tree from a very general shape. Think of the drooping branches of the

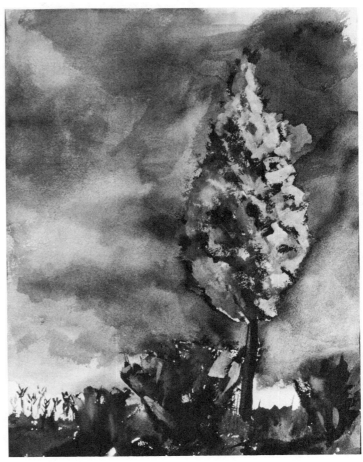

Figure 7.55
FRED CASSELMAN
Poplar Tree.

Figure 7.54
WINSLOW HOMER (American, 1836–1910)
Palm Trees, Florida (watercolor, 13½ × 19⅛ in.).
Courtesy Museum of Fine Arts, Boston (Spaulding Collection, 48.731).

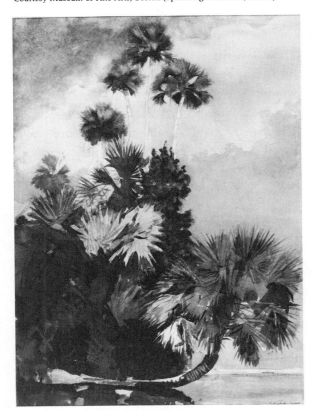

weeping willow, or the conical shape of the poplar (Figure 7.55). Colors and textures can be characteristic as well, like the white bark of the birch tree or the yellow, red, and rust colors of maple trees in the fall.

Beginners often have difficulty placing trees in a landscape. Trees, like other plants, grow and take up space. This is not quite so obvious as it sounds, since most trees are "open" structures and far from solid, as the palm and fir trees show in Figures 7.56 and 7.57. Students often make the mistake of focusing on the parts of a tree, losing sight of its overall shape and volume. A look at the growth pattern of trees will help you distin-

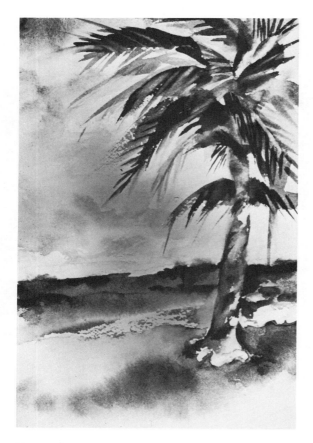

Figure 7.56
CHRISTINE CORTIZAS
Palm Trees.

Figure 7.57
KATHY DIDONATO
Fir Tree.

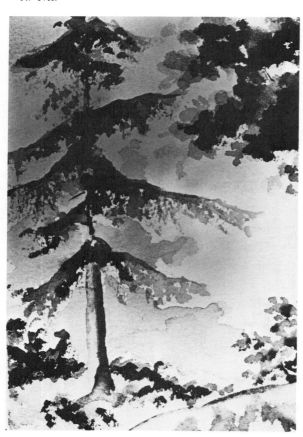

Figure 7.58
SUSAN ARON
Drawing of the basic shape of a tree.

guish major features from superficial details. (See drawing, Figure 7.58.)

The trunk of a tree can be considered the armature on which its foliage rests. Branches grow out of the trunk and are thickest at the juncture, becoming thinner as they grow away from the trunk. The foliage, usually growing from the smaller branches, forms an umbrella sheltering the inner structure of branches and trunk (Figure 7.59). If you paint from the general to the particular—branches first, then foliage—you have to remember that your watercolors are transparent and will not hide those branches that do not show. When you are dealing with an opaque medium, dark branches can easily be painted in and disguised later by foliage. With watercolors, you should paint first only those branches that are visible (Figure 7.60). It is best to deal next with the foliage and *its* appearance, and then to define the connecting branches.

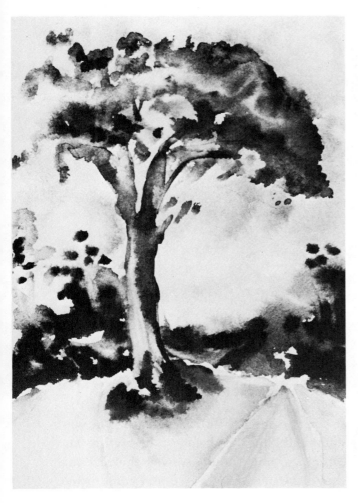

Figure 7.59
CHRISTINE CORTIZAS
Elm Tree.

Color of Vegetation

Use cool and warm colors as well as colored shadows to bring out the volume of trees. Green is often the dominant color in trees, but that green can vary significantly. The particular hue of green depends on the specific tree and on the season. Spring trees should be painted in light greens, greys, and even pinks. The full trees of summer should be saturated in rich greens, browns, and rusts. Colors also vary according to the age of the tree and its location. Young trees usually have delicate, almost transparent leaves. Illumination by di-

Figure 7.60
KATHY DIDONATO
Large Tree.

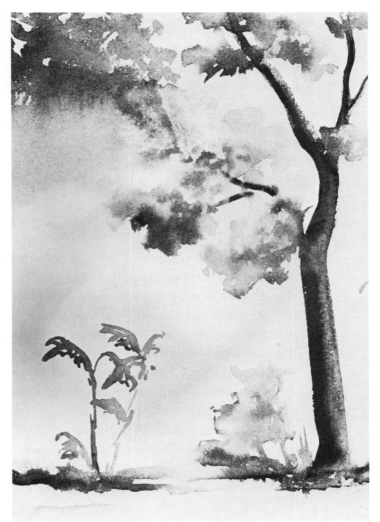

Unlike plants, which have green stems, the trunks and branches of trees, with the exception of birch trees, are usually dark. If you use watercolor transparently you cannot paint light-colored foliage over dark-colored bark, so decide, as you are drawing, which dark areas you want to be exposed. Be sure to show where the foliage and branches join the trunk. As the drawing shows, you should define the shape of the tree first and then define general clusters of foliage in pencil as well.

Figure 7.61
BROOKE KOLTON
Three Trees.

rect sunlight also alters colors. There are many variables. If you want to be expressive, you can paint them as in Plate 25. Green is not the only color you should consider while you are painting trees. Try to see how many different colors you can find in the trees around you. This will also depend on the season, of course.

Practice painting individual trees until you get the feeling of their shape, color, and structure. Be as realistic or abstract as you like (Figure 7.61). When trees are grouped with other trees, however, the whole becomes more important than its parts, and the individual trees can be abbreviated. (See Plate 23.) You can emphasize the volume of a group of trees by placing them against a blue sky; the sky will seem to recede, leaving a pocket of space for the trees. A setting sun, on the other hand, might illuminate background trees, making those in the foreground darker. As long as you bring out the volume of the trees, the effect will be convincing.

Architecture

If you include man-made structures in your paintings, such as bridges, highways, and buildings, you should convey the fact that they have been engineered and constructed. By definition, to construct means to make or form by combining parts. In architecture, the materials used and the method of assembling them determine a structure's appearance. Its function, however, also gives a structure a compositional "look," at least in our century (for instance, Thöny's "New York Harbor," Figure 7.62).

The building materials in architecture are like the medium in artistic creations: They determine form. A house made of bricks looks quite different from one built of concrete or wood. Because of its distinctive properties, each material requires a special method of construction. If your goal is a realistic rendering, take note of the building materials; they add character and interest, and

160

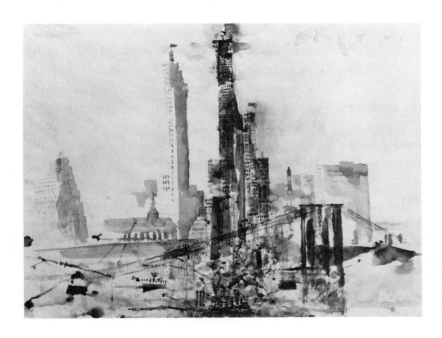

Figure 7.62
WILHELM THÖNY (Austrian, 1888–1949)
Hafen von New York [New York Harbor]
(watercolor, 1933; 7¾ × 24½ in.).
Graphische Sammlung Albertina, Vienna; 26.789.

help define the structure. Think from the inside out. Don't paint the skin at the expense of the skeleton.

Since you are dealing with a constructed object when painting a house or building, make sure that you represent its three-dimensional appearance. Think of a house as a linear formation resembling roughly a rectangle or a cube. It is made up of a series of planes that have parallel lines. In watercolor painting, you have a variety of means of representing these.

In "House with Picket Fence," (Figure 7.63), you see one approach. This is the most

Figure 7.63
EDITH BURGER
House with Picket Fence.

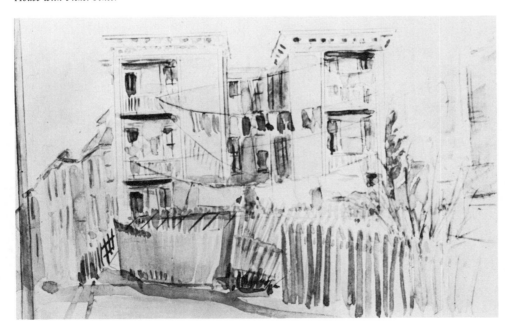

traditional one and can be described as a pencil drawing with watercolor added for more definition. The pencil sketch first delineates and defines the architecture of the house and the additional landscape elements. The watercolor is applied in light glazes and washes to add character and interest to the planes of the house, the fence, and the pieces of clothing blowing in the wind. To get an idea of what this looks like in color, see Plate 24, by the same artist, of a similar subject. This type of watercolor, called "colored drawing," reminds us of many landscapes painted in the eighteenth and nineteenth centuries, in which artists achieved a subtle balance between pencil line and colored areas.

A more contemporary approach to representing architecture is structuring its cubic appearance by the use of color in precise planes to indicate the various sides of a house. The painting "Houses on Cape Cod"

(Figure 7.64) emphasizes the constructed nature of New England clapboard houses by sharply defining the planes and their rectangular shapes by means of a tiny white line. In addition to emphasizing the *constructed* and *assembled* appearance of the houses, the white line distinguishes the color's value, which is almost the same on the various sides of the houses.

Here the watercolorist used the technique you learned in the color-isolation exercise discussed in Chapter 4 (see Plate 6). However, since the buildings were painted quite methodically, the technique is used less for color control than for color separation of similar values and for conveying the constructed appearance of the object. Remember, there are two ways of placing colors next to one another on your paper. One is to separate them with a tiny white line (if you wish to work spontaneously and prevent them from flowing together); the other is to wait until

Figure 7.64
BETTY YOUSE
Houses on Cape Cod.

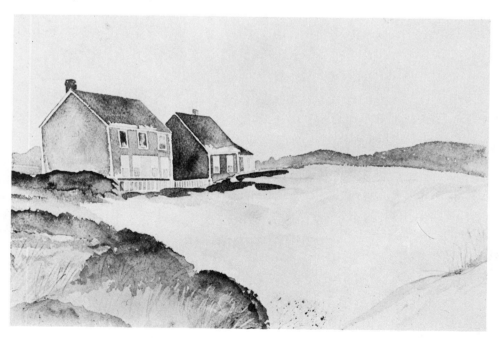

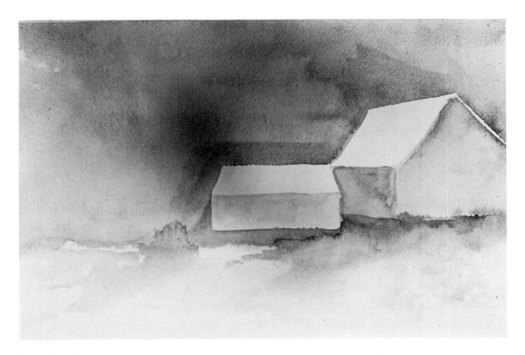

Figure 7.65
SUSAN SPIERLING
Beach Front.

one area of color is dry. Both techniques can be used in painting the planes of a house. In addition, varying the color (not just the value) of your planes, as in "Beach Front" (Figure 7.65) introduces *color structuring*, and this is the most modern approach to defining the three-dimensional appearance of an object.

Which technique you prefer depends not only on the building materials of your house (all these may vary from one part to another), but also on the quality of the outdoor light. Color is light and color identity is due to light. As mentioned previously, light is responsible for the appearance of your landscape. "Light-house on Cape Cod" (Figure 7.66) represents a bright day with no distinct shadows. The artist has made almost no color distinction between the various planes of the houses. In "Beach Front" (Figure 7.65), on the other hand, there is fog and mist in addition to strong sunlight. Thus the houses are strongly illuminated while at the same time they are cradled in mist. In "Houses on Cape Cod" (Figure 7.64), there is the suggestion of

Figure 7.66
BETTY YOUSE
Light-house on Cape Cod.

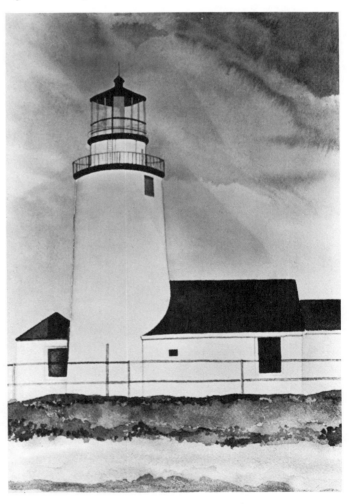

a rather bright day. Note that one of the houses is partially hidden by the other and has a more prominent shadow. For shadows cast from objects not visible in your painting, use glazes for sharp shadows and washes for diffused ones. In either case, keep your colors light.

If you plan to include architecture in your watercolor landscape, you will have more preparation to do in planning your composition and in drawing the layout. For example, questions often arise about positioning houses in a landscape. Should they be painted from one point of view or from many? Should a building be seen from the same angle as all the other objects in the composition? Again, your choice of point of view depends on your artistic intentions. Do you want to be realistic and mathematically correct with your perspective, or are you more interested in making the pictorial elements visually pleasing and integrated in your composition? Most students strike a balance between interpretation and realism. A painting

is not an architectural drawing. It is enough to suggest the parallel lines, the relative proportions and dimensions of your building, without being mathematically exact. These suggest an engineered or constructed appearance but actually reflect an intuitive approach. (See Figure 7.67).

After sketching your objects into the landscape, begin to define their various planes with color. Make sure that you use watercolor's ability to be *line and plane* as discussed in one of the exercises in Chapter 4. Define separately the planes of a house, for instance, first by applying a watercolor line and then pulling the still wet line into a plane. Whether you separate your planes with a white line or let each plane dry first before placing another plane next to it depends on your painting style. Note that the painting "Cornice of a House" (Figure 7.68) has no lines separating its colors, yet each plane is made distinct by its solid dark edge. This is another way to make colors of similar values distinct. On the other hand, Figure 7.69 relies

Figure 7.67
CHRISTINE CORTIZAS
Church and Evening Sky.

Figure 7.68
LAURA BROADDUS
Cornice of a House.

mostly on dark values but uses many white lines to separate forms from one another.

The use of block-out solution to help you paint architecture is a personal decision. After they have drawn their composition, many students like to use it to block out certain areas so they can apply a sweeping wash without having to stop for a hard edge. In Figure 7.69, for example, the light reflections were blocked out first. If your architecture is very intricate or has finely delineated detail and much texture, block-out agents might help you in its rendering. For separation of the various planes of a house, on the other

Figure 7.69
SHEILA WELCH
City at Night.

hand, I would advise you against its use. It is difficult to apply in a thin and continuous line; it works much better for irregular shapes. But even if you did succeed, you would miss practice of how to develop a steady hand and of the important watercolor technique – color separation via tiny white lines.

The objects you include in your landscape—be they houses, highways, or trees—are only contributing parts to the mood emanating from your painting. The ambiance conveyed in a landscape depends on the particular light you represent in it. Take a look at the illustrations and note the different types of illuminations: the bright and shadowless sunlight on the lighthouse on Cape Cod (Figure 7.66), the hazy and misty atmosphere of the "Beach Front" (Figure 7.65), or the dim light of the sky (Figure 7.67). Light reveals and conceals. If you paint architecture, make use of these two qualities by defining them with both washes and glazes. The crisp, hard edge of a glaze allows you to define the constructed, three-dimensional appearance of man-made objects, whereas a wash envelops them with the uncontrollable forces of nature.

Some Concluding Remarks

Specific details peculiar to a geographic location make landscapes memorable. Make these the center of attraction. Deciding which elements to emphasize and which to delete is crucial to artistic creation and is often especially difficult in landscape painting. In a Van Gogh wheat field we feel the sun-drenched ripeness of each stalk. The intense focus of the painting transmits the excitement the artist felt while painting it.

Use of color in a landscape is a matter of personal choice. Every painter has a preference for certain colors and for particular ways of using them. But most beginners are timid with colors. I continually urge my students to give up the safety of their personal color schemes, to go beyond them and explore new color combinations. Create new colors by adding primaries and allowing them to interact; this may be the single most important lesson you can learn about watercolor. Knowledge of brushstroke techniques is less essential than an understanding of color formation and its accompanying interaction. Any water-based medium requires skill with a brush, but in watercolor you are always dealing with the interaction of colors. The reputations of some of our greatest watercolorists were made on the basis of their distinctive use of colors.

Not every landscape you try will be successful. Uneven work is quite common for beginners. Sometimes, however, you can save a section of an unsuccessful work by blocking it off and cutting it out. This practice, called *cropping*, is common among photographers. Most photographs you see in magazines and books have been stripped down. A single element has been extracted and blown up. Most painters have an aversion to cropping, because they consider it somewhat unethical. Perhaps they feel that their competence is at stake; a cropped work might show that they had not accomplished what they set out to do. In any case, in most art forms it is difficult to extract a portion of the composition. Canvases, for instance, are stretched on a frame; cropping would mean restretching the painting, a process that is both time-consuming and wasteful. Usually an artist reworks the painting or stretches a new canvas.

With a medium involving paper, such as watercolor, cropping is much easier, since paper can be cut. The traditional watercolorist's aversion to this practice comes probably from a feeling that the artist should be in total command of his or her medium. This notion disregards the artistic decision involved in cropping. Selecting which piece of a painting to save is a decision comparable to those made in planning a composition. Cropping does not mean simply going at the painting with a pair of scissors and cutting off the undesirable parts. Use two *L*-shaped mat board angles to block off sections of the painting. Move them around, narrowing and widening the space between them, until you have found the best section of the painting.*

*This will be discussed further in the chapter on framing (Chapter 9).

I consider cropping a perfectly legitimate practice in watercolor painting. It is *the* final artistic decision, reinforced by matting and framing. It can literally make a painting. In landscape painting, cropping has an added advantage: It can alter the perspective of the composition, changing an aerial, bird's-eye view to a frog's-eye view. Shifting the foreground, the middleground, and the horizon line often results in a dramatic change. A more interesting perspective may suddenly give life to forms in the background. Few other subjects can be changed so dramatically or profit so considerably from cropping as landscapes. But most importantly, cropping gives the artist a second chance or a final say on the composition of the painting. And the sense that no painting is a total loss has a calming effect, particularly on self-critical students.

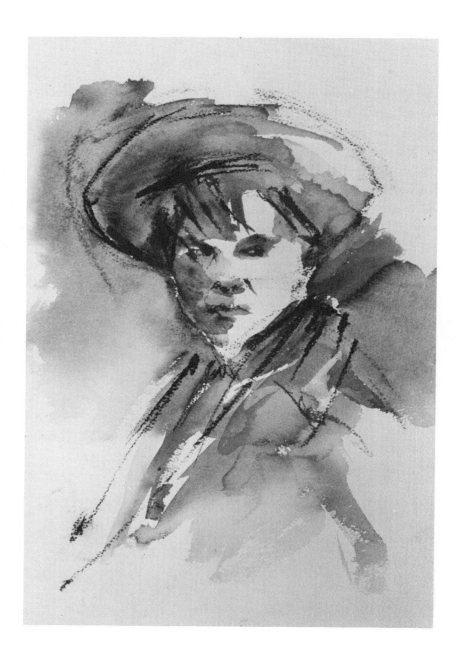

WATERCOLOR PORTRAITS FASCINATE but also intimidate beginners. They are, of course, more difficult to paint than landscapes. The washes and glazes that so readily convey the ever-changing face of nature require much more control when they are used to define the features of the human face. But the subtle color modulations and the quicksilver effervescence of watercolor can capture facial expressions that reveal and conceal momentary feelings. A few spontaneous brushstrokes and a quick color wash record the twinkle of joy in a mother's eye or the fleeting smile of a child, suggesting emotional undercurrents that go well beyond a person's "likeness." And it is this psychological substructure, after all, that makes a portrait captivating and memorable.

Nevertheless, even though they are attracted to its many possibilities, beginners

CHAPTER EIGHT

Portraits

often shy away from watercolor portraits. When confronted with the human figure, many prefer to paint an entire scene, introducing elements from the environment in which the person is posing. In these compositions the human figure usually has no more prominence than do other pictorial elements; still, it lends a certain charm to the painting and often exerts a special influence on the viewer. Encountering the human form in the fictitious world of the artist's imagination is a little like meeting an acquaintance in a strange country. What was once a nodding acknowledgment suddenly becomes an exuberant "hello."

Paintings of the human figure often tell us as much about the times in which they were painted as about the person portrayed. Portraits, as we know them today, were started as so many ground-breaking innova-

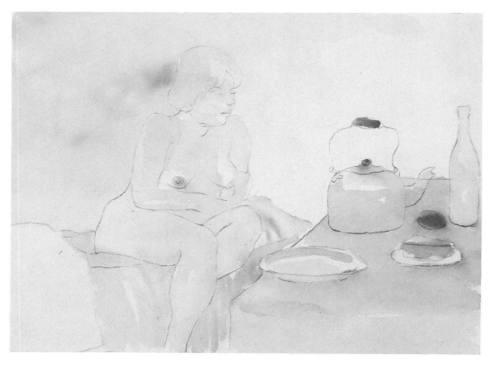

Figure 8.1
LESLEY COOPER
Sitting Figure (watercolor and pencil).

tions in the Renaissance. With the discovery of nature and the focus on man's relationship to his surroundings, the observation of his individuality began. The Middle Ages abstracted the human form, stylizing its features to give them universal significance. Kings and queens were portrayed as emblems rather than as historical personages. In the Renaissance, however, we see noblemen, politicians, and philosophers portrayed with specific characteristics and personality traits, and these are so accurate that in many cases we can identify the subjects from contemporary literary accounts.

Yet even when recording a likeness, Renaissance artists also idealized, because the individual and the specific were considered subordinate to a higher ideal of beauty. Leonardo da Vinci perhaps best shows the paradox of the Renaissance fascination with both

the real and the ideal. Drawn to the deformed faces he saw in the streets of Florence, he followed these people, studying their peculiar physiognomies and recording them in his numerous sketchbooks. He also left us the most famous portrait of all time, the *Mona Lisa*, whose countenance embodies the ideals of beauty and motherhood. Generation after generation has sought the secret of her mysterious smile.

When painting the human figure, the artist traditionally used oil or tempera paint. For sketching or drawing, a *linear* medium such as charcoal, pen, or pencil, was favored, because it better described the curvilinear forms of the human body and was easily controlled. A line made with a pencil stays in place, and you can make alterations by covering over or erasing. A pen line used with a wash is more animated and shares qualities

with watercolor, giving descriptive lines the appearance of planes and thus suggesting volume. Numerous quick pen and pencil sketches of the human figure during the fifteenth and sixteenth centuries used watercolor-like inks (sepia and bister), as an extension of line (Figure 8.2).

The great age of portraiture was the seventeenth century. The Renaissance movement toward individualization continued; but the seventeenth-century portraitists introduced some new elements. Figure paintings began to reveal something of the psychological state and social status of the sitter. With the rise of a wealthy merchant class in northern Europe, the portrait was no longer solely the prerogative of the nobility. People of nearly all social classes could afford to have their portraits painted. Rich merchants in Holland commissioned portraits of themselves in professional attire. Often they were painted surrounded by merchandise or business associates, or performing tasks, such as counting money, that signified their wealth.

For watercolor portraits, gouache was favored primarily because it could be applied spontaneously, but also because it was reversible, thus permitting changes from dark to light by overpainting. Water-based opaque colors could be used like oil paint, but required less preparation and were more convenient to set up. In the seventeenth and eighteenth centuries, numerous delicate gouache portraits, small enough to fit in a shirt pocket, were painted by amateur and professional watercolorists (Figure 8.3). They resemble small oil paintings, and patrons often preferred them because they were less expensive. Water-based painting, however, was still not taken as seriously as oil painting. Along with sketching and drawing, it was considered suitable as a dress rehearsal of

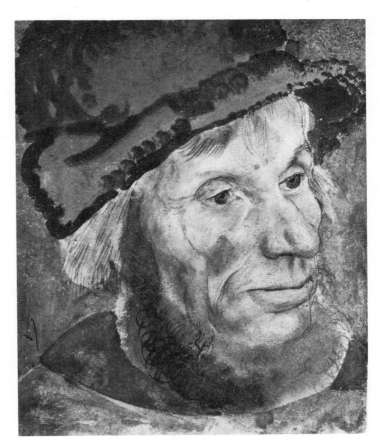

Figure 8.2
LUCAS CRANACH, d.Ä. (German, 1472–1553)
Head of a Farmer (Kopf eines Bauern) (ca. 1520) (watercolor and pen, 8¼ × 10 in.).
Basel, Öffentliche Kunstsammlung Kupferstichkabinett.

Figure 8.3
JEAN HONORÉ FRAGONARD (French, 1732–1806)
Girl with Ground Hog (Mädchen mit Murmeltier) (ca. 1785) (watercolor and bister, 6¼ × 7½ in.).
Graphische Sammlung Albertina, Vienna.

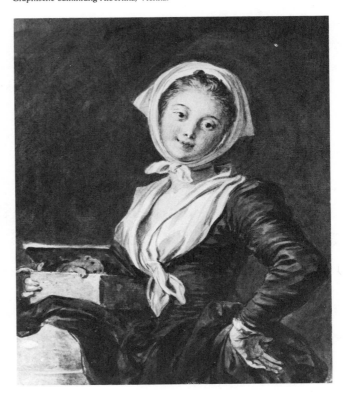

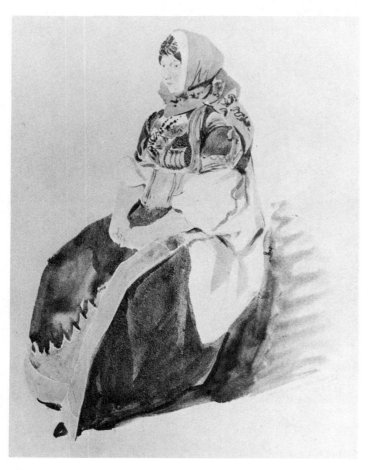

Figure 8.4
EUGENE DELACROIX (French, 1798–1863)
Study of a Jewess (watercolor).
Musée Fabre, Montpellier.

major productions. This attitude prevailed well into the nineteenth century.

In the late eighteenth and early nineteenth centuries, the transparent application of watercolor was more frequently explored for the human figure. But even then, the figure was integrated into a scene in which its colorful attire or surroundings were as important as it was (Figure 8.4). A woman dressed in a colorful costume or the vendors in an open market might be seen in specific attitudes or poses, but little attention is being given to their anatomies. The embroidery on the woman's skirt is as important as the position of her feet. The overall impression

matters most. For the watercolorist, the attire was in fact *more* interesting, providing an opportunity to explore textures, patterns, and a variety of colors. The clothing became a second skin—one that was much less complicated to paint.

The nineteenth century saw a variety of portrait styles. The Romantic artist injected the tension and uneasiness of revolutionary times into portraits of contemporary personalities. Mid-century Realists left few portraits, and the Impressionists, as already noted, were more interested in landscapes. When human figures appear in their works, they blend into their surroundings like blossoms on a tree. Degas and Renoir painted portraits, often emphasizing the inner disquietude of a subject, which was heightened by their fractured painting technique.

The development of the camera ushered in a whole new era of portraiture. This sophisticated device satisfied the growing demand of the bourgeoisie for quick and inexpensive portraits. In many ways it signaled the end of traditional portraiture. Still, at the close of the nineteenth century the painted portrait won again the interest of artists. For some it became a vehicle for social commentary, for others, a means of ethnic documentation. Toulouse-Lautrec used a variety of media (graphics, oil, and watercolor) to depict the night life of Paris, drawing us into the shadowy world of the café houses and the theater (Figure 8.5).

For most turn-of-the-century artists, however, the portrait, like the still-life, was useful for exploring artistic problems and a variety of new painting styles. Watercolor, along with other media, became primarily a vehicle for the exploration of color and form. With the notable exception of Emil Nolde, who painted extraordinary transparent wa-

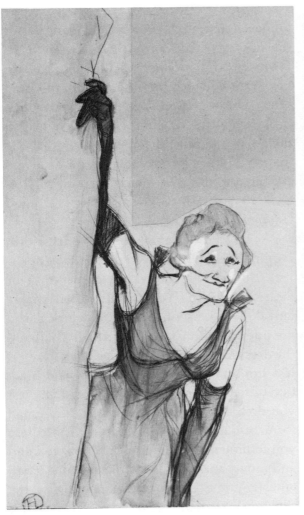

Figure 8.5
HENRI DE TOULOUSE-LAUTREC (French, 1864–1901)
Yvette Guilbert Taking a Curtain Call (crayon and watercolor,
9 × 16⅜ in.).
Museum of Art, Rhode Island School of Design (gift of Mrs. Murray S.
Danforth, 35.540).

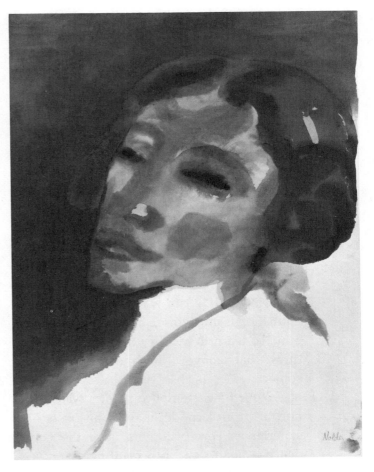

Figure 8.6
EMIL NOLDE (German, 1867–1956)
Portrait of a Woman (watercolor, 13¾ × 18¾ in.).
Courtesy Museum of Fine Arts, Boston (Sophie Friedman Fund, 69.1063).

tercolor portraits, mirroring in the qualities of his paint the personality of his sitter (see the female portrait, Figure 8.6), most artists used the human face and figure as a means for stylistic experimentation. Cézanne painted portraits as he painted still-lifes; so did most Cubists and Fauvists. Henri Matisse painted a number of exquisite oil portraits in the early twentieth century, but most of them were excuses for experiments with color. His numerous drawings in pen, pencil, and brush and ink better capture the personalities and psychological states of his sitters. Look at one example in Figure 8.45.

Today, interest in portraits varies considerably. The camera has largely taken care of the need for portrait painting.* The linear media, such as pen, pencil, and pastel, are still favored for the human face or figure, perhaps because they are easier to control. Watercolor portraits are usually painted by seasoned painters, by more traditional watercolorists,

* An interesting hybrid combining the camera and painting can be seen in photorealism, especially in the portraiture of Chuck Close.

or by those who use the medium as if it were gouache or oil. For every dozen landscapes, perhaps only one or two transparent watercolor portraits exist. Still, this should not discourage beginners.

In painting a portrait, you will be confronting problems similar to those you faced in still-lifes. You can begin by painting the human figure in a context (a room or a landscape), using some of the techniques you have already mastered. Remember, though, that you are not just dealing with the still appearance of a still-life object. You now have an animated pictorial element: a woman seated on a chair or reading on a couch. (See Plates 30 and 32.) In watercolor portraiture, animation is much more important than anatomy, so learn to identify the poses and gestures that convey the most about your subject.

Your first attempt to paint a watercolor portrait from a model may be an unsettling experience. Few beginners have the confidence to leap right into painting. Even seasoned portraitists feel a twinge of anxiety before taking the plunge. You must bring two important skills to the sitting: the ability to see the general shape of the face, and the ability to flesh out that shape with the individual attributes and features of your sitter. Observational skill combined with good hand–eye coordination form the basis for successful portraiture.

Beginning students first attempting watercolor portraiture often produce primitive likenesses, images that could have been carved on a totem pole or painted by a preschooler. They do not actually "see" the human figure this way, but they lack the skill to create watercolor equivalents (forms, values, lines, and planes) for what they see. The crudely painted portrait is also a result of

a focus on the external appearance of the human figure, with little or no awareness of the internal mechanisms that determine its forms and functions. Like the child, beginners translate what they see into a simple and often crude pictorial language. Although these delightful human images touch us with their naive charm, they remind us that the human figure is one of the most intricate and challenging subjects. It can often take a lifetime to achieve the necessary visual and technical mastery.

The study of anatomy was once a firm requirement in art education, and traditionalists still consider it necessary preparation for figure painting. It is, undoubtedly, an important skill, and essential for watercolorists who are interested in painting nudes. If you paint the dressed figure, a knowledge of anatomy is less important. To orient yourself and practice observational skills, however, I suggest you do a few pencil sketches of the human form, or quick movement studies. These help you to understand the body's ability to bend and move, and the variety of positions it can take (Figure 8.7). An understanding of the skeleton's structure and its mechanics will prevent confusion when your model suddenly changes position, altering his or her appearance entirely.

You can also do these quick studies with watercolor (as seen in Figure 8.8) to improve your visual rendering in washes and glazes. Five- or ten-minute poses are sufficient to pick up your figure's essential movement and record it with color. In fact, the shorter the pose, the more you must "tune in" to the animation of the figure and the less you can be concerned with superficial details.

In movement studies of this sort you must proceed from the general to the particular, especially if you decide to use them for

Figure 8.7
LEONARD NEWCOMB
Studies in Motion (pencil drawings).

Figure 8.8
JANE BARROW
Six Movement Studies (watercolor).

more elaborate compositions. Your goal is to become familiar with the intricacies of the human figure in motion and to learn to speak with eloquence its complex visual language. (See the example of "Four Movement Studies," Plate 29.)

To shift from the human figure to the face, you must first of all train yourself to see objectively which forms are basic to the human physiognomy and which are individual traits. This sorting-out process is similar to the one I suggested for painting fruit and plants in a still-life.

When you are trying to paint a face, first analyze its basic forms. The skull is anatomically the same in every person; it varies, however, in shape and size. Your model may have a large cranium, a protruding jaw, and widely set eyes, but these features are placed in the same proportional relationship to each other on every human skull. Each of these parts also has its basic shape and form, determined largely by position and function. These are the genetically distinct aspects of human physiognomy. Individual variations in size and shape make each of us unique

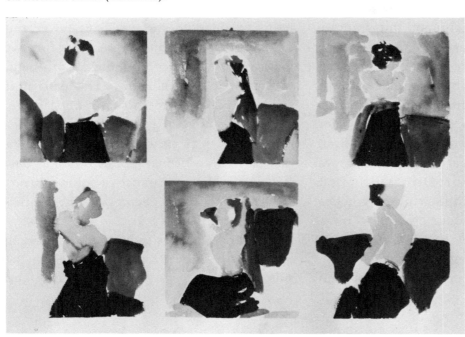

among human beings. A guide to general forms, however, will help you to render the specifics you will be facing on your own.

Contour of the Face

When we look at a face, we see the skin and individual features. Rarely do we note its contour or particular shape. As an artist you will have to train yourself to focus first on the face's "contour" and then on its surface distinctions.

The contour of the face has a particular shape and volume. It is, of course, part of the head, even though a hairdo (particularly on women) or a hat might disguise this fact. You must develop a "painter's eye" that looks beyond decoration and sees what at first glance might not be readily apparent. Practice by noting facial contours in daily life, on the people you meet, and in photographs and artwork. (See Plate 34.)

The particular appearance of the facial contour is important as an indication of a person's age, much more so than skin texture, hairstyle, or dress. Newspaper halftones, for example, are usually not sharp enough to show skin texture, but they show the firmness of the facial contour, and thus indicate roughly the subject's age.

In young faces, the muscles are firm and the skin is tightly stretched over the skull. In a baby's face, as in a plump, succulent fruit, the subcutaneous layers of fat and the water content of the skin tissue account for a firm, smooth, and round facial contour. Alas, as we grow older, the water content and the fat layers diminish, and in their place wrinkles appear. The facial contour gives in to these changes, becomes uneven, and sags.

Light reflects differently from a smooth, taut surface than from one that is uneven and

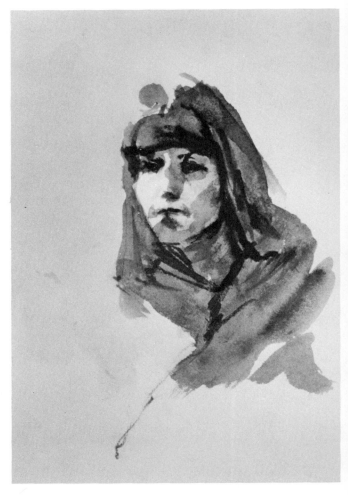

Figure 8.9
HOPE EPSTEIN
Male Portrait (volume of head is emphasized by light/dark color values).

wrinkled. Smooth surfaces have fewer and broader shadows, while the lines and furrows of an uneven surface trap and absorb light, thus creating more shadows. This pattern of shadows accounts for a face's appearance. Your light source in a portrait setting, therefore, becomes an extremely important agent that reveals and conceals, distorts and flatters. Just as the appearance of color depends on light, so to a large degree does the appearance of form (Figure 8.9).

Portrait painters usually prefer a strong light source, either from above or from the side, because it creates distinct shadows, and

defines the features. Strong light also emphasizes facial contour and the three-dimensional aspects of the figure. Needless to say, shadows thus created are not always the most flattering. A commercial photographer using such lighting for portraits would infuriate customers. Subjects might instantly age ten to fifteen years. This is why in portrait photography light sources are usually distributed evenly from all angles.

Daylight, evening light, and candle light all cast different shadows and create special effects on the human face. Pay attention to these differences, and note how texture, color, and facial contours depend on them. Most of all, be aware of the difference between the face's three-dimensional structure and its texture. The distinction is essential: The first is volume; the second, surface.

Facial Features

Beginning portraitists struggle most with the features of the face. The eyes, nose, and mouth all have intricate shapes whose forms and functions must be understood before they can be rendered accurately. Rendering them with watercolor is particularly difficult, because the fluid nature of the medium is not easily controlled. For this reason, watercolor has the reputation of being a difficult art.

The features of the human face are anatomically alike in all people. It is their shape, size, and relative proportions that differ in individuals. The expressive use of these features also gives each face its identity: The eyes may be squinting or wide open, the lips tightly set or turned upward in a smile. We decipher these characteristics as signs of emotions. The features are also the parts of the face most affected by physical and psychological health and by the wear and tear of

time. Again, train yourself to notice individual variations while you are comprehending anatomical similarities.

If you want to paint a human likeness, few pictorial elements are necessary to convey the face. Paint a circle, add two dots and a vertical and horizontal line; instantly you have a face. Although extremely schematized and scarcely personal, it still suggests a human appearance (Figure 8.10).

In watercolor portraiture, however, improvisation, abbreviation, or exaggeration are always based on understanding and comprehension. In fact, the most abstract and distorted portraits by painters such as Matisse or Picasso are clearly based on a thorough knowledge and mastery. You must know what you are leaving out before you take shortcuts. (See "Woman with Flowers," Plate 35.)

Watercolor portraits demand more accuracy than do landscapes or still-lifes. In landscapes, and to some degree in still-lifes, a haphazard brushstroke can mean a happy accident and give your composition an interesting twist. In portraiture, however, accidental

Figure 8.10
Schematized head (pencil drawing).
Illustration by Inessa Derkatsch.

strokes (especially in the area of the face) are more difficult to integrate into the composition. It will be hard to convince your viewers that the brightly colored stripe across the forehead represents the eyes of "Mrs. X." Even though you may choose to abstract or abbreviate the facial features, you must give them enough definition so that the viewer can decipher them.

How do you paint the eyes, the mouth, and the nose of a face? Beginners asked to look at a model and to paint the face from "real life" are usually at a loss. Even if they know what to look for and can distinguish the

Figure 8.11
INESSA DERKATSCH
Young Boy (quick calligraphic rendering of a portrait).

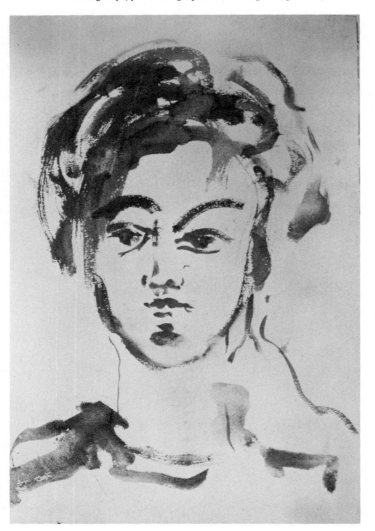

basic forms from the superficial details, they find it difficult to translate what they see into pictorial shapes and forms. Thus, before you begin work, take a look at earlier styles of portraiture and observe the sorts of *visual equivalents* that were used for the eye or nose in primitive, Egyptian, or Renaissance art. Artists learn from one another, and certainly from history. Each generation of painters does not invent its own visual vocabulary, but rather builds upon the pictorial language of previous generations.

Practice drawing the features until you understand their shapes; then you can warm up to watercolor portraiture by practicing with brush and ink in a calligraphic style (Figure 8.11). Ink has the same fluidity as watercolor and allows you to learn three-dimensional structuring with washes and glazes without the complications of color. Students sometimes concoct fantasy portraits while practicing basic facial features. This exercises the imagination while building up technical skill. For the same purpose, you may also use photographs and paintings. Painting from photographs may be more challenging, because you must invent your own visual vocabulary while translating one medium into another. Painting from paintings, on the other hand, teaches you about an artist's choices, in terms of color, shapes, and composition. Compare the similarities and differences in your various renderings, noticing whether you have mastered the basic anatomical structures. Understanding them is a crucial step toward painting them with watercolor.

In the next section I will discuss the individual features and the basic procedures involved in painting them with watercolor. When you have mastered these, you will be ready to begin preparation for the portrait sitting.

Eyes

Seen in profile, eyes have a recessed appearance, fitting into the eye cavity of the skull. But they also protrude from the socket as round, semiconvex forms. How much they protrude varies with the individual. In schematized terms, we can refer to the eye as a *ball and socket* (Figure 8.12).

To give the illusion of the eye's concavity and convexity, use the same light–dark color modulation that you employed to indicate the roundness of fruit in a bowl. The eyebrow forms a half-crescent above the eye, indicating the upper part of the eye's socket. It is usually on the same level of protrusion as

Figure 8.12
CAROL HOOVER
Male Portrait in Profile.

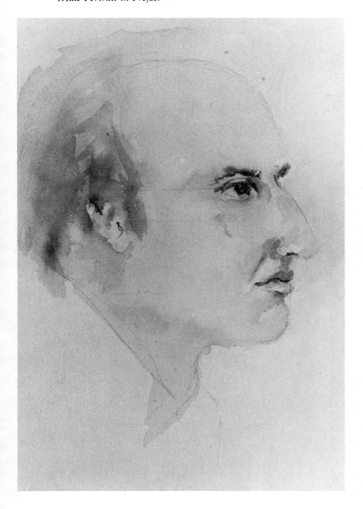

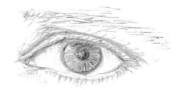

Figure 8.13
SUSAN ARON
Drawing of an eye.

the cheeks, especially when the face is seen from three-quarter view.

Before painting the eye, sketch its outline with a soft pencil, but not as precisely as in the example (Figure 8.13). The eye of a human does not resemble that of a fish; it is not an almond shape with a circle in it. The upper eyelid always covers from one-half to one-third of the iris, unless your subject is watching a horror movie. The lower lid usually, but not necessarily, touches the iris. (See Plates 31 and 34.) Again, this is an individual difference you should watch for. Smiling eyes move the lower lid upward (pushed up by the rising cheeks), and the iris may be covered by it as much as by the upper lid (Figure 8.14). The ability to use the eyes expressively without making many other facial movements is usually the sign of an accomplished actor or actress, and can be studied in close-up shots in films. A smiling mouth unaccompanied by eye movement is not very convincing and often appears phony.

The upper lid stretches over the eyeball and helps to indicate the curvature. Its extension over the iris is therefore much more vital than the lower lid's in the rendering of the eye's basic shape. The lower lid, on the other hand, does not have to be pronounced, because it usually blends into the shadowed area underneath. (See Figure 8.15 and all of the other examples mentioned thus far.) The upper lid also retracts, pulling behind a bulge

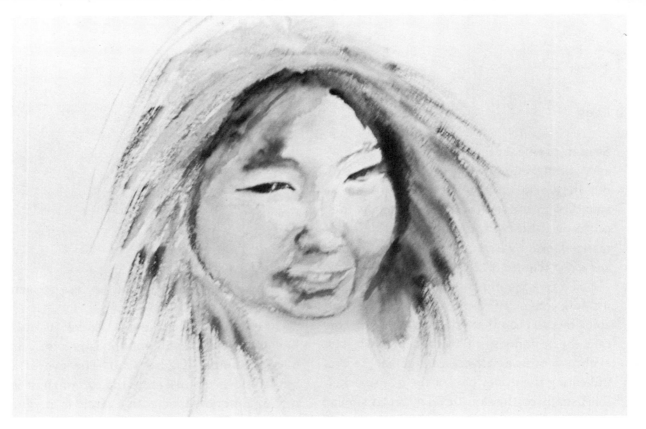

Figure 8.14
CAROL HOOVER
Smiling Eskimo Girl.

Figure 8.15
MELISSA CAMPBELL-RILEY
Two Figures (after Emil Nolde).

Figure 8.16
DEIDRE MENOYO
Old Man with Beard.

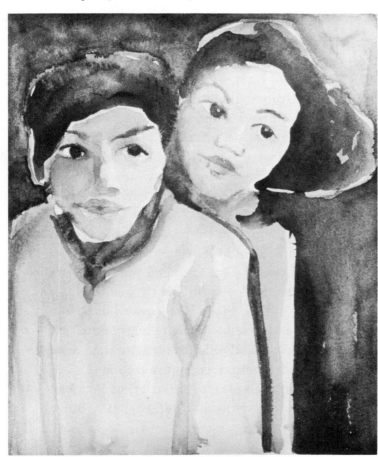

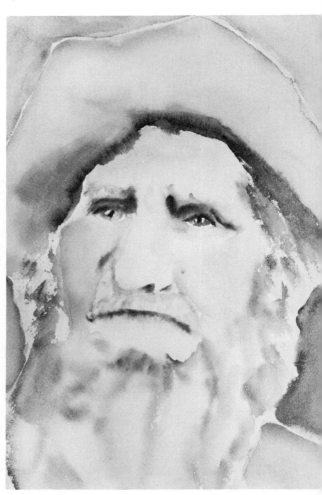

of flesh underneath the eyebrow. The prominence of this bulge varies. In Oriental persons it is quite heavy, letting just a sliver of eyelid show. The older we get, the more this bulge of skin sags, until it covers more than half of the iris and gives the eyes a tired look (Figure 8.16).

Practice drawing the eye and applying color to emphasize its form and three-dimensionality. Learn to make adjustments in order to portray the eye from different angles. Keep in mind its basic structure: The same elements are relevant here, whether the eye is seen in profile, three-quarter view, or frontal position.

Use the following step-by-step procedure to paint the eye. Draw the shape of the eye from, let us say, a three-quarter point of view. Indicate the eye socket with a cool color, preferably a primary color, such as blue. Apply more cool color (such as a purple or green) in the corner of the eye closest to the nose. This is the farthest-recessed part of the face. (Think of the eyes as pinched into the sphere of the head; this is the deepest part of

the pinch.) The other corner also gets some cool color, although not as much. By defining the eye socket with cool colors on either side, you begin to get a protruding eye ball. A little demarcation of the lower lid and quite a bit of the upper (use a double line) indicate the shape of the eye. The eyebrow's crescent shape reinforces this bulging curve. Paint it darkest and thickest close to the nose, thinner and lighter toward the cheekbones. A highlight just underneath the eyebrow indicates the bulge and makes the eyelid seem to slide beneath it (Figure 8.17).

The iris has three important parts. First, its periphery: This is usually colored, and, depending on the individual, can be of various blues, greens, and browns. The lens within the iris is always dark and can be more or less open, depending on the light. It is not crucial for you to be exact; usually the lens is painted as a dark disk floating on the iris. What is important, however, is the highlight within the lens and the iris, which also depends on the light source and on how close a view you are painting. The cornea encasing

Figure 8.17
DEIDRE MENOYO
Detail of eyes from *Portrait of a Young Woman* (Plate 34).

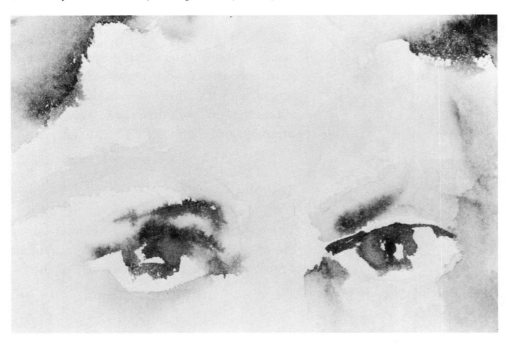

the whole eyeball is highly reflective. As light falls on it, a highlight appears in the middle of the iris, giving the eyes their lively quality. Eyelashes give color and depth to the eye, but cannot be painted. The best portraitists cast a faint shadow of the lid on the eyeball to indicate some of the eye's depth.

Again, when painting with watercolors you do not have to be absolutely precise about the outlines of these parts. In fact, the more you comprehend the salient parts of each feature, the more you can abbreviate (Figure 8.18). The iris can blend into the surrounding area and still be convincing. You

Figure 8.18
DAVID HALVORSON
Woman in Red Chair.

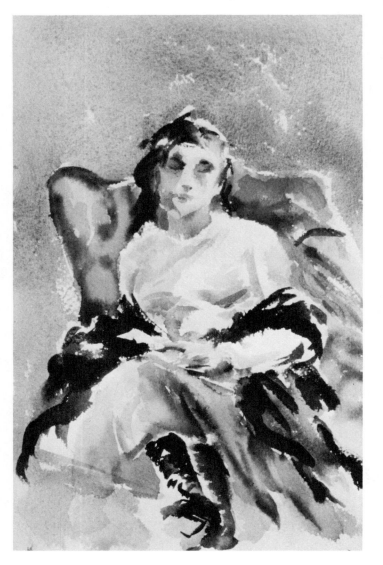

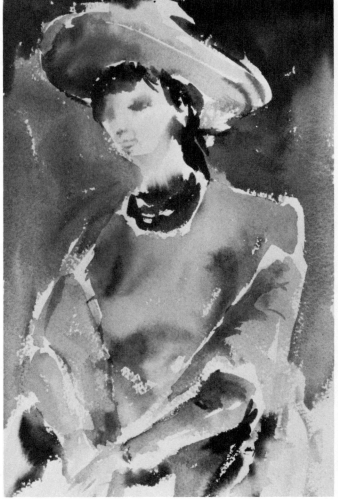

Figure 8.19
DAVID HALVORSON
Woman with Shawl.

can give the outlines of the eye a soft-and-hard appearance—*lost and found,* as one watercolorist describes it—with washes and glazes that are both crisp and hazy. (See Figure 8.19, and Plate 33.)

The Nose

The nose gives the face character and is often the most distinctive feature of an individual. Think of the classical Roman nose or the Es-

Figure 8.20
SUSAN ARON
Stippled drawing of a nose, indicating shadow pattern.

Figure 8.21
SUSAN ARON
Drawing of a nose: front and profile views.

kimo nose, and notice how you can identify cultural and ethnic groups by noses. Take some time to observe noses around you and note how they can characterize faces.

The nose is, without a doubt, the most complex form in the human face and, for many artists, the most difficult to paint. Identifying its most important parts will make the rendering of individual noses easier (Look at the drawing, Figure 8.20.)

Invariably, noses are made up of three parts, the bridge, the tip, and the wings (nostrils), which are all assembled in a wedge-like structure. These three parts meet at the tip of the nose (Figure 8.21). Each part varies in shape and size. The bridge can be wide or narrow, long or short, crooked or flat. The tip can be full or pointed, turned up or down. The wings can be flared and curving, or flat against the tip; their shape and size determine the shape of the nostrils. Visibility of the nostrils depends on the projection of the tip, its upward or downward curve, and on the tilt of the head (Figure 8.22).

Figure 8.22
SUSAN ARON
Watercolor wash indicating the different planes of the nose.

Obviously, the nose is painted most easily in profile, because from the side its basic wedge-like structure can best be observed, and its parts are easily recognizable and fit together logically. (See the "Male Portrait in

Profile," Figure 8.12.) A three-quarter view of your sitter also shows contour but requires foreshortening. Depending on the direction of your light source, one of the wings may be partially hidden from view and either highlighted or in shadow. The area underneath the nose is usually in shadow and marks a significant transition to the upper lip of the mouth. (See Plate 31.) Indicate this shadow with a cool color, and note the tiny shadow in the groove between the tip of the nose and the upper lip's two points. (This visual and structural joining of the nose and mouth is a principal aspect of characterization, as seen in the illustrations.)

Figure 8.23
HOPE EPSTEIN
Girl in Three-Quarter Pose.

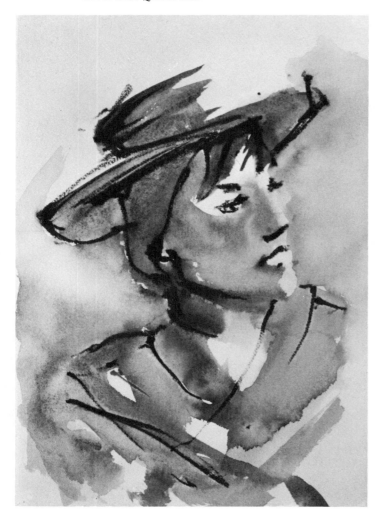

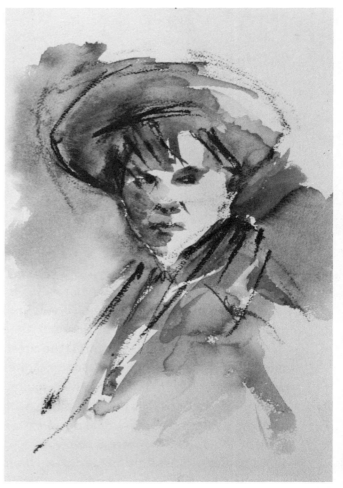

Figure 8.24
HOPE EPSTEIN
Young Boy with Straw Hat.

Since the nose is a projecting part of the face, as are cheekbones, eyebrows, and chin, highlight it with a warm color, as the "Portrait of a Young Woman" shows in Plate 34. It must seem to rise from the face. The parts of the nose (the bridge, the tops, and the wings) are joined at various angles; when you are defining them, indicate these angles not with rigid lines but with a series of light-and-dark color modulations (Figure 8.23).

Color washes often help you to make subtler transitions. Let the wetness of the paper work for you. Cool colors, such as those used for eye sockets or the corners of

the mouth, can also be used for subtle tonal nuances or middle values on the nose's various planes. The nostrils, of course, are quite dark by contrast and should be painted with a fairly dark hue. Their visibility depends on the sitter's angle and the head's position, but they can be just as distinctive as the eyebrows or the mouth (Figure 8.24).

The Mouth

The mouth presents the same painting problems as the eyes and nose. What are its basic parts? How do the parts fit together, and how do they, in turn, fit into the face?

The mouth stretches literally around the sphere of the head. Starting with the corners of the mouth, which are little grooves or small hooks, depending on the person's age, it curves around the dental arch, swelling out toward the middle of the face, and narrows again toward the opposite corner. (See the drawing of the mouth, Figure 8.25.)

There are only two parts to the mouth—the upper and lower lips—but they are two distinct shapes, each of which has its own form. The way they fit together indicates a specific expression on the face. For example, an open mouth with teeth showing might indicate laughter or astonishment. A tightly set mouth causes the planes of both upper and lower lip almost to disappear, as in the "Girl

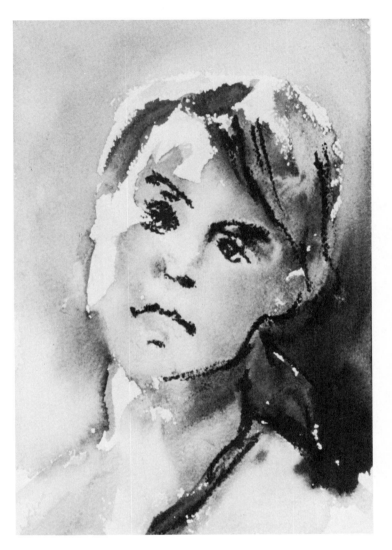

Figure 8.26
HOPE EPSTEIN
Girl with Sad Expression.

with Sad Expression," Figure 8.26. Thus the mouth is the most mobile part of the face, capable of more expressive variation than the other features are.

Let us assume for now that we are dealing with a closed mouth in a state of rest. No big smile or tightly set lips. The shapes of the upper and lower lip differ considerably. The upper lip is thinner, more defined, and fairly flat; the lower lip has more bulge and more curvature. In light coming from above or

Figure 8.25
SUSAN ARON
Pencil drawing of a mouth.

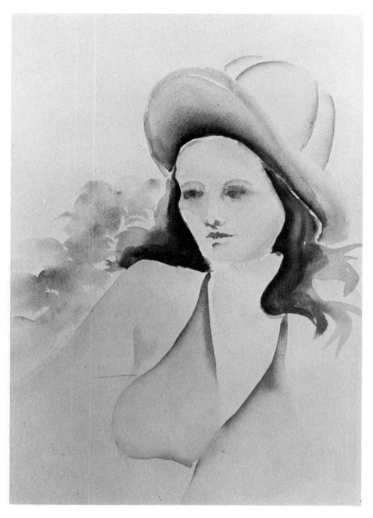

Figure 8.27
KATHY DIDONATO
Woman with Blue Hat.

Figure 8.28
DEIDRE MENOYO
Detail of mouth from *Portrait of a Young Woman* (Plate 34).

from the front, the lower lip will be high-lighted and the upper lip will be in shadow. It is this unique combination of light and dark that gives the mouth its distinct appearance.

When you are painting the mouth, first indicate the curvature. Start with the corners, making them fairly dark, and then let your brushstrokes swell out and become lighter as they move into the center. (See Plate 33.) Once the general protrusion is defined, you can differentiate the upper lip from the lower. The upper lip is usually in shadow, and the darkest part of the shadow is where the two lips meet. Think of the shadow as a small wedge that has been chopped out, leaving the upper lip somewhat flat in comparison to the bulge of the lower lip (Figure 8.27).

The lower lip gets its definition from the shadow underneath it, the little dip or groove that is actually part of the chin. This shadow should be darkest underneath the center of the lower lip and lighter as it moves into the corners. Highlights above the lower lip can be broad or slight, depending on the size of the mouth. These also indicate the lip's curvature and bulge (Figure 8.28).

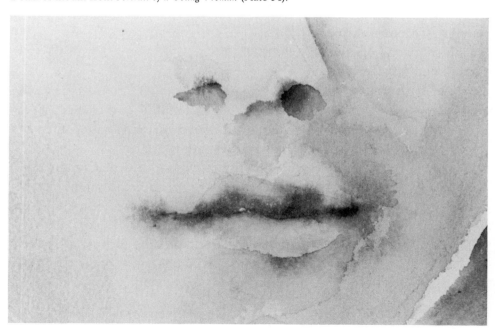

Integrate the mouth into the face and do not let it float on its surface. Use the corners of the mouth to anchor it; they provide structural support, can lift or lower it, and draw it together or stretch it, depending on the individual's expression. Because of its mobility, the mouth is thus an important indicator of the sitter's feelings. It is also vitally important in portraying age. Since it is supported by facial muscles rather than by bone structure, the mouth tends to become lax as the muscles lose their firmness. (See the "Old Man with Beard," in Figure 8.16.) In a youthful mouth the corners are uplifted and set tightly into the cheek muscles, as in the "Portrait of a Young Woman," Plate 34. There are no pronounced wrinkles on either side, and the transition from corner to cheek is fairly smooth.

Expressiveness of the Features

The eyes and mouth are considered the most expressive parts of the face. They are also the most mobile features, creating by subtle shifts a variety of expressions. Think about how the slightest movement of the eyes or the corners of the mouth produces a smile or a frown. Other parts of the face move as the eyes and mouth shift position. The cheeks, for instance, are lifted when we smile. Eyes, and the lines around them, distinguish a person and show age especially well. Perhaps that is why they are called "the mirror of the soul." It is interesting to note that newspaper editors block out the eye area in photographs to conceal a person's identity.

As we grow older, our faces become more expressive because our features become more sharply delineated, literally carved into our faces. Thus the slightest movement animates them. We lose facial padding and gain thousands of fine lines that fall into place with our habitual expressions of emotion. A mature person automatically carries an expression on his or her face, without even moving the features. It has been said that after forty, people have the faces they deserve.

After you have mastered the basic forms of the facial features, begin to study different facial expressions. After all, a perfectly rendered mouth or eye is not what portraiture is all about. It is concerned with the emotion emanating from the sitter, the feelings that we get from looking at a face; these must be captured in a memorable portrait.

Preparation for Portrait Painting

When you confront your model for the first time, you will have to make decisions about the composition of your watercolor. Look carefully at your model and at the setting and note the aspects that you want to emphasize. Do you want to focus primarily on the face, or will you also include the shoulders? What about the attire, the colorful blouse or that funny hat your model might be wearing? Are there interesting things in the environment, such as a nicely shaped chair, a bouquet of flowers, or a colorful rug?

A few thumbnail sketches will help you to decide what to focus on when looking at your model and what to emphasize in your composition. These may be brief outlines in pencil (as in Figure 8.29) or more elaborate studies of a feature's shape and placement on the face. If you do them with watercolor, you can experiment with different color combinations, structuring the appearance of your fig-

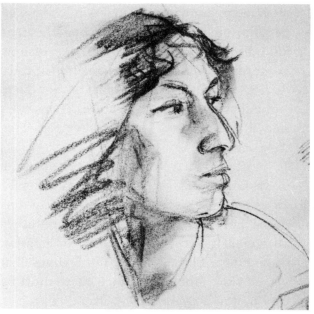
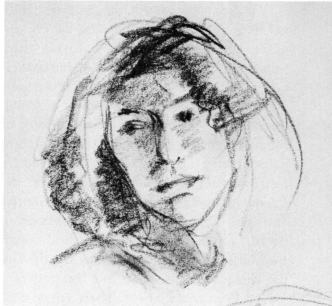

Figure 8.29
LEONARD NEWCOMB
Studies of heads (drawings).

ure with cool and warm or light and dark values. At the same time, you can use color to define your particular compositional point of view (Figure 8.30).

If you decide to paint only the model's head, focus mainly on the face, as many beginning watercolorists like to do. Use the features to make a statement about the subject's personality, provided that you are interested in portraying his or her likeness. However, also be aware of how the *attitude* of the body, especially of the shoulders and arms, carries a powerful emotional message. Square shoulders held rigidly or shoulders hunched over in a relaxed position say something about the emotional state of your sitter; if emphasized in your painting, they carry part of its expressive content (Figures 8.31 and 8.32).

If all of this seems too complicated at first, expand your vision of your sitter by introducing supporting agents: Emphasize his

or her activity or attire, or the background. (See Plate 30.) You can take an overall view of the situation and paint it almost as you would a still-life (Figure 8.33). In this case, you are expressing more about the situation than about the personality of the sitter, but this can be a way of easing into portrait painting. Many watercolorists (not just beginners) prefer to paint the human figure in a context, because this allows them to introduce additional colors, textures, patterns, and shapes. (See the "Jamaican Festival" in Plate 36.)

How much to draw on your watercolor paper after you make your thumbnail sketches is up to you. You can transpose the compositional arrangement in your sketch with very general lines. Remember, this drawing only serves as a layout to help you plan color application. Sketch it with a light touch, making sure that your pencil lines will not compete with your colors, especially if you plan to use light values. If your pencil

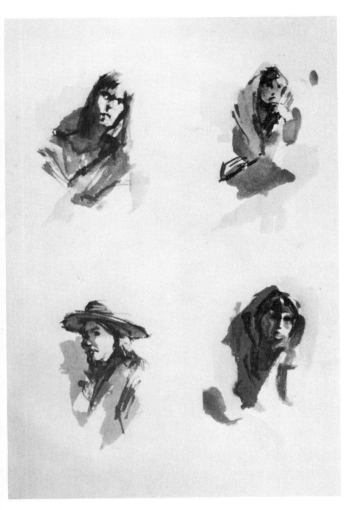

Figure 8.30
HOPE EPSTEIN
Quick preliminary watercolor sketches.

Figure 8.31
LAURA BROADDUS
Sitting Figure.

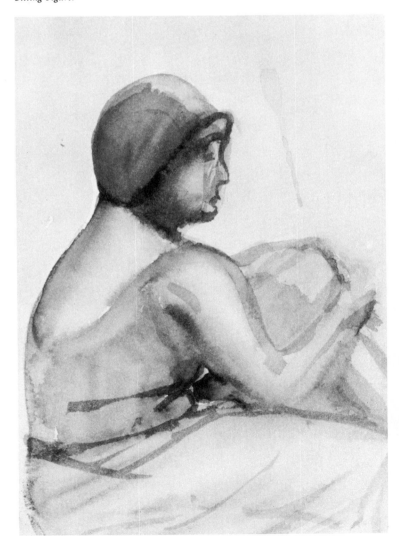

189

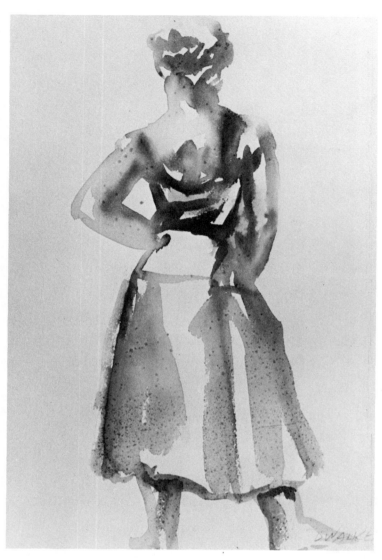

Figure 8.32
DANIEL WALKER
Standing Figure.

Figure 8.33
ALEXA THAYER FULLER
Woman in front of a Window.

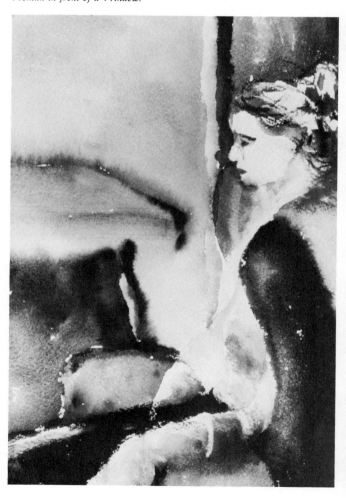

190

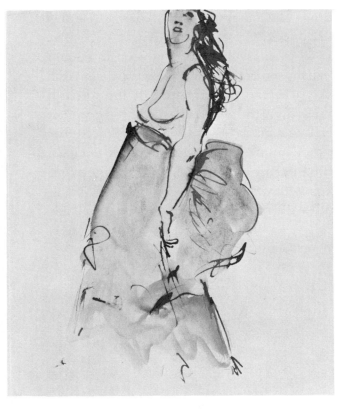

Figure 8.34
ROBERT HENRI (American, 1865–1929)
Nude Model with Blue and Red Skirt (brush and watercolor,
10 × 12⅜ in.).
Courtesy Museum of Fine Arts, Boston; 63.444.

Figure 8.35
LAURA BROADDUS
Sitting and Standing Figures.

lines are too dark and pronounced, viewers may see your work as a "colored drawing" rather than as a watercolor. If this is what you want, I suggest that you immediately use the pen and ink approach and combine it with a watercolor wash, as in Figure 8.34.

Many watercolor portraitists prefer to do little drawing and to start painting immediately, in order to take advantage of the spontaneous behavior of the fluid colors (Figure 8.35). If you are hesitant about jumping right in, make a few quick watercolor sketches on newsprint or on any other inexpensive paper, to warm up and focus your vision. (See Plate 29.) This procedure lets you practice without the pressure of accomplishment. I do not consider painting a portrait on quality watercolor paper until I have done at least three quick watercolor sketches.

Head–Neck–Shoulders

As most of the illustrations show, beginners like to focus on the upper torso of the human figure and paint it in a variety of attitudes.

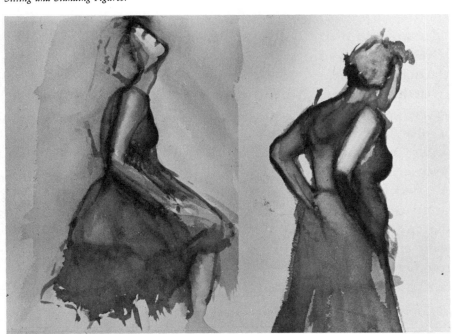

Figure 8.36
SUSAN ARON
Schematized drawing of head–neck–shoulder relationship.

Most of the models are dressed, and their anatomies are disguised. Nevertheless, you must think in terms of the support system (armature) underneath that clothing. Indicate the set of those shoulders even if they are covered by a shawl or a fur collar. One way of making the *head–neck–shoulder* relationship intelligible is to think of it schematically: The shoulders form a square, the neck a cylinder, and the head a sphere. Assemble these one on top of the other (as in the drawing, Figure 8.36). When you paint your model sitting, partially reclining, or twisted and bent, the shapes and the relationships remain the

same. Only their positions change (Figures 8.37 and 8.38).

Let us assume that you want to paint a realistic portrait focusing primarily on the face. Keeping the armature of the torso in mind, draw the general shape of the head (an oval) and mark the position of the facial features within it. Your pencil marks do not have to be precise or detailed; work out specifics later with watercolor. Still, you must be accurate with size and placement. These details

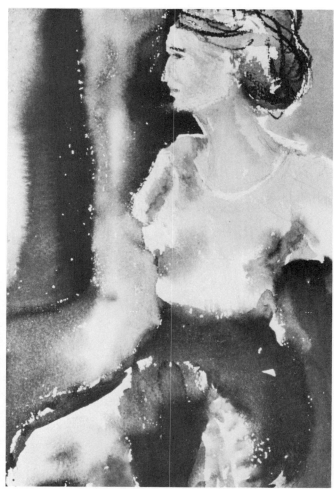

Figure 8.37
ALEXA THAYER FULLER
Woman in Profile.

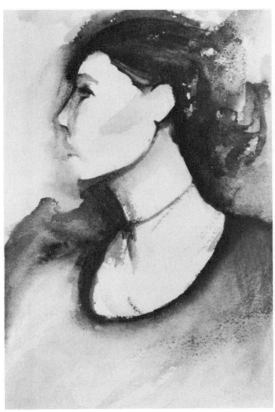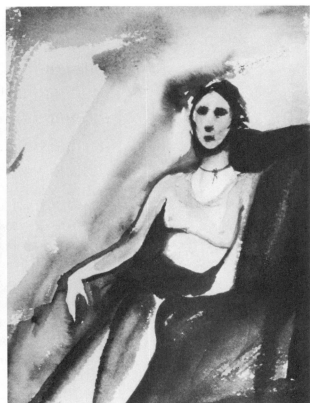

Figure 8.38
MICHAEL BOWIE
Double Portrait.

are essential to producing a good likeness. The length of the nose and the shape of the jaw, for instance, may give clues to gender or ethnic background.

I have stressed your working from the general to the particular in order for you to retain the transparency of watercolors. In portraiture there is another rule: *Work from the most important features of the face to the least important.* Since the eyes are the key to a good likeness, start there. Then proceed to the nose and mouth (the mouth is usually painted while you are defining the lower part of the nose), and wrap up by defining the contour of the face.

Be aware of the "hills and valleys" of the face while you are painting the eyes, and define the advancing and receding parts using cool and warm colors, in addition to lights and darks. The eye's recessed quality has to be balanced with the protrusion of the eyebrows and cheeks. The upper part of the face, the cheekbones and the forehead, can be filled in with a line or with the shape of the hair. If your model has shoulder-length hair it can define the contours of the face.

The neck and shoulders follow. Beginners frequently have trouble painting the neck so that it sits properly under the head. Remember, the neck can be compared to a cylinder. Emphasize its three-dimensional quality by shading. To push it back from the chin, paint it in darker or cooler hues than those you have used for the rest of the face (Figure 8.39). Often a shadow cast onto the neck by the chin will give it a recessed ap-

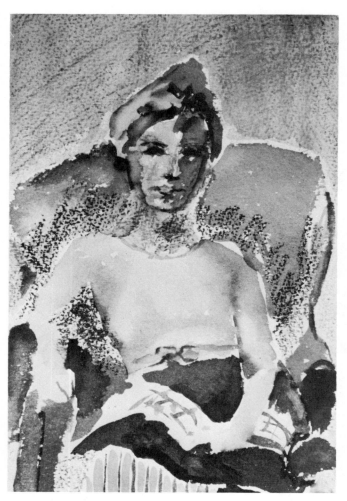

Figure 8.39
BETSY KAUFMAN
Woman in Green.

your watercolor all visual elements should have equal weight and artistic significance.

Painting your portrait in this order has many advantages. It helps you to concentrate your efforts where they matter most. If you paint the eyes first, you will know immediately whether you have captured the person's likeness. You can conserve energy by working until you have mastered this important feature. Then go on to the next most important part. Place all the features into their proper relationships before you set definite margins (Figure 8.41). Working from the inside of the face (features) outward (to the contour) also provides flexibility. Positions can be changed and proportions altered while you define the features. If you paint the contour of the face first, however, you will have limited the area before finding out whether you can fit in all the features. Often a hairdo, a fancy headdress such as the fur hat of the Eskimo girl in Figure 8.14, a hat, or a scarf can shape or replace the facial contour. By leaving the contour open, you can improvise and be more daring with externals.

Color of the Face

Traditional portraitists usually mix a combination of red, yellow, and brown for skin color. The face is covered with this tonality except for protruding parts, which are left white. The receding parts are darkened while the individual features are defined. The result is usually a lifelike skin tone in an often lifeless portrait. This traditional procedure does not employ watercolor's greatest asset: color formation by the use of washes and glazes.

For a transparent portrait, apply colors in primary hues directly onto the paper

pearance. Highlight the chin with an advancing color (red or orange) to bring it forward. Place the neck on the shoulders, if you plan to include them in your portrait. If you paint them covered by clothing, do not give them more detail than you have given to other parts of your portrait (Figure 8.40).

Be careful to balance all the parts of your portrait. The hair should not overpower the face and appear to be too heavy for the head and shoulders. Within the composition of

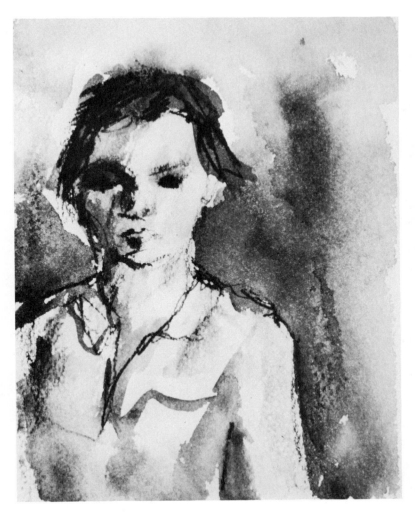

Figure 8.40
VALERIE BOLGER
Little Girl.

without premixing. Paint your portrait with successive color layers, defining shapes and volume with cool and warm colors as in a still-life. Blues and yellows make excellent bases, since they allow maximum color formation. Consider those "hills and valleys" of the face again and apply colors accordingly. (See Plates 31 and 34.) Try blue, for instance, for the receding parts of the eye, the corners of the mouth, or the dip in the chin. Yellow or red can highlight the advancing parts, such as the forehead, the nose, the chin, and the cheekbones. Allow these primary colors to interact and form secondaries (purple, green, and orange) or combine complementary colors (orange and blue or purple and yellow) to produce muted hues. Working additively in this way permits subtle transitions from one facial contour to another. Flesh tones are actually achieved without premixing, giving the portrait an immediacy and lifelike quality special to the watercolor medium (Plate 37).

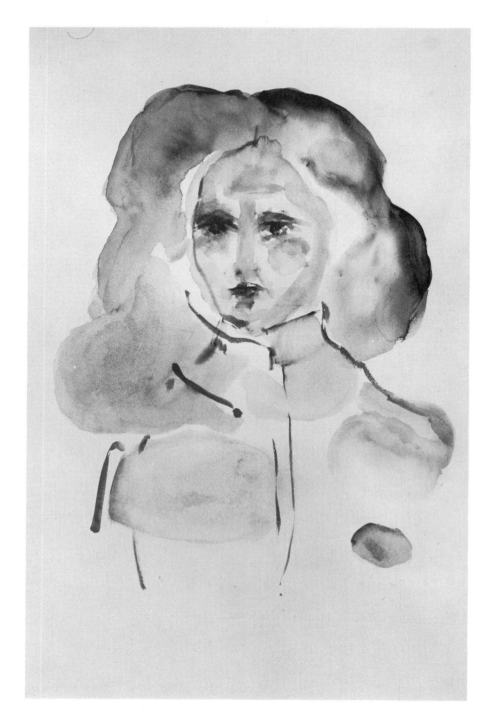

Figure 8.41
INESSA DERKATSCH
Woman from Munich.

Your method of color application (washes or glazes) is less important than your principle of color mixing. With practice, you will learn to apply colors not only additively, layer upon layer, but also spontaneously, in washes, controlling their interaction and predicting the resulting hues. Keep thinking in terms of *cool* and *warm* color combinations that can bring out the contour, shape, and volume of your subject's facial features. Actually, women have been doing this for ages with makeup. Highlighting their cheekbones with rouge, painting their lips red, and defining their eyes with blue shadow are, whether or not women are conscious of it, ways of defining their features, giving them more or less prominence. For stage productions, theatrical makeup is an absolute neces-

sity. It not only adds character to a face, but also exaggerates the features which, under strong stage lights, have a tendency to be blotted out.

Hair

Hair is not simply black, blond, or brown. These are just convenient classifications that say little about the particular texture of a person's hair or its subtle color nuances. Brown hair contains tones of blond, red, and perhaps grey. And hair is shiny and picks up reflections of additional colors in its surroundings. In the sun, black hair takes on a bluish tone, while blond hair turns golden and glistens with highlights. Texture also affects color. The thickness or curliness of hair influences light distribution and, consequently, color.

The most common mistake made by the beginner is to paint hair simply black or brown, dipping generously into the palette to pile on thick color and varying tonalities only between light and dark hues of the same color. This works in monochrome media such as charcoal or India ink, but not in transparent watercolors. When you are painting the hair of your sitter, introduce a variety of colors, capitalize on watercolor's special transparent properties, and let your color washes and glazes interact for an exciting portrait. Since hair is visually prominent, be very careful not to overpower the delicate colors of the face.

The face has profile; the entire head, however, has volume. Volume can be emphasized in the shape of the hair. Whether it is straight or curly, hair covers and envelops the head (Figure 8.42). Do not paint the hair's texture, individual curls, for example, at the

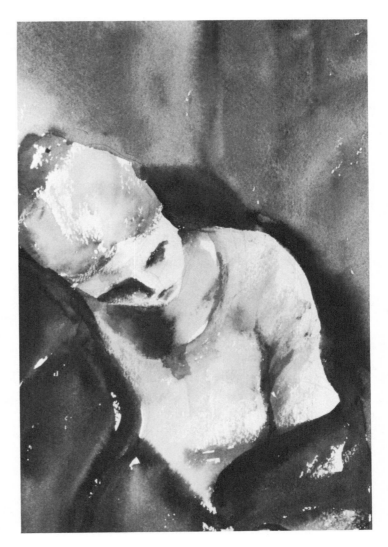

Figure 8.42
ALEXA THAYER FULLER
Girl Resting.

expense of the shape of the hairdo. As you did when painting fruits and vegetables, you are confronting the problem of *surface versus shape and volume.* Texture is surface, and subject to variation; curls, after all, can be straightened, or straight hair curled. But the solid three-dimensional structure of the head is permanent. The hair must appear to fit the head and to be supported by it, and the shape of the hairdo conforms to its shape and structure. (See Plate 37.)

Select colors for the hair that will balance the colors in the face. Working additively, paint in the hair, emphasizing the shape of the hairdo and its three-dimensional appearance. This necessitates your working with light and dark or cool and warm colors to give the appearance of volume. Even if your sitter has raven black hair, avoid using black. In portraiture, as in the other subjects discussed in this book, black is much too dark and can overpower areas in a composition. Substitute dark brown or grey, especially if you are using light colors. A good choice is Payne's grey. (See Plate 34.) It contains a good deal of blue and thus can be combined with yellow or purple to create new hues. Blond, brown, or any other light-colored hair can be defined first with burnt sienna or ochre; white areas can be left for highlights. Later, fill these white areas with lighter hues introducing additional colors, reflections perhaps from a light source or from colorful attire.

Hair does not sit like frosting on a cake. It has body, motion, and a life of its own. Make use of the fluidity of watercolors to suggest liveliness and immediacy. After defining the volume and shape of the hair, introduce a few particulars—a strand of hair or a few curls falling loose (See Plate 31.) Suggestion is enough. You do not have to paint every curl to indicate an Afro. Again, allow your viewer to complete the statement.

Since hair is the most changeable part of the human body, it offers an opportunity for you to improvise and be expressive. (See Figure 8.41 and Plate 35.) German Expressionists and French Fauvists whipped up the hair in their portraits until it looked like a fruit parfait. This was their chance to introduce or exaggerate all sorts of colors and forms. In his pen and ink drawings, Matisse shaped the hair of his women into elaborate configurations that perhaps expressed personality traits. Whether he braided it into a pretzel or coiled it into a spring, the hair was visually very prominent, towering high and framing the face.

Hats envelop the face like hair and can be used by the artist for similar effects (Plate 33). A hat with colorful plumage, ribbons, or an interesting texture can make an important statement about the personality of the sitter. Think of the sleek fedora, the military hat, the sailor's cap, or look at the crisp, starched bonnet of the little girl in Figure 8.43.

Background

The background of your portrait is usually the area *behind* the model and functions as a backdrop, giving the subject a context. The composition of your portrait, which represents your particular view of the model, will determine to a large extent the prominence of the background. (Note the background in Plate 37.) If your focus is primarily on the upper torso or head of your sitter, simply surround the face with a wash of color to integrate the composition. On the other hand, if you depict a figure in a context, as in "Woman on a Couch," Plate 30, or "Jamaican Festival," Plate 36, your background can be defined by the elements of the setting.

In most of the portraits given as examples, however, the background is improvised rather than specific. Ideally, of course, it should be painted simultaneously with the foreground, while you are giving definition to your model's hair, shoulders, and neck, since these parts are in its immediate vicinity and often touch it. But in portraiture, unlike in other subjects, you can make an exception

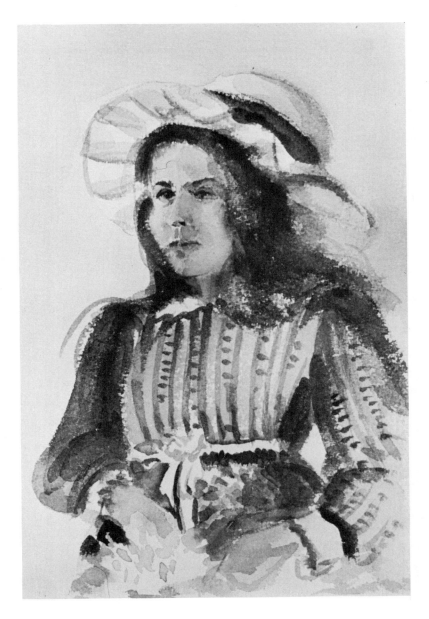

Figure 8.43
EDITH BURGER
Girl with Starched Bonnet.

and fill it in later. In many cases the background is added only when the portrait itself is completed. Often it makes more visual sense to consider the background after you have defined the foreground, because facial and hair colors are already established, and you can choose a background color to complement them. (See "Woman with Flowers," Plate 35, and "Woman with Green Hat," Plate 33.)

But do not underestimate the importance of the background to the composition of your watercolor. It is an important supporting element in your portrait, and your opportunity to create colors, shapes, and textures that add to the situation or to the expression of the sitter.

Expressiveness of Your Portrait

Traditional portrait sessions required sitters to pose for long hours over many weeks, to allow the painter to study carefully the face, its features, and its expressive characteristics.

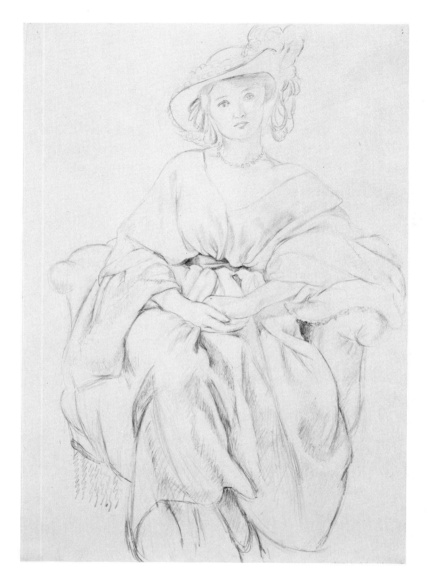

Figure 8.44
HENRI MATISSE (French, 1869–1954)
The Plumed Hat (graphite on white paper)
(H. 541 × 365 mm)
Courtesy of the Fogg Art Museum, Harvard
University (Grenville L. Winthrop bequest,
1943.874).

These portraits were usually painted in oil, gouache, or other opaque media (pastel, charcoal) that permitted revisions and alterations. Capturing the likeness of the sitter was the eventual goal, and the painting gradually took shape as the painter became familiar with the sitter's personality.

Today, portraitists who paint with transparent watercolor choose this type of medium because they consider the demand for intuitive response a challenge. They see wa-tercolor's additive application as an asset rather than a liability. Indeed, the watercolorist must make observations and respond with the brush in one spontaneous movement, often without vacillation. This can be used to advantage in capturing the expressiveness of your portrait—a transient smile that could never be sustained for the length of time that it would take to pose for a portrait in oil.

Watercolor portraits can be painted

quickly with heavy washes, or more slowly with the glazing method. Whatever your style or method, do not lose sight of the mood or feeling emanating from your sitter or situation. The expressions you capture will be re-experienced by the viewer, through empathy. Emotions are not contained only in the facial features, but can also be carried in other parts of the body. For example, sadness might reveal itself not just in a tightly set mouth and lackluster eyes, but also in drooping shoulders and a particular tilt of the head. (See Figures 8.26 and 8.35.) In fact, the position of the head in relation to the torso is an extremely important expressive sign of the personality and the mood of the sitter. Take a look at the illustration and make a note of it. Details of clothing or props in the background can reinforce this. Also, a color or a quality of light can create a feeling. Think of Picasso's

paintings from his blue period, and of how the color *blue* is part of the message in the paintings. Likewise, the mood emanating from your watercolor portrait is carried in the sum of all its parts.

Matisse, one of the greatest portraitists, captured a person's characteristic expressions in every part of the body. In his pencil drawing, note how he tilts the head, raises the shoulders, and subtly exaggerates these parts to convey the plumed lady's personality (Figure 8.44). When it is overdone, however, exaggeration can easily lead to caricature.

In a fluid medium like watercolor, you can translate your immediate feelings with spontaneous brushstrokes. You will have mastered portraiture when your response to the subject and your ability to record with color become one.

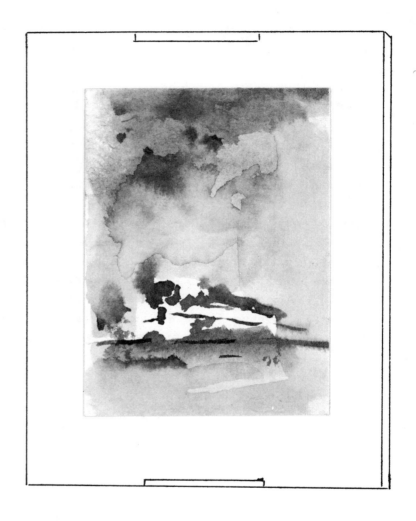

MOST BEGINNERS ARE RELUCTANT to frame their watercolors, thinking that only great works of art deserve such treatment. Then there are those few who frame their paintings immediately, to hang them or give them away as presents. Both attitudes are understandable. Before framing, I suggest that you first hang your watercolor temporarily with a bit of tape or push pins in an area where it can be seen for a week or so. This is an important and vital part of artistic activity. With distance and continuous exposure, the work will reveal itself in a totally different manner. While you were struggling with the painting process, your involvement with all sorts of trials and tribulations was too immediate and marred your perspective. Distance (in space and time) brings your judgments into proper perspective; you might actually surprise yourself by liking parts of your wa-

Framing watercolors

tercolor that you thought were utter mishaps. Your instructor's judgment will perhaps also become more understandable. Remember, he or she always was detached and therefore had perspective. Exposure to your work over a period of time lets you experience "aesthetic distance" and enables you to judge it more objectively and give you ideas on framing.

You may decide that you do not want to frame the entire watercolor. In the chapter on landscapes, I have already mentioned cropping. This involves extracting from your composition portions that are successful. Although this sounds like a drastic measure, it is a perfectly legitimate procedure practiced by some of our most famous watercolorists. Recently the Boston Museum of Fine Arts exhibited some of Winslow Homer's watercolors that were actually cropped. Instead of trimming the composition, however, he cut

mats that revealed only a selected portion of the composition. It was evident that the exposed colors of the composition had faded while those covered by the mat retained much of their original brilliance. This brings us back to the vital fact that watercolors are quite fragile and that all the materials that come in touch with them should be chosen very carefully.

The choice of a frame is the final artistic decision and should be made only by the artist. It is tempting simply to leave your work at a framing shop, but I urge you not to do this without giving precise instructions. Decide on the size, color, and type of materials, leaving only the mechanical work for the shop. Framing shops are good places for the layman to bring work that has been inherited or received as a gift, but an artist should know the basics of framing in order to choose the frame that best supports the artistic statement.

Eventually you will be able to do the framing yourself, and save the thirty or forty dollars that most framing shops charge for an average-sized watercolor. The less expensive do-it-yourself framing shops that have surfaced in the past few years are also good alternatives, since they force you to become involved in the framing procedure. Experienced personnel will be on hand to make suggestions and propose alternatives. Make use of their advice, but trust your own judgment. Here are a few suggestions that will help you make decisions.

A frame's function is to provide the right enclosure in which your watercolor will not prematurely fade or deteriorate. But in addition to this protective measure, it also has an aesthetic function and should enhance your work and display it to its best advantage. Let us first turn to the visual importance of the frame.

The Mat

The most immediate frame around your composition is the mat. It can actually be considered an extension of your paper, since it creates an area of rest, or almost a pause, visually speaking, between where your work ends and where reality begins (Figure 9.1).

Figure 9.1
The mat.
Illustration by Susan Aron.

Setting definite margins around your work, the mat makes the work stand out and should visually support rather than compete with it. Brightly colored mats, often recommended by frame shops, are much too strong for a watercolor painting. Even if the painting shows the use of primary colors, as is true of Emil Nolde's work, for example (see Plate 2), invariably the watercolors' depth, subtleties of hue, and a delicate softness will be overpowered by a strongly colored mat. Furthermore, if a mat is darker in appearance than the watercolor, the painting will seem like a hole cut from the mat. This effect might be acceptable for more traditional painting styles that attempt to show window space, but it tends to distort the reality of a contemporary use of picture space.

Light-colored mats are visually more effective with watercolors. Cream, off-white, and light grey all provide attractive frames, especially if the painting's colors are light or have a considerable amount of white from the paper showing through. In this case, the mat becomes almost an extension of the colors in the composition. One rule of thumb you can use when you are selecting the particular hue of your mat is to determine the predominant light color tonalities in your painting and to decide whether you want to reinforce or complement them. For instance, if your predominant values are cool, such as green-blue, you might choose a cream-colored mat, because it would emphasize the warmer colors in the composition. On the other hand, if the pinkish yellow hues predominate, you might choose a mat of a cooler tone, an off-white or grey, for contrast. Usually frame shops have *L*-shaped pieces of mat board in a large variety of colors to hold next to your painting while you select the correct color. (See Figure 9.2.)

Figure 9.2
L-shaped mat sections.
Illustration by Susan Aron.

Double Mats

Another attractive solution is the use of a double mat. A light mat on the outside and just a tiny edge (1/8″ or 1/4″) of a colored mat showing on the inside give you the best of both: the predominant calmness of the light mat with a bit of strong color for emphasis or contrast (Figure 9.3). Traditionally,

Figure 9.3
Double mat with dark inside.
Illustration by Susan Aron.

Figure 9.4
Illusion of double mat. Let a bit of the margins you made with your tape show.
Illustration by Susan Aron.

double mats were used quite frequently in the eighteenth and nineteenth centuries. Usually the inside mat was gold (gilded wood or paper) or covered with velvet, silk, or linen. The double mat gave the work a precious appearance, and also ushered the eye into the composition, providing a transition from the very ornate picture frames used at that time. Impressionistic paintings are still displayed in these heavy, decorative frames. You can also create the illusion of a double mat by letting a tiny bit of the white margins that you made with masking tape show. This technique is especially effective if the peripheral forms of your composition are interesting (Figure 9.4).

Mat Size

Generally, the size of the mat depends on the size of your composition. I happen to be partial to large mats and always say, when in doubt, "Be generous." Nothing is as stingy looking as a very narrow mat. Contrary to what one might think, a small painting looks

better with a large mat, perhaps because it gives the work more prominence and keeps it from getting lost on the wall. On the other hand, the larger the painting, the narrower the mat may be. Sometimes, in fact, large paintings do not need mats, because they are already visually imposing. Modern, nonobjective paintings are frequently framed without a mat.

For a standard-sized sheet of watercolor paper (18″ x 22″), 3½″ or 4″ margins on the sides are generous. Do not go below 2½″. Whether to make the mat's dimensions even or uneven on all four sides is a personal decision that must depend to a large degree on your artistic composition. Traditionally, mats were always cut wider on the bottom than on the other three sides. Again, it depended on what the artist wanted to emphasize. If the composition was very narrow and horizontal, the artist made the sides of the mat smaller than the top, but still left the largest margin on the bottom. Sometimes the artist made the sides wider than the top to broaden a vertical composition. The emphasis on the bottom width, however, was intended to give the painting a certain visual stability (Figure 9.5).

Figure 9.5
Mat with wider bottom.
Illustration by Susan Aron.

Furthermore, in old houses, paintings were usually hung in rooms with high ceilings. The bottom width of the mat had the function of balancing the dimensions of the wall's space. Another reason for the emphasis on the bottom margin was that most traditional paintings represented realistic space. The painting simulated outdoor reality and the mat framed the composition's point of view. A landscape, for instance, with a view from the bank of a river onto a city gave the spectator the feeling that he or she was indeed standing on the ground somewhere on the bank of the river. Visually, it centered and stabilized the composition. The mat's format also reinforced the illusion of looking through a window, with the bottom perhaps mimicking a window sill.

In modern, nonobjective painting, on the other hand, where picture space instead of window space is represented, gravity is almost nonexistent. The picture has no realistic space, and even though the viewer stands outside (and is gravity bound), our eyes do not have to be centered. In fact, the forms and their movement often ask us to circulate and free float. Consequently, mats today are often cut with unilateral dimensions (Figure 9.6).

Figure 9.6
Equal-sided mat.
Illustration by Susan Aron.

On a nonobjective composition they can be quite successful, and, as one of my students noted, they have the added advantage of enabling you to hang the picture in whatever direction you choose.

Matting Procedure

Choose a mat board the size of your outside dimensions (meaning the painting's dimensions plus the width of the mat's border), and then cut out the window to the size of your composition. This cut is customarily bevelled on a 45° angle (Figure 9.7). The outside dimensions of the mat can be best cut with any kind of sharp handy knife.

Figure 9.7
View of mat with bevelled edge.
Illustration by Susan Aron.

Making the window into your mat is trickier because you are cutting on a bevel. This is difficult to do freehand, even with some practice. The fancy mat cutters that framing shops use, with clamp-in devices and metal rulers in which you can insert a knife and simply slide it through the mat in a perfect bevel cut, are ideal. If you have access to

Figure 9.8
Dexter mat cutter.
Illustration by Johanna Bohoy.

one, use it. In my opinion, the small handheld bevel cutters ("Dexter Artist's Mat Cutter," Figure 9.8) with adjustable blades are not worth the money. Pressing them down with one hand while you hold your ruler and mat board with the other requires extreme dexterity and strength and can be very trying. Some students nevertheless learned to use them; others had no success with these. Somewhat easier to use are the large, heavy metal rulers with 45° angle slots in which you insert a sharp knife. Because they are heavier, they do not require as much pressure, and in a pinch they can be clamped to a table, thus stabilizing the mat board and leaving both of your hands free to press down on the knife. Needless to say, the knife should be very sharp!

A good alternative to having a frame shop cut your mat (which can be expensive, because the shop usually charges you for the full-sized mat board) is to buy your own mat board, cut your mat, and have the shop cut only the window. You might have to look around for a shop that will do this, but usually the fee is minimal, because you provide your own material. Eventually, however, artists who are serious about selling or exhibiting their work should find a relatively inexpensive way to cut their mats.

In addition to being visually pleasing,

the mat surrounding your watercolor is also a very important protection. Usually mats are one-ply or two-ply (1/32″ or 1/16″ thick), but they can also be heavier, and when placed on your work, they prevent it from scuffing. Furthermore, they also provide a tiny air shaft that allows air to circulate between your work and the glass, Plexiglas, heavy acetate, or flexible clear plastics (mylar) that cover the painting.

Since watercolor paper is very absorbent, it attracts moisture during humid weather. If glass is fit directly onto the paper, airborne spores and fungi use the tight surface as a breeding ground, and grow and spread on the paper, staining and discoloring its surface. Sometimes historical work on paper shows this disfiguration. Molds can be arrested (conservation departments have fumigating devices for it), but the discoloration stays. The mat thus provides air circulation and allows the paper to expand freely without touching the glass cover. A protective transparent cover also prevents dust from collecting on the watercolor's surface. Unfortunately, ordinary glass does not shield the watercolor from ultraviolet rays. But special glass that is now available has that feature.

Types of Frames

Several different types of frames are available. Traditionally, a wooden frame held the painting, its mat, and glass cover in place. Wooden frames come in a large variety of styles, sizes (widths), and colors. Again, be conscious of the delicate nature of your watercolors and do not overpower them with a heavy ornate frame. Often a plain narrow wooden frame with minimum gilding works best. Modern metal-section frames made of

Figure 9.9
Welded aluminum or metal-section frames.
Illustration by Johanna Bohoy.

Figure 9.10
Eubank frames.
Illustration by Johanna Bohoy.

Figure 9.11
Braquettes.
Illustration by Johanna Bohoy.

aluminum are simple and unobtrusive, and available in a variety of colors (Figure 9.9). These frames are often quite expensive, but similar and cheaper ones can be ordered from an outlet in Ohio. (The sources are listed in the appendix.) Metal-section frames are sold in pairs, so you will need two sets.

The traditional wooden frame is obviously much more lasting than the other framing devices. It seals your painting shut with a backing that is glued to the frame and attempts to prevent destructive forces, such as dust, from entering. Paintings in wooden frames are not intended to be removed from the frames. Metal frames are somewhat more mobile. They also have the standard components of mat, backing, glass, and frame, but the back is open. Since they are held together with hardware (screws and nuts), they come apart easily. If your work is one size, every so often you can move paintings in and out of the same frame.

Instant Frames

Alternatives to wood or metal frames are frames that use clamp and hook devices and a tension system to hold the glass cover to the mat. These tie in back with string, wire, or nuts and bolts and have a mechanism for hanging the painting. Your mat needs a fairly stiff backing, since the clamps hold the glass against the mat and need that extra support. Also, these clamps usually have a certain width and will fit securely only with added backing. Eubank makes frames in both metal and plastic that hold the painting with two clamps on either side (Figure 9.10). Braquettes makes one that has two clamps holding the painting just on the top and on the bottom (Figure 9.11).* Another brand called Fast-Frame has corners, similar to photographic corners, that hold up the painting on four sides (Figure 9.13). There is also an

*For a large painting, however, you need two sets for better support (see Figure 9.12).

Figure 9.12
Braquettes: two on each side for large work.
Illustration by Susan Aron.

Figure 9.14
Gallery clip.
Illustration by Johanna Bohoy.

Figure 9.13
Fast-Frame.
Illustration by Johanna Bohoy.

Figure 9.15
Mat with gallery clip: front.
Illustration by Susan Aron.

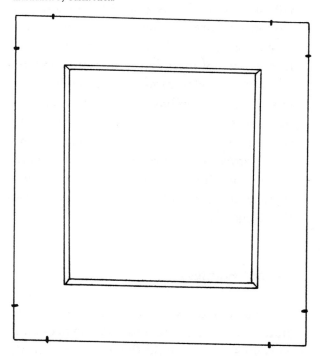

210

attractive clamp called Gallery Clip, which resembles those found on the European market (see Figures 9.14, 9.15, and 9.16 for how they are attached to the painting and also for their stringing mechanism). The Swiss Clips are similar devices (Figure 9.17).

These brackets and clamps are obviously the answer to the need to frame all sorts of art work quickly and inexpensively. They work quite well for photographs, posters, and other printed material, but I do not consider them adequate for watercolors. I only recommend them for *temporary* framing, when you want to hang your work before you decide on a permanent frame. Since they leave your painting open on the sides and do not shield it from dust, they do not meet archival standards for framing art work and are not recommended by art conservators.

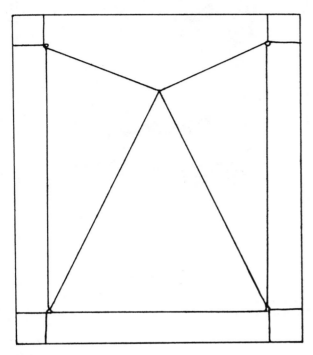

Figure 9.16
Mat with gallery clip: back (stringing mechanism).
Illustration by Susan Aron.

Floating Your Watercolor

Floating a watercolor is probably the simplest fast framing method. You just hinge your watercolor on a backing and then cover it with glass, holding everything together with clamps (Figure 9.18). This framing, however,

Figure 9.17
Swiss clips.
Illustration by Johanna Bohoy.

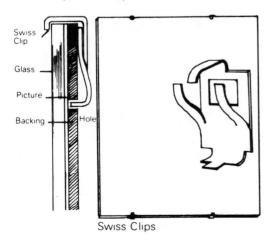

Swiss Clip
Glass
Picture
Backing — Hole

Swiss Clips

Figure 9.18
Quick-stick frame clip.
Illustration by Johanna Bohoy.

is not recommended, since it does not offer the air circulation provided by a mat. On very humid days water can actually condense behind the glass, making your painting buckle if it is clamped too tightly, and causing eventual deterioration. In all fairness to "archival standards," I should qualify my caution somewhat. Mold will not grow in one or two days, nor in one or two weeks, unless you live in the tropics. And even then, it takes a certain time before disaster strikes. Thus, for temporary display, floating your work or using fast frames is okay (Figure 9.19).

Box Frames

Transparent box frames are made by many companies and can be bought in various sizes. Dax makes one variety resembling Plexiglas, but it is actually some kind of styrene. This extruded plastic is molded into a box shape that fits over your work (Figures 9.20 and 9.21). Ideally, you should mat your work before inserting it into the box, but the work can also be floated. The Dax frame has a cardboard box that inserts into the plastic frame and keeps everything tightly in place. Holes in the back of the cardboard provide hanging devices. Another variation on the box-type frame is the Kulicke Frame (Figure 9.22).

A custom-made Plexiglas frame usually has a transparent front, and white sides to the box. Screws on the sides tighten a backing that holds the work securely in the box. These frames can be ordered in various sizes, with varying widths. A small work will look much better in a wide box than will a large work, but this is a matter of individual taste. You can also make your own Plexiglas box

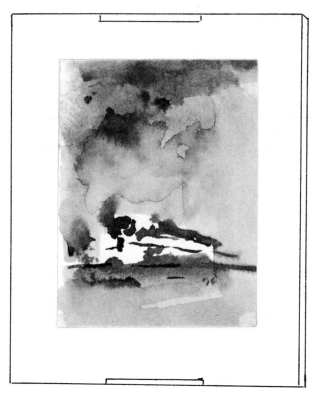

Figure 9.19
Floating watercolor.
Illustration by Susan Aron.

Figure 9.20
Plexiglas box frame.
Illustration by Susan Aron.

Figure 9.21
Plexiglas frame (similar to Dax).
Illustration by Johanna Bohoy.

frames. I make my own and exhibit all my work in them. Since it takes power tools that you might not have to cut the plastic, let the plastic retailer cut the clear top sheet and the white side strips. With a plastic solvent, laminate the white strips to the clear front. Measure your pieces carefully, and add the width of your side pieces to the dimension of your mat.

Shrink Wrapping

Perhaps the most modern means of protecting your work for storage and shipping is shrink wrapping. This procedure requires tools like a heat-sealing and a blowing machine, and a particular kind of plastic not usually available to the student. Framing shops, however, will shrink-wrap your work for a moderate fee. If you provide the mat, they will cut a backing (the size of your matted work) and enclose it in plastic similar to but more substantial than plastic food wrapping. The plastic is cut and heat sealed on four sides, and shrunk with a hot-air blower to your work's exact dimensions.

This is a convenient means of temporary storage for artwork, and often recommended for work placed in a bin that people leaf through at a gallery. It protects the work from fingerprints, dust, and moisture, to an extent, but does not provide circulation and will,

therefore, allow some mold spores to grow. So it is not recommended as a permanent solution for art preservation. Nevertheless, it does make an attractive package when you are giving your work away and are in doubt about the choice of a frame. In a shrink-wrapped work, you provide the mat and the correct mounting of your work and allow the benefactor to choose the frame. Otherwise, Aunt Emma might cut your painting to fit it into that special antique frame she has in her attic.

Archival Standards

Ideally, none of the materials that come in contact with your art work should have a detrimental effect on it. If you use acid-free watercolor paper (pH neutral), it also makes sense to have your mat board, glue, and tape acid-free and of archival quality. Using quality materials in your painting but not in your framing does not really make sense, since one affects the other.

Mat Board

Like watercolor paper, mat board comes in a variety of qualities. Ordinary, commonly available mat board is made out of wood pulp paper and has a thin veneer of high-quality paper on both sides. The veneer can be of various textures and colors, but the inside board is invariably light in color. Such mat board is moderately priced, so it is often bought by students, who may not know the difference between it and high-quality, acid-free mat board.

The detrimental effects of this matting

are caused by the wood pulp paper. Again, it is not a matter of weeks before damage is noticeable, but often months or years. It depends on such factors as where the work is hung (with or without direct sunlight) and what kind of pollutants are in the environment. Smoke from a fireplace or excessive exhausts from automobiles are especially detrimental. Like newsprint, which turns brown with age, the inside of this mat board yellows and eventually turns brown. In proximity to delicate watercolors, it can accelerate their deterioration and cause fading. Sometimes in museums or galleries you see matted and framed work that is aged by such mat board.

Tapes and Glues

To hold your watercolor to the mat board, you will need tape. Linen tape is recommended because it has a water-soluble glue, and is thus fairly neutral, devoid of harsh chemicals that can attack your work. Since it is water-soluble, it is easily removable in case the work needs to be rematted. It also absorbs moisture, as does your watercolor paper, allowing your painting to stretch underneath the mat. Under no circumstances should masking tape or scotch tape be used. These self-sticking tapes are very high in chemical content and deteriorate quickly. They also hold the watercolor rigidly and do not expand freely. Scotch tape, for example, turns brown and falls off; masking tape also turns brown and leaves a very sticky residue. The chemicals in these tapes can affect the permanency of your watercolors. An alternative to linen tape (which is available in most art supply stores in a roll or even by the inch) is butcher's tape. Strange as it may seem, this tape is fairly free of chemicals and harmless

Figure 9.22
Kulicke FK frame box.
Illustration by Johanna Bohoy.

to art work. The chemicals in glues such as Duco, rubber cement, or the polymer white glues (Elmer's, Tight-Bound) dry hard and inflexible. Aside from their detrimental effects, a watercolor fastened with them will buckle while it is expanding.

The approved method of fastening your watercolor to the backing of your mat is to make one or two hinges from the linen tape on the top (Figure 9.23). Letting the work hang freely allows for maximum expansion. A method similar to that used for photographic picture mounting is to make small corners out of quality paper, or snip off the corners from envelopes, tape them to the mat backing, and slide your work into them (Figures 9.24 and 9.25). Do not, under any circumstances, put ordinary glue on the back of your work. In time, the glue will deteriorate and stain through to your picture surface, thus causing considerable damage. If you need to glue, use wheat paste or dry-mount tissue to hold your watercolor to the mat backing. All of these cautions will probably not be heeded by students, who do not think that their work will last forever. However, even if you do not follow the directions, I would like you to be informed and knowledgeable about the archival manner of matting and framing art work.

Figure 9.23
Hinging with linen tape.
Illustration by Susan Aron.

Figure 9.24
Paper corners.
Illustration by Susan Aron.

Figure 9.25
Watercolors inserted in corners.
Illustration by Susan Aron.

Signing Your Watercolors

Placing your name on the watercolor personalizes your work and tells the world that you are its creator. This fact should be pointed out without too much fanfare. If the signature overpowers the composition, something is definitely wrong. It indicates that the artist was insensitive to the painting's appearance. Ideally, the signature should be integrated into the composition, and should appear not in the middle but somewhere on the margins.

Where on the margins does not really matter. The lower right-hand corner used to be the proper place. But many watercolorists, Paul Klee and Emil Nolde, for example, place their signatures almost anywhere in the painting. Also, they sign their names in color (probably with tiny brushes), which accounts for the signatures' visually pleasing effects. Study these paintings before signing your work.

If the composition is delicate and light, sometimes lettering, even when it is done with utmost care, seems out of place. Consider just signing your initials, but make sure that your name appears in full on the back. Yes, this is for posterity, lest someone forget who you were! Do not sign your work in pencil or ink. The pencil might rub off or smudge in time (also, it can easily be erased), and when the watercolor paper attracts moisture, the inks might bleed. Also, the inks in ball point or felt tip pens are synthetic chemicals and in time might have detrimental effects on your colors.

Whether or not to include the date with your name or initials is, again, a personal matter. Most watercolorists add a date for their own reference. Undated art has caused art historians quite a bit of distress and sleuth work. For example, there is still a controversy about when the first nonobjective painting was painted, and whether Kandinsky's work (Figure 3.6) was the first one. Not dating work allows the artist to claim any date (usually an earlier date for an avant-garde style). Artists have been known to redate their work.

Finally, as a courtesy to your buyer and also for posterity, write your full name and your birthdate in pencil or with color on the back of the watercolor. If you wish, you can also note where the painting was painted and the subject matter. I include the colors and the kind of paper that I used. This information is important for your own records and is sometimes requested by museums. In addition, it provides reference for restorers, should your work deteriorate and need retouching in the future. Lastly, I like to add a short statement on the back of the framed painting saying that watercolors should not be hung in direct sunlight. This might seem superfluous, but many people are ignorant of the effect of sunlight on watercolor, or simply forget about it, or do not want to be reminded of it because they have a perfect sunny spot in their home where they want to hang their watercolor.

Hanging Your Work

I would like to conclude by saying a few words about hanging your work. Hang it, preferably, in places where you can see it every day and are exposed to it naturally. This is the final test of its success or failure. Once it is on the wall, the watercolor has a life of its own. The umbilical cord is cut and the painting exists as a self-contained entity. You no longer do anything to it; now it does something to you. Being around it constantly will tell you whether it exerts an influence and provokes a fascination. If you become indifferent to your work, this means that its presence makes no difference, and that it might as well not exist. You might be surprised at how your work has the ability to change. The initial fascination vanishes, and something you never gave much credit to because it was an utter mishap may become the most captivating part of your work.

Aside from the changes in your own vision of your work, someone else's response

can also be illuminating, and most artists are eager to have people respond to their work. Maturing, or employing detached vision, is thus an important step in comprehending your own work. Exposure to a work on a continuous basis, perhaps for a few weeks, will reveal how well a painting will wear or hold up in its effect on the viewer. And this is, after all, the most crucial test of any work of art.

THIS BOOK ON WATERCOLOR is intended primarily for reference, to show the aspiring watercolorist how to paint the various subjects discussed. But I hope that it will go further, to suggest new painting styles and artistic explorations. Maybe it will be the match that will light your artistic flame.

Artistic inspiration can have many sources. Creative impulses can come from personal feelings, observations of nature, re-ligious convictions, or other works of art. You may want to paint in a realistic style, using the natural world as a means of verification for your work. Most of Western art, up to the twentieth century, can then serve as your example. But you may also find primitive or children's art inspiring, as did the Expressionists and Cubists.

However, the source of inspiration is less important than the willingness to trans-

CHAPTER TEN

Conclusion

late your creative impulses into an artistic medium. Classroom instruction provides structure and discipline. Like exercising in a group, painting with others will keep you going, especially if you are a beginner. The various painting styles of your classmates may suggest new pictorial solutions to the problems you share as beginners. Students learn as much from one another, by example, as they do from their instructors. A good in-

structor will also offer you guidance and encouragement when you feel like giving up. Every instructor has something different to offer; your own intuition will tell you when you have outgrown a classroom situation.

Whether you choose formal training in a school, private lessons with an artist, or self-instruction, it is important for you to work regularly and with discipline. Like other arts—music, drama, and dance—watercolor

painting has to be practiced. Your hand–eye coordination, like the muscles of a dancer, must be exercised. Expect regression when you stop painting. In this respect, watercolor painting resembles any other skill: You do not lose it, it just gets rusty. Students who paint every day, even if only for an hour or less, learn much faster than those who paint just once a week in class. Have your artistic tools and materials easily available; lay them out on a table at home, if you do not have a studio, so that you can turn to them in spare moments.

Continuous practice will create what I call the *push and pull* effect. For beginners, each painting session is usually anxiety-provoking. You are confronting yourselves, your aptitudes, and the possibility of success or failure. So at first you must push yourselves into taking chances. The more you paint, however, the more momentum you build up. There comes a point at which the watercolor will pull you, exerting its own influence on you. You will begin to see each work not as an isolated effort but as a link in the chain of an artistic process.

Do not become absorbed in a single effort, good or bad. If you do not succeed at first, go on to another painting. A writer rewrites, edits, and refines sentences to produce a polished manuscript. A painter can repaint. But since you are not using opaque colors such as oil or gouache, you will have to make another "draft" of your painting.

Using your first painting as reference for painting the same subject over again can be useful in many ways. You will have already made and tested certain compositional decisions. Now you can alter, adjust, or simplify them. Having struggled with definition (and perhaps having overworked your subject), you can be less specific, and hint at shapes and forms instead of spelling them out. The same goes for color combinations. Try different hues, and apply them with different techniques. In many ways, you are much better off than the painter who overpaints and erases previous decisions. With your first painting in front of you as a point of reference, the second time around you may be able to relax and paint with a certain élan.

Remain flexible and open-minded during these early efforts. Color combinations, at first, are often more a matter of accident than of planning. This is fine. We learn by imitation and by trial and error. So take advantage of watercolor's unpredictable nature. As with so many things in life, not what happens but rather how you adapt to an event is what counts. In watercolor, an accident can be much more exciting than an overworked effect.

What happens on the surface of your watercolor is just as important (if not even more so) than what you set out to achieve. No one will know or even care what the subject "really" looked like. Your painting must speak for itself. Art is separate from reality and actually has very little to do with it. Matisse once told an outraged patron who complained that her portrait was not a good likeness, "Madame, this is not a person, this is a painting." This attitude is not the privilege of just our century. Artists have defended their right to *artistic license* for generations. More than four hundred years ago, the sculptor Michelangelo is said to have answered complaints that his statue of Giuliano de' Medici* did not resemble him with "A thousand years from now, nobody will want to know what he really looked like."

*Tomb of Guiliano de' Medici. 1524–34. New Sacristy, S. Lorenzo, Florence, Italy.

With practice, you too can learn to distance yourself from your subject. Once your struggles with technique are over and forgotten, the missed detail in the upper left-hand corner will no longer seem important. The technical skill, the mastery of the watercolor medium, and the success of the composition are what stand out. Most important of all is the creation of a delicate balance between what is represented in your painting and the dynamics of the watercolor paint. Thus, let a completed work rest, and defer judgment about its success or failure until you have distance from the subject and can consider the composition on its own terms.

Students who paint as a hobby often worry that they may always be "amateurs." There is no magic transition from amateur to professional. The word *amateur* does not even make much sense any more. Traditionally, it was used to separate artists who painted for pleasure from those who made their living practicing art. In the nineteenth century this might have been a useful distinction; artistic training started at an early age and the goal was a career in the arts. But even then, there were exceptions. The painter Gauguin, for instance, did not begin painting until his mid-thirties, when he left a successful business career (as well as an angry wife and children) to paint full time in the South Seas. Kandinsky was first trained as a lawyer and economist. He had earned a secure position at a Russian university when he left for Germany to become a painter. When does professionalism start? I tend to agree with the axiom "There are no amateurs, there are just bad painters."

Professionalism is more a matter of commitment than of talent. Nevertheless, students worry endlessly about whether they are talented. This wastes valuable energy and often stifles their artistic development. As a beginner, you should be concerned primarily with gaining experience and building up technical skill within the watercolor medium. This is a slow process. It can be compared to the process of a child learning to walk: the step-by-step mastery of movement, coordination, and balance would be impossible if it were accompanied by an ambition to be a champion runner.

Students often ask me to evaluate their work and tell them whether they have talent. In many cases, this question is premature. Dexterity, an ability to grasp essentials quickly, a good sense of color and design, and an unusual point of view can all be signs of talent. But a willingness to apply yourself, to work steadily at producing paintings, and to set yourself challenges, are what count in the long run. "Talent" is too often given as an excuse for laziness.

Of course, the talent will eventually single itself out. Obviously, our great artists would not be considered great had they lacked talent. But note how hard some of them struggled. Looking at their early work, few art historians could have predicted that Van Gogh or Cézanne would be the cornerstones of modern art.

It would be misleading, however, to suggest that a professional artist should have no worries. It is inevitable that you will compare yourself with other artists, especially to prominent figures in the art scene. Unfortunately, the contemporary art world is not always a good model to follow; there seems to be more emphasis on *novelty* than on *originality*. It is interesting to compare the definitions of these two words. *Novel* means "of a new kind, unusual, strange, not generally known." *Original* refers to derivation, as well as to newness; when a work is both derived

from a tradition and independent of it, then we may truly speak of it as *original.*

Today, artists are celebrated as stars; they shine brightly on the artistic horizon at one moment and are extinct the next. Concerning this phenomenon, Andy Warhol has remarked that anyone can be famous for fifteen minutes. Publicity by the media, exposure via shows and reviews, often make a person the man of the hour—a choice not always based on merit. Should you be concerned about this? You cannot be indifferent, but your central concern must be with your work. You can find a certain comfort, however, in the knowledge that your work originates from an historical context and thus will always have conventional as well as novel features. In this respect, art is often compared

with language. Art has a vocabulary that can be understood by anyone who knows it, but its use can also be highly personal. Similarly, watercolor's visual vocabulary is inherent in the methods and materials of transparent rendering. You can learn the basics as outlined in these chapters, but your application of them determines how eloquently you speak watercolor's artistic language. The washes and glazes, colors and forms compose your still-life, landscape, or portrait into a pictorial reality that interprets what you see, what you know, and what you feel about these subjects. In watercolor painting, as in any other artistic discipline, your goal is mastery of the medium and the expression of a personal point of view.

Appendix

Suggested Watercolors

This palette lists basic primary and secondary colors to get you started. Eventually, you may want to supplement these with colors of your own preference. Colors are selected for their compatibility and permanency.

Red: ALIZARIN CRIMSON—A clear, bright red that leans toward blue. This color mixes well with blues and purples to form intermediary reddish-purples. It makes excellent pink and rose hues in a light wash or glaze.

CADMIUM RED—A metal-derived color that is grittier in consistency and leans toward yellow. It mixes well with yellow to form orange and a variety of analogous orange-yellow hues. When mixed with blue, it turns brown because of its yellow overtones.

Yellow: CADMIUM YELLOW—An all-purpose bright yellow. It comes in medium and light hues called *pale* and *deep*. It mixes well with cad-

mium red for orange, or cobalt blue to form green hues. Lemon yellow (a cadmium color and extremely permanent) is often preferred by artists who plan to use yellow in a pale wash.

Blue: COBALT BLUE or ULTRAMARINE BLUE—Both bright, clear blues without green overtones. They mix well with Alizarin Crimson for a variety of intermediary purple hues. Winsor blue comes closest to these as a less-expensive color.

Green: HOOKER'S GREEN—A clear, bright green without excessive blue or yellow overtones. It mixes well with yellows and blues, but for mixing I prefer Viridian green, which is a very bright and concentrated yellow-green

(it has strong tinctorial qualities) and yields a variety of blue or yellow greens.

Orange: Mix your own from Cadmium red and yellow.

Purple: COBALT VIOLET or WINSOR VIOLET—Clear, bright purples like these are impossible to achieve by mixing primaries. The cobalt tends to be grittier and difficult to apply as a thin wash. The Winsor violet has a nice tinctorial quality and is a good mixing color.

Grey: PAYNE'S GREY—A smoky grey leaning toward blue. I prefer it instead of black because it mixes well with other colors and when applied in washes and glazes allows colors to show through.

The Permanence of Artists' Colours

The word *permanence* is capable of such broad interpretation that it has seemed desirable to define with some exactitude what is meant in our Classification Lists by the permanence of a colour.*

1. By the permanence of a Water Colour we mean its durability when washed on the best quality water colour paper and, while under a glass frame in a dry room, freely exposed to ordinary daylight for a number of years, no special precaution (other than the usual pasting of the back of the frame) being taken to prevent the access of an ordinary town atmosphere. By an ordinary town atmosphere we signify an atmosphere normally containing as the active change-producing constituents, oxygen, moisture, and a small percentage of carbonic acid, together with chronic traces of sulphur acids, spasmodic traces of sulphuretted hydrogen, and a certain amount of dust and organic matter in suspension.

2. By the permanence of an Oil Colour we mean its durability when laid with brush and palette knife on ordinary prepared canvas and, while under a glass frame in a dry room, freely exposed

* This and the following three sections are reprinted from "The Composition and Permanence of Artists' Colors" by kind permission of Winsor & Newton.

to ordinary daylight and the above-described town atmosphere. With these colours, the action of the oil medium (sometimes reducing, sometimes oxidising) has to be considered, and similarly the white lead priming of the prepared canvas must be taken into account as in many instances it influences the result.

It will be seen from the above definitions that our colours are tested under conditions which are as nearly as possible the same as those which obtain in the ordinary practice of painting and exposing easel pictures. This we regard as a point of some importance; and as it is, for instance, of little use to test the durability of water colours by any method which does not afford them a due measure of protection from atmospheric impurities, or to test the durability of oil colours on glass or porcelain, while artists nowadays paint, practically without exception, on canvas or board coated with a white lead or titanium preparation. Parallel tests on inert backgrounds are, however, useful in determining the bearing of the orthodox preparation on the question of permanence.

It may perhaps be argued that since in general oil paintings are not protected by glass, the results obtained when these colours

are tested under glass frames with plenty of 'breathing space' may be unduly favourable for ordinary conditions. It must, however, be borne in mind that, for the proper ascertainment of the durability of Oil Colours, it is necessary that actual dirt and dust should be ruled out. Any method of testing Oil Colours for resistance to the action of light and atmospheric agencies, based on open exposure in London rooms, or indeed in any situation where delicate colours may become soiled, must therefore be ruled out also.

Apart from the dirt film, and possibly some slight deprivation of ultra-violet rays, there is no reason to suppose that tests of unframed colours, openly exposed in reasonably dry rooms, would have given any different results, except in those cases where the glass may have to some degree protected colours likely to be acted upon by the sulphur compounds referred to above. In country districts concentrations of these aggressive substances are generally much lower than in urban areas. Pigments liable to attacks of this sort are specially marked in the tables, in order to indicate that they will probably stand less well if openly exposed to a sulphur-tainted atmosphere.

It should be pointed out that, where practicable, the protection of oil paintings by glass is a great aid to permanence. The mere physical impurity present in the air of towns, or of smoky rooms often does as much damage in its way as the more generally recognised enemies of durability, for it is apt to become so intimately associated with the superficial layers of paint that it is impossible to remove it without removing the colour as well.

Our method of indicating the degrees of durability of our colours consists of sub-dividing the ranges into four classes. Extremely Permanent Colours (Class AA), Durable Colours (Class A), Moderately Durable Colours (Class B) and Fugitive Colours (Class C).

CLASS AA EXTREMELY PERMANENT COLOURS

These are colours which may be regarded as having extreme stability under all ordinary conditions of water colour or of oil colour painting, according to type.

CLASS A DURABLE COLOURS

It is, as is generally recognized, impossible for a good colourist, in most classes of work, to confine himself entirely to the pigments in Class AA. A second class is therefore necessary for the inclusion of those colours which, while having very high durability, nevertheless have an element of weakness which prevents their inclusion in Class AA. The permanence of these colours depends somewhat on the conditions of their use and exposure. Many of them may be looked upon as practically completely stable when used *per se* in full strength, and yet only as 'Moderately Permanent' in thin washes, or glazes as the case may be, or in tints with the appropriate white; much also depends on the cumulative amount, and on the intensity and character of the daylight to which they are exposed. There are too, certain cases in which colours act on each other chemically when mixed together and in this category Winsor Orange Oil Colour, Winsor Red Oil Colour and Scarlet Lake Oil Colour should not be used in the form of very pale tints with white. Such tints, particularly when the white is Flake White, tend to fade out, even in the dark. Winsor Red and Scarlet Lake Water Colour tints with white are not subject to this limitation and behave normally.

With regard to our method of indicating

the degrees of permanence of our colours, it should be noted that while in the case of 'Extremely Permanent' Colours (Class AA) a sharp separation can be made, it is impossible to draw any hard and fast line between a 'Durable' (Class A) and a 'Moderately Durable' (Class B) or a 'Moderately Durable' (Class B) and a 'Fugitive' (Class C) Colour. The arrangement is therefore, in these cases, an arbitrary one, made only for convenience, and strictly speaking, the terms themselves have no meaning apart from some statement of the degrees of change and the duration of exposure on which the distinctions are based. It may be remarked in conclusion that, strictly speaking, there can be no such thing as 'absolute' permanence. As pointed out by Field long ago, the colour of Genuine Ultramarine, otherwise reliable for centuries, may be destroyed at once by a drop of lemon juice. Even under ordinary conditions of painting, as defined in these notes, the term has rather more force for water colour work than for painting in oil, since the appearance of a pigment, however permanent to light and oxidation this may be in itself, must necessarily be affected by changes in the medium. If, however, it is understood to apply to the pigments from which paints are prepared, and their exposure under specified conditions, the term 'Absolutely Permanent' becomes thoroughly legitimate because it signifies that, in so far as permanence, in its dependence on the nature of the pigment, is,

or has ever been in the past realizable by the Artist, the use of those colours classed by us as 'Extremely Permanent' will secure it for him.

Finally, it should be pointed out that one very important consideration which comes into play in the case of actual pictures—the mutual action of mixed colours—is not taken into account at all in our Classification Lists, which have reference only to colours exposed *per se*, but with the exception of Winsor Orange, Winsor Red and Scarlet Lake Oil Colours in very pale tints with White already referred to, it is true, that, as a general rule, the durability of a mixture may be safely deduced from that of its components. It is also true, however, that the permanence of a colour is not, as a rule, improved by mixing it with white (Lead, Zinc or Titanium White in oil colour, and Chinese White in water colour), or, in fact, by mixing it with other pigments, even permanent ones. If the colour is a durable one, it will probably suffer no injury, but any weakness in resistance to light and air is frequently accentuated by the dilution which is a necessary consequence of such admixture.

With the exception of Winsor Orange, Winsor Red and Scarlet Lake Oil Colours, which are excluded, the colours in the classes AA and A constitute Winsor & Newton's 'Selected List', the labels being marked thus, or with the letters 'SL'.

Classification of Winsor & Newton Artists' Colours

ARTISTS' WATER COLOURS

Class AA Extremely permanent colours

Azure Cobalt	Chinese White	Lamp Black	Sepia
Blue Black	ⓣ Cobalt Blue	Lemon Yellow	Sepia, Warm
ⓣ Burnt Sienna	Cobalt Violet	Light Red	Terre Verte
Burnt Umber	Davy's Gray	Oxide of Chromium	Venetian Red
Cerulean Blue	Indian Red	ⓣ Raw Sienna	ⓣ Viridian
Charcoal Grey	Ivory Black	Raw Umber	Yellow Ochre

CLASS A DURABLE COLOURS

ⓣ☐ Alizarin Carmine	● Cadmium Yellow	☐ Neutral Tint	○ Scarlet Vermilion
ⓣ☐ Alizarin Crimson	● Cadmium Yellow Deep	ⓣ Olive Green	Steel
ⓣ✦ Antwerp Blue	● Cadmium Yellow Pale.	☐ Payne's Gray	✖ Ultramarine Ash Blue
● Aureolin	‖ Chrome Orange	ⓣ✖ Permanent Blue	✖ Ultramarine Genuine
● Aurora Yellow	● Cobalt Green	ⓣ Permanent Magenta	(Lapis Lazuli)
Bright Red	ⓣ✦ Cyanine Blue	● Permanent Mauve	○ Vermilion
ⓣ Brown Madder	ⓣ✖ French Ultramarine	ⓣ Permanent Rose	ⓣ Winsor Blue
(Alizarin)	Gamboge, New	ⓣ✦ Prussian Blue	Winsor Emerald
● Cadmium Lemon	ⓣ Hooker's Green Dark	ⓣ Rose Doré	ⓣ Winsor Green
● Cadmium Orange	Indian Yellow	ⓣ Rose Madder Genuine	Winsor Red
● Cadmium Red	Indigo	ⓣ☐ Rose Madder (Alizarin) ⓣ	Winsor Violet
● Cadmium Red Deep	Manganese Blue	Scarlet Lake	Winsor Yellow
● Cadmium Scarlet	Naples Yellow		

CLASS B MODERATELY DURABLE COLOURS

‖ Chrome Deep	ⓣ⁑ Prussian Green
ⓣ Crimson Lake	ⓣ Purple Lake
ⓣ⁑ Gamboge	ⓣ Purple Madder (Alizarin)
ⓣ Hooker's Green Light	ⓣ Sap Green
● King's Yellow	ⓣ Violet Carmine

ⓣ Transparent or semi-transparent.
☐ Only 'moderately durable' in very thin washes.
✖ Bleached by acids, either liquid or gaseous, such as sulphurous fumes given off by coal fires.
● Colours that cannot be relied on to withstand damp. All others with the exception of vermilions, are proof against damp and sunlight.
✦ A permanent but fluctuating colour. Fades in the light and recovers in darkness.
○ Blackened if much exposed to the direct rays of the sun.
‖ Sullied if Sulphuretted Hydrogen obtains access.
⁑ Fugitive in very thin washes.

CLASS C FUGITIVE COLOURS

ⓣ Carmine	ⓣ Mauve
‖ Chrome Lemon	ⓣ Rose Carthame
‖ Chrome Yellow	Vandyke Brown

Composition of Pigments Prepared by Winsor & Newton and Used by them in the Manufacture of their Artists' Oil and Water Colors

Use this as a guide for selecting watercolors and to familiarize yourself with the chemical composition of the colors' pigments.

Alizarin Carmine; Alizarin Crimson: These Lakes, prepared from 1:2 dihydroxyanthraquinone do not approach in beauty of colour those obtained from the genuine Madder Root. In Oil Alizarin Carmine is synonymous with Alizarin Crimson.

Antwerp Blue: A weak variety of Prussian Blue containing alumina.

Aureolin: Double nitrite of cobalt and potassium. This colour, originally introduced by us, has always been a specialty of ours.

Aurora Yellow: Sulphide of cadmium.

Azure Cobalt: A greenish variety of ordinary cobalt.

Blue Black: In Water Colour this is a variety of carbon black. In Oil a mixture of Ivory Black and Ultramarine.

Bright Red: Prepared from an organic pigment.

Brown Madder (Alizarin): Prepared from synthetic alizarin in Water Colour but a blend of natural iron oxide with a synthetic alizarin in Oil Colour.

Burnt Sienna: Calcined raw sienna.

Burnt Umber: Calcined raw umber.

Cadmium Lemon; Cadmium Yellow; Cadmium Yellow Dp.; Cadmium Yellow Pale: Different shades of sulphide of cadmium.

Cadmium Green; Cadmium Green Pale: A mixture of Cadmium Yellow and Viridian.

Cadmium Orange: A mixture of cadmium sulphide and selenide.

Cadmium Red; Cadmium Red Deep; Cadmium Scarlet: Complex cadmium sulphoselenides.

Carmine: A lake prepared from cochineal.

Cerulean Blue: Stannate of cobalt.

Charcoal Grey: The composition of this colour is expressed by its name.

Chinese White: A specially dense variety of oxide of zinc. Chinese White was first introduced by us and is still one of our greatest specialties. It should be noted that ordinary Zinc White is often sold as Chinese White; buyers should therefore test it for covering power on a piece of black paper.

Chrome Green; Chrome Green Dp.; Chrome Green Lt.: Combinations of Chrome Yellow with Prussian Blue.

Chrome Lemon: A combination of chromate of lead with sulphate of lead.

Chrome Yellow: Normal chromate of lead.

Chrome Deep; Chrome Orange: Chromates of lead, more or less basic.

Cinnabar Green; Cinnabar Green Dp.: Combinations of Chrome Yellow, Prussian Blue and Raw Sienna.

Cobalt Blue; Cobalt Blue Deep: Cobalt aluminate or phosphate containing some alumina. Our Cobalt Blues are unusually free from a tendency to become greenish on exposure.

Cobalt Green; Cobalt Green Deep: Complex mixtures of cobalt and zinc oxides.

Cobalt Violet: Arsenate of cobalt in Oil but a blend of phosphate of cobalt and Cobalt Blue in Water Colour.

Cobalt Violet Dark: Phosphate of cobalt.

Cremnitz White: Pure basic carbonate of lead, ground in safflower oil.

Crimson Lake: Similar to Alizarin Crimson but more purple in tone. It supersedes the old fugitive colouring matter obtained from cochineal.

Cyanine Blue: A combination of Cobalt Blue and Prussian Blue.

Davy's Gray: A colour prepared from a special variety of slate and suggested by Mr. Henry Davy. It is particularly recommended as a reducing agent, as it does not, like the blacks, sully the colours with which it is mixed, but gives pure and translucid effects, and is an excellent drier.

Flake White No 1; Flake White No 2 (less stiff than No 1): Basic carbonate of lead combined with a small percentage of zinc oxide, ground in safflower oil.
N.B.—The addition of a little zinc oxide not only improves the consistency and general

working properties of this pigment, but also conduces to the maintenance of its whiteness and enables it to give clearer tints with the colder colours. Artists who prefer to work with the pure basic carbonate of lead employed by the Old Masters should use Cremnitz White.

Flesh Tint: Flake White tinted with Naples Yellow and Cadmium Red.

Foundation White: A variety of Flake White ground in linseed oil and thus particularly suitable for priming or foundation coats. (Whites ground in poppy oil or safflower oil should never be used for this purpose.)

Gamboge: A water colour preparation of the gum resin known under this name.

Gamboge, New: Prepared from organic pigments. It is not as transparent as Gamboge but has a brighter undertone and is more permanent to light. Used only as a Water Colour.

Geranium Lake: Prepared from an organic pigment.

Gold Ochre; Transpt. Gold Ochre: Native earths containing hydrated ferric oxide.

Hooker's Green Dk.; Hooker's Green Lt.: Water Colour lakes prepared from mixtures of organic pigments. They are more permanent to light than the old mixture of Gamboge and Prussian Blue.

Indian Red: A blend of both natural and synthetic oxides of iron.

Indian Yellow: Prepared from a mixture of organic pigments. The original Indian Yellow was prepared from Indian "Puree," a substance no longer available.

Indigo: The natural colouring matter obtained from the Indigo plant is no longer available. In Water Colour this is now a mixture of Alizarin Crimson, Lamp Black and Winsor Blue. In Oil it is a mixture of Ivory Black, Prussian Blue and Ultramarine.

Ivory Black: A product obtained from the calcination of bones.

Jaune Brillant: A reddish variety of Naples Yellow prepared from Cadmium Yellow, Flake White and Vermilion.

King's Yellow: A Water Colour prepared from Cadmium Yellow and Chinese White.

Lamp Black: A variety of carbon black obtained by the imperfect combustion of hydrocarbons.

Lemon Yellow: Chromate of barium. It may be well to state that a more brilliant but less permanent preparation of chromate of strontium is sold by some houses under the name of "Lemon Yellow."

Light Red: Calcined yellow ochre in Oil Colour but a blend of both natural and synthetic oxides of iron in Water Colour.

Magenta: Prepared from organic pigments.

Manganese Blue: Barium manganate on a barium sulphate base.

Mars Brown; Mars Orange; Mars Red; Mars Violet; Mars Yellow: Chemically prepared iron oxides.

Mauve; Mauve (Blue Shade); Mauve (Red Shade): Prepared from organic pigments.

Naples Yellow: In Water Colour it is a combination of cadmium sulphide, ferric oxide and zinc oxide. In Oil it is a mixture of Cadmium Yellow, Flake White, Light Red and Yellow Ochre.

Neutral Tint: A Water Colour prepared from Alizarin Crimson, Lamp Black and Winsor Blue. It was originally made from fugitive constituents.

New Blue: A pale variety of French Ultramarine.

Oil Painting Primer: Titanium White pigment ground in a non-yellowing oil-modified synthetic resin medium of thixotropic character. Is quick drying.

Olive Green: In Water Colour this consists of a mixture of Raw Sienna and Winsor Green. In Oil a combination of Ultramarine with an organic pigment takes the place of the old fugitive mixture.

Oxide of Chromium: This is, as suggested by its name, chromium sesquioxide. No praise can be too high for this permanent and unassumingly beautiful pigment.

Payne's Gray: In Water Colour this consists of a mixture of Alizarin Crimson, Lamp Black, Prussian Blue and Ultramarine. In Oil it is prepared from Davy's Gray, Lamp Black, Mars Red and Ultramarine.

Permanent Blue: A pale variety of French Ultramarine.

Permanent Green Dp.; Permanent Green; Permanent Green Lt.: Varying proportions of Viridian and Zinc Yellow.

Permanent Mauve: Phosphate of manganese.

Permanent Magenta; Permanent Rose: Quinacridones; organic pigments first produced in 1958. Transparent colours of outstanding fastness to light, even in pale tints.

Permanent White: Synonymous with Titanium White.

Prussian Blue: Potassium ferric-ferrocyanide.

Prussian Green: In Water Colour this consists of a mixture of Gamboge and Prussian Blue. In Oil it is a mixture of organic pigments.

Purple Lake; Purple Madder (Alizarin): Prepared from synthetic alizarin lakes.

Raw Sienna: Native earth containing hydrated ferric oxide.

Raw Umber: Native earth containing ferric oxides and manganese dioxide.

Rose Carthame: A blending of organic pigments.

Rose Doré: A variety of genuine Rose Madder (inclined to scarlet) in Oil Colour but an organic quinacridone pigment in Water Colour.

Rose Madder Deep; Rose Madder Gen.: Lakes of exquisite beauty, prepared from the Madder root. Our Rose Madder has long been renowned for its delicate bloom, transparency and the clearness of its tints with white.

Rose Madder (Alizarin): Lake prepared from 1:2 dihydroxyanthraquinone. In Oil Rose Madder (Alizarin) is synonymous with Alizarin Crimson.

Sap Green: A mixture of organic pigments.

Scarlet Lake: Prepared from an organic pigment. It is not liable to darken in sunlight as did the original mixture of Alizarin Crimson and Vermilion.

Sepia: An intimate mixture of Burnt Sienna and Lamp Black. It is more reliable than the colouring matter formerly obtained from the bags of the cuttle fish.

Sepia, Warm: Containing a larger proportion of Burnt Sienna, this Water Colour is warmer in tone than Sepia.

Silver White: Synonymous with Flake White.

Steel: A mixture of Alizarin Crimson and Winsor Blue.

Terra Rosa: A native earth tinctured with sesquioxide of iron.

Terre Verte: Native earth containing ferric and ferrous oxides, the colour of which may be adjusted with chromium sesquioxide.

Titanium White: Titanium oxide, with a small percentage of zinc oxide ground in safflower oil. N.B.—The addition of a little zinc oxide not only improves the consistency and general working properties of this pigment, but also conduces to the maintenance of its whiteness and enables it to give clearer tints with colder colours.

Ultramarine Genuine: The choicest extract of lapis lazuli.

Ultramarine Ash Blue: Obtained from lapis lazuli.

Ultramarine, Brilliant; Ultramarine Deep; Ultramarine, French; Ultramarine Light: Complex combinations of silica, alumina, soda and sulphur.

Underpainting White: Titanium oxide with a small proportion of zinc oxide ground in polymerised linseed oil. Outstanding for texture and speed of drying.

Vandyke Brown: A native bituminous earth containing ferric oxide.

Venetian Red: A synthetic ferric oxide in Oil Colour but a blend of natural and synthetic oxides in Water Colour.

Vermilion; Vermilion, Scarlet: Varieties of mercuric sulphide.

Violet Carmine: A blending of organic pigments.

Viridian: A hydrated and very transparent variety of chromium sesquioxide, originally introduced by us.

Winsor Blue: Copper phthalocyanine. An organic pigment originally introduced by the Imperial Chemical Industries Ltd. in 1937 under the name of Monastral Fast Blue.

Winsor Green: Chlorinated copper phthalocyanine. An organic pigment originally introduced by the Imperial Chemical Industries Ltd. in 1938 under the name of Monastral Fast Green.

Winsor Emerald; Winsor Lemon; Winsor Orange; Winsor Red; Winsor Violet; Winsor Yellow: A range of organic pigments of exceptional brilliance and excellent durability.

Yellow Ochre: A native earth containing hydrated ferric oxide.

Yellow Ochre Pale: Chemically prepared hydrated ferric oxide.

Zinc White: Oxide of zinc, ground in safflower oil. Although not possessing the body of white lead, this beautiful white keeps its colour better. It has, unfortunately, a tendency to crack.

Zinc Yellow: Chromate of zinc.

Caution

In order to anticipate possible claims, Winsor & Newton Ltd. wish to remind users of their colours that some of these are more or less *poisonous, viz.:*

Chinese Vermilion 2	Liquin
Chrome Deep 1, 2, 3	Magenta 1
Chrome Green 1	Managanese Blue 1, 3
Chrome Green Deep 1	Mauve 3
Chrome Green Light 1	Mauve Blue Shade, 1, 2
Chrome Lemon 1, 2, 3	Mauve Red Shade 1
Chrome Orange 1, 2, 3	Medium Yellow 6
Chrome Yellow 1, 2, 3	Naples Yellow 1
Cinnabar Green 1	Oleopasto
Cinnabar Green Deep 1	Ostwald Leaf Green 6
Cobalt Violet 1, 2	Ostwald Yellow 6
Cremnitz White 1, 2	Primrose 6
Flake White 1, 2	Purple Lake 3
Flesh Tint 1	Red No 1, 4
Foundation White 1	Rose Carthame 3, 5
Geranium 5	Rose Malmaison 5
Geranium Lake 1	Rose Tyrien 5
Geranium Lake Pale 5	Scarlet Vermilion 1, 2, 3
Havannah Lake 5	Silver White 1
Jaune Brillant 1	Terra Cotta 6
Lemon Yellow 1, 3	Vermilion 1, 2, 3
Lemon Yellow Deep 2	Win-Gel
Lemon Yellow Pale 2	Zinc Yellow 1

1 Artists' Oil Colour	4 Brilliant Water Colour
2 Artists' Powder Colour	5 Designers' Gouache Colour
3 Artists' Water Colour	6 Fabric Printing Colour

Although there is no danger whatever in using these Colours in the orthodox manner, Winsor & Newton Ltd. can in no circumstances hold themselves responsible for any mishap that may arise from such practices as those of applying Oil Colours with the finger or putting Water Colour Brushes into the mouth.

Every possible care is taken to maintain the highest standard of quality, but Winsor & Newton Ltd. desire to make it clearly understood that it is the user's responsibility to make sure that the goods he purchases are suitable for his particular requirements. In no case can claims be entertained for the value of work alleged to be spoiled by the employment of a product which proves unsatisfactory, the makers' liability being confined to replacement of any product proved to be defective in respect of materials or workmanship.

In particular, the connotation of such descriptions as 'Permanent,' 'Waterproof,' etc., is that generally accepted in the trade.

Framing: Sources for Tools and Materials

CHARRETTE

Mail Order Department
44 Brattle Street
Cambridge, Ma. 02138

212 East 54th Street
New York, N.Y. 10022
This is an excellent art-supplies outlet. A catalog will be sent on request.

DAVID DAVIS

539 La Guardia Place
New York, N.Y. 10012

Large selection of artists' materials, especially papers, are available.

DICK BLICK

Mail Order Art Supplier
P.O. Box 1267
Galesburg, Ill. 61401

EUBANK FRAME, INC.

P.O. Box 425
Salisbury, Maryland 21801

You can order the metal Eubank Frame or the plastic Uni-Frame directly from them, or they will inform you about suppliers in your area.

GRAPHIC DIMENSIONS LIMITED

Department AA
131-37 41st Avenue
Flushing, N.Y. 11355
Call: 800-221-0262
 (212) 544-7286 (N.Y.)

Wholesale prices for aluminum section frames.

ASF SALES

P.O. Box 6026
Toledo, Ohio 43614
Call: 800-537-7083
 800-472-7016 (Ohio Residents)

Excellent prices on aluminum section picture frames. They cut them to order to any fraction of an inch and have many colors.

KULICKE

636 Broadway
New York, N.Y. 10012

Mail order for the Kulicke metal section frame, Box Frame, and others.

NEW YORK CENTRAL SUPPLY COMPANY

62 Third Avenue
New York, N.Y. 10003

Features a large supply of artists' papers and a variety of matboards.

AIKO'S ART MATERIALS IMPORT

714 N. Wabash Avenue
Chicago, Ill. 50511

Good outlet for artists' papers and framing supplies.

PROCESS MATERIALS CORPORATION

329 Veterans Boulevard
Constadt, N.J. 07072

Large supply of artists' papers, framing tools, and materials.

HEINZ JORDAN & COMPANY

42 Gladstone Avenue
Toronto, Ont. M6J 3K6
Canada

Artists' papers, tools, and materials.

TALAS

Division of Technical Library Service
104 Fifth Avenue
New York, N.Y. 10011

An excellent outlet for a variety of tools and materials for framing and restoring artwork on paper. They carry a large assortment of all rag, archival papers, and archival glues. They will send a catalog for $1.00.

TWIN CITY MOULDING AND SUPPLY

2505 University Avenue
St. Paul, Minn. 55114

Good source for framing tools and materials and all sorts of frames and frame kits. Will send catalog.

DENNISON MANUFACTURING COMPANY

Coated Paper Division
300 Howard Street
Framingham, Mass. 01701

For gummed linen tape used for matting.

BOOK ON FRAMING

DUREN, LISTA. *Frame It. A Complete Do-It-Yourself Guide to Picture Framing.* Boston: Houghton Mifflin Company, 1976. An excellent book on the basics of framing watercolors as well as a variety of other paintings. Well illustrated with simple-to-follow directions.

Watercolor Paper

Listed are some of the major manufacturers and distributors who offer fine artists' papers, either made by machine or by mold. These companies supply art stores with paper stock. Should your local artists' supply retailer not have papers you desire, contact these companies.

> Andrews, Nelson, Whitehead
> 7 Laight Street
> New York, N.Y. 10013

This is one of the largest companies and has a huge selection of a variety of quality papers, including oriental papers. Imports watercolor papers from England, Germany, and France. For a small fee there are sample books available.

> Crestwood Paper Co.
> 315 Hudson Street
> New York, N.Y. 10014

They stock 100% cotton, 140 lb, and neutral pH Fabriano papers.

> Morilla Paper Co.
> 43-01 21st Street
> Long Island City, N.Y. 11101

Has in addition to the Arches watercolor paper a less expensive type called Archette. This student-grade paper contains only 25% rag and is available in the standard sizes.

> Papers of All Nations
> 62 Third Ave.
> New York, N.Y. 10003

Imports colored and textured hand-made papers from England, Spain, Sweden, and Mexico. It also has the domestic hand-made papers. Write for brochure.

> Strathmore Paper Co.
> South Broad Street
> West Westfield, Mass. 01085

Makes a variety of artists' papers, including a new watercolor paper called Gemini, which is 100% cotton and neutral pH. Comes in various finishes and weights.

Hand-made Papers. Apparently what is difficult to achieve if you make your own paper is quality control. For a beginner it can be a hit-or-miss undertaking. The following individuals listed have devoted themselves to papermaking by hand. Some of them offer workshops as well as lecture demonstrations. They will also work with artists and produce papers according to their specifications. For further information contract them directly.

EAST COAST:

> Douglas Howell
> 625 Bayville Road
> Locust Valley, N.Y. 11560

Has been making paper for the last 30 years without chemical additives.

> John and Kathy Kroller
> H.M.P. Papers
> Woodstock Valley, Connecticut 06282

Quality papers for printmaking, drawing, and custom-made without or minimal sizing.

Bruce and Susan Gosin Wineberg
Dieu Donné Press and Paper Inc.
3 Crosby Street
New York, N.Y. 10013

This is a more commercial production of paper, made from 100% cotton or linen rag. Also provides custom-made papers.

Elaine and Donna Koretzky
Carriage House Handmade Paper Works
8 Evans Road, Brookline, Mass. 02146

Papers made from natural (and uncommon) plant fibers, such as those of banana, sea-weed, sea onion, papyrus, etc. They learned their craft in the Far East. Samples are available.

MID WEST:

Kathryn and Howard Clark
Twinrocker, Inc.
R.F.D. 2
Brookton, Indiana, 47923

Variety of papers, custom made according to artist's specification. All papers are 100% rag, in a variety of sizes and white tones.

Joe Wilfer
Upper U.S. Papermill
999 Glenway Road
Oregon, Wisconsin 53575

Quality papers in a variety of formats and sizes. Custom-made papers according to artist's specification. Mill can be rented by artists and used for seminars.

SOUTH:

Walter Neals
Snail Pace Paper Mill
1251 Via Estrella,
Winter Park, Florida 32789

Custom-made papers, including those made from local plants (banana).

Richard Clifford
Botanica Mills
Box 1253
Fort Worth, Texas 76101

Handmade papers from a variety of fibers (lotus, alfalfa, corn, thistle) and custom made with specific properties.

WEST COAST:

Don Farnsworth
D. S. Farnsworth Hand-Made Paper
2325 Third Street, Suite 406
San Francisco, Calif. 94107

A catalog is available listing services and types of papers.

Bob Serpa
1333 Wood Street
Oakland, Calif. 94607

Associated with Farnsworth at one time. Write for catalog.

Vance Studley
295 Cherry Drive
Pasadena, Calif. 91105

Custom-made papers using a variety of fibers (hemp, jute, bamboo, iris, etc.).

OUT-OF-STATE HAND PAPERMAKERS:

Andrew Smith
O Handmade Paper
RR 2
Beaverton, Ontario
Canada

Variety of papers made of cotton or fibers and mixes. Papers made to order.

For more information on hand-made papers and the revolution in papermaking, see *American Artist* magazine, August, 1977.

The following is a list of sources for Oriental or Japanese papers.

Aiko's Art Materials Import
714 N. Wabash Avenue
Chicago, Ill. 50511

Yasutomo Company
24 California Street
San Francisco, Calif. 94111

Both companies import a variety of oriental papers, including heavier types for Sumi-e painting, such as Hosho and Koso papers, not usually found at stores.

For Washe No Mise oriental paper, mentioned in text, contact:

R D No. 2
Kennett Square, Pennsylvania 19384

This outlet is used by art conservators, but it will also sell paper to students.

If you are interested in learning to make your own paper, Strathmore Paper Company features a *Papermaking Kit*, which has the basic tools and materials that are necessary for making paper at home. The kit is intended to introduce the artist who works with paper (watercolorist or printmaker) to the craft of papermaking. The kit has enough supplies for making 30–40 sheets of paper approximately 7 × 10 inches. Additional materials are available from the company. Inquire at your art-supplies retailer or write to:

Strathmore Paper Company
Westfield, Mass. 01085

Books on papermaking:

HELLER, JULES. *Papermaking.* New York: Watson-Guptill, 1978. This book will introduce you to papermaking by a step-by-step demonstration. You learn about various types of papers: laid, woven, mould-made, and oriental "rice" papers. An excellent introduction that lists suppliers and a bibliography.

SCARBOROUGH, JESSICA. *Creating Handmade Paper.* New York: Crown, Arts and Crafts Library, 1978.

STUDLEY, VANCE. *The Art and Craft of Handmade Paper.* New York: Van Nostrand Reinhold, Inc., 1978.

Booklet and Pamphlets on Color

These include valuable information about the permanency rating of various organic and inorganic artists' pigments that are used in oil and watercolor. You can order these from the manufacturers.

Enduring Colors for the Artist: A Treatise on Permanence in Painting. This booklet discusses the pigments used in a variety of paints manufactured by Permanent Pigments. It gives permanency ratings, a short history on the methods of measuring color and color change. It also discusses vehicles, oils, and mediums. It is quite informative. Write to:

Permanent Pigments,
Division of Binney & Smith, Inc.
2700 Highland Avenue
Cincinnati, Ohio 45212

The Composition & Permanence of Artists' Colors including a description of oils, painting media, and varnishes. This pamphlet discusses the pigments prepared by Winsor & Newton that are used in their artists' oils and watercolors. This is an excellent guide for selecting colors with an eye on permanency. Its section on watercolors is reprinted here. You may obtain a copy by writing to:

Winsor & Newton, Inc.
555 Winsor Drive
Secaucus, New Jersey 17094

Bibliography

Books on Watercolor Painting and Technique

The bibliography covers a broad range of watercolor books written for the amateur painter or student. Most of them are by watercolorists who teach their own personal painting style. I have limited myself primarily to books published in the 1960s and 1970s.

I have omitted periodical entries, even though they often have very informative articles on historical as well as contemporary watercolor painters. Of interest to the watercolorist would be the *American Artist* magazine, which contains much valuable information about watercolor materials and supplies. It has a "Watercolor Page" devoted to issues on watercolor painting.

BARBOUR, ARTHUR J. *Painting the Seasons in Watercolor.* New York: Watson-Guptill, 1974.

————. *Watercolor: The Wet Technique.* New York: Watson-Guptill, 1976.

BLAKE, WENDON. *Landscapes in Watercolor.* New York: Watson-Guptill, 1978.

————. *Watercolor Painting.* New York: Watson-Guptill, 1978.

BRANDT, REX. *Watercolor Technique* (Revised ed.) New York: Reinhold Publishing Corp., 1963.

————. *Watercolor Landscape.* New York: Reinhold Publishing Corp., 1963.

BROMMER, GERALD F. *Transparent Watercolor: Ideas and Techniques.* London: Oak Tree Press, 1973.

BROOKS, (FRANK) LEONARD. *Course in Wash Drawing.* New York: Reinhold Publishing Corp.; London: Chapman & Hall, 1961.

CARLSON, CHARLES X. *Watercolor Painting.* New York: Sentinel Books, 1963. (A paperback edition.)

CHOMICKY, YAR G. *Watercolor Painting: Media, Methods, and Materials.* Englewood Cliffs, N.J.: Prentice-Hall, Inc., 1968.

COHN, MARGORIE B. *Wash and Gouache: A Study of the Development of Materials of Watercolor.* Center for conservation and technical studies. Cambridge: Fogg Art Museum, Harvard University, 1977.

COOPER, MARIO. *Painting with Watercolor.* New York; London: Van Nostrand Reinhold, 1971 (i.e., 1972).

DEHN, ADOLF (ARTHUR). *Water Colour, Gouache and Casein Painting.* New York: Studio; London: Thames and Hudson, 1956.

FEI CH'ENG-WU. *Brush Drawing in the Chinese Manner.* London: Studio, 1957.

FITZGERALD, EDMOND JONES. *Marine Painting in Watercolour.* London: Pitman, 1972.

FLETCHER, GEOFFREY. *Paint in Water Colour.* Paintings by the author. London: Daily Telegraph, 1974.

HILL, TOM. *The Watercolor Painter's Problem Book.* New York: Watson-Guptill, 1976.

INGEN, J. VAN. *Aquarelle and Watercolor Complete.* New York: Sterling. London: Ward Lock, 1972.

JONES, BARBARA. *Water-colour Painting.* London: Adam and Charles Black, 1960.

KAUTZKY, THEODORE. *Ways with Watercolour.* New York: Reinhold Publishing Corp.; London: Chapman and Hall, 1951.

————. *Painting Trees and Landscapes in Watercolor.* New York: Reinhold Publishing Corp., 1952.

KENT, NORMAN. *100 Watercolor Techniques;* edited by Susan E. Meyer. New York: Watson-Guptill, 1966.

LEECH, HILTON, and EMILY HOLMES. *The Joys of Watercolour.* New York; London: Van Nostrand Reinhold, 1973.

MEYER, SUSAN E. *40 Watercolorists and How They Work.* New York: Watson-Guptill, 1978.

MEYER, SUSAN E., and NORMAN KENT. *Watercolorists at Work.* New York: Watson-Guptill; London: Pitman, 1972.

OLSEN, HERB (i.e., Herbert Vincent Olson). *Painting the Marine Scene in Watercolor.* New York and London: Reinhold Publishing Corp., 1967.

————. *Painting Children in Watercolor.* New York: Reinhold Publishing Corp.; London: Chapman and Hall, 1960.

————. *Painting the Figure in Watercolor.* New York: Reinhold Publishing Corp.; London: Chapman and Hall, 1958.

PELLEW, JOHN C. *Painting in Watercolor.* New York: Watson-Guptill, 1970.

PIKE, JOHN. *Watercolor* (new ed.). New York: Watson-Guptill; London: Pitman, 1973.

REID, CHARLES. *Figure Painting in Watercolor.* London: Pitman; New York: Watson-Guptill, 1972.

————. *Portrait Painting in Watercolor.* New York: Watson-Guptill; London: Pitman, 1973.

————. *Flower Painting in Watercolor.* New York: Watson-Guptill, 1978.

RICHMOND, LEONARD, and J. LITTLEJOHNS. *Fundamentals of Watercolor Painting.* New York: Watson-Guptill, 1978.

ROGERS, JOHN. *Watercolor Simplified.* New York: Reinhold Publishing Corp., 1962.

SANDERSON, GRETCHEN, and ALPHONSE J. SHELTON. *Mixed Media and Watercolor.* London: Pitman, 1973.

SCHMALZ, CARL. *Watercolor Your Way.* New York: Watson-Guptill, 1975.

————. *Watercolor Lessons from Eliot O'Hara.* New York: Watson-Guptill, 1976.

SZABO, ZOLTAN. *Landscape Painting in Watercolor.* New York: Watson-Guptill, 1975.

————. *Zoltan Szabo Paints Landscapes: Advanced Techniques in Watercolor.* New York: Watson-Guptill, 1977.

————. *Creative Watercolor Techniques.* New York: Watson-Guptill, 1976.

————. *Zoltan Szabo: Artist at Work.* New York: Watson-Guptill, 1979.

WHITAKER, FREDERIC. *Whitaker on Watercolor.* New York: Reinhold Publishing Corp., 1963.·

WHITNEY, EDGAR A. *Complete Guide to Watercolor Painting.* New York: Watson-Guptill, 1978.

WOOD, ROBERT E., and MARY CAROLL NELSON. *Watercolor Workshop.* New York: Watson-Guptill, 1978.

WORTH, LESLIE. *The Practice of Watercolour Painting.* New York: Watson-Guptill, 1978.

Books on the History of Watercolor Painting

DAULTE, FRANCOIS. *French Watercolors of the 19th and 20th Century.* 2 vols. London: Thames and Hudson, 1968.

GARDNER, ALBERT TEN EYCK. *History of Watercolor Painting in America.* New York: Reinhold Publishing Corp., 1966.

HAFTMANN, WERNER. *Master Watercolors of the Twentieth Century.* New York: H. N. Abrams, 1965.

HARDIE, MARTIN. *Watercolour in Britain.* 3 vols. London: Batsford, 1966–1968.

HOFMANN, WERNER. *Aquarelle des Expressionismus: 1905–1920.* Cologne: DuMont Schauberg, 1966.

KOSCHATZKY, WALTER. *Das Aquarell: Entwicklung, Technik, Eigenart.* Vienna: Anton Schroll, 1969.

SELZ, JEAN. *XIX and XX Century Drawings and Watercolors.* 2 vol. New York: Crown, 1968.

STEBBINS, THEODORE E. *American Master Drawings and Watercolors. A History of Works on Paper from Colonial Times to the Present.* New York: Harper and Row, 1976.

Exhibition Catalogues on Watercolor Painting

British Watercolors: 1750–1850. A Loan Exhibit from the Victoria and Albert Museum, London. Houston: Museum of Fine Arts, 1966.

Das Aquarell: 1400–1950. Munich: Haus der Kunst. 1973.

Masterdrawings and Watercolors from the Louvre. Darmstadt: Hessisches Landesmuseum, 1972.

Masters of Watercolor: Ten Americans. New York: Andrew Crispo Gallery, 1974.

200 Years of Watercolor Painting in America. New York: Metropolitan Museum of Art, 1967.

Books on the Historical Watercolorists Reproduced in the Text

Albertina Museum. *Claude Lorrain und die Meister der Römischen Landschaft im XVII. Jahrhundert.* Vienna: Albertina, 1965.

ANANOFF, ALEXANDER. *L'oeuvre Dessiné de Jean Honoré Fragonard.* 3 vols. Paris: F. de Nobele, 1961–1970.

BARR, ALFRED H. *Matisse: His Art and His Public.* New York: Museum of Modern Art, 1951.

BUSCH, G., and W. HOLZHAUSEN. *August Macke: Tunisian Watercolors and Drawings.* London: Thames and Hudson, 1971.

BUTLIN, MARTIN. *Turner's Watercolors.* Watercolors from the Turner Bequest. London: Tate Gallery, 1962.

CASSOU, JEAN. *Wassily Kandinsky: Watercolors, Drawings, Writings.* London: Thames and Hudson, 1961.

FRIED, MICHAEL. *Morris Louis.* New York: H. N. Abrams, 1971.

GAUNT, WILLIAM. *Turner's Universe.* Les Carnets de Dessins. New York: Barron's, 1974.

GROHMANN, WILL. *Wassily Kandinsky: Life and Work.* New York: H. N. Abrams, 1958.

————. *Das Werk Ernst Ludwig Kirchners.* Munich: K. Wolff, 1926.

HAFTMANN, WERNER. *Emil Nolde: Ungemalte Bilder.* 1938–1945. Stiftung Seebüll. Cologne: Du-Mont Schauberg, 1963.

――――. *Paul Klee: Watercolors, Drawings and Writings: The Inward Vision.* London: Thames and Hudson, 1958.

HOMER, WILLIAM INNESS. *Robert Henri and His Circle.* Ithaca: Cornell University Press, 1969.

HOOPES, DONELSON F. *Sargent: Watercolors.* New York: Watson-Guptill, 1970.

――――. *Winslow Homer: Watercolors.* New York: Watson-Guptill, 1969.

KOSCHATZKY, WALTER. *Albrecht Dürer: The Landscape Watercolors.* New York: St. Martin's Press, Inc., 1973.

――――. *Wilhelm Thöny: Zeichnungen und Aquarelle.* Salzburg: Galerie Welz, 1963.

MARTIN, KURT. *Edouard Manet: Watercolors and Pastels.* London: Faber, 1959.

NOVOTNY, FRITZ. *Toulouse-Lautrec.* New York: Frederick Praeger, Inc., 1969.

RITCHIE, ANDREW C. *Charles Demuth at the Museum of Modern Art.* New York: Museum of Modern Art, 1950.

ROSENBERG, JAKOB. *Die Zeichnungen Lucas Cranachs d. Ä.* Berlin: Deutscher Verein für Kunstwissenschaft, 1960.

SCHMIDT, GEORGE. *Watercolors by Paul Cézanne.* New York: Macmillan, 1954.

SEITZ, WILLIAM C. *Monet.* New York: H. N. Abrams, 1960.

SÉRULLAZ, MAURICE. *Eugène Delacroix: Aquarelles du Maroc.* Paris: F. Hazan, 1951.

SPASSKY, NATALIE. *John Singer Sargent: A Selection of Drawings and Watercolors.* New York: Metropolitan Museum of Art, 1971.

TAYLOR, BASIL. *Constable: Paintings, Drawings and Watercolors.* London: Phaidon Press, 1973.

URBAN, MARTIN. *Emil Nolde: Landscapes, Watercolors and Drawings.* New York: Frederick Praeger, Inc., 1970.

――――. *Emil Nolde: Flowers and Animals.* New York: Frederick Praeger, Inc., 1964.

WILKINSON, GERALD. *Turner's Early Sketch-books.* Drawings in England, Wales, and Scotland from 1789–1802. London: Barrie and Jenkins, 1972.

Books on Color

ALBERS, JOSEPH. *The Interaction of Color.* New Haven: Yale University Press, 1963.

FABRI, RALPH. *Color: A Complete Guide for the Artist.* New York: Watson-Guptill, 1978.

GRAVES, MAITLAND. *Color Fundamentals.* New York: McGraw-Hill, 1952.

HILL, TOM. *Color for the Watercolor Painter.* New York: Watson-Guptill, 1978.

ITTEN, JOHANNES. *The Elements of Color. A Treatise on the Color System of Itten.* Ravensburg: Otto Maier Verlag, 1970.

SALEMME, LUCIA. *Color Exercises for the Painter.* New York: Watson-Guptill, 1979.

Books on Drawing

CHAET, BERNARD. *The Art of Drawing.* New York: Holt, Rinehart and Winston, Inc., 1970.

GOLDSTEIN, NATHAN. *Figure Drawing.* Englewood Cliffs, N.J.: Prentice-Hall, Inc., 1976.

――――. *The Art of Responsive Drawing* (second edition). Englewood Cliffs, N.J.: Prentice-Hall, Inc., 1977.

HILL, EDWARD. *The Language of Drawing.* Englewood Cliffs, N.J.: Prentice-Hall, Inc., 1966.

HOGARTH, PAUL. *Drawing People.* New York: Watson-Guptill, 1970.

KANPELIS, ROBERT. *Learning to Draw.* New York: Watson-Guptill, 1969.

Books on Materials and Techniques

CHAET, BERNARD. *An Artist's Notebook.* Techniques and Materials. New York: Holt, Rinehart and Winston, 1978.

HERBERTS, K. *The Complete Book of Artists' Techniques.* New York: Frederick Praeger, Inc., 1958.

KAY, REED. *The Painter's Guide to Studio Methods and Materials.* Garden City, N.Y.: Doubleday and Company, Inc., 1972.

MAYER, RALPH. *The Artist's Handbook of Materials and Techniques* (Revised Edition). New York: Viking, 1965.

WEHLT, KURT. *Materials and Techniques of Painting.* New York: Van Nostrand Reinhold, 1975.

Index

241